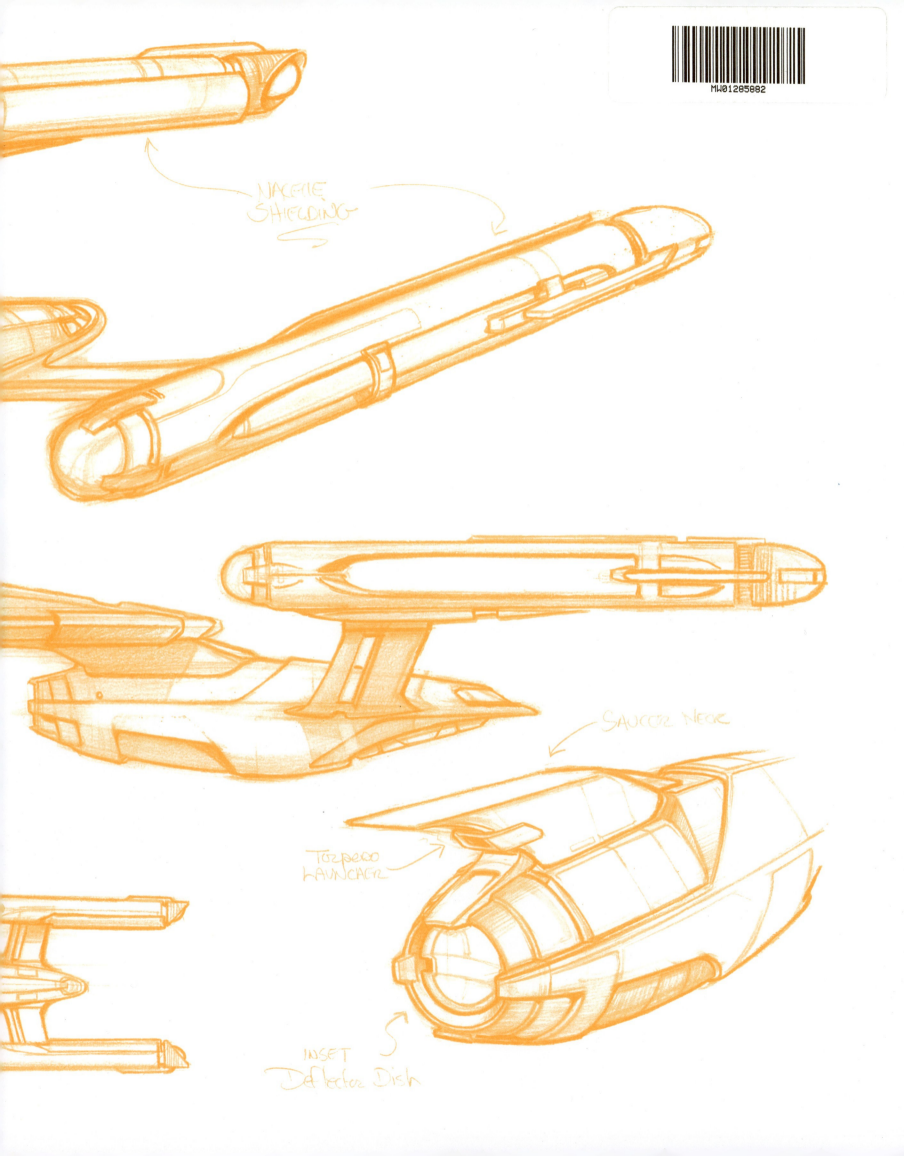

# STAR TREK
## THE ART OF
# JOHN EAVES

STAR TREK
THE ART OF JOHN EAVES
ISBN: 9781785659119

Published by
Titan Books
A division of Titan Publishing Group Ltd
144 Southwark Street
London
SE1 0UP

www.titanbooks.com

First edition: November 2018

10 9 8 7 6 5 4 3 2 1

TM & © 2018 CBS Studios Inc. © 2018 Paramount Pictures Corp.
STAR TREK and related marks and logos are trademarks of CBS Studios Inc.
All Rights Reserved.

Did you enjoy this book? We love to hear from our readers. Please e-mail us at: readerfeedback@titanemail.com or write to Reader Feedback at the above address.

To receive advance information, news, competitions, and exclusive offers online, please sign up for the Titan newsletter on our website:
**www.titanbooks.com**

No part of this publication may be reproduced, stored in a retrieval system, or transmitted, in any form or by any means without the prior written permission of the publisher, nor be otherwise circulated in any form of binding or cover other than that in which it is published and without a similar condition being imposed on the subsequent purchaser.

A CIP catalogue record for this title is available from the British Library.

Printed and bound in China.

# STAR TREK™
## THE ART OF
# JOHN EAVES

**JOE NAZZARO**
Foreword by Greg Jein
and Herman Zimmerman

**TITAN** BOOKS

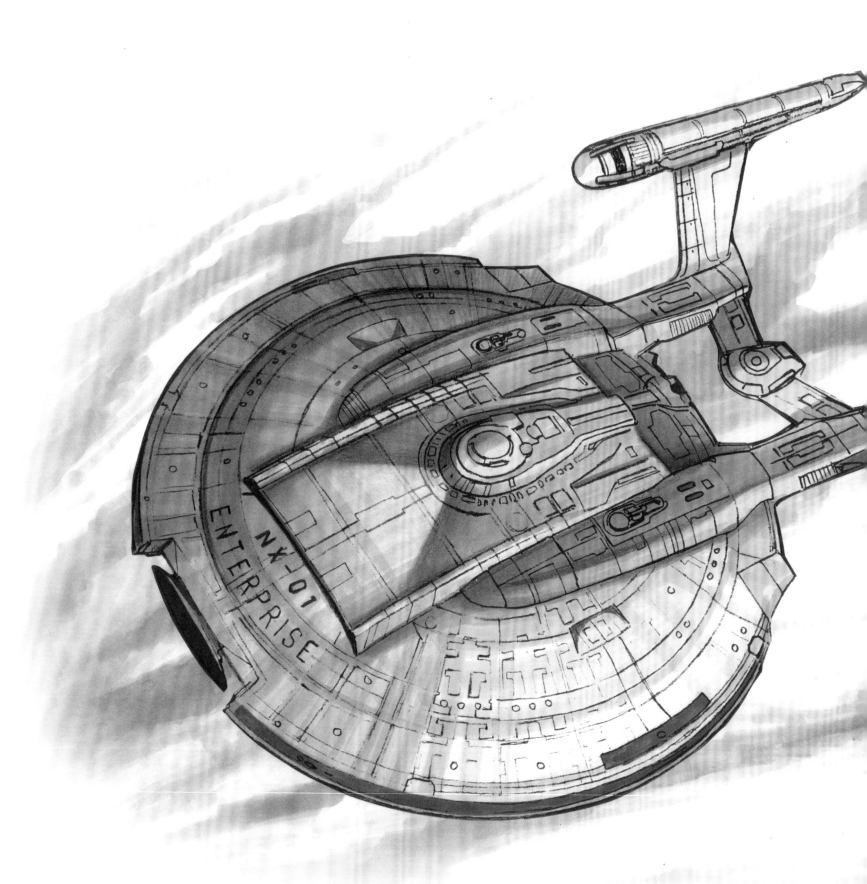

# CONTENTS

Foreword by Greg Jein 6
Foreword by Herman Zimmerman 8

## CHAPTER 1:
### TO BOLDLY GO: LIFE BEFORE STAR TREK 10

## CHAPTER 2:
### THE MOVIES 20

Star Trek V: The Final Frontier 22
Star Trek Generations 26
Star Trek: First Contact 42
Star Trek: Insurrection 60
Star Trek Nemesis 76

## CHAPTER 3:
### THE TELEVISION SERIES 94

Star Trek: Deep Space Nine 96
Star Trek: The Next Generation and Voyager 116
Star Trek: Enterprise 120

## CHAPTER 4:
### THE KELVIN TIMELINE 140

Star Trek 142
Star Trek Into Darkness 154
Star Trek Beyond 166

## CHAPTER 5:
### STAR TREK: DISCOVERY 178

Afterword by John Eaves 206

Acknowledgements 208

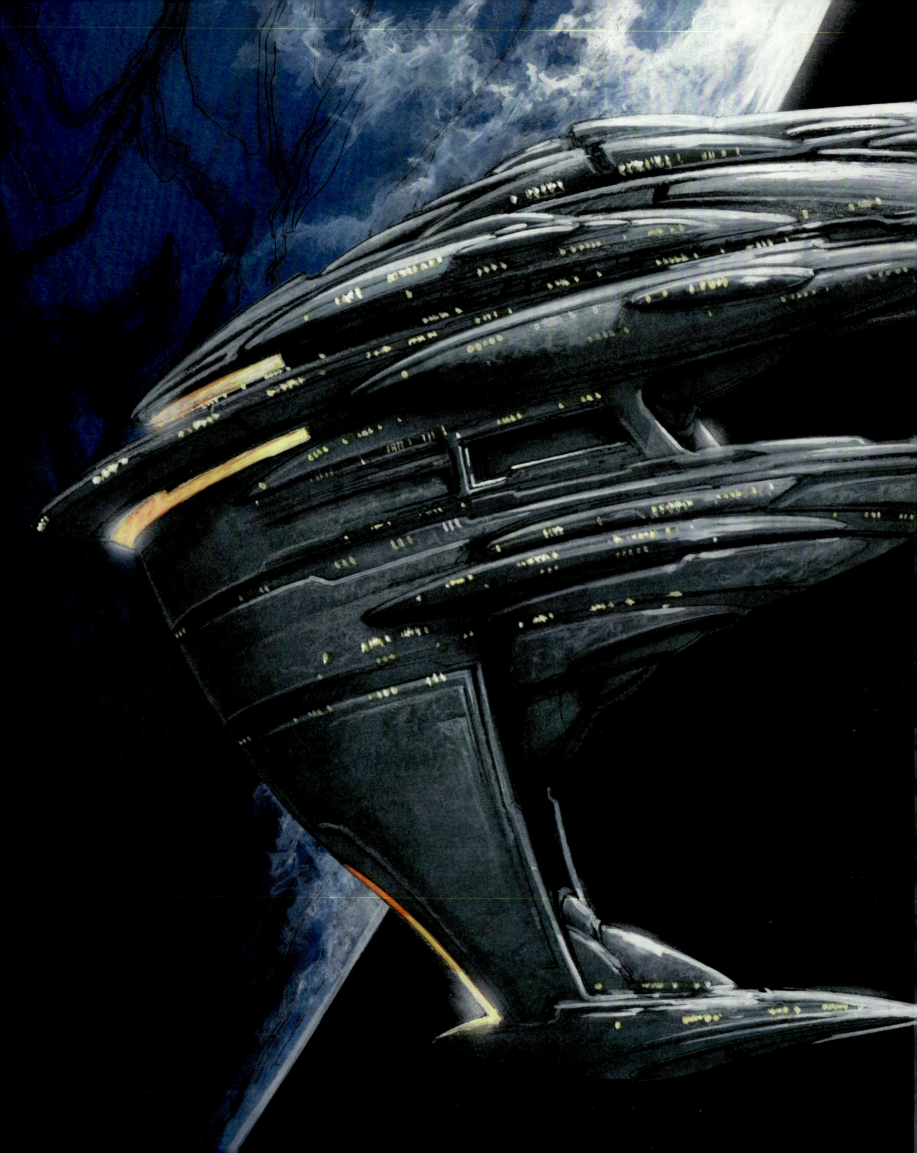

# FOREWORD
## BY GREG JEIN

I've always prided myself in having top crews on all my projects. No brag, just fact. What I was constantly after were the best people, regardless of age or sex, willing to give their all in the current "adventure." Many were relatively green, but enthusiastic and able to adapt to new challenges. Most importantly, I didn't have to constantly look over their shoulders. Living on pizza and burgers, we battled deadlines and budgets in true "Hollywood" tradition.

I look back with great fondness at these talented kids, especially those who went on to have successful careers. One of the brightest stars was young John Eaves. His father had a law enforcement background, which gave John a strong sense of duty and responsibility, traits characteristic of a dedicated craftsman and a natural team player. Once when I was bedridden with a cold, John stopped by my favorite Chinese restaurant and brought me a large container of chicken soup!

John and I shared an interest in many esoteric things—aviation design, old serials, and the Three Stooges. Ironically, Moe Howard's granddaughter, Jennifer, also worked with us. It was amusing to watch the two prank each other—always with great respect. We were a happy group.

Because John always displayed an inexhaustible work ethic, I never failed to enjoy having his attention to detail on our projects. Our main product was model making, which he was so accomplished in. To my surprise, John began to display other skills. He did some illustrations showing how to handle some of the action props we supplied. They were basically instruction sheets to the propmaster, detailing how to take apart props like our phaser pistols to change the batteries between takes, or which buttons the actor was to push on the tricorder to get the scanner to pop up. He made it easy for the "talent" to properly handle the props.

Working at all the top effects companies like Apogee, Boss Film, Paramount, and Disney, John developed his design and illustrative skills to become an industry standard. He's a true trailblazer and an inspiration to new generations of industry artisans. As a popular guest at sci-fi conventions, his artwork is highly collectible.

Although I have not worked with John for a number of years, I have enjoyed following his illustrious career, and see no reason for it to be anything but limitless. Despite all the ever-present anxiety of working in the trade, John continues to have the carefree spirit of Peter Pan's Lost Boys.

May you live long and prosper, John. I am very proud of you.

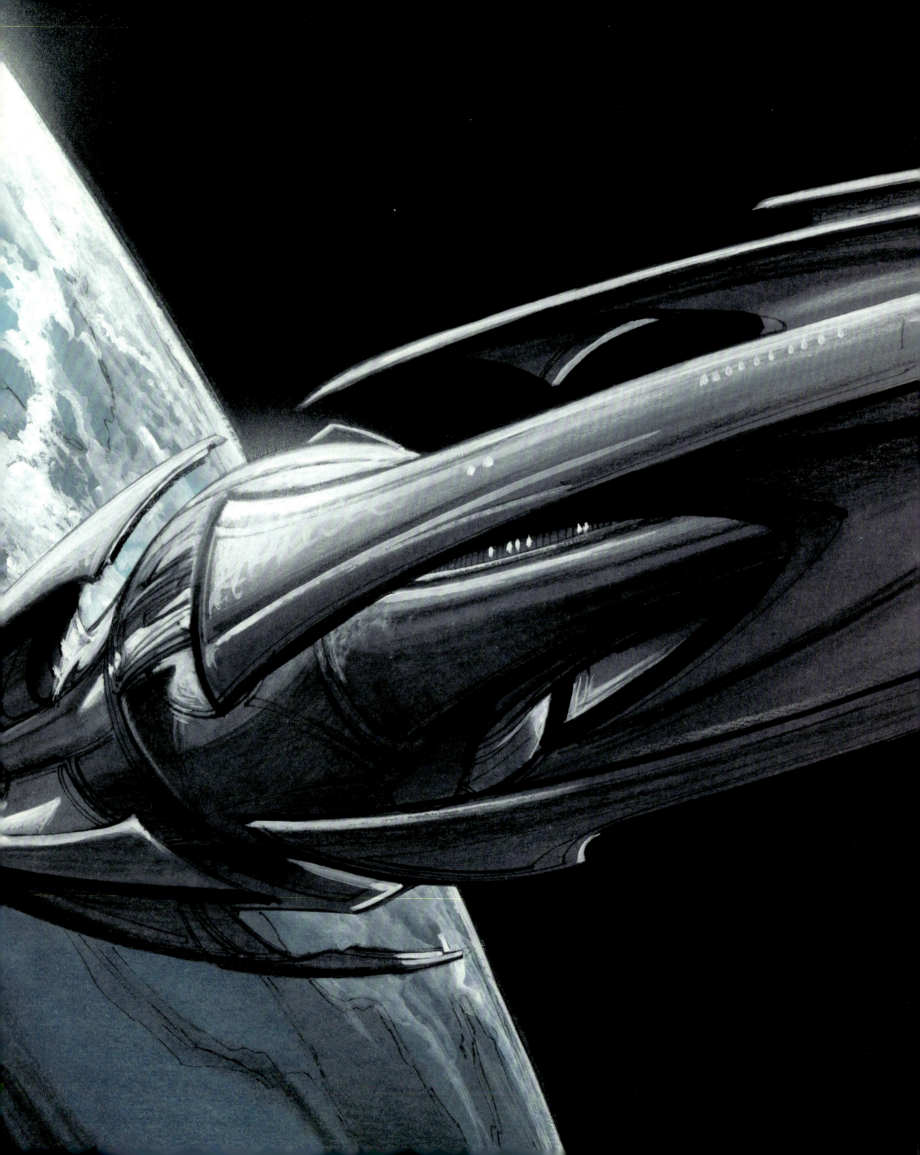

# FOREWORD
## BY HERMAN ZIMMERMAN

**M**y friend John Eaves is a multi-talented creative artist, an old soul with a youthful twinkle in his eyes, whose energy and enthusiasm for whatever is happening at the moment is infectious. As a concept artist, John's work makes him one of a handful of great modern illustrators. As a model maker, he is easily one of the top two. As a sci-fi visionary, he is prolific; his boundless imagination is driven by his zest for life.

John worked with me as part of an elite art department at Paramount Pictures on two *Star Trek* television series and four *Star Trek* motion pictures. When one is fortunate enough to have a long, continuous run on a TV series or a series of movies, the people you work with become family. I'm proud to say that for more than a decade John Eaves was a part of mine. I value our time together and cherish our friendship.

I'm predicting that the book you are holding will amaze you.

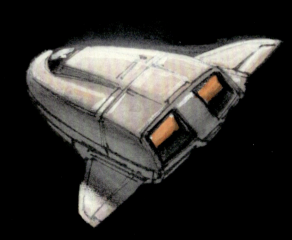

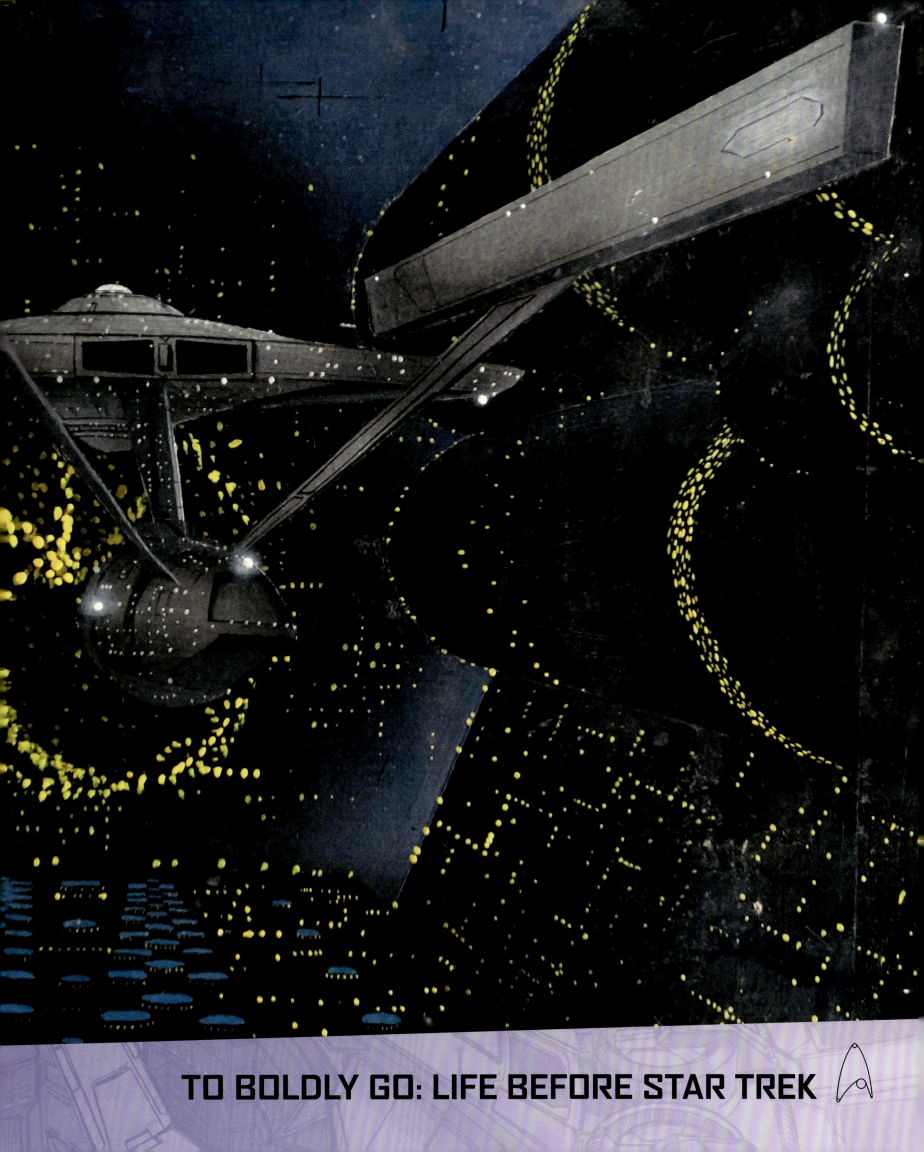

TO BOLDLY GO: LIFE BEFORE STAR TREK

# TO BOLDLY GO: LIFE BEFORE STAR TREK

## "JAWS MADE ME REALIZE THAT PEOPLE COULD DRAW FOR A LIVING."

It was a shark that got me started on my journey to Hollywood. My family lived just outside of Phoenix, Arizona when I was young, and in 1975 I saw the first commercial for *Jaws*. Across the globe, beaches were empty that year because of this blockbuster movie that scared everyone from going into the water. I was thirteen at the time, and at that point I was only allowed to see Disney movies, so it was an enormous shock to go from *Bambi* to a shark eating everyone.

We lived in a very small area outside of Phoenix, which meant there wasn't a movie theater nearby. Most of what I watched was on TV, including reruns of old animated films like *Pinocchio* and *Dumbo*, which I actually found fascinating. I couldn't get over how realistic the animation looked, although nowadays they look almost primitive compared to modern digital films.

This was also the time when Disney had their Sunday night movies on TV, like *The World's Greatest Athlete* with Kurt Russell or Fred MacMurray's movie *The Absent-Minded Professor*, but every once in a while they threw in an amazing sci-fi movie such as *Escape to Witch Mountain*. Our local Channel 5 station was also playing old sci-fi movies every night, so there were flying saucers and robots galore for me as a kid.

Everything I saw was pretty much G-rated, until we went to see *Jaws*, which was my first PG movie. My young mind wasn't quite ready for what I saw on screen. That included a nude woman getting eaten by a shark, and more profanity than I'd ever heard in my life. I was horrified, but I also couldn't get enough of it!

I became fascinated by that movie, even more so after my dad bought me a book called *The Making of Jaws*, written by screenwriter Carl Gottlieb. I actually thought they had trained real sharks, just as filmmakers had done before with dolphins. When I found out it was a mechanical shark in *Jaws*, and saw some of the artwork that production designer Joe Alves had done, I thought, "This is what I want to do!" *Jaws* made me realize that people could draw for a living, so that turned into a goal for me.

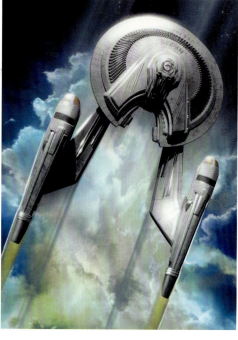

I originally started drawing from the age of eight. Where we lived in Phoenix there was a place called Turf Paradise Gliding School across the street from us. One day, my dad took me over there to see the gliders. The planes fascinated me, and when the man behind the counter let me have a pad and pencil, I started drawing them.

Having drawn pictures that looked, to my young mind, as though I had taken an actual photo, I tried to take things a bit further, as if I was in the glider looking down, creating a different perspective of what the ground would look like from that vantage point. Our area of Arizona was mostly orange groves back then, so it was easy to draw those little orange balls in rows.

My parents really encouraged my creativity when I was growing up, and I was always drawing or building models. My dad was a highway patrolman, and he would bring home bits and pieces that he found along the road for me to play with. One day he brought back a big box from a wreck, which included all kinds of dashboard parts and wires. I loved anything to do with sci-fi or aviation, and I would transform a simple box of wires and auto parts into the internal panel of a spaceship.

This was the mid-sixties and the early days of the space race; the Gemini and Apollo missions taking us to the moon captivated me. I loved building models with my dad, and he would buy kits for us to build together. We would have models like the Atlas rocket platform and lots of missiles. I would set up the finished models in my bedroom and I would try to draw them as though they were real and not just a toy.

I originally used to draw everything in pencil, until one day when *Silent Running* was on one of our local TV channels. I was so excited when I saw the spaceship with the domes on it that I started drawing while the movie was still on. I started with a little sketch and then thought, "I need a little color here!" but all I had was several containers of model paint. I started using that paint, which dried on paper almost instantly and made it really tricky to use.

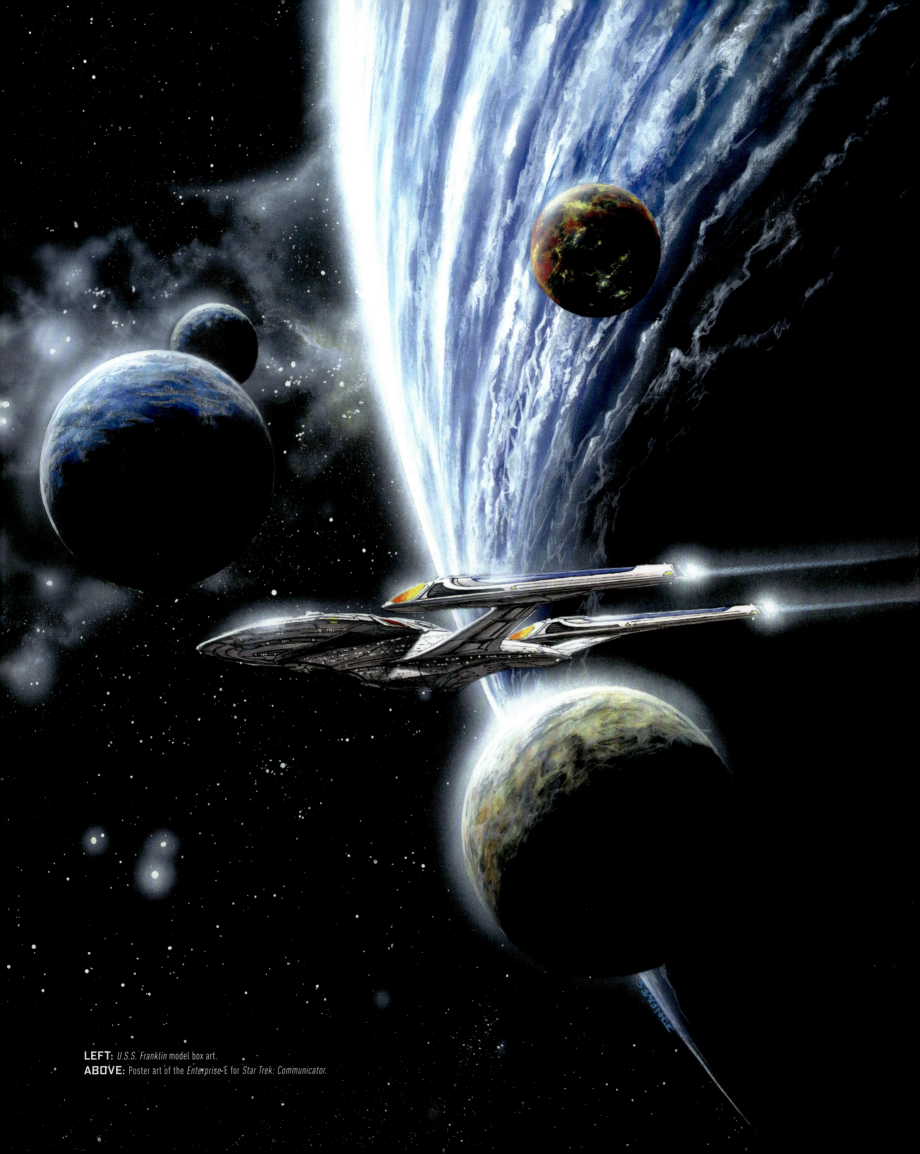

**LEFT:** *U.S.S. Franklin* model box art.
**ABOVE:** Poster art of the *Enterprise*-E for *Star Trek: Communicator*.

I ended up doing eight or nine paintings using model paint, until I finally discovered acrylics and other easier-to-use products. The entire house would stink, because that paint absolutely reeked. My dad would come into my room and say, "What are you doing? You're supposed to use it *outside*!"

As a young boy growing up in Arizona, I was never really interested in 'western art,' but my parents used to get the magazine *Arizona Highways* all the time. One day, in 1975, there was a cover done by a local artist named Robert McCall. The cover featured this incredible wraparound painting of a chromed city situated in the Arizona desert. McCall had turned the entire state into a sci-fi world and it blew my mind. Looking through the pages, they were filled with amazing art depicting solar cities and fantastic aircraft floating around the state.

It was the first time I had been introduced to sci-fi art, and I was fascinated by this new vision of the world around me. I took the magazine to school and showed it to everyone I knew, and of course I went off and drew some of it myself. McCall's work was gritty and cool, he was the artist who turned the Southwest into sci-fi and mixed the two perfectly. I ended up meeting him years later, where I was able to thank him for inspiring me and changing my view of Arizona (and the world). He was a legendary artist, and his work could take you to places far beyond the boundaries of Earth.

It was in junior high school when I seriously began pursuing my interest in sci-fi and movie art. I had a science teacher named Chuck Bell, whose classroom had pictures of the Apollo rocket and other cool spacecraft. I drew my version of the Apollo rocket taking off and he hung it up, and after a while his entire wall was covered with my work. Outside of my parents, Mr. Bell was the first adult that took that little extra time to encourage me on my way, and he became one of the most influential teachers in pushing me to become an artist.

My first real art class was with an art and photography teacher named Richard Gross. There was one day when he talked about vanishing points and perspective, which I had never heard of before. He drew a dot on a piece of paper with four lines to it from the corners, and then drew buildings on either side to create that forced perspective. That was an amazing class, and he taught us so much. During my sophomore year in high school, there was also a special art class you could take off-campus, where the teacher taught us all about airbrushing and friskets, so that was fantastic too. My teachers were always there with an encouraging word and giving me extra art assignments in class, which was a huge help for a little kid with a big imagination.

I first discovered I was color blind in high school. I made a belt in leather class that had a deer in the forest on it, for which I painted the deer green and the trees brown. Nobody told me I had done it backwards until my parents explained it to me later on.

Not long after that, I was taking electronics class and this was in the days of resistors, which were little fuses with colored bands on them. The order the bands were in determined how you would use them. If you put the resistors in the wrong order, either nothing would work or you'd start a fire. There was a little poem to remember the order they went in, and when the teacher asked if I knew it, I said, "Yes, this band is brown—" and he said, "No, it's red!" I said, "Well, the one next to it is yellow—" and he said, "No, that's green!"

The teacher took me over to the special education department, where they had a book with Ishihara plates in which you try to see the picture embedded in the dots. I could see the number one on the first page, but everything else was gone. I was diagnosed with red-green color blindness, and of course the problem for an artist is that everything is made up of red and green.

As it turned out, color blindness was never the handicap to my work I thought it would be. If I had to paint something, I just looked at the paint lid that said 'Green,' and the same with markers until Pantone came out and they were all numbered and didn't have the colors written on them anymore. Photoshop was the same way, where you opened up the color palette and it had eight million little squares, so that was pretty awful. I thought, "I'll never be able to do this!" Thankfully I had a teacher show me how you could sample colors and pull them over, and I managed to learn how to work around the problem.

**THIS PAGE:** Eaves taught himself to paint using model paints. From a young age he was fascinated by space exploration.

Thankfully, what I thought would be the end of my career never got in the way as I had feared, apart from my early model shop days when they asked me to mix paint. It happened two or three times and they never asked again.

Growing up in Arizona, it was unusual to be a fan of science fiction. Everybody else was into racecar drivers, hockey players, rodeo ropers, and cowboys. You didn't bring up sci-fi stuff, because 'nerd' would be a gentle word for the way you were looked on back then. But at the time, *Star Trek* had just come out, as well as *Lost in Space*, so the sci-fi world was booming all around me.

Luckily, I had a buddy who liked sci-fi shows too. He would bring things in to school, like the *Star Trek Tech Manual* by Franz Joseph. One day, I begged him to let me borrow it. I took the book home on the school bus, where the other guys said, "What is this garbage!" I was just about ready to get beaten up, but one of those guys had a notebook—everybody had those denim notebooks back then—on which he had drawn a 'K' on it for Kiss. I knew what the logo looked like, so I offered to draw the Kiss logo for him. Luckily I ended up having him as my bodyguard instead of my killer. After that, I would do all kinds of drawings on the other kids' notebooks (including the *Enterprise*).

In 1977 my world, and the world of movies and science fiction, changed forever with the release of *Star Wars*. This was

**ABOVE:** Eaves documented his visit to Sky Harbor Airport, Phoenix.

**BELOW:** An early art piece based on poster artwork for the film *Sorcerer*.

a hugely influential year for me, and George Lucas opened my eyes to a whole new galaxy of possibilities. Sometimes I look back and wonder where I would be if it weren't for movies like *Star Wars* that set me on a path for my creative future ahead.

When the film opened, there was just one theater in Phoenix with the exclusive rights to show it, so it ended up playing there for well over a year and a half. The lines went all the way around the building, and there was no way our dad was going to take us. We got to July and he still wouldn't budge, because it was still too crowded.

One afternoon, my dad was pouring concrete for a new patio, and at the time we had this little chihuahua that was really old, so it had grown a bit nippy and mean. Somehow, it got out of the yard and got hit by a car down the street. My sister and I were kind of bummed about it, and my dad said, "I'm sorry, kids, it was my fault, so if there's anything I can do to make it up to you…" My sister and I looked at each other and we said, "Take us to see *Star Wars*!"

When we finally got to *Star Wars* my dad fell asleep maybe half an hour into it. Back in those days, they didn't clear the theater between showings, so everybody cleared out, a new group of people came in and my dad was still asleep, waking up just about the same spot where he fell asleep, so we got to see it twice.

*Star Wars* was inspirational for me. As soon as we got home that first time, I tried to draw everything I had just seen on screen, including the Jawa vehicle, the Death Star, and everything else. I not only wanted to learn how they did all that, but I wanted to learn how to do it myself.

As my love of sci-fi continued to grow, I started researching the movies and learning everything I could about the amazing artists involved. When Joe Johnston's *Star Wars Sketchbook* came out, I bought it immediately and that was my first real introduction to behind-the-scenes sci-fi movie books. *Starlog* was the holy grail of magazines and the big source of sci-fi information back in the 70s. I grabbed every issue I could, and the same with *Cinefantastique*—that's where you could find little teasers about sci-fi films and movie artists.

The next big anticipated film to come after *Star Wars* was *Star Trek: The Motion Picture*. Usually *Starlog* magazine would feature some artwork or a teaser, but for *Star Trek* they showed some of McCall's production paintings for the scene flying through V'ger. I was so excited to see his work in *Star Trek* that I wanted to see it even more just because of his involvement. Thirty years after seeing the film for the first time, that sequence is still one of my favorite parts of the film.

A lot of artists were hugely inspirational to me in those early days, and their work helped me look at my own style in a completely different way. I used to read all the articles I could find, so I knew about the work of people like Nilo Rodis-Jamero, Ralph McQuarrie, Joe Johnston, and Syd Mead.

Back then, you really had to research artists and try to

**THIS PAGE:** Eaves was fascinated by helicopters from an early age. He would make a regular study of the aircraft in his drawings. The colored drawing is an example of Eaves' early experiments with airbrushing in high school.

contact whoever had the artwork out. Occasionally you might get lucky and find a blurb from Ron Cobb or Ralph McQuarrie and hear their point of view, even if it was just a sentence where they said, "Well, I used this as inspiration..." and you thought, "A toaster? What are you talking about? You made an entire spaceship out of that?"

I was first introduced to my hero Ron Cobb through his work on John Carpenter and Dan O'Bannon's movie *Dark Star*. *Starlog* magazine featured Ron Cobb's sketch for the *Dark Star* spaceship and it was the first design, beyond the *Star Trek* ships, that really caught my eye.

I started drawing my spacecraft pictures using Ron's work as my guide, and I kind of copied his style at first. Ron always outlined his designs in heavy black ink, and I picked that detail up from him. When I first started showing my work to people, they often said, "This is very reminiscent of Ron Cobb!" and it was cool to be mentioned in that way. I eventually made the decision not to copy but just to use his work as inspiration.

There were many talented people who inspired my path to Hollywood, but Ron Cobb was the one who was the most inspirational to me.

Ron Cobb's original sketch for the *Dark Star* spaceship was drawn on the back of a napkin. Eventually, this design made its way to legendary model maker Greg Jein. I read the specials about Greg's work on *Close Encounters* and *Dark Star* and thought his models were just the coolest. If you'd told me at the time that I'd end up becoming great pals with him I wouldn't have believed you. But in the end, Greg was a huge influence in my life and my career. Greg is one of the greatest model makers of all time, and his passion for *Star Trek* is equally as great.

All these awesome guys changed the way I saw the world and inspired me as an artist. It's funny to look back on those times when I only knew them from books and the big screen. Years later, when I started my first job at Apogee, I discovered that they had a Rolodex on the desk and Ron Cobb and Syd Mead were both in there. I asked my boss, "Do you mind if I take

**BELOW:** Inspired by the film *Silent Running*, Eaves used his model paints to try and render his own take on the *Valley Forge*.

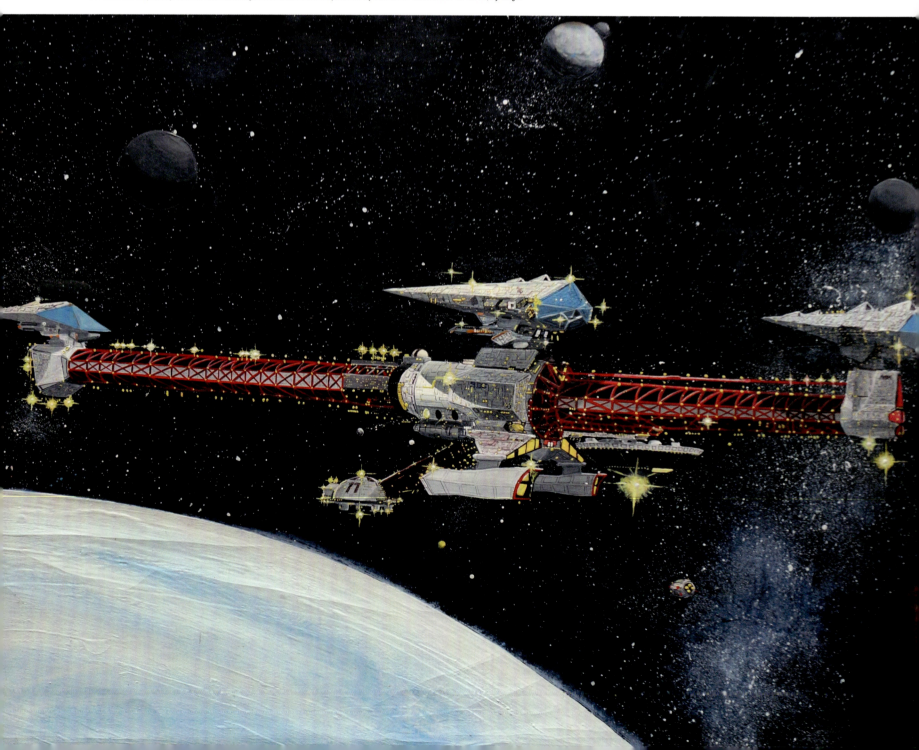

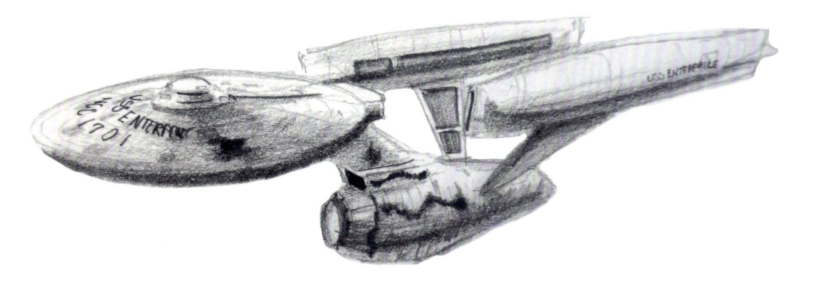

**ABOVE:** Eaves' sketch of the *U.S.S. Enterprise* after seeing the film *Star Trek II: The Wrath of Khan*.

these numbers and call these guys?" I called them and they both invited me to their houses and they were both normal, real guys.

When I started at Glendale Community College in 1980, *The Empire Strikes Back* had just come out, and I began to think, "I've really got to get into this business somehow!" I talked to my college professors, but they didn't offer anything like film design. It was all Southwest or life art, and everything was oriented to the Arizona lifestyle. One day I brought in my *The Art of Star Wars* book to class and said to my teacher, "This is what I want to do; is there anything you can do to help me?" My teacher, Darlene Goto, curtailed her regular class assignments (at least from my end) in favor of creating motion picture art. She would say, "Take a chapter from this book and turn it into storyboards!" She gave me unusual assignments to help with what I wanted to do, and this helped developed my art style in the right direction for the movies.

In 1983, *Return of the Jedi* came out, and I was calling Hollywood all the time. I only knew three cities in California: Burbank, Hollywood, and Los Angeles. Back then, you only had 411 Information, so I would call and try to get phone numbers for companies like Apogee, ILM, and Boss Film, but I could never locate them because their numbers were so specific to the cities they were in.

At the time, my friend Rod Andrewson and I found a pop culture store called Darcy's Discoveries, and on the bookrack were *Cinefex* #2 and #3. One of them had an article called 'Star Trekking with John Dykstra,' and in the headline of the piece it referred to 'Apogee of Van Nuys,' which was exactly the information I needed. I called Van Nuys Information and then contacted the folks at Apogee who said, "Bring out your résumé and we'll look at it."

I started traveling back and forth to LA to drop off my portfolio in person. I usually had Fridays off at the grocery store I worked at, so I would get out of college at noon on Thursday and hit the road. My uncle lived in Fullerton in Orange County, which was about as far as you could get from the studios. I'd get up at four in the morning, and drive from my uncle's house to Van Nuys in about two hours. I could get to Apogee, Fantasy 2, Boss Films, and Dream Quest, all in a big loop and then head home.

> "THE SCI-FI WORLD WAS BOOMING ALL AROUND ME."

But even after a year of traveling back and forth, I never had a response. At one point I had just dropped off a new résumé and portfolio and was walking back to my car when I saw the secretary throw them in the trash. I asked what she was doing, and she said, "Oh, I'm sorry you saw that, but we get too many of these things. If you had somebody's name I could give it to them, but it doesn't work just sending things to the office!" so that was a real education for me.

By that time, the movie *Firefox* had just come out, so I looked at the credits and came across Grant McCune, who was chief model maker at Apogee. I was already aware of Grant's work with Bill Shourt on the mechanical shark from *Jaws* and his VFX work in *Star Wars*. I decided to contact him directly, and I was amazed when he wrote back.

I first met Grant in early 1984, and for the next year I would frequently make the drive from Arizona to visit him and the other guys at Apogee. During this time, I changed my approach to what I was doing and I continued to develop my portfolio. On my days off I built models and took pictures of them as realistically as I could. I would also do a bit of kit bashing, where I would experiment with pieces from my kits and try out new designs.

It was a tricky time, juggling the journey and my college work, but it was definitely worth it. Grant was the person I saw most often, and when I got there he would always stop what he was doing and show me something new. Model making was my other great love, and I used to be in one of those Revell Master Modeler clubs (where you built so many models a year). I started showing my models to Grant, who said, "Cool, you make models; that's my thing, so keep it up!"

After the weekend in LA at the studio, I would talk to my teacher in college and show her what I had learned from Grant and the guys. My teacher would then set a challenge for me to do in art class. Whenever I was creating new material, I would take photographs of my drawings and put them in these little black three-ring binders ready to send out to the other studios.

Now what I didn't realize at the time was that if I wanted to make it into the business then I had to live in California. Nobody was going to hire somebody out of state, because they didn't

**ABOVE:** Eaves experimented with perspective and composition in his early paintings.

want the responsibility of paying your board.

Ultimately my decision to move to Los Angeles came down to a P.S. in a letter that I wrote to Steven Spielberg. I knew that Spielberg had once jumped the fence at Universal and snuck in, so I basically did the same thing. I knew where Amblin Entertainment was at the studio, so I pretended I had a package to deliver. I got to the gate with this package and they let me right in. The guard asked if I knew where Spielberg's office was and gave me a map. It was actually a lucky day for me, because the regular secretary wasn't there so there was a replacement instead. She took the package right to Spielberg's office, and I got a letter back two months later saying, "We don't hire an entire art department; we hire that stuff out, but if I can give you a piece of advice, if you want to work in Hollywood, you should live here. No one is going to hire you if you live out of state, especially if you're just getting started." It was just a throwaway sentence, but it was exactly what I needed to hear.

That summer I took a two-week vacation from the grocery store I worked in and came out to LA. Even though I was really staying at my uncle's house in Fullerton, I was going to drive in and tell everyone I lived in LA now. I decided my first stop would be Apogee, so I went over there and said, "Yeah, I live here now—" and before I was done, Grant said, "You do? Well, would you like to work here? We've got this dinosaur project we're working on right now!" I started working at Apogee the very next day. It turned out that everything in that Spielberg letter was 100% true.

I still remember when I called my boss at the store and gave my two-week notice over the phone. I could hear the sound of cheers ringing out from everyone standing by the phone on the Arizona side of the line. I have Grant McCune to thank for bringing me into the world of VFX, and my uncle for putting up with me for so long! Both those great guys helped one young boy's dreams come true.

When I started at Apogee, they were working on a giant tyrannosaurus—a mechanical robotic creature for a mall up in Canada. It was the end of July, and they had these giant molds out in the parking lot, but nobody wanted to go out there because it was too hot to work so they said, "You're from Arizona, you don't mind the heat; go paint the skin for

that mold!" I had just come from 120-degree Arizona heat to California, which was barely 100 degrees. I loved working outside, and the heat was nowhere near as bad as back home.

*Invaders from Mars*, *Top Gun,* and *Spaceballs* were the first films I worked on with Grant at Apogee. Grant was more like a friend than a boss. He loved his job and he so gracefully shared all of his knowledge with you. Everybody loved working at Apogee; it was a place that felt more like a house full of your favorite relatives than a job. I met some of my very best friends at the studio, including Cory and Allen Faucher, Pete Gerrard, Glen Campbell, Bill and John Shourt, Greg Jein, and way too many others to mention.

Those first five years were just unbelievable. Apogee was booming at the time and I was there in their heyday before CG started coming in during the nineties. I just kept thinking I was lucky to get hired, because I didn't know 3D modeling and I had a horrible problem with red and green color, so there were all these goofy factors that could have hindered my work. But I was really fortunate to get my foot in the door right off the bat.

During those early days at Apogee I didn't have to be worried about getting pigeonholed as an artist or model maker, because we were working in an effects facility where everybody was under the same roof. There was an art department, a matte department, a model shop, and a machine shop, so sooner or later you learned a bit of everything.

It was interesting because in those days you could move around easily. There was almost this built-in switch-over and when a new project came up the model shop crew would move from Apogee to Boss Films, DreamQuest Images, Fantasy II, LA Effects, and up north to ILM for other jobs. It wouldn't matter which shop got the job; the crew would pretty much be the same. That's the way it happened in Hollywood back then, you really didn't have to look for work.

The more different skills you had, the more the phone would ring. I would do models or work in the art department for all the effects houses, which was an interesting situation that doesn't really exist anymore. Today, they hire you to do one thing and that's all you do, but in those days you could do just about anything.

The business was more like a family when I started in Hollywood. You could work on something all day and stay and watch people working on a model at night. There was a real sense of camaraderie, and I learned so much from just being on the job. It was a real shared experience.

As I said earlier, I was a big fan of Greg Jein and his model work. In 1988, Greg came over to help with a project we were doing at Apogee. Greg really took me under his wing, and we became good buddies. I remember at some point he said, "I have *Star Trek V* coming up if you want to work on it..."

**BELOW:** A painting of the flight of the Apollo-Soyuz. The image was created with pencil and model paint.

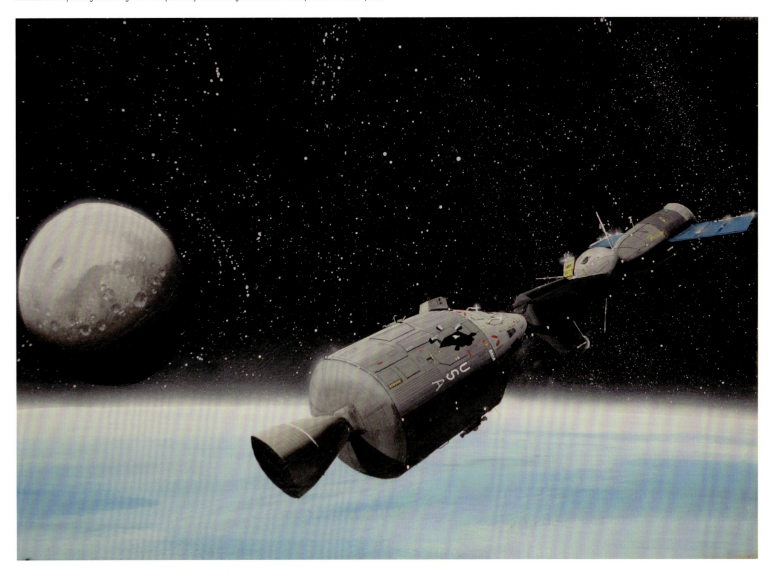

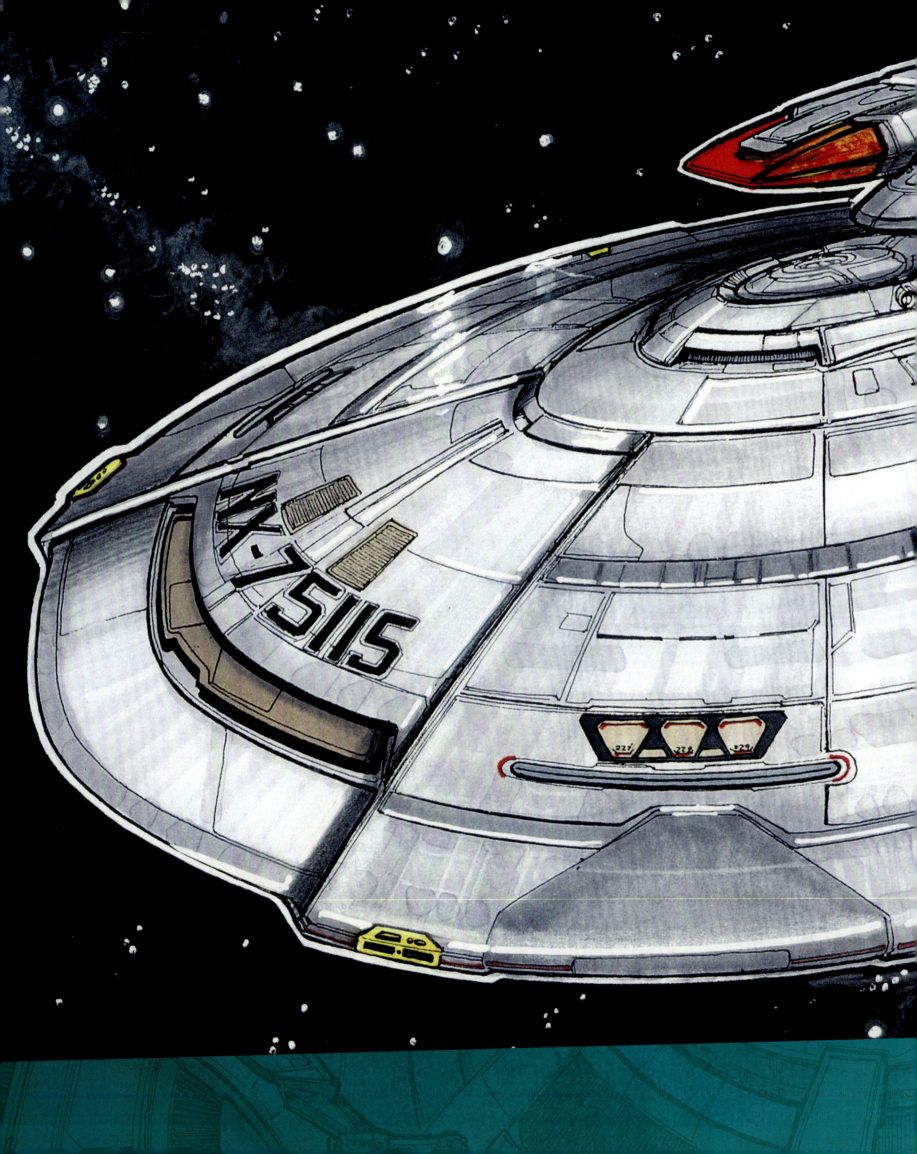

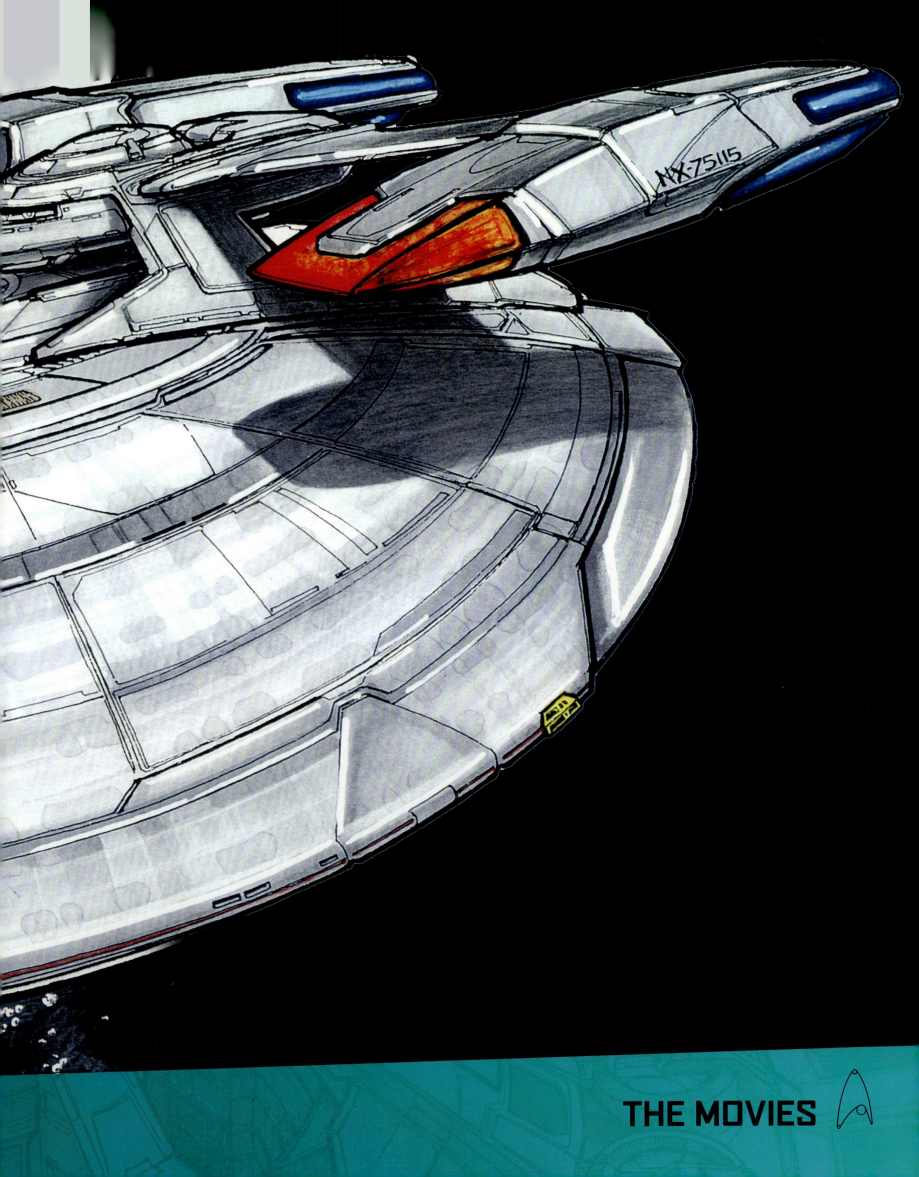

THE MOVIES

# STAR TREK V: THE FINAL FRONTIER

## "GREG JEIN WAS ALWAYS THROWING A LOT OF OPPORTUNITIES MY WAY."

My first foray into the *Star Trek* universe was thanks to Greg Jein, who was doing some model and prop work on the fifth movie. That included a giant Klingon bird-of-prey wing cannon that was built for a close-up shot. It was going to be used for a stop-motion animated sequence, in which the bird-of-prey de-cloaks, and instead of a normal firing blast from the guns, they were going to animate it so there would appear to be some kind of recoil action. We built the wing section, and then had to figure out what the cannon would look like, so Greg asked me to do a quick sketch. From there, it went to Mike Joyce, who built the actual stop-motion piece. Mike had worked with the Fantasy 2 guys on *The Terminator*, so he was well-versed in building stop-motion pieces. Although the scene looks a bit primitive by today's standards, it was a lot of fun to work on.

We also built the phasers for the film, and the instruction sheet for the prop man ended up getting printed in a magazine along with my phone number. When the magazine came out, I started getting calls in the middle of the night saying, "Hey, I hear you have *Star Trek* phasers?" I couldn't figure out what it was all about until I finally saw the magazine article. Greg laughed and said, "Yeah. I made sure they would call you!"

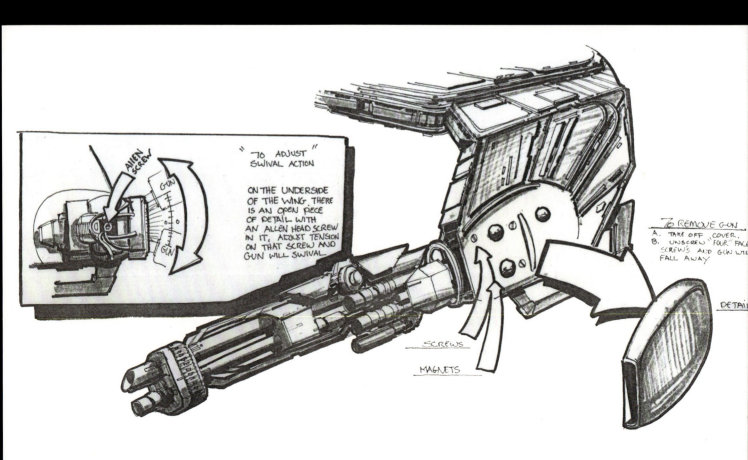

**ABOVE:** Early sketch of the Klingon bird-of-prey wing cannon.

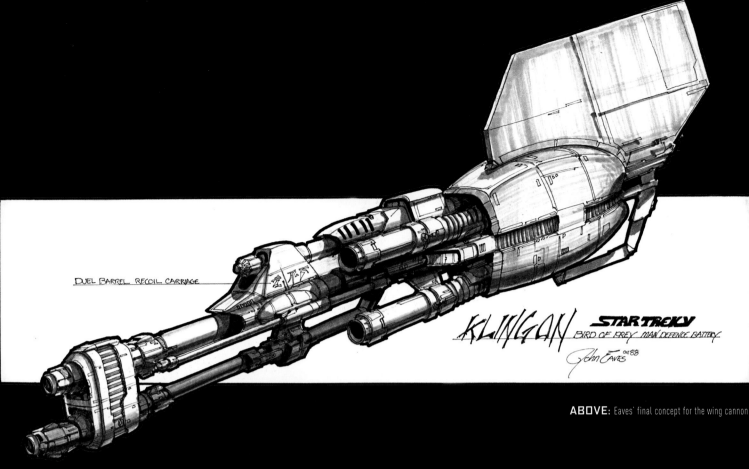

**ABOVE:** Eaves' final concept for the wing cannon.

There was a new version of the *Galileo* shuttlecraft that had to be built, so Greg asked me to draw it up. We were crunched for time and I did a quick rough, but while I was doing it the drawings came in that art director Nilo Rodis-Jamero had done. Our idea got scrapped, but it was still really cool to work on.

As I mentioned, Greg Jein was always throwing a lot of opportunities my way. It was actually working alongside Greg on *Star Trek V* where I first met production designer Herman Zimmerman, a man who would set the course of my career. I didn't know it at the time, but this was the start of a collaboration that would last some sixteen years.

Herman wanted us to build the interior of the shuttlebay, which was going to be in the back of the *Enterprise*. The set was going to be used in a scene where the shuttlecraft comes in for a crash landing inside the shuttlebay, throwing sparks and all that stuff. He had already designed it to fit on a stage, but what he built on stage didn't really fit in the back of the *Enterprise*, so we had to build our *Enterprise* to match his set, which made it taller than it was wide. But when you looked at the miniature of the *Enterprise* with the exterior we built, the two didn't match, so we built an interior that matched the set perfectly. We built every inch of it; the floor, the ceiling, the walls, and shipped it all up to Hoboken where they were going to shoot it, so it was a massive project to build it in LA and ship it to New Jersey. We also built the shuttlecraft, as well as the satellite the Klingon ship shoots down. It was a very big show as far as construction went.

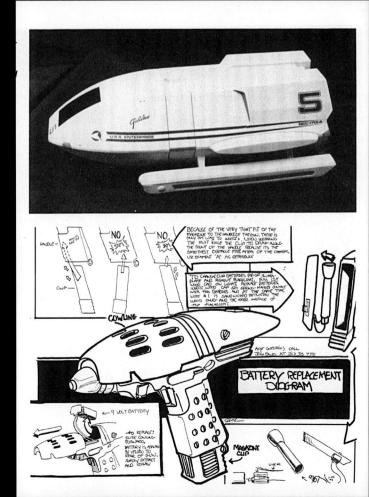

**RIGHT:** The magazine clipping with Eaves' breakdown of the phaser model.

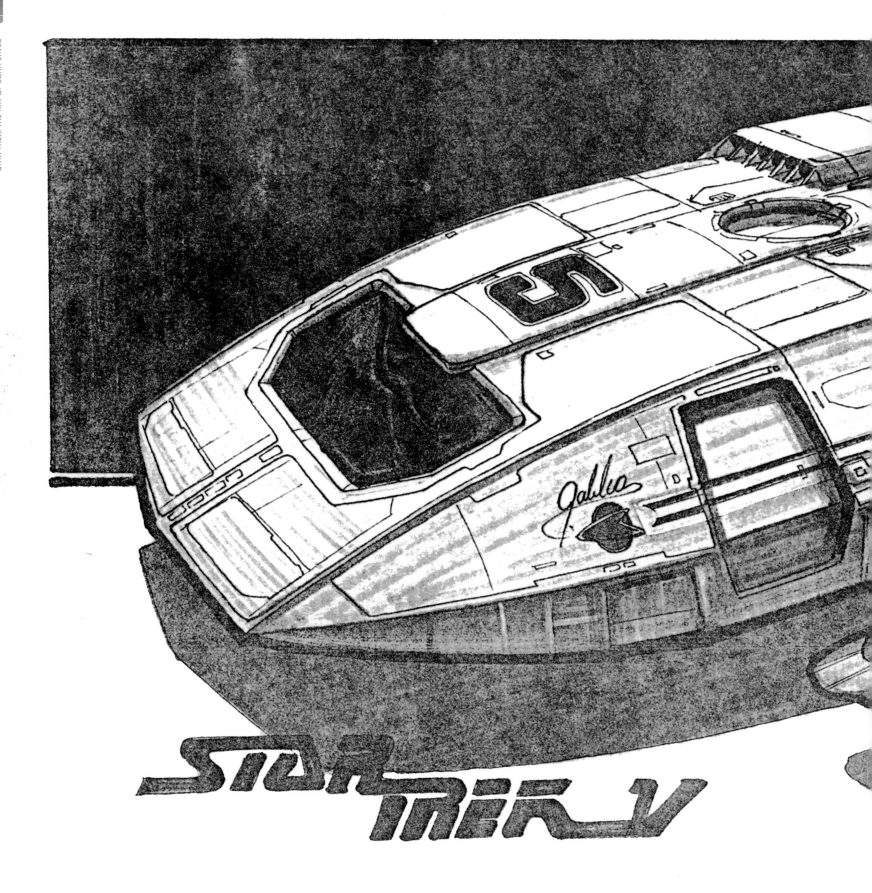

Greg's shop was a crazy place; you never knew what adventure awaited you. One night, Greg Jein and I were working late in his shop, and he was experimenting with new materials in order to paint the outside of this huge *Enterprise* model so we could sand it and it would look like a smooth material. Greg made this concoction of fiberglass and Bondo, and it *stunk*. We had one respirator shared between us while we were painting this material on, and afterwards we were just as sick as you can be.

We tried to do most of this work late at night when nobody was around, and the Odeon movie theater had just opened across the street. We finished our work for the night and went home, coming in late the next day, and we were looking at the newspaper, which said, "The Odeon theater has to close because of strange toxic fumes in the air," so that whole area had to be closed because of this terrible concoction that Greg had come up with.

**THIS PAGE:** Concept design for the *Galileo*.

In his shop, Greg also had this awesome room with all his collectibles in it, like the dome from the *Silent Running* ships and an outfit from *2001*. I was working late just outside that door when there was suddenly a big boom from inside, as though everything had fallen down. I forgot all about it until a few days later when Greg opened that door and all the models were on the floor, completely destroyed. We were trying to figure out what the heck happened, and after a little bit of investigation we found a hole filled with shotgun shell BBs in the wall right next to where I had been working on the other side. Apparently there had been a shotgun fight in the bar next door and the guy fired a shotgun, with the blast going through the wall. If there had been one less wall it would've been the end of me!

# STAR TREK GENERATIONS

## "HERMAN WAS THE GUY WHO HELPED ME MAKE THE MOVE FROM THE MODEL SHOP AND INTO THE ART DEPARTMENT."

Models are fantastic, and I had great fun working on *Star Trek V*, but it was such a toxic environment in terms of the materials we used. I would get there early in the morning, and by 2 o'clock in the afternoon I was thinking, "I've got to get out of this stinky environment!"

I was still working full-time in the model shop at Apogee, as well as doing miniature work at Boss Films, when I met Richard Lewis and James Lima from Spielberg's Amblin, who saw some of my drawings and said, "Would you like to work on *SeaQuest* with us?" That was my first break out of the model shop and into the art department, which is what I really wanted to do.

After working on *SeaQuest*, I wanted to continue with my art department work. Around 1992, I met Phil Edgerly, who was doing *Star Trek* posters as side projects for Herman Zimmerman. I had met Herman on *Star Trek V* but only briefly, so Phil introduced me because they were starting *Deep Space Nine*.

I met Herman at Paramount, where he was working on the first season of *Deep Space Nine* and the art department was inundated with creating new stuff. He had three illustrators—Jim Martin, Ricardo Delgado and Rick Sternbach—and they were doing all the ships, sets, props, and visual effects, which was an enormous amount of work. *Deep Space Nine* was already fully staffed, but Mike Okuda reminded Herman I had done the models with Greg Jein on *Star Trek V*. Herman said, "Oh yeah, I thought I knew you from somewhere. If you don't mind, I might hire you to do some model projects for me."

About a year later, Herman called and asked if I would make some models of the *Enterprise*. I built them, and drew up a diagram on how they went together, and brought them in to Herman, who said, "Oh, I forgot you can draw; I'm starting a new movie, *Generations*; would you like to come on as an illustrator?" So he brought me in, and Herman was the guy who helped me make the move from the model shop into the art department.

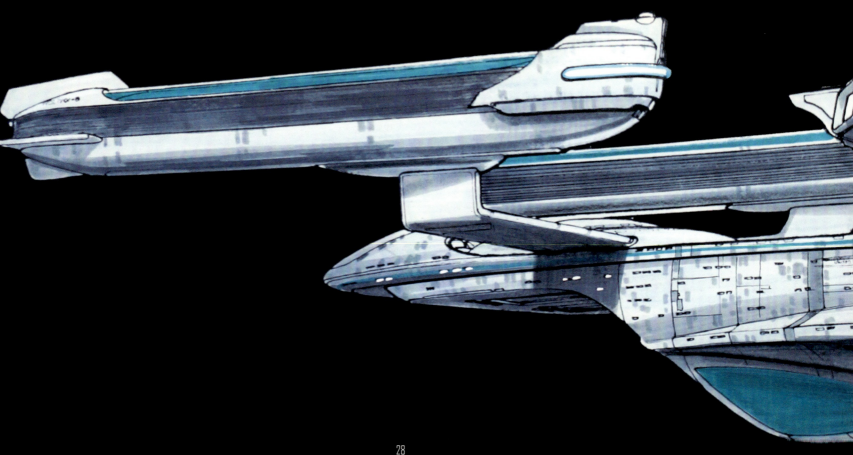

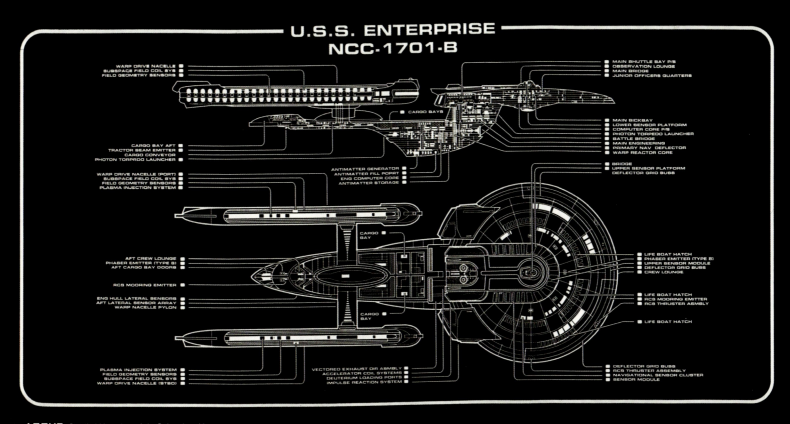

**ABOVE:** Detailed blueprints of the Federation ship.
**BELOW:** Concept art for the *Enterprise*-B.

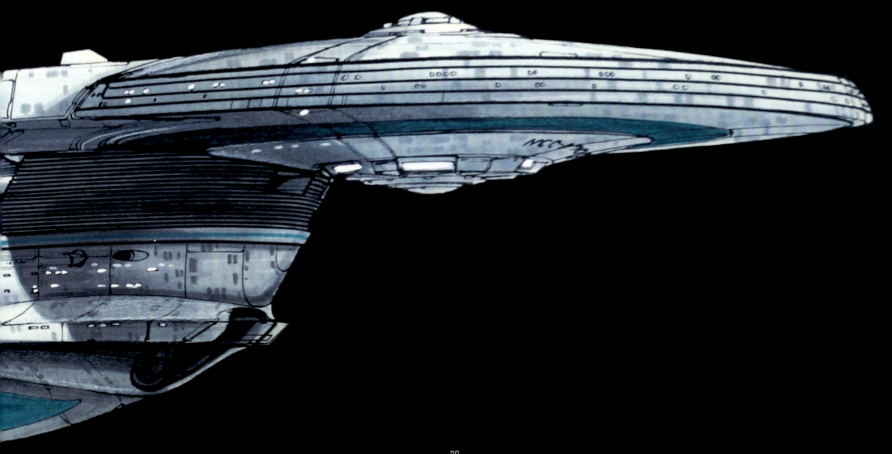

# U.S.S. ENTERPRISE-B

Looking back, I don't think I was a very good artist at the time; I could put things down on paper, but the execution was very crude. Jim Martin, who was working on *Deep Space Nine* at the time, introduced me to this trick with a blue pencil. I was still using a normal Ticonderoga #2 pencil and ink, so Jim told me to use the blue pencil instead. The non-photo blue dropped out in the copier, and you ended up with a beautiful clean ink drawing. You can't do it now because scanners and copiers pick up everything, but it was definitely the way to go at the time.

My first assignment on the film was the *Enterprise*-B. They didn't have a big budget to make a new *Enterprise* model, so they brought in some pictures of models they already had in storage at ILM. They had the *Excelsior*, the *Grissom* and a couple of other models and said, "We need to use one of these ships, so make some changes and add-ons to the models, which will be cheaper and we'll get more bang out of our buck." I loved the *Excelsior*, and Herman and Rick Berman said it was their favorite too, so we chose the *Excelsior* as our ship to redo.

There was a beat sheet that mentioned the *Enterprise*-B getting hit with this energy ribbon that knocks out a section of the ship, but we didn't want to knock out a chunk of the saucer. I kept saying, "If it knocks out a nacelle or a deflector dish everything is going to be destructively catastrophic, so let's try making an addition to the ship that the ribbon can hit and knock a chunk of that out, as opposed to the whole ship."

I showed Herman a picture of an old World War II airplane called the *PBY Catalina* and said, "The bottom of the *Excelsior* is pretty close to this PBY; what do you say we do something like the bottom of that aircraft, where it tapers into the hull, and that can be the section the ribbon knocks out?" He told me to give that a go and it was a really good addition.

While I was working on my sketches, Mike Okuda would walk by and say, "Don't forget the RCS thrusters!" or, "Don't forget the transporter array!" He helped a lot by bringing up things he knew I wouldn't know, and Herman did the same thing.

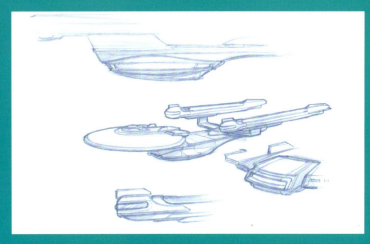

**ABOVE:** Early concept designs for the *Enterprise*.

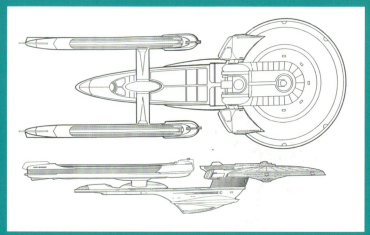

**BELOW:** Profiles of the *Enterprise* show the addition to the hull.

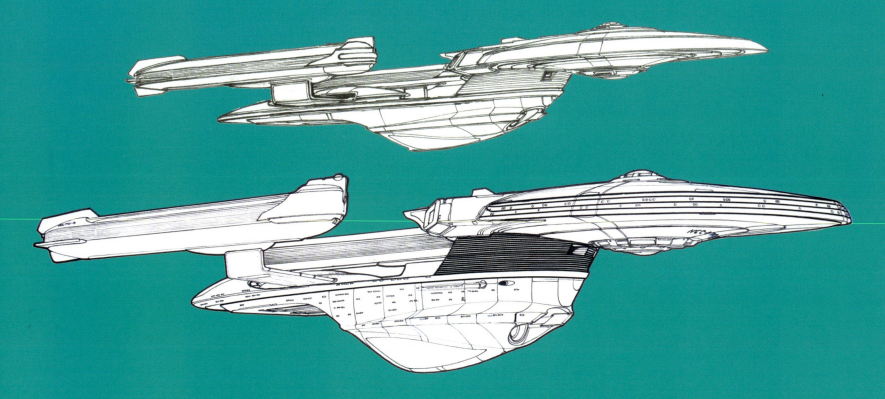

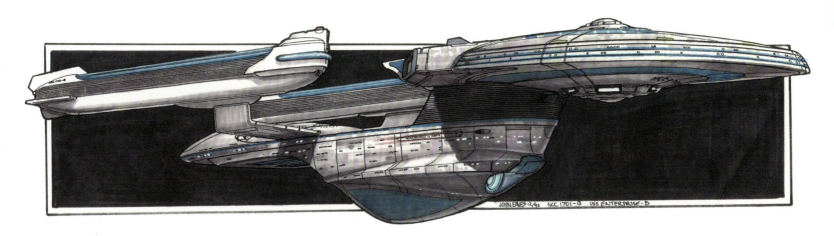

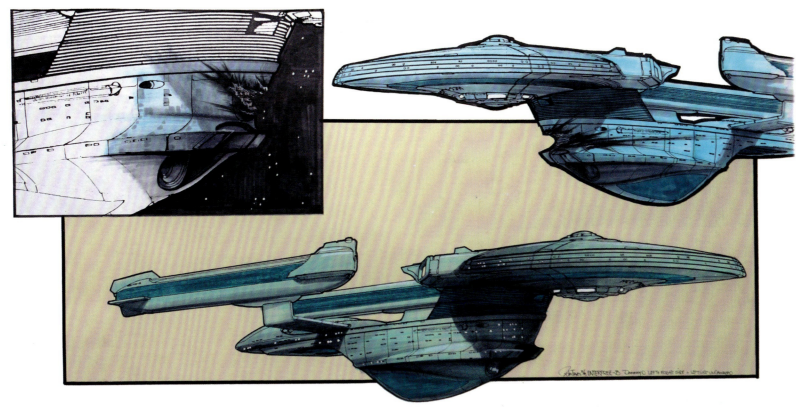

**ABOVE:** Concepts showing damage to the reactor room from the energy ribbon.

**BELOW:** Eaves breaks down the changes and additions he made to the design of the ship.

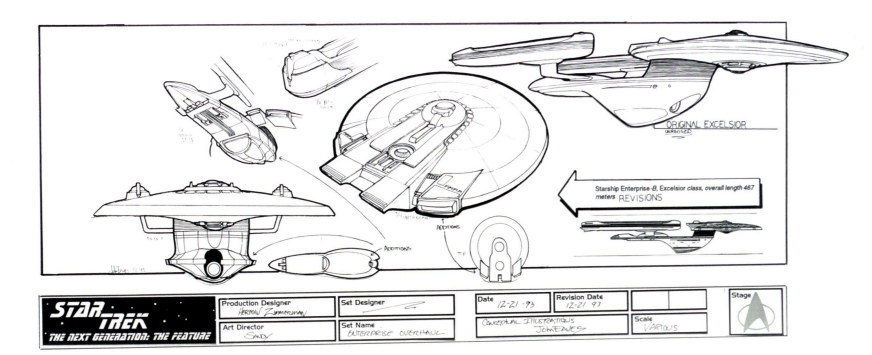

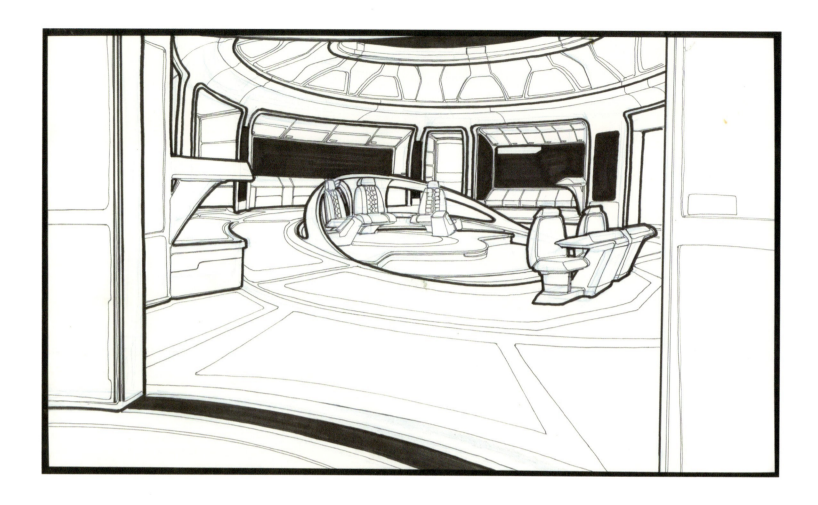
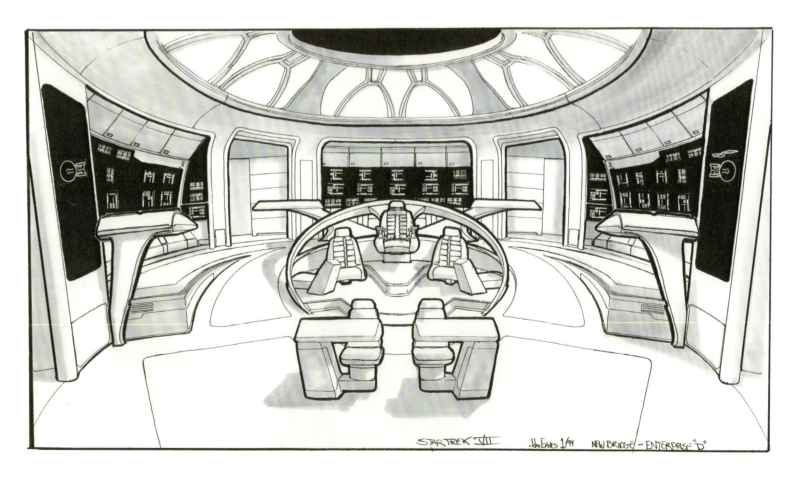

**THIS PAGE:** Concepts of the *Enterprise* bridge.

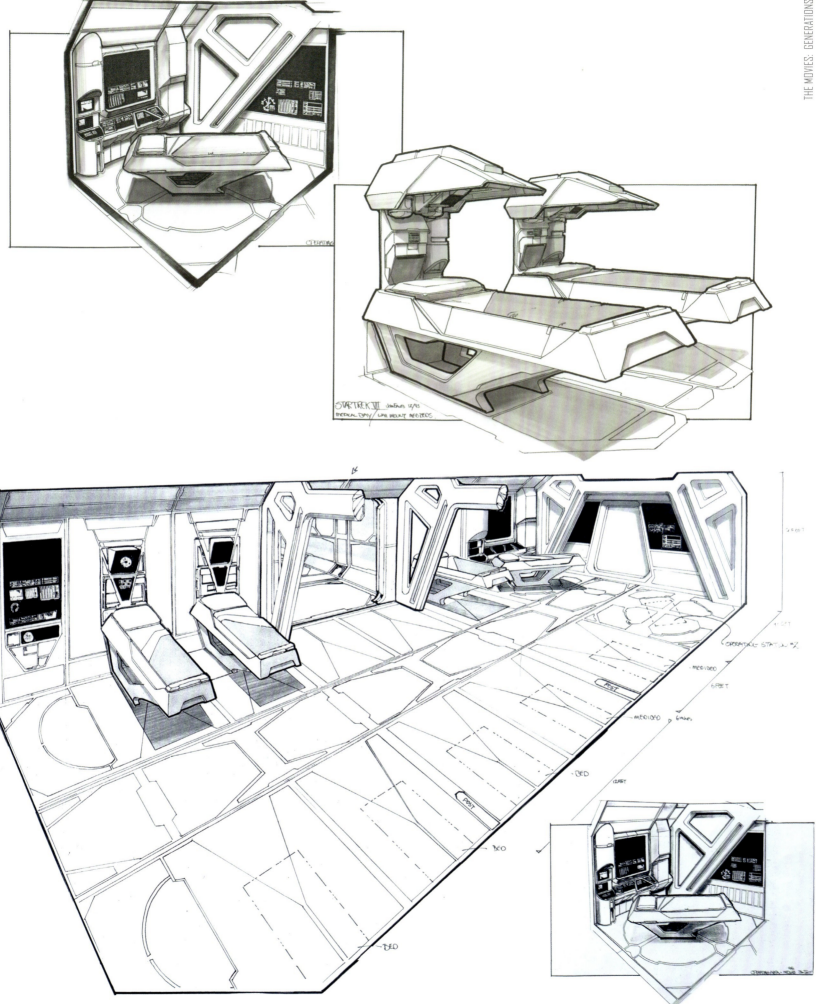

**THIS PAGE:** Concepts of the *Enterprise* sickbay.

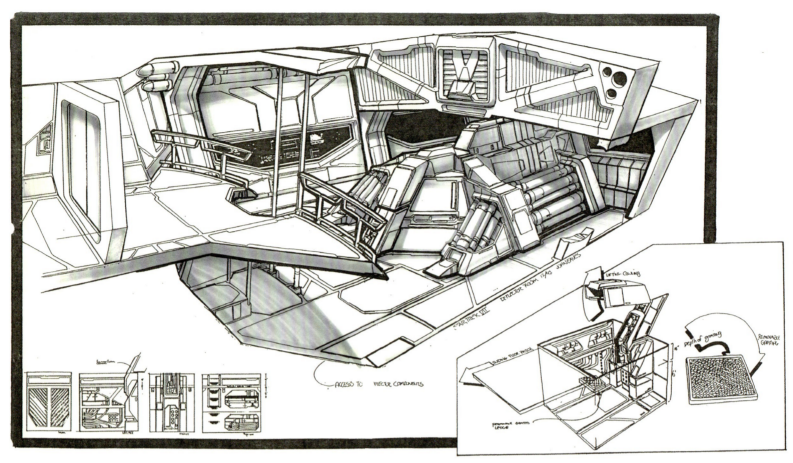

**ABOVE:** Concept for the deflector room.

**BELOW:** From left to right: Nautical instruments for the holographic sailing ship the *Enterprise*, Starfleet data cards, Romulan tricorder.

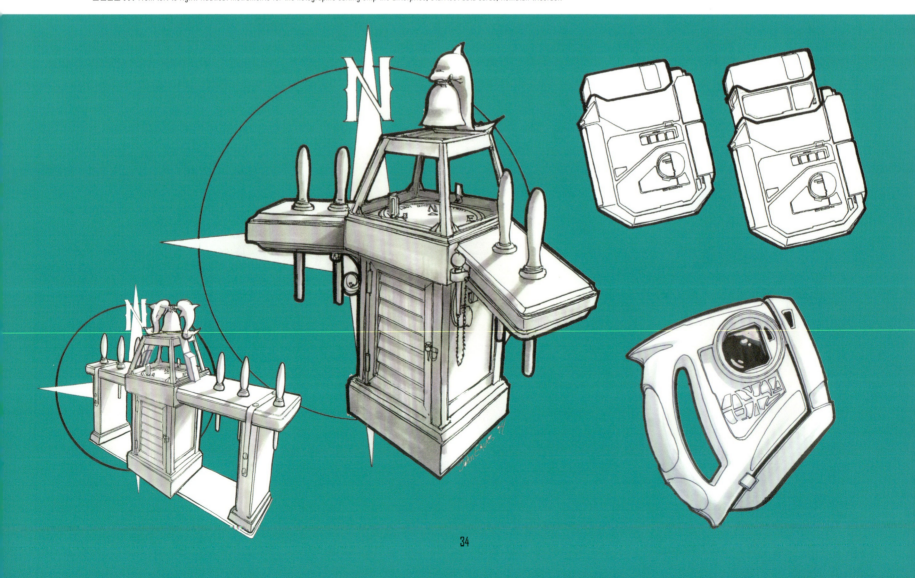

# SORAN'S GUN

**THIS PAGE:** Soran's powerful blaster weapon features a rotating emitter assembly and fires green energy bolts. In ready position, the rotated barrel allows for "gangsta style" shooting, without the distinct disadvantages inherent in firing a normal handgun sideways.

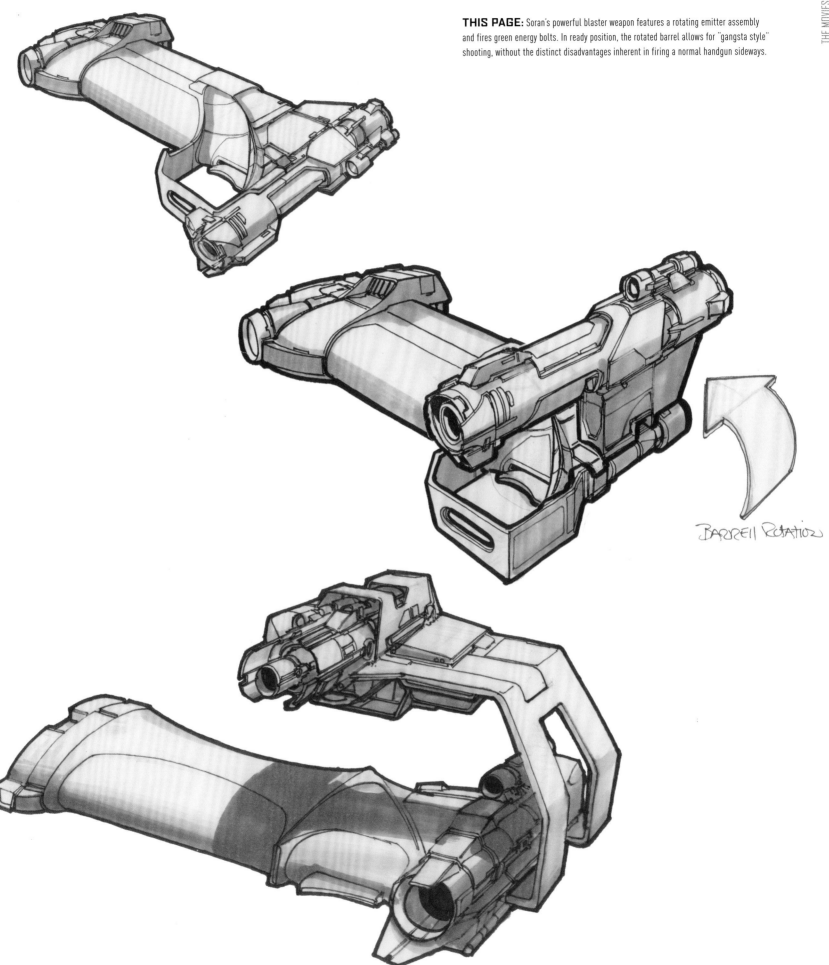

BARREL ROTATION

# AMARGOSA OBSERVATORY

The Amargosa Observatory was my favorite piece in the film. We had to do this space station from which Soran (Malcolm McDowell) fires a torpedo to change the gravitational pull so that the Nexus wave alters its course. As we were working on the design, I suggested we do something that was NASA style and Herman and Rick Berman agreed, so I designed a circular observatory with exterior gravity walkways, deflector telescopes, and solar panel arms.

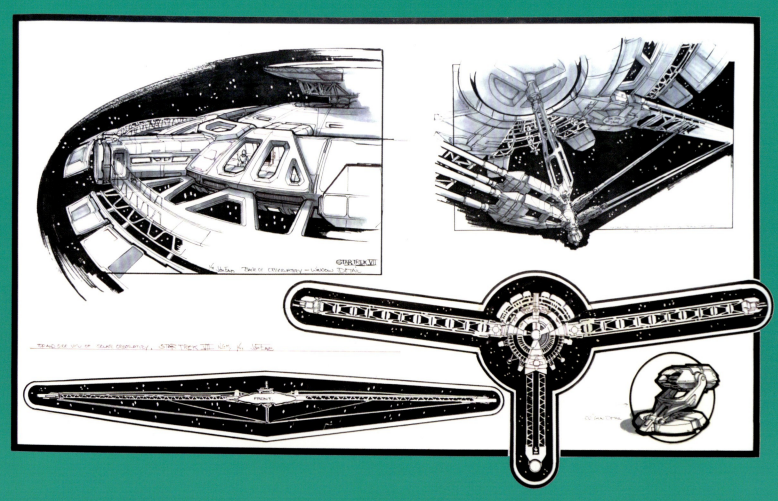

**THIS PAGE:** Eaves' designs for the Amargosa observatory.

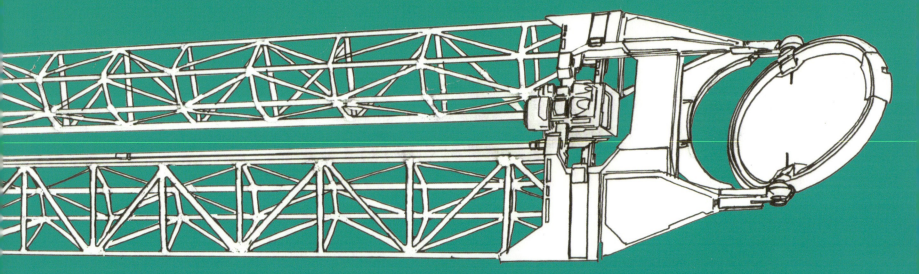

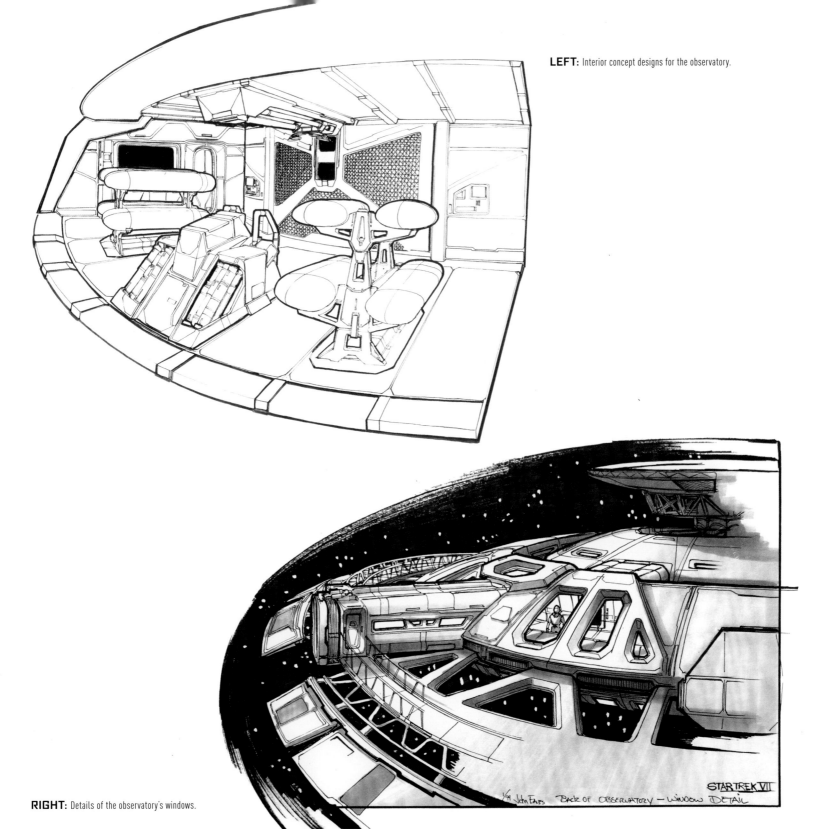

**LEFT:** Interior concept designs for the observatory.

**RIGHT:** Details of the observatory's windows.

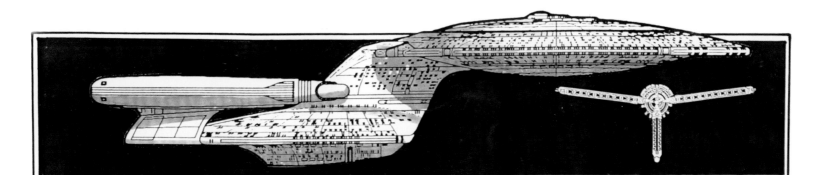

**ABOVE:** A size comparison of the *Enterprise* and the observatory.

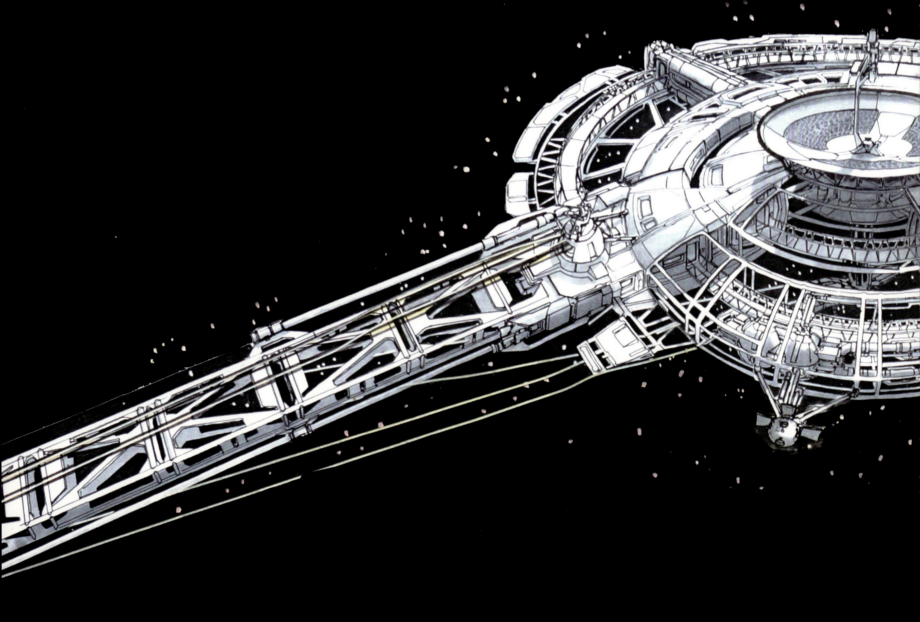

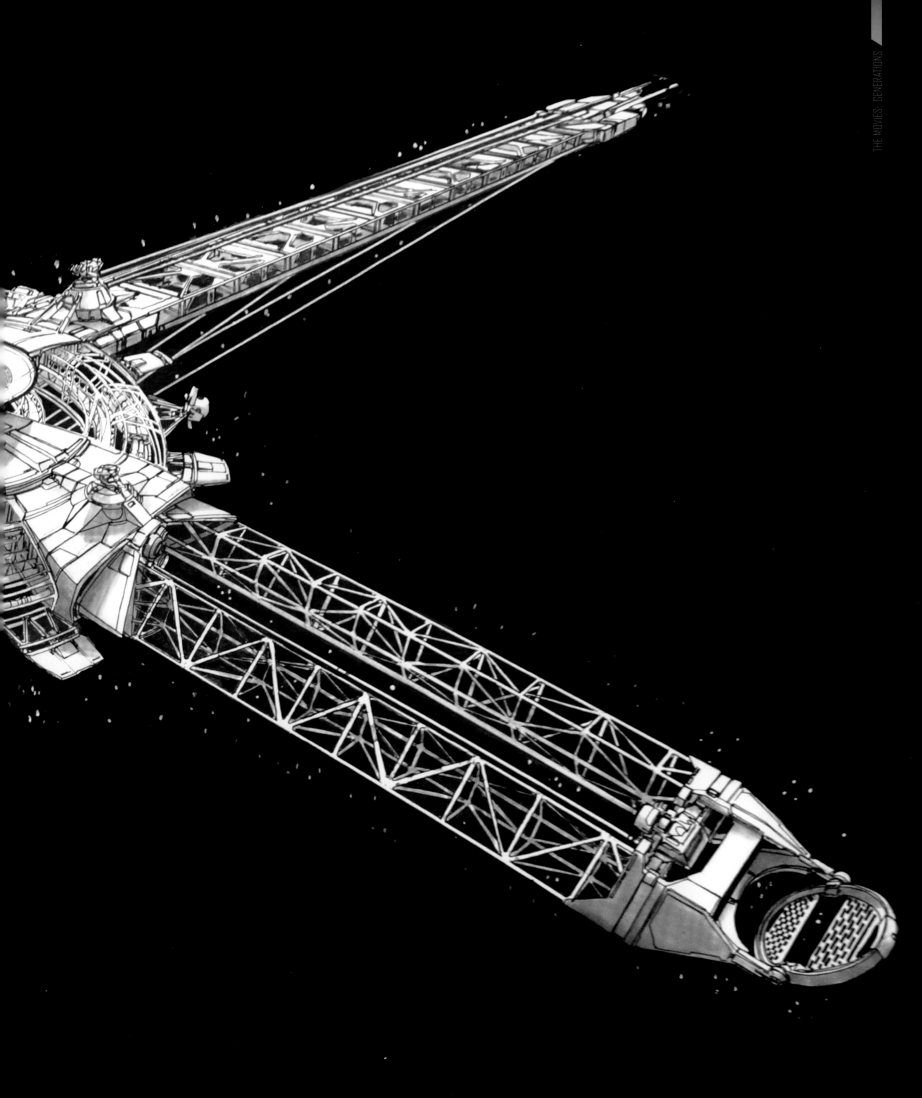

# STELLAR CARTOGRAPHY SET

For the stellar cartography set, Herman wanted something we could see in 360°, so I came up with a cylinder design, where you walk out onto a little platform and everything is projected around you. The walkway retracts, leaving you with this gigantic 360° view, but practically you couldn't do that on a set, so we had to leave the walkway there. I added four 'ribs' that go up the sides, which broke the room up into quadrants as far as what part of space you were looking at.

That was our first big set on the film, and it was really exciting to do. Rick Sternbach did the big graphics you see when it's not animated, so he created a beautiful galaxy with little stars with their names and numbers on it. ILM did the graphics and animation, so it was really cool to see it all completely animated. I had left the production before any of those sets were built, so I didn't get to see any of them until I went to a screening several months later and thought, "That looks so cool from an artist's point of view!"

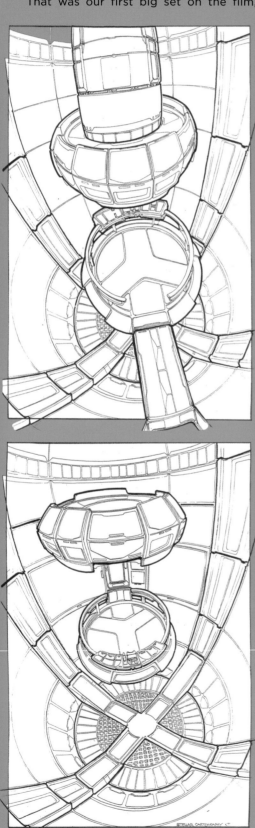

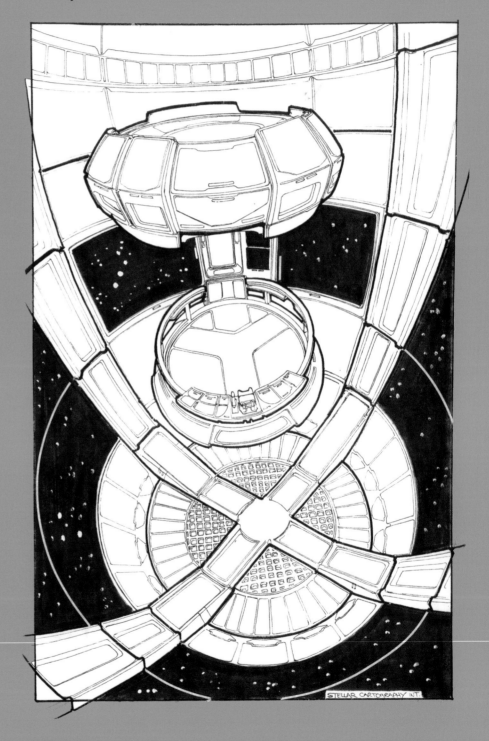

**THIS PAGE:** Eaves' concept designs for the stellar cartography lab with 360° views from the viewing deck.

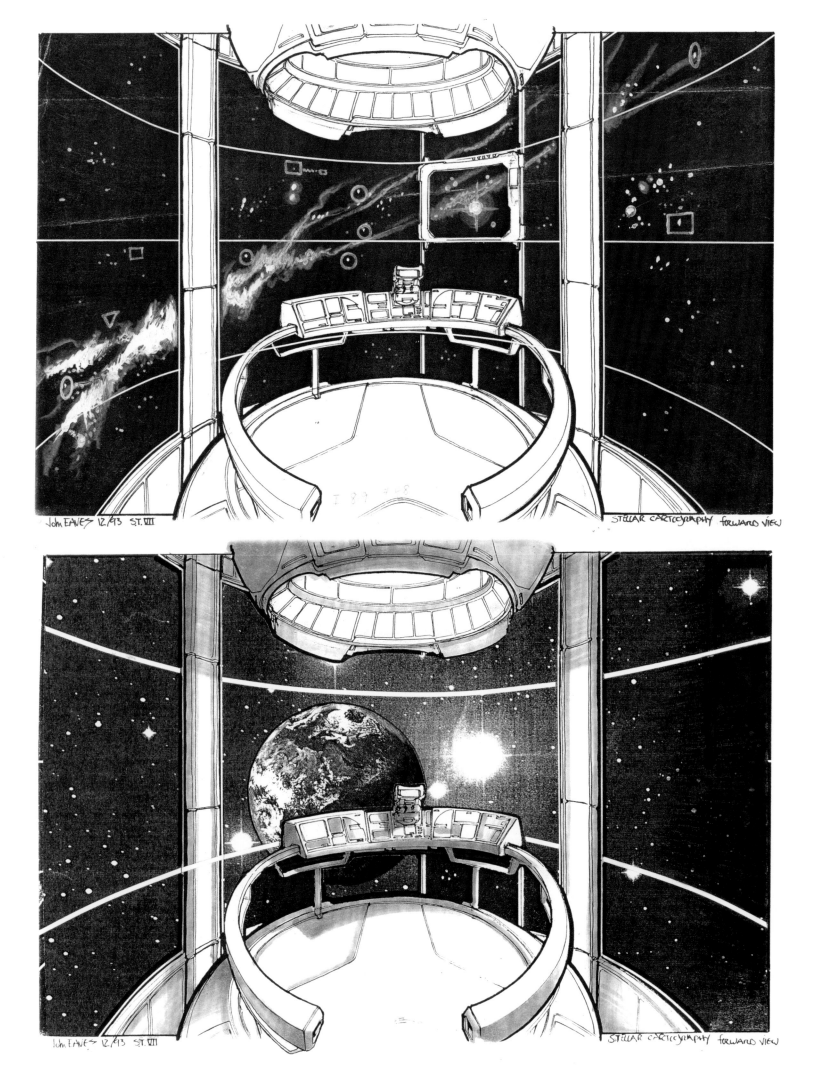

# STAR TREK: FIRST CONTACT
## U.S.S. ENTERPRISE-E

### "*FIRST CONTACT* WAS MY FIRST FULL-TIME GIG WITH THE ART DEPARTMENT."

Once we finished work on *Generations*, a vacancy opened up in the art department for *Deep Space Nine*. I admit I was a bit surprised when Herman invited me to join the team—I guess I must have made an impression!

We had been hearing rumors about a new *TNG* film for a while, and we were anxious to know when it would get off the ground. Whilst Herman was making his morning rounds in the studio for *DS9*, he came in with a beat sheet for *First Contact*.

From there, the art department would be spending half the time on *Deep Space Nine* and the other half on *First Contact*. The *Star Trek* world at this time was like a well-oiled machine, so all the departments easily transitioned between the two projects. I was still making my move from working in the VFX model shops, and *First Contact* was my first full-time gig with the art department.

**THIS PAGE:** Eaves' concept designs for the *Enterprise*. The design and shape were altered with the threat of fighting the Borg in mind.

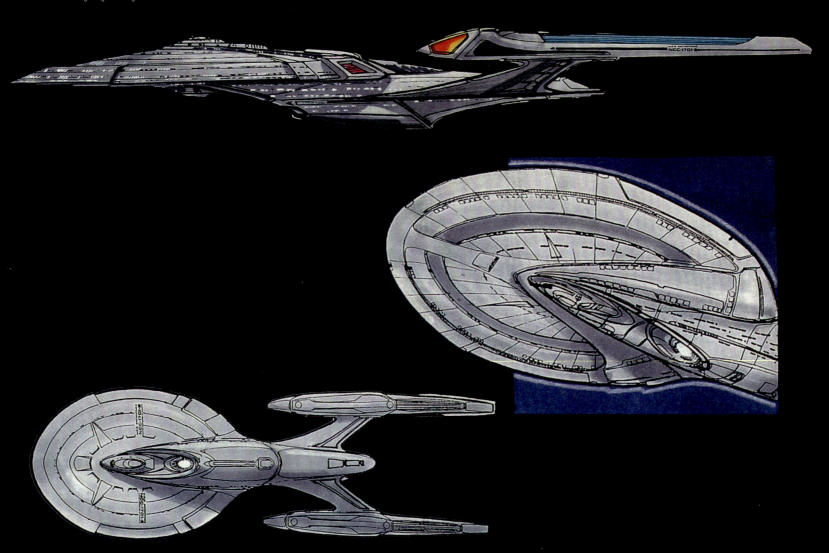

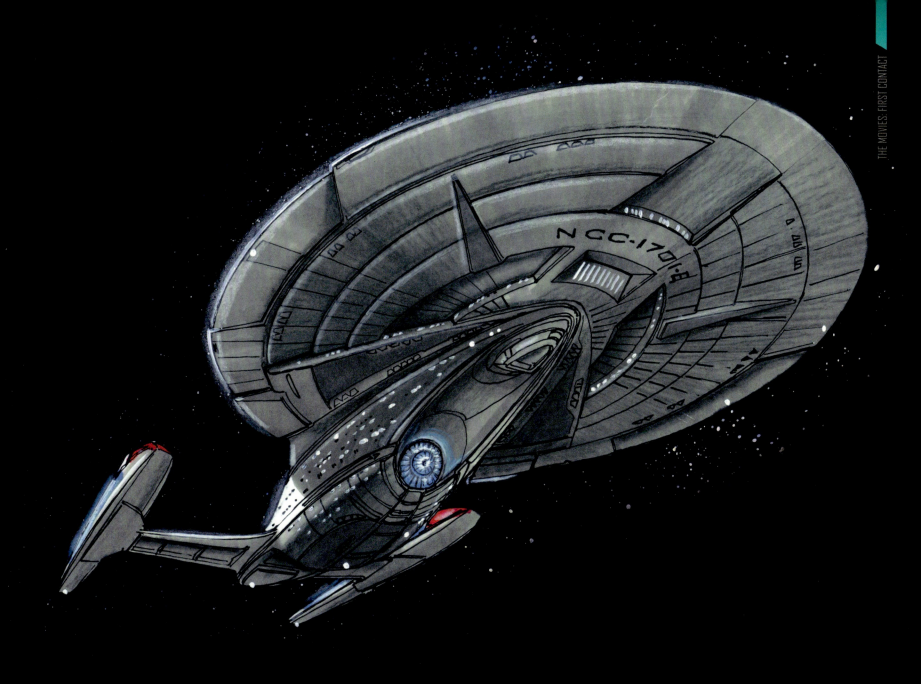
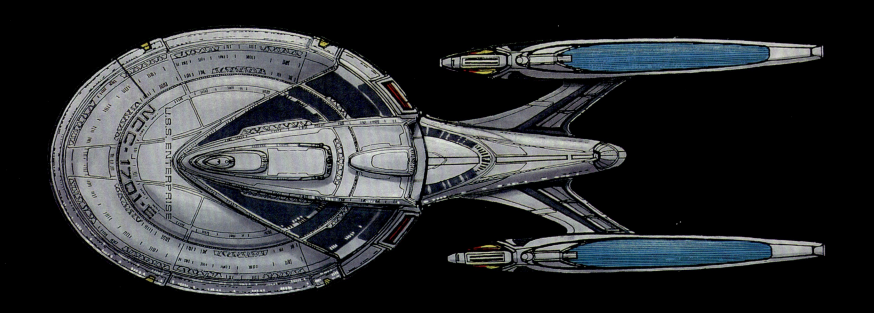

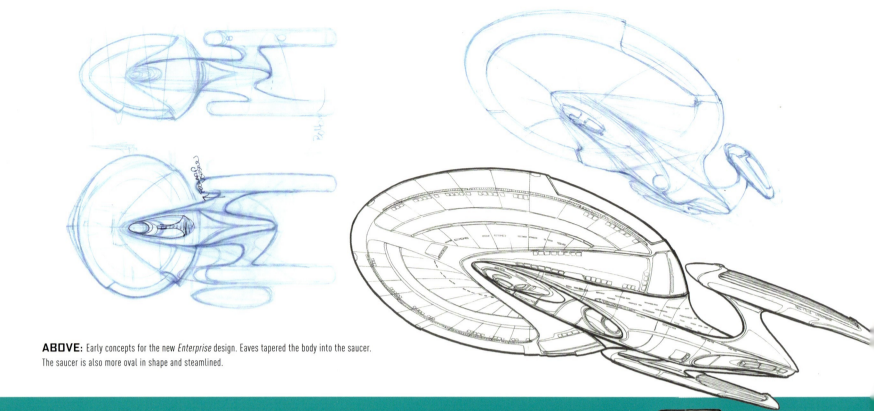

**ABOVE:** Early concepts for the new *Enterprise* design. Eaves tapered the body into the saucer. The saucer is also more oval in shape and steamlined.

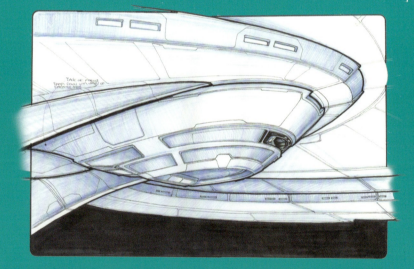

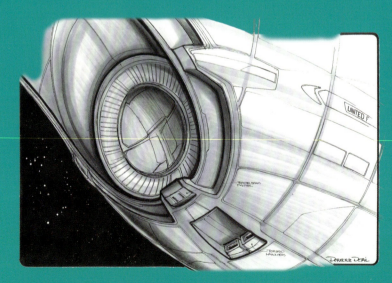

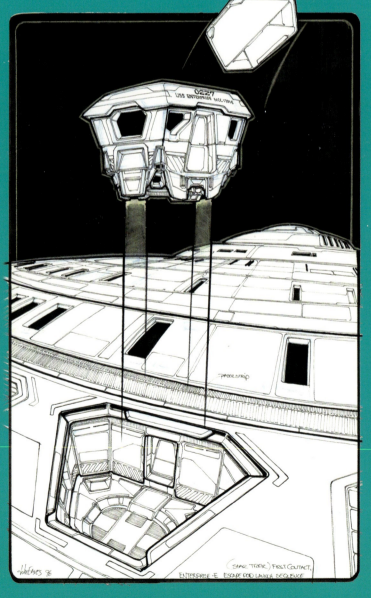

**ABOVE:** Eaves added additional weaponry to the *Enterprise*, including a torpedo launcher on the hull and a tractor beam emitter and torpedo launcher on the deflector dish.

**ABOVE:** Concept design for the *Enterprise* escape pod ejection sequence.

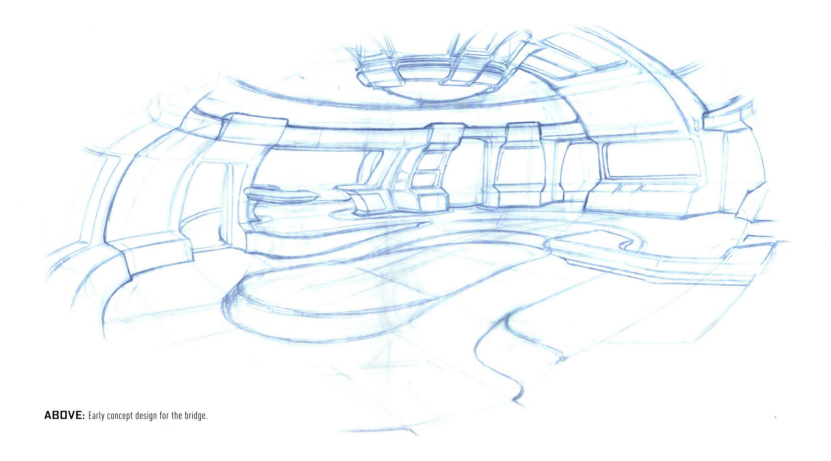

**ABOVE:** Early concept design for the bridge.

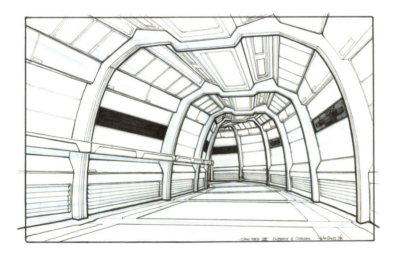
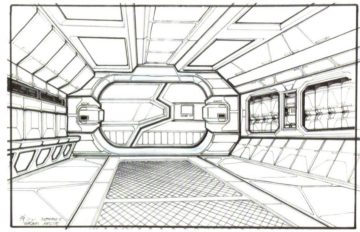

**ABOVE:** Corridors on the *Enterprise*.

The first thing Herman said was that we needed to start doing sketches of the *Enterprise* for the next movie. It took a while for the idea of a new *Enterprise* to sink in, and I was up all night thinking about that iconic ship. The next day, we started sketching and I was so excited to get all designs I had in my head down on paper.

As the *Enterprise* was going to be a new ship, we needed to get the interior and exterior sets designed right away. From first drawing to visual effects we had a little less than a year's turnaround, so it was very quick.

We decided the *Enterprise*-E had been designed with the threat of fighting the Borg in mind, so that was the reason for its design and shape. They were such a big threat that Starfleet and the Federation were designing ships for combat. We also had to come up with new weaponry, such as the quantum torpedoes they could use to battle the Borg.

It was Mike Okuda who reminded me I didn't need to emulate the *Enterprise*-D, which had been designed for TV. They needed to show the entire ship on screen, which meant it had to be compacted into a squatter shape, but we were now able to make it a longer ship again for the big screen. I had worked on the *Enterprise*-D model at Greg Jein's shop, which was such a short little ship, and after that conversation with Mike it was interesting to find out that I had a lot more freedom.

With the *Enterprise*-E, my thought was to make it long, elegant, and racy. One of the first things I did was get rid of the neck, because I had been watching *Star Trek II* and during the scene where Khan was blasting the neck of the ship I thought another blast or two would have blown the ship apart! I thickened up the struts, tying them into the body, and got rid of the neck so the saucer tapered into the hull. Architecturally, I also followed what Andy Probert had done, with the windows on the bottom and the shuttlebay on top of the saucer, so I was tying in some of the architecture from *TNG* with the new movies.

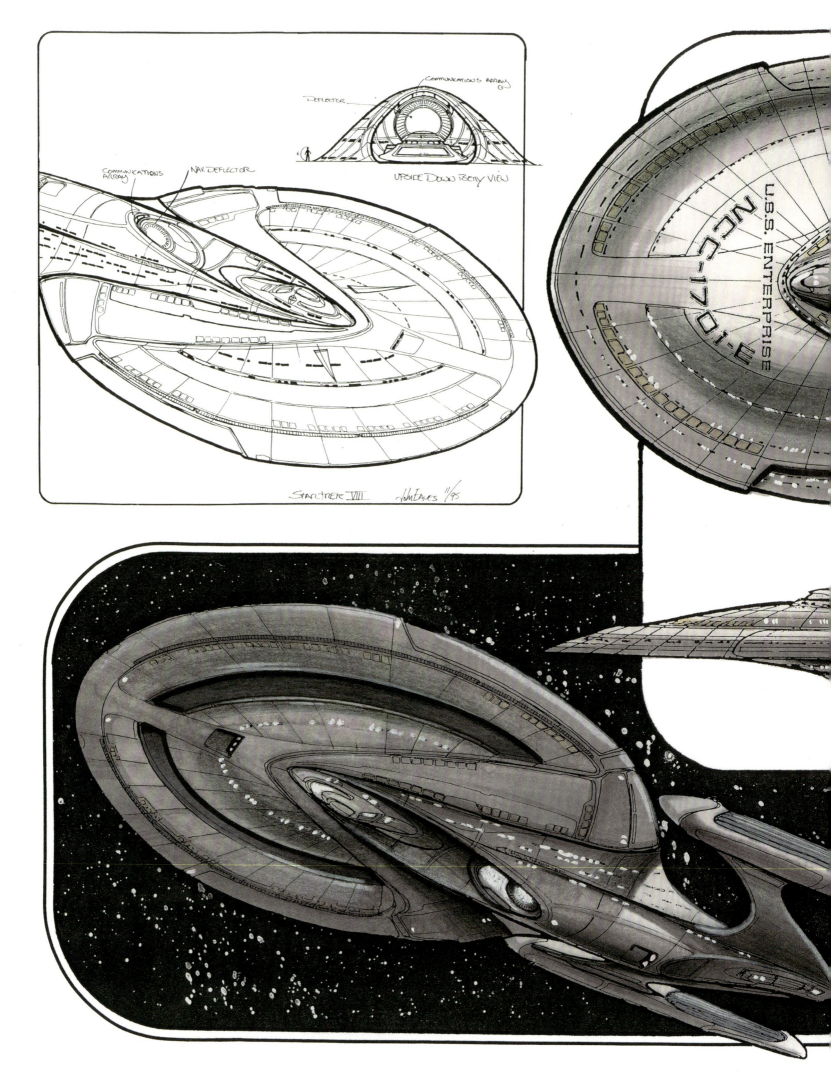

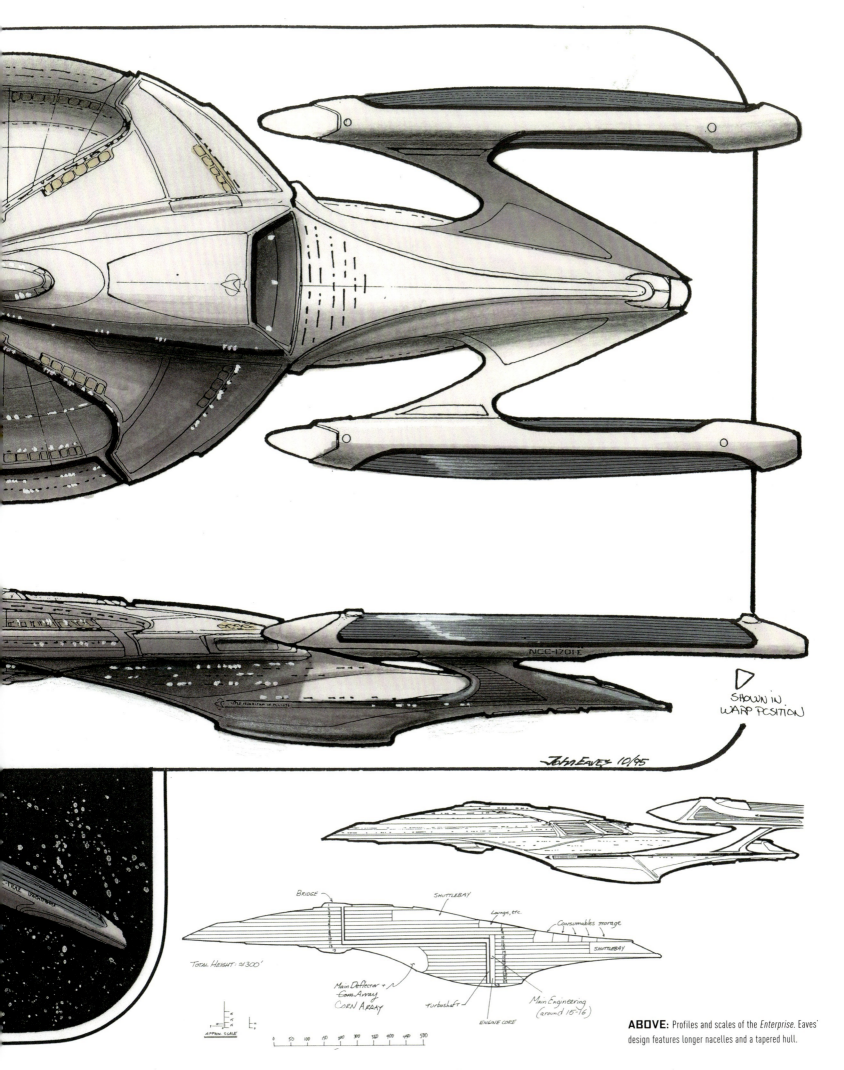

**ABOVE:** Profiles and scales of the *Enterprise*. Eaves' design features longer nacelles and a tapered hull.

# BORG CUBE AND SPHERE

The sphere was interesting because we got a note that the Borg sphere ejects out of the cube, and I thought, "Oh no, not a sphere!" because there are so many recognizable sphere shapes in science fiction, most notably the Death Star from *Star Wars*. I went and talked to Peter Lauritson, one of our effects supervisors, to see if we could maybe change the shape. I took along this *Star Wars Chronicle* book, which had big pictures of the Death Star in it. I said, "Hey Peter, could we maybe change the shape from a sphere to something else?" He asked why so I showed him a picture of the Death Star.

He looked at it for a *long* time, and finally said, "Nobody will remember this!" As far as I could tell, he had never seen *Star Wars*, and had no idea why I was showing that to him.

Ironically, this was the early days of the *Phantom Menace* at ILM, so they used to give a lot of tours around the studio. John Goodson told me, "Every single person that walked through would say, "Is that the Death Star for the new *Star Wars* movie?" He ended up putting a jar out so every time someone asked that question they put a dime in it, and that jar filled up all the time!

**BELOW:** Early concepts for the Borg sphere.

**NEXT PAGE:** The design for the Borg sphere moved ahead to a full color pass.

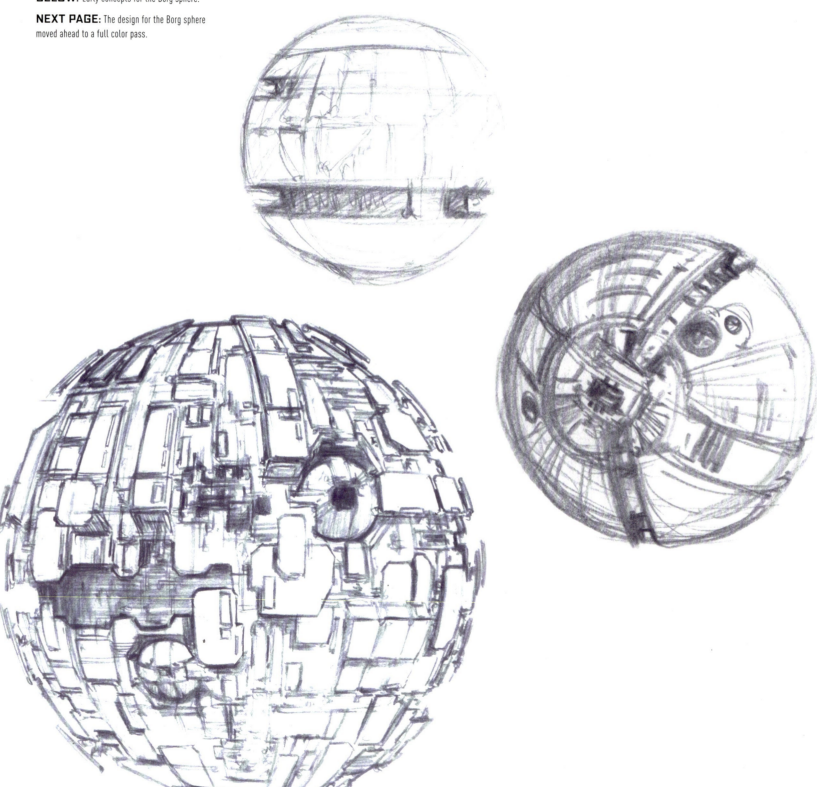

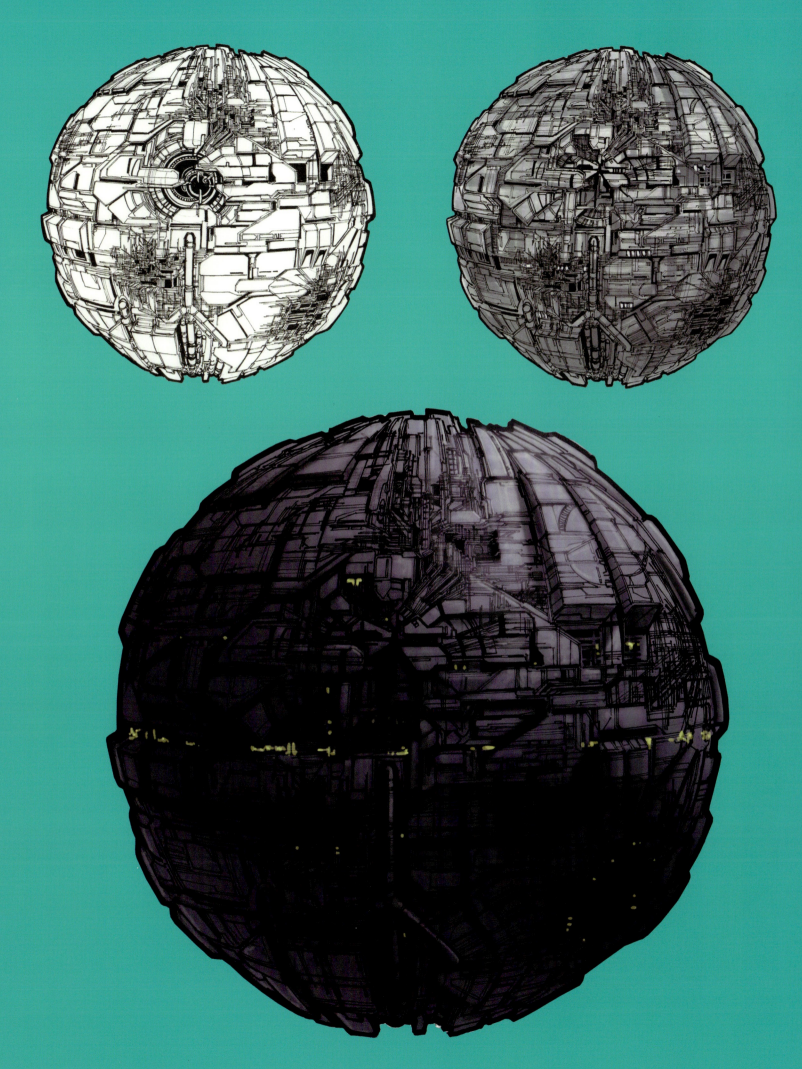

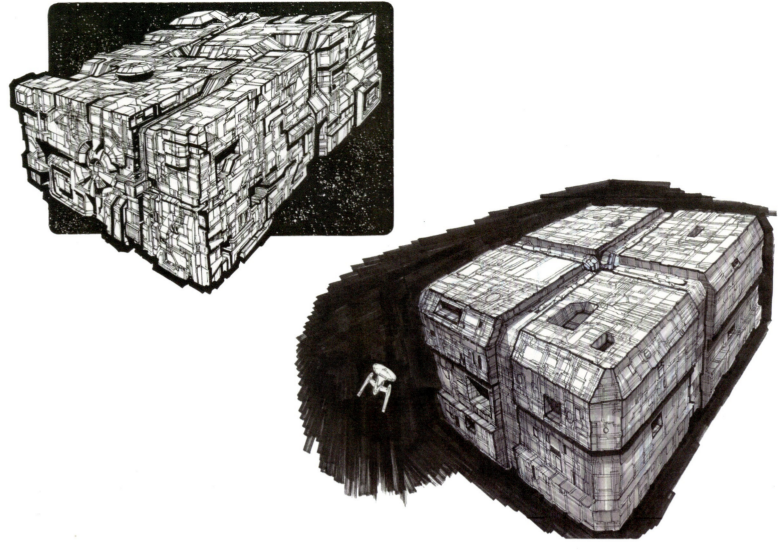
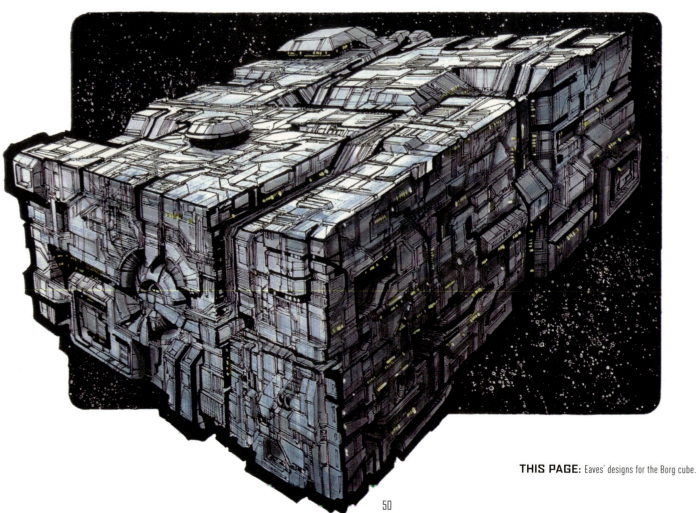

**THIS PAGE:** Eaves' designs for the Borg cube.

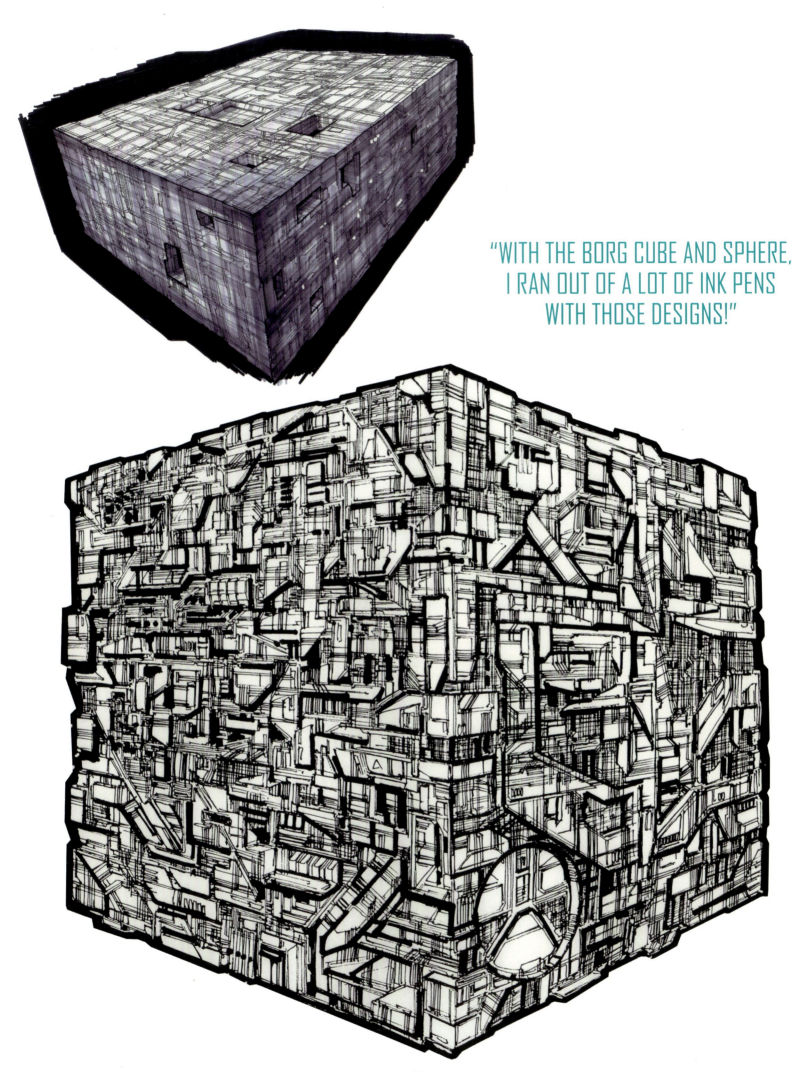

"WITH THE BORG CUBE AND SPHERE, I RAN OUT OF A LOT OF INK PENS WITH THOSE DESIGNS!"

The original *TNG* cube was built by Kim Bailey, who built it as a three-sided model using 'model trees'—when you buy a model kit, it has that center 'tree' with all the parts on it, so when you take the parts off you're left with the tree. He layered those model trees over a giant cube, which was a bit fragile and the pieces kept falling off, so John Goodson and Bill George at ILM decided they were going to use 'brass etch,' which is a wonderful material. You take a sheet of brass and draw a pattern on it, and whatever is inked out drops away, leaving this strong, thin, beautiful material that adds a lot of density and weight when you're layering it. You can light it from behind and do all kinds of stuff with it, so it was the perfect material for the Borg cube.

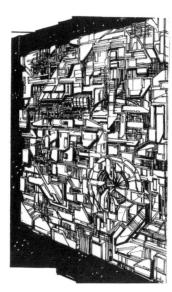 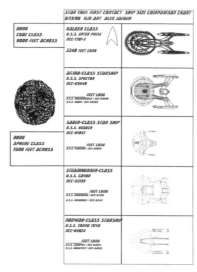 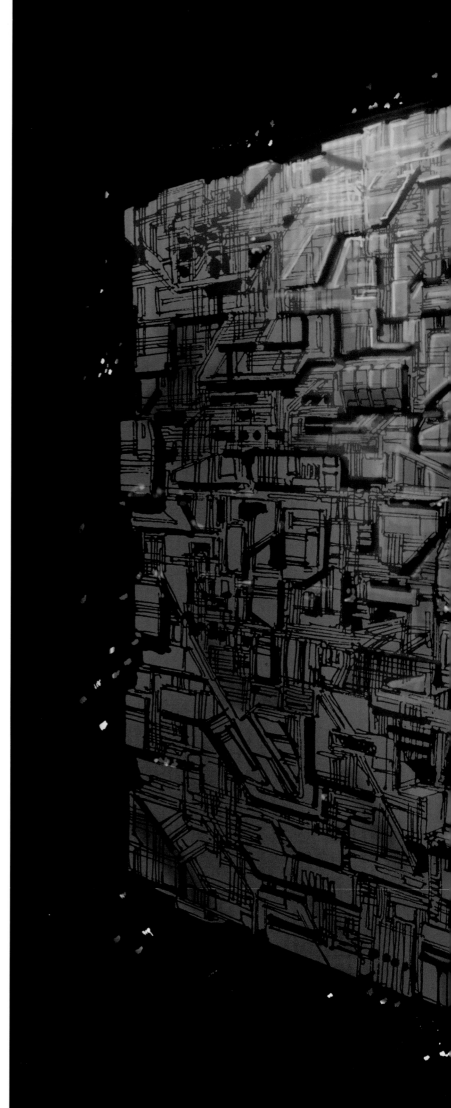

**ABOVE:** A size comparison chart of the Borg cube, sphere, and Federation ships from *First Contact*.

**RIGHT:** For his final design, Eaves incorporated 45° lines across the surface of the Borg cube. The cube also features a concealed hatch that is visible on the drawing but was revealed later in the film.

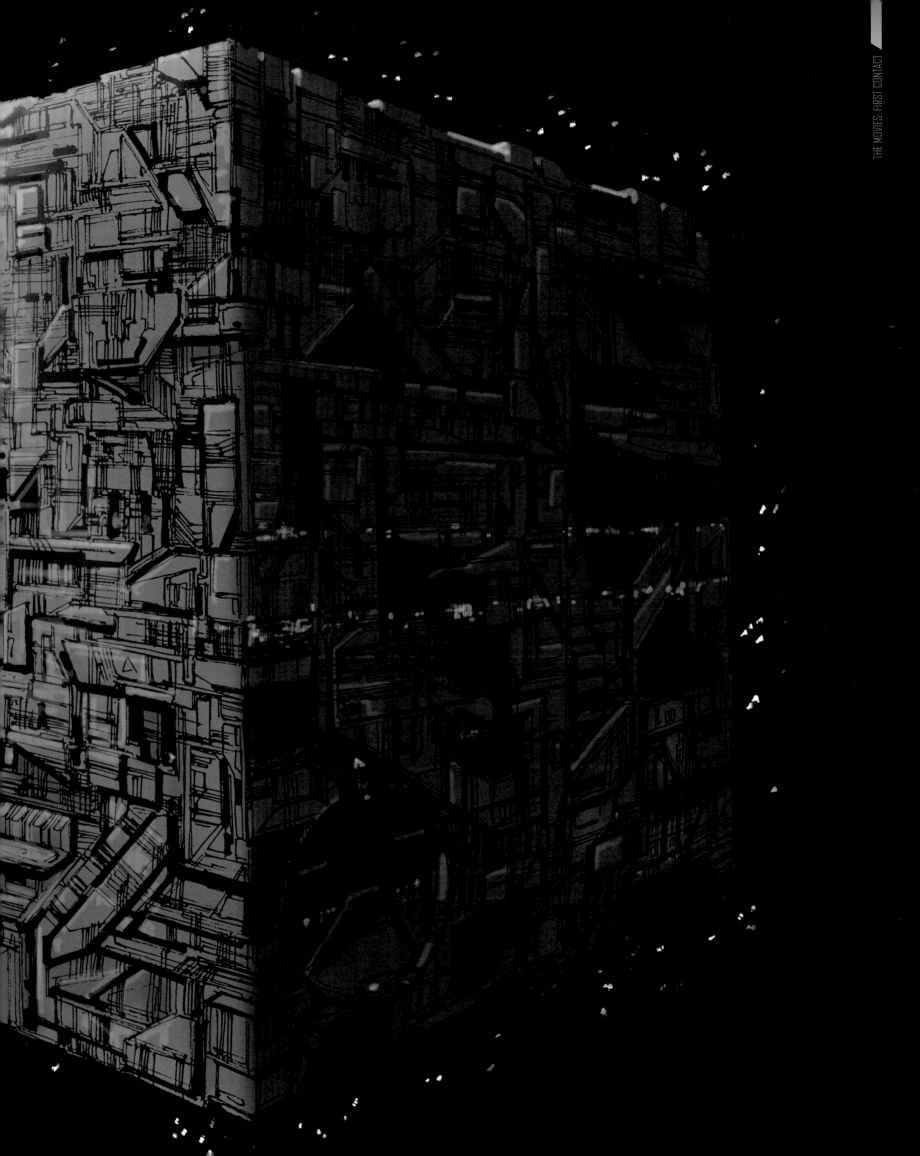

# BORG QUEEN

For the Borg Queen, there was a sequence where you see her head floating around before it comes down and connects to the body. We went back and forth with lots of piping and tubing, but this was still the early days of CG so those multiple cables became a big chore in terms of what would look good. In the end, we used just two cables to bring the head down. We originally carried on all the cabling used in the Borg designs for the hallways and sets, but it was just too expensive for the Borg Queen as far as what you could and couldn't do at the time.

**THIS PAGE:** Eaves' concept designs for the Borg queen.

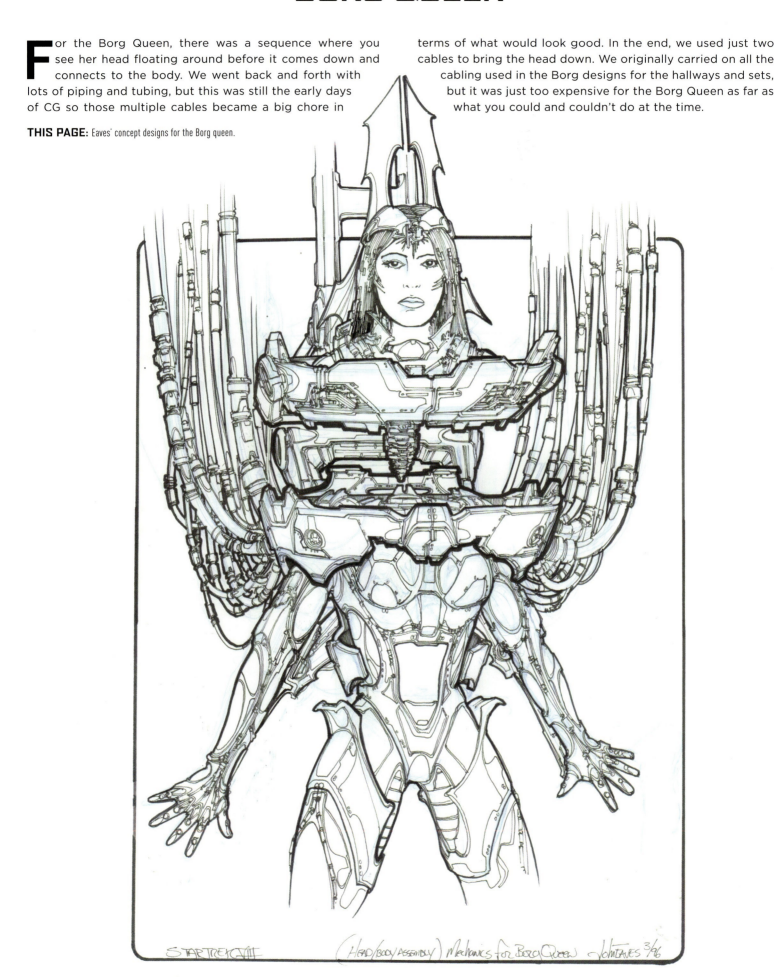

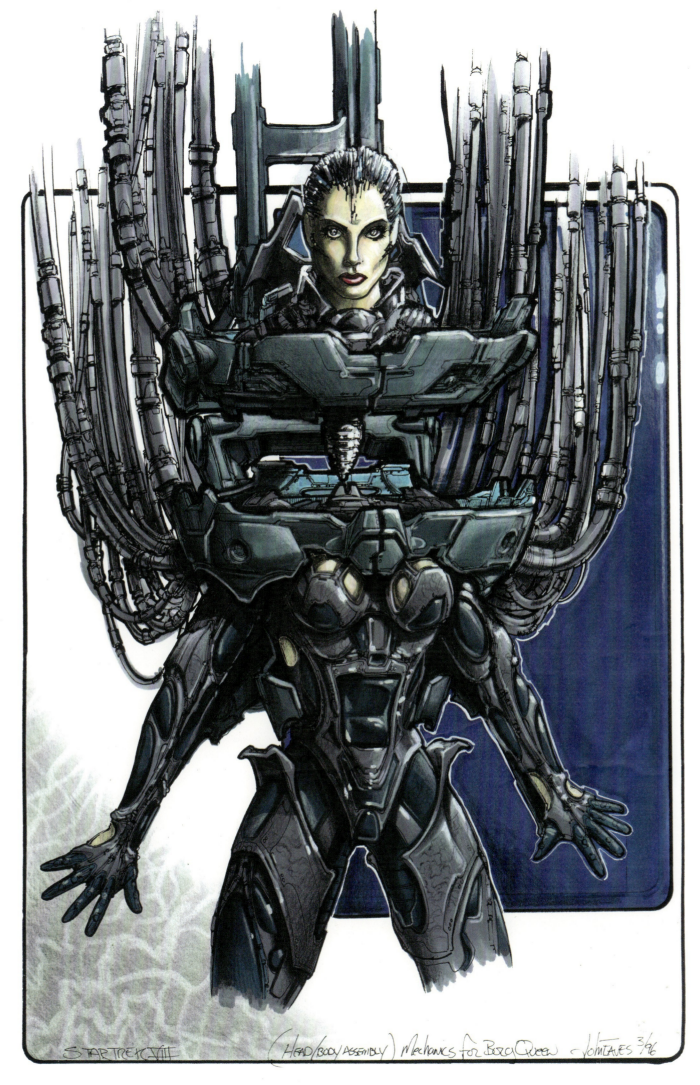

# VULCAN LANDER

When I was designing the Vulcan lander, Herman asked me to draw something fast for him, because they needed to get the discussions going right away. I showed my first drawing to Mike Okuda, who was going to the meeting and said, "Get ready to do some more drawings, because this one is too far out." When he came back, he said, "I can't believe it; they like it!"

The idea was to make the lander more artistic than architectural, so we made it like a piece of jewelry. I had a hard time drawing the lander at first, so I asked Herman if I could build a model for reference. I built that model over the weekend and used it as reference, which really helped as far as getting those shapes right.

We knew we would need a set that actors could come in and out of, and I thought it would be a cool idea if the doorway was in the feet of the landing gear, so when the ramp comes out, it basically just slides out of that door.

We didn't have a name for the Vulcan ship, so we called Ron Moore, who co-wrote the script, and he came up with the *T'Plana-Hath*. I eventually looked it up, and it turned out to be a Vulcan philosopher, so that was the perfect name.

**BELOW:** The main body of the lander is triangular with three arms extending from the center containing the engines and propulsion systems.

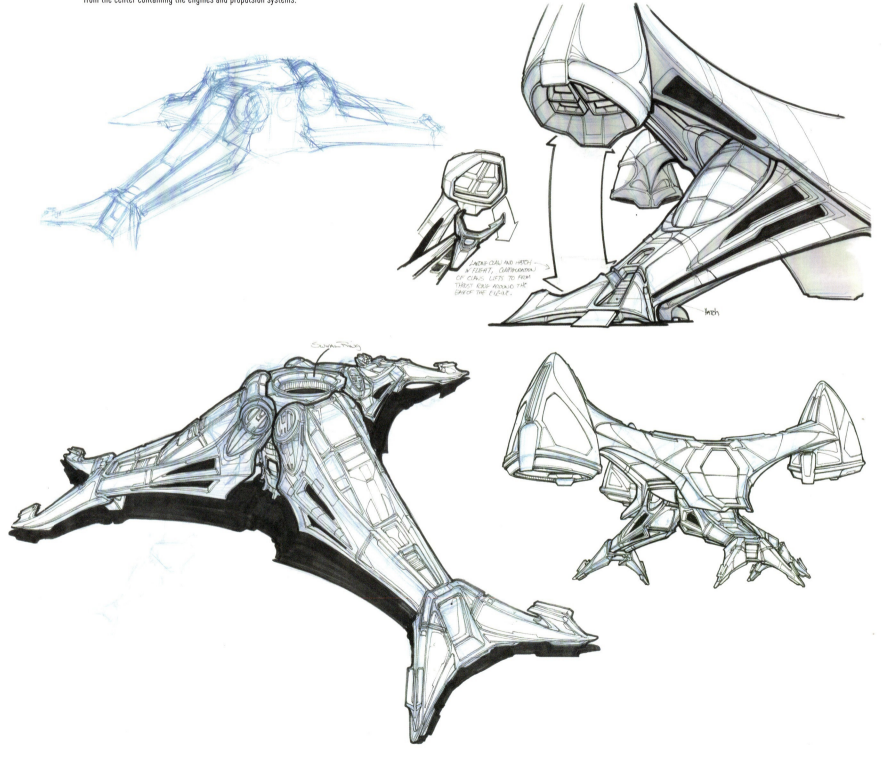

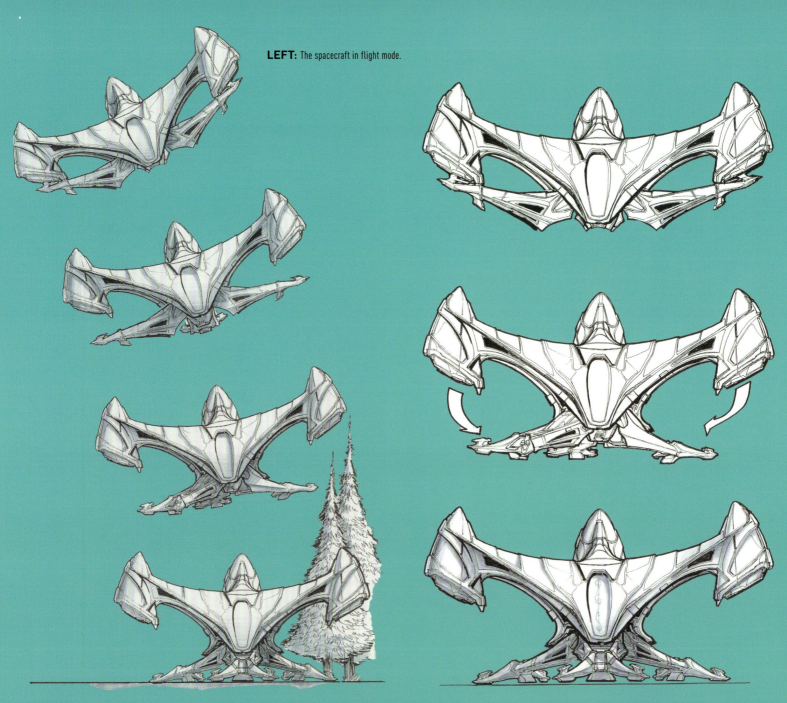

**LEFT:** The spacecraft in flight mode.

**ABOVE:** During the landing sequence, the arms serve a secondary purpose as landing legs. The legs deploy for landing and the thrust-ring drops down to form the platform. The main hatch is situated in the center.

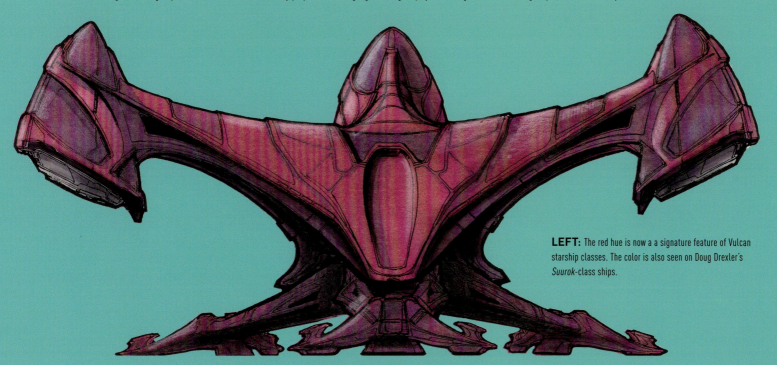

**LEFT:** The red hue is now a a signature feature of Vulcan starship classes. The color is also seen on Doug Drexler's *Suurok*-class ships.

# PHOENIX

The designs for Zefram Cochrane's ship, the *Phoenix*, were originally quite different. The direction changed when Herman came in and said, "We're going to use the Titan Missile Museum in Arizona, so it has to fit in that space!" which was only 10-12 feet across. We had come up with the idea of the nacelles being attached to the body that were inline so they didn't come out. At this point, Herman said, "What if the ship has a couple of cavities with the nacelles inside them? When the ship comes out, the nacelles are on retractable arms and they open up, then it's ready for the warp test?"

We also had to come up with an idea for a braking system, and after devising a complicated system of multiple elements I decided it was better to keep those elements to a minimum. I was out in Arizona, at a little outdoor restaurant called the Cook Shack, and I came up with an idea, which I drew on a napkin, for a scenario where the ship is like a ship within another ship, with an arched framework holding the whole thing together.

The film *Fat Man and Little Boy* had just come out and a friend of mine was working on the film, so he showed me some of the drawings they did for the bomb's atomic trigger. I liked that circular segmentation with all these little triggers that all had to go off at once. I thought it would be cool if that was how the warp ship worked, where you had all these segmented triggers around it, which was the warp initiator, and all of them had to tie together to make the warp process work. In the final scenario, the thruster has those segmented pieces, which is the warp trigger that feeds through the struts to the nacelles.

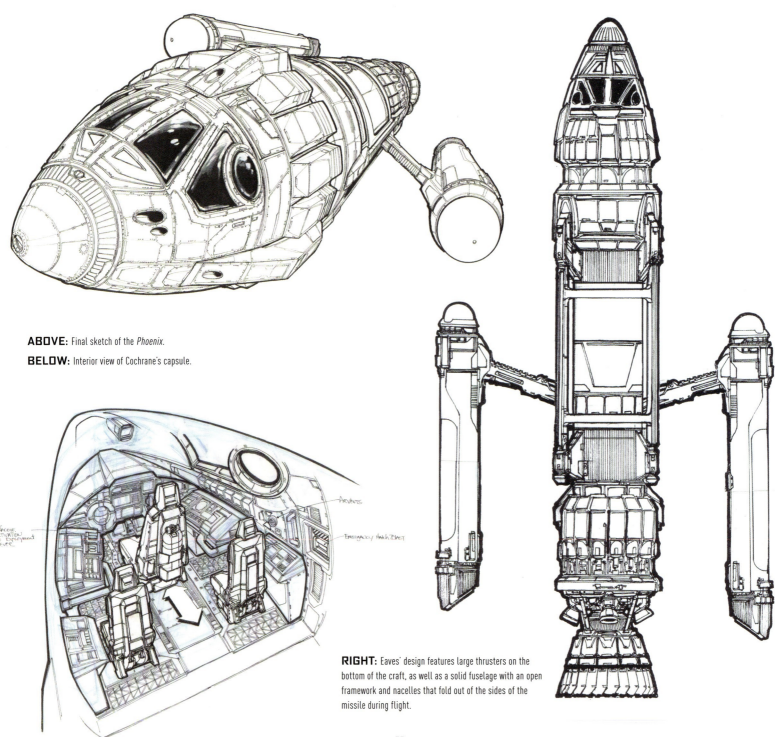

**ABOVE:** Final sketch of the *Phoenix*.
**BELOW:** Interior view of Cochrane's capsule.

**RIGHT:** Eaves' design features large thrusters on the bottom of the craft, as well as a solid fuselage with an open framework and nacelles that fold out of the sides of the missile during flight.

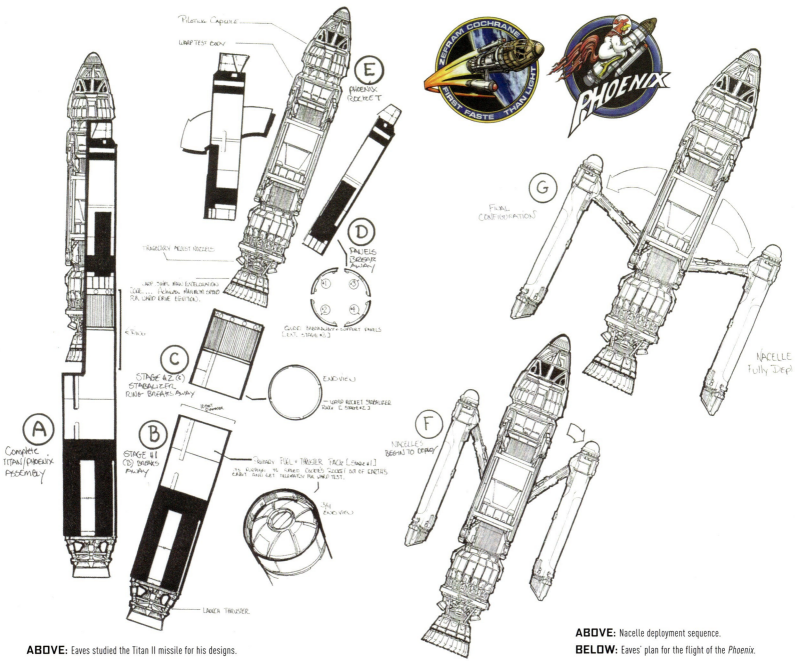

**ABOVE:** Eaves studied the Titan II missile for his designs.

**ABOVE:** Nacelle deployment sequence.
**BELOW:** Eaves' plan for the flight of the *Phoenix*.

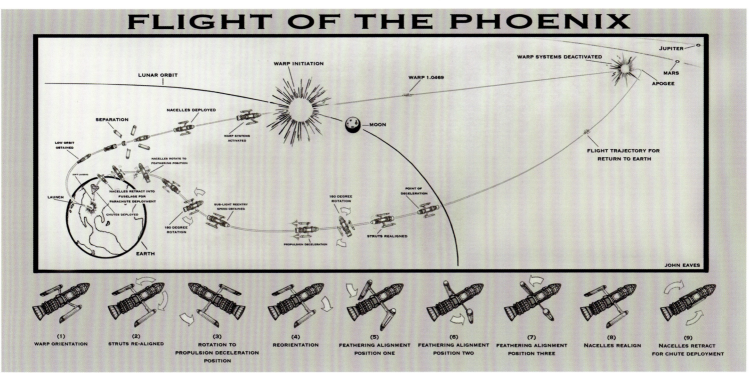

# STAR TREK: INSURRECTION
## BA'KU VILLAGE

### "HERMAN ZIMMERMAN WAS BORN TO DO THESE FILMS."

Herman Zimmerman was born to do these films because he has such a keen sense of what can be reused. Herman started his career on the Sid and Marty Kroft shows like *Sigmund and the Sea Monsters*, so he was used to working with a limited budget. When he got to *Star Trek*, where there were as many as three different shows going on at the same time, he knew how to use this and borrow that so he could go a long way with very little. There wasn't anything construction coordinator Tom Arp and his crew couldn't do.

The first thing Herman gave me to design was the Ba'ku village. Our budget was a lot bigger in the beginning, so if you look at the initial sketches, we've got buildings set into a mountain, and a real tropical island look to it. We eventually had to come up with something a bit simpler story-wise that could be created in the holoship, so we ended up with a couple of buildings and a bridge where everything is concentrated in a smaller area.

**ABOVE:** Many of Eaves' early designs for Ba'ku village were more detailed and included cliffside architecture and elaborate bridges.

# ENTERPRISE WARP CORE

One of the additions to the *Enterprise* for this film was a sequence in which the warp core gets ejected. We had a new company, Santa Barbara Studios, who were well-known for their planets and atmospheric stuff, but model work was brand new territory for them. Unlike ILM, where I could send them three-quarter sketches and they would fill in the blind spots, this company wanted plans drawn up for everything: scales, top, side and front views; they needed everything because they had never done ship modeling before.

We had made a warp core hatch for the *Enterprise* in *First Contact*, but never showed how it worked, so on this film we had to work out a process to show how the hatch blows off and the warp core ejects, but when we realized the entire core was getting ejected, I thought, "That thing is enormous!" I came up with a sequence in which the doors were widened to eject the core, but it was going to be prohibitive budget-wise and schedule-wise, so in the end it's only mentioned in the dialogue and you never see it take place.

**BELOW:** The *Enterprise* warp core.

**RIGHT:** Shuttlebay detail of the *Enterprise*.

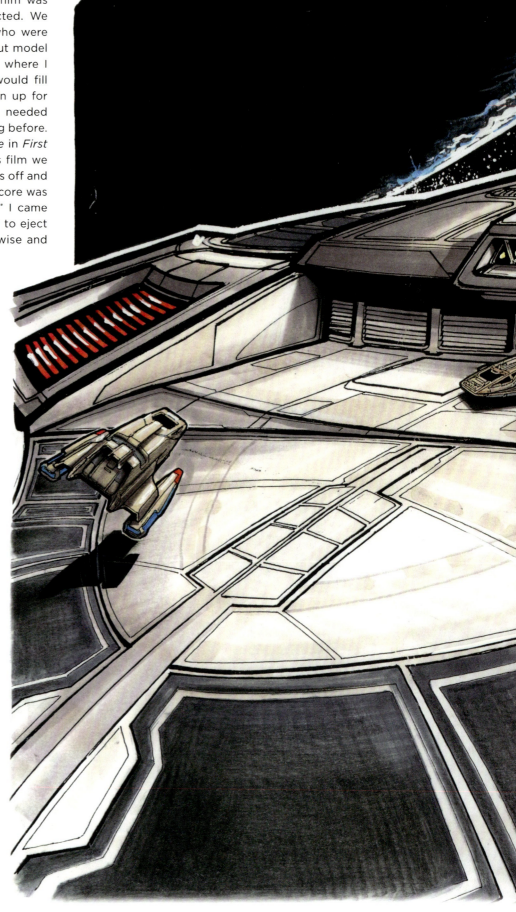

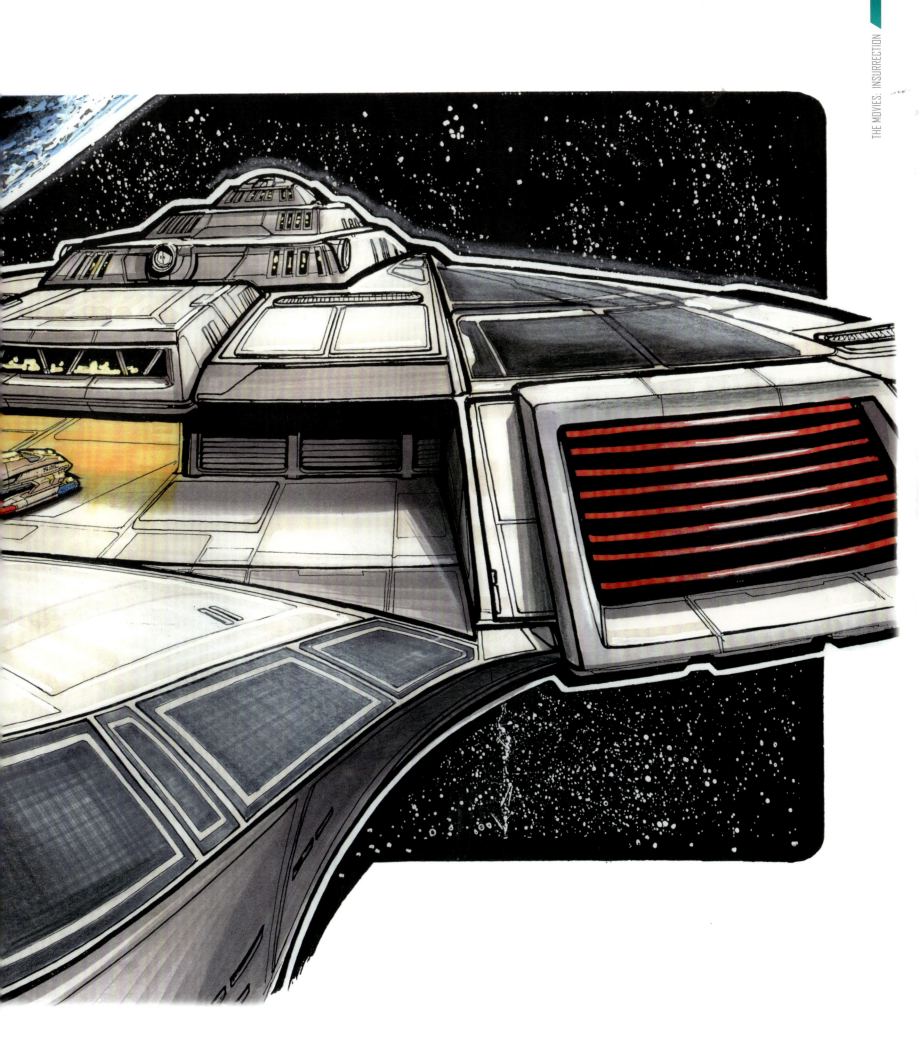

① Core Drop Sequence

② Explosive Bolts fire and outer hatch is jettisoned

**ABOVE:** Red warning lights flash as the ejection sequence begins and the hatch is released.

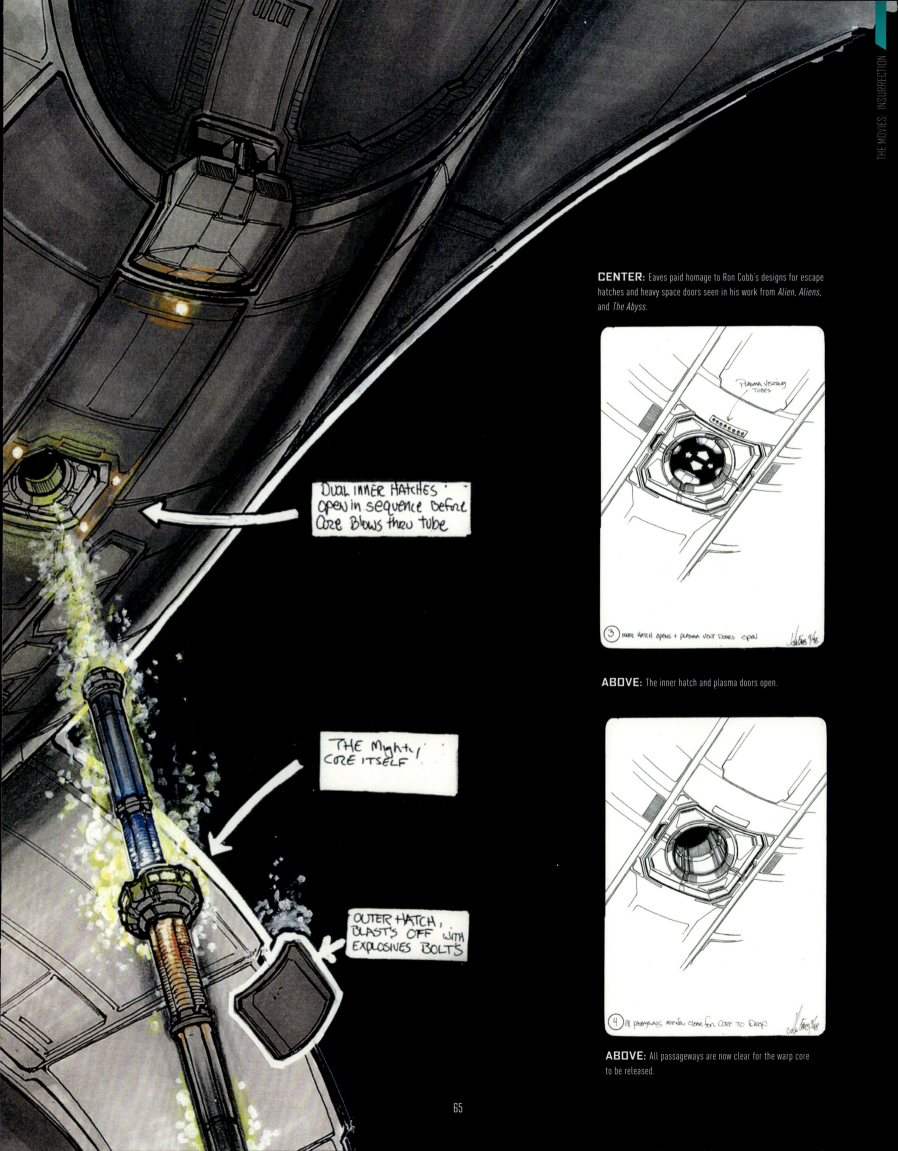

DUAL INNER HATCHES OPEN IN SEQUENCE BEFORE CORE BLOWS THRU TUBE

THE MIGHTY CORE ITSELF

OUTER HATCH, BLASTS OFF WITH EXPLOSIVES BOLTS

**CENTER:** Eaves paid homage to Ron Cobb's designs for escape hatches and heavy space doors seen in his work from *Alien*, *Aliens*, and *The Abyss*.

**ABOVE:** The inner hatch and plasma doors open.

**ABOVE:** All passageways are now clear for the warp core to be released.

# DATA'S SCOUT SHIP

Data's scout ship was a brand-new vehicle that was written in the script. The description we got from the script is that Data is flying erratically through the atmosphere, but that was about it. Herman, Mike Okuda, and I talked about what its function in the story was; it was going to be on its own, and it had to be armed, but it was a scout ship not a battleship, so we combined a shuttlecraft with the *Defiant*. We were doing *Deep Space Nine* at the time, so I thought it would be cool to put the Jim Martin *Defiant* engines on it but combine it with a shuttlecraft look.

It's funny, I like all the angles and views on the scout ship except for the profile, which is a bit puffy and fat, so I wish I could have streamlined that view a bit. I like the top, three-quarters and the back, but that's one design I would love to go back and rework.

**BELOW:** Concept designs for Data's scout ship.

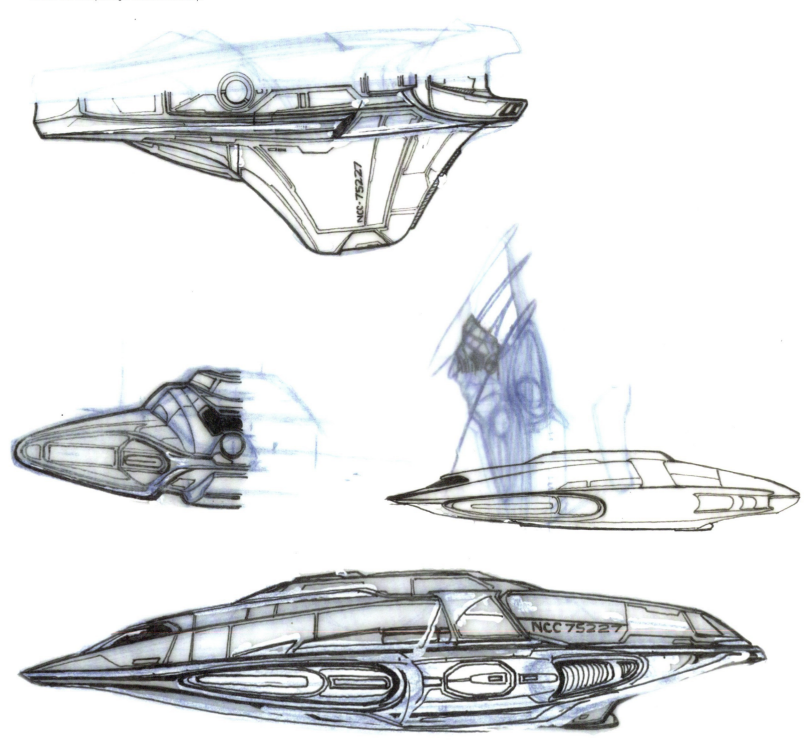

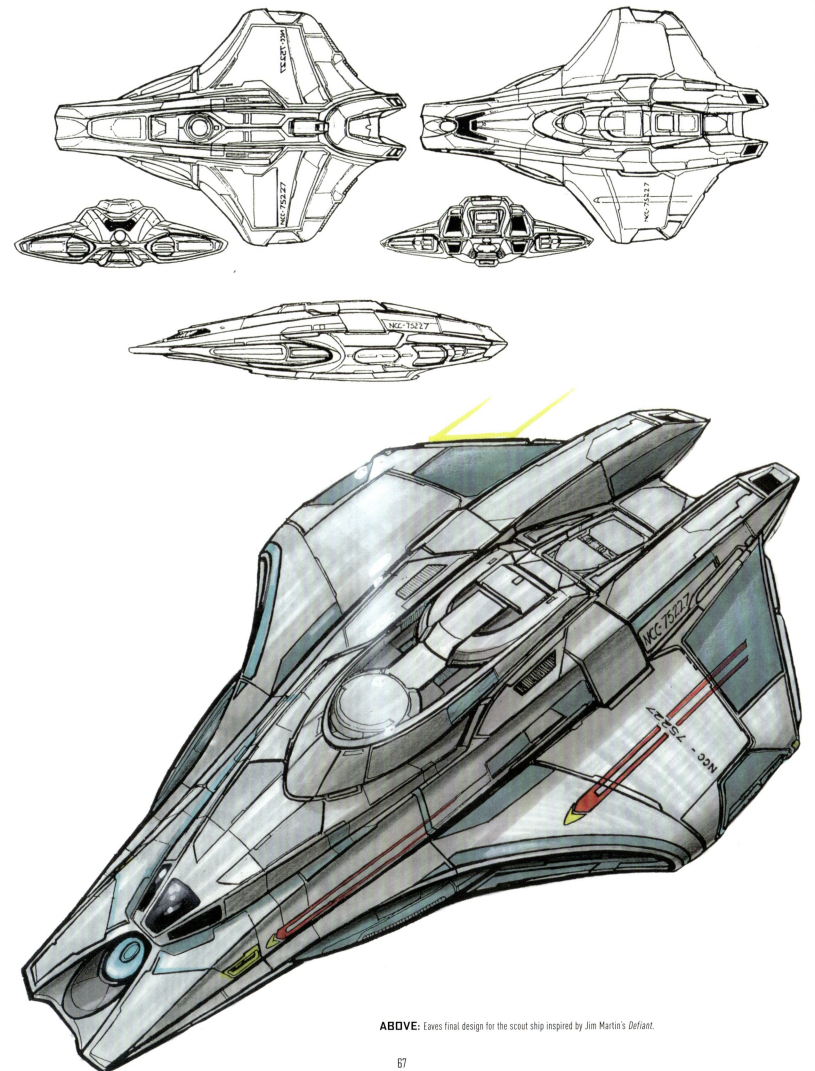

**ABOVE:** Eaves final design for the scout ship inspired by Jim Martin's *Defiant*.

# SON'A SHIPS

With the Son'a collector ship, I was asked to create multiple elements to create a symmetrical kind of pattern, so they became the outer wings. I figured I would just do everything in *Insurrection* in triplet, so you got the three major wing sets on that big cylindrical body. For the actual radiation collection, we had external arms that opened up and the giant umbrella collector machinery comes out, but somewhere along the line I said, "Let's have exterior hatches on the ship open up so it's a little more action-packed, and since we're doing it with CG we can do a lot more with it!" I made everything internalized, with wings that came out and opened up. I almost did one where the whole thing opens up as a gigantic collector, but it basically looked like an umbrella. I gave it more of a double Chinese fan look instead, which director Jonathan Frakes really liked, but that ship went through an enormous change.

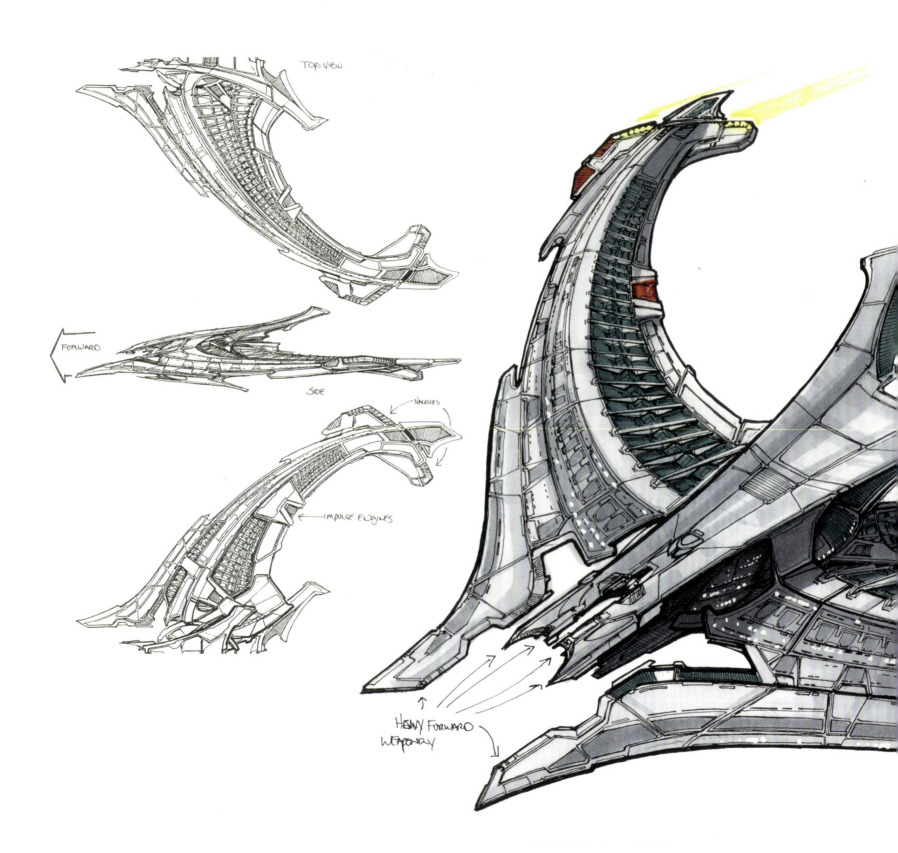

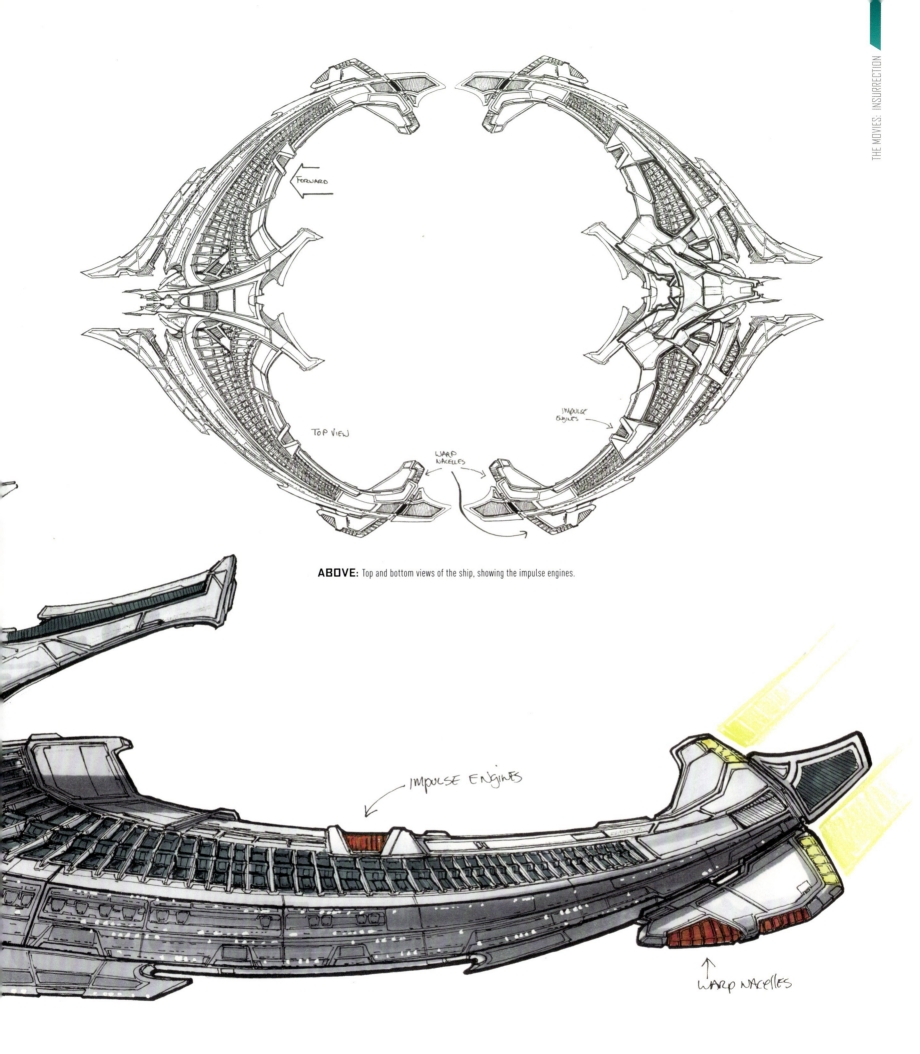

**ABOVE:** Top and bottom views of the ship, showing the impulse engines.

**ABOVE:** Eaves used the shape of a boomerang as his inspiration for the architecture of the Son'a battleship.

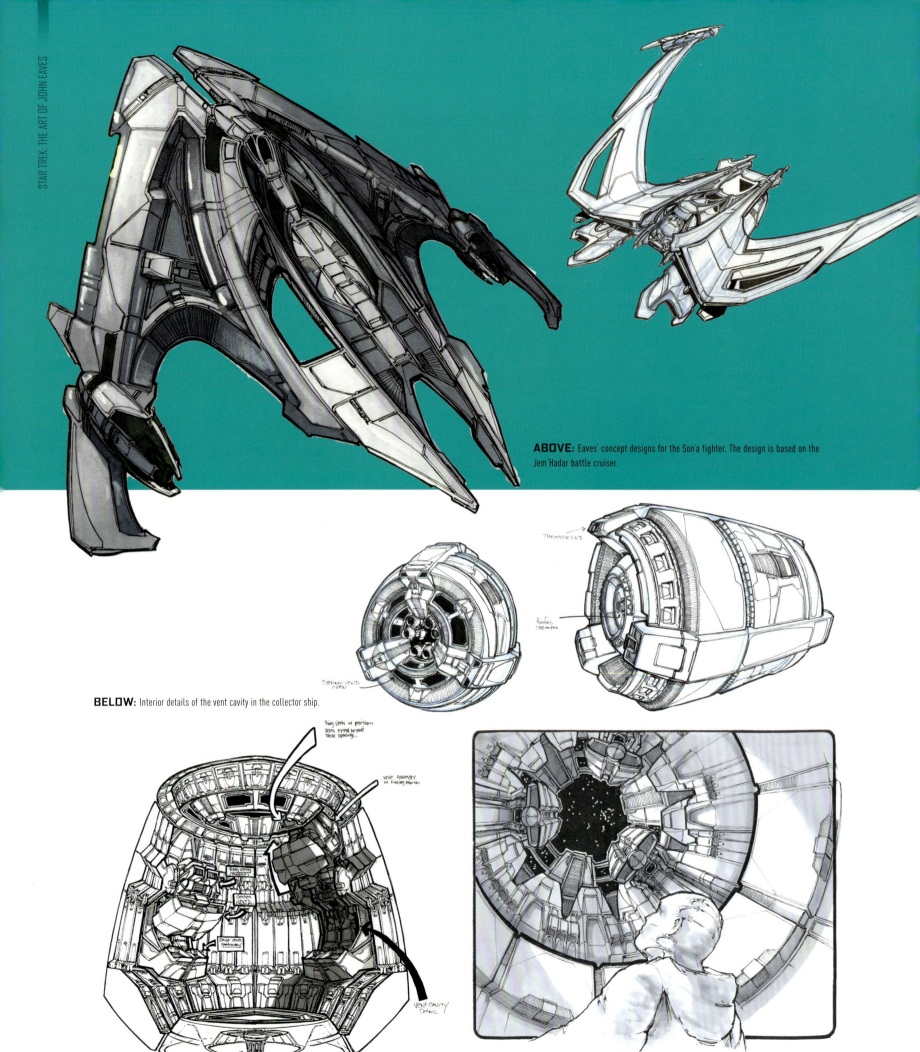

**ABOVE:** Eaves' concept designs for the Son'a fighter. The design is based on the Jem'Hadar battle cruiser.

**BELOW:** Interior details of the vent cavity in the collector ship.

**ABOVE:** Ru'afo looks upward as the collector ship opens in its final stage.

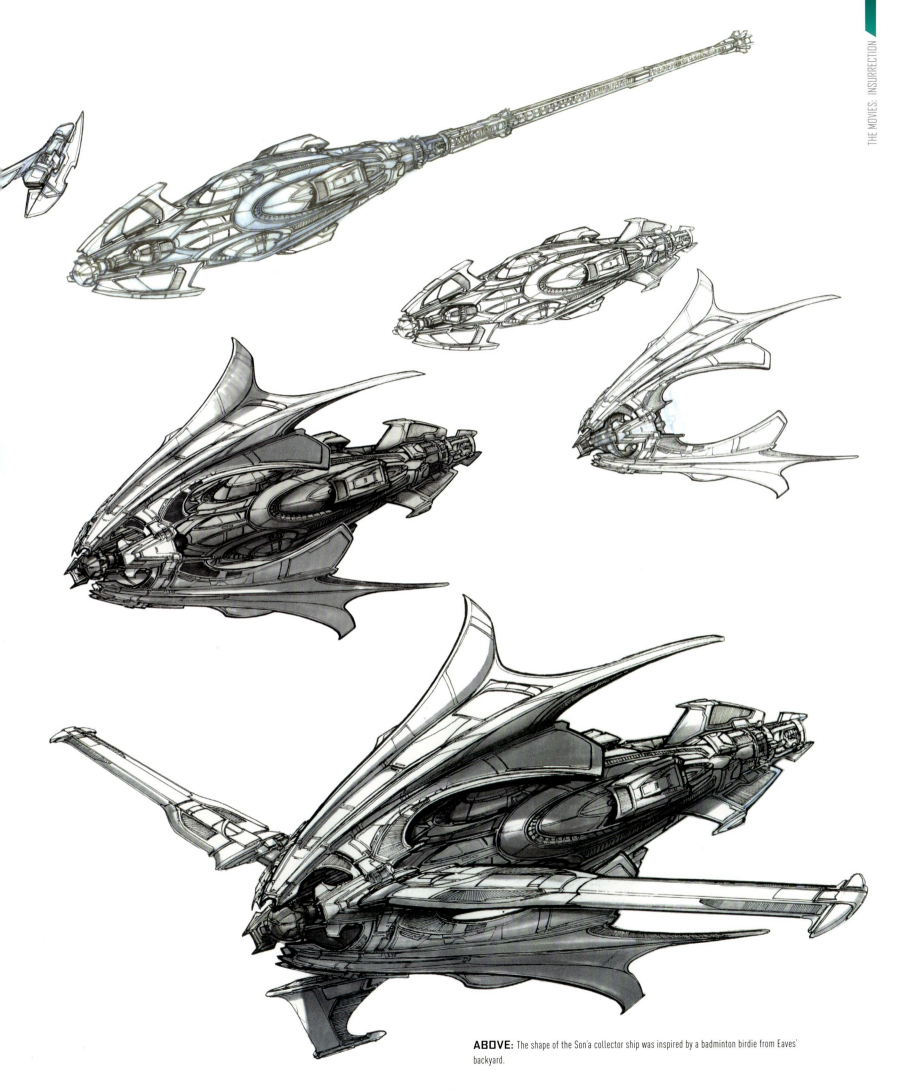

**ABOVE:** The shape of the Son'a collector ship was inspired by a badminton birdie from Eaves' backyard.

# RU'AFO'S SHIP

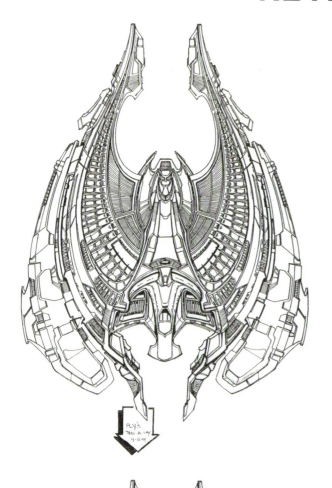

Ru'afo's ship had a much more unusual origin. My daughters were rodeo girls at the time, so we were all deeply entrenched in horseshoes and that kind of stuff, and just for the heck of it I thought, "What if I used horseshoes as a basis for all of the Son'a ships?" Ru'afo's ship is basically a horseshoe, and their big battleship is also a wide-open horseshoe shape, and all of that was inspired by the rodeo.

The inspiration for new ship designs would come from all around me. We used to sneak over and watch Jerry Goldsmith do the scoring for the movies, and at one point I remember seeing a grand piano with the lid open, and thought, "I don't know how to do it, but wouldn't that make part of a cool spaceship?" When *Insurrection* started up, I thought I would put all that piano intricacy into the wings of the ships, which had these multifaceted pieces that run down through the ribs.

At one point, Ru'afo was supposed to get trapped on the ship, and the collected radiation makes him reverse in age until he doesn't exist anymore, and that was all going to take place in a little capsule at the bottom of the ship. That was his fate for a long time, but in the end his death wasn't as dramatic. The only element that remained from the original designs was the fans that emerge.

I also noticed when I saw the film that the ship's scale changed from scene to scene. It goes from 5,000 feet to four miles when the *Enterprise* flies across the top, so that was the film when we decided we needed to make ship scale charts from then on, because we were all over the place.

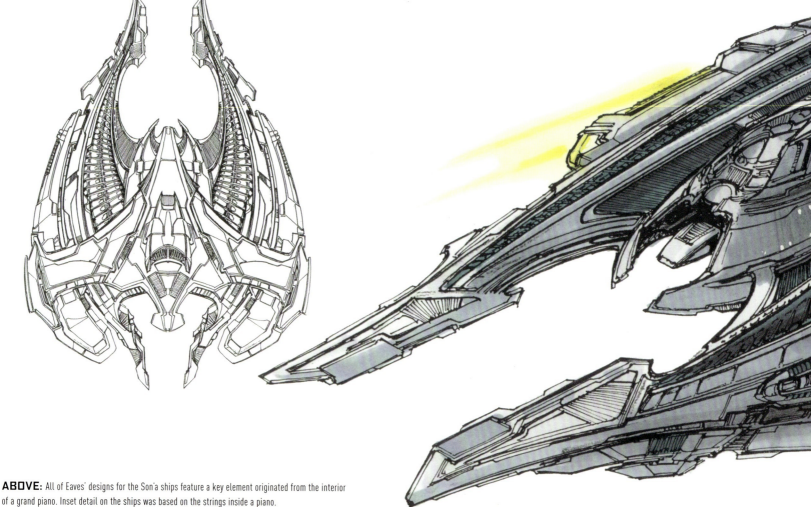

**ABOVE:** All of Eaves' designs for the Son'a ships feature a key element originated from the interior of a grand piano. Inset detail on the ships was based on the strings inside a piano.

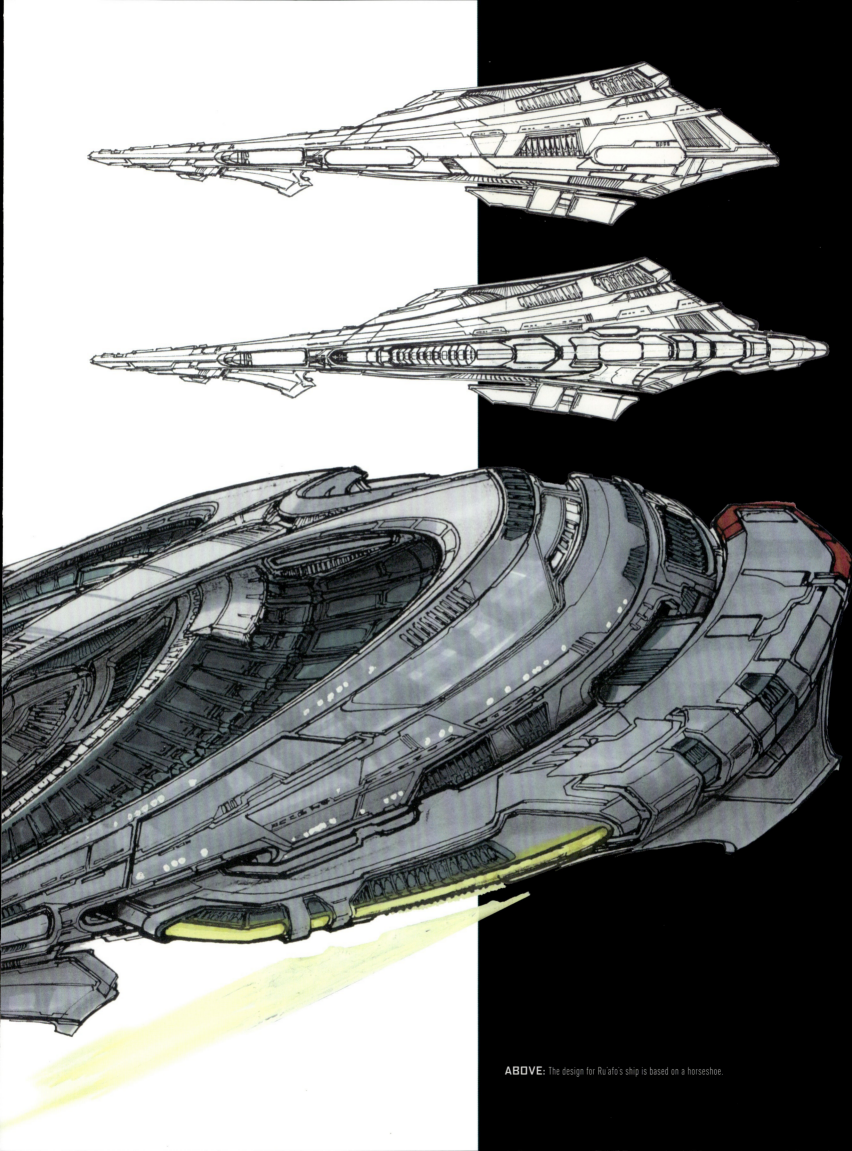

**ABOVE:** The design for Ru'afo's ship is based on a horseshoe.

# FEDERATION HOLOSHIP

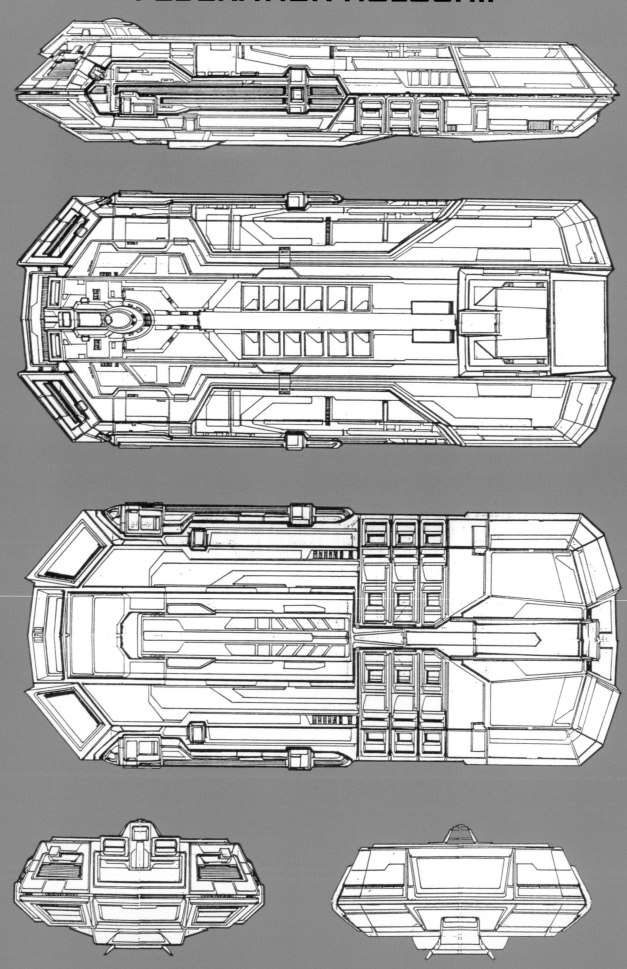

**ABOVE:** Eaves tried to carry a lot of the Federation shapes through the designes for the holoship, including the bevelled sides.

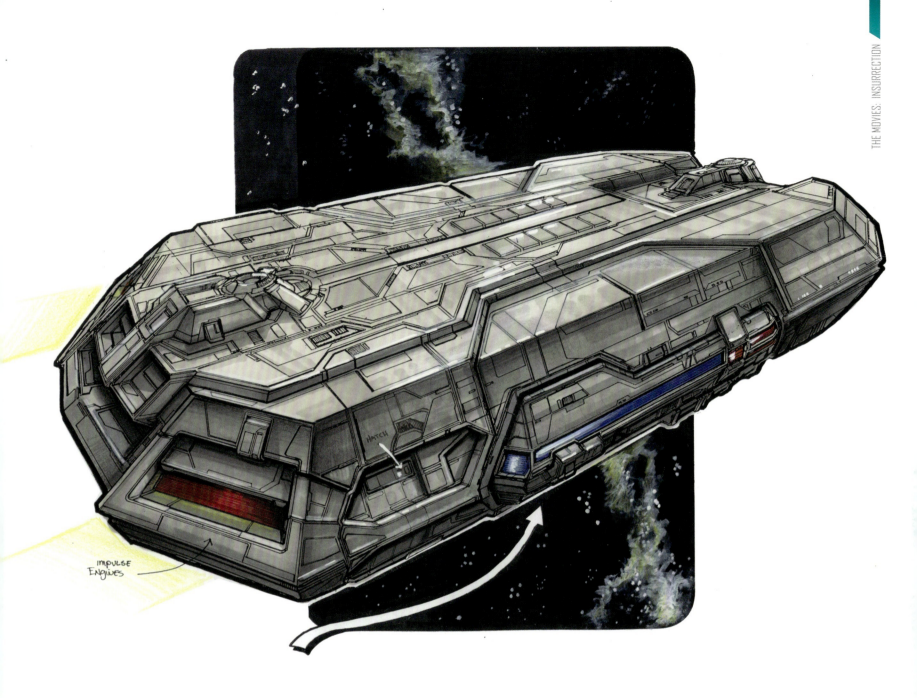

The Federation holoship was a frumpy freighter. We were going down a couple of different roads design-wise and Rick Berman said, "It's going to be invisible anyway; just make it a brick!" That's why it has the basic shape of a gigantic brick. I always find those designs a bit more challenging, when they give you a goofy, one-word description for a new ship, like a block or a brick and you have to figure out what you can do to *not* make it look like a brick. There was one version with curved sides that just didn't work at all, so we went back to the brick look.

**ABOVE:** The holoship went through a lot of changes during the early stages. Originally it was a traditional Federation design with the iconic saucer. As the design process continued, Eaves was asked to make the ship look more industrial and he took inspiration from the bulky shape of an oil tanker and cargo ships.

**BELOW:** A close-up of the bridge.

# STAR TREK NEMESIS
## ARGO SHUTTLE VEHICLES

### "EVERYTHING WAS GOING ON AT THE SAME TIME, SO WE WOULD DO WHAT WAS NEEDED."

For the past several films, Herman Zimmerman's art department was doing double duty. Most of us would spend half a day on the TV show (*Enterprise* in this case), and the other half on whatever film we were working on at the time. With *Nemesis*, Herman had his art director Louise Dorton run *Enterprise* while he oversaw the feature. Everything was going on at the same time, so we would do what was needed, whether it was props, sets or ship interiors.

The script called for an *Argo* shuttle truck, for example, so I bought a bunch of four-wheel-drive magazines to find somebody with a shop in southern California who built these things. We ended up using a Ford Pro Truck for the skeleton, and a local guy put a new fiberglass body over the framework for it. For the dune buggies, we found a couple of guys in San Diego who did the same thing. It worked out really well, because we could get three or four of the same vehicles and the new parts would fit on each vehicle.

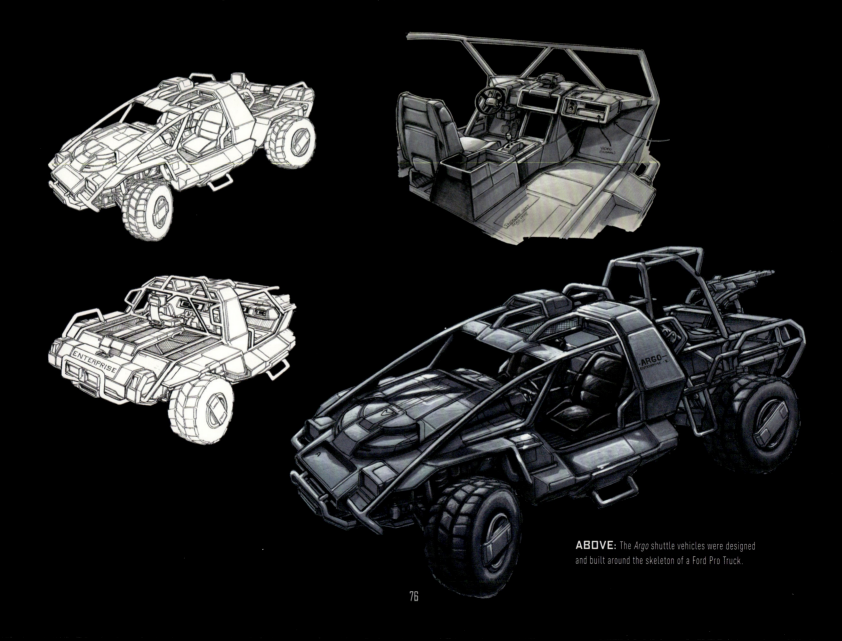

**ABOVE:** The *Argo* shuttle vehicles were designed and built around the skeleton of a Ford Pro Truck.

# ARGO SHUTTLE

With the *Argo* itself, I wanted to revisit the idea of using telescoping wings for atmospheric travel, which is an idea we had tried before, but it never really worked. At some point I went to see the *USS Midway* in San Diego, which had a lower deck full of World War II aircraft, including a Corsair. I thought, "Why don't we just add hinged wings to the shuttle that come down for atmospheric travel? That way, it doesn't interfere with the shuttle interior, and it solves the visual effects problem, because it's just a giant hinge." Herman and the producers really liked that idea, which resolved all of our problems at once.

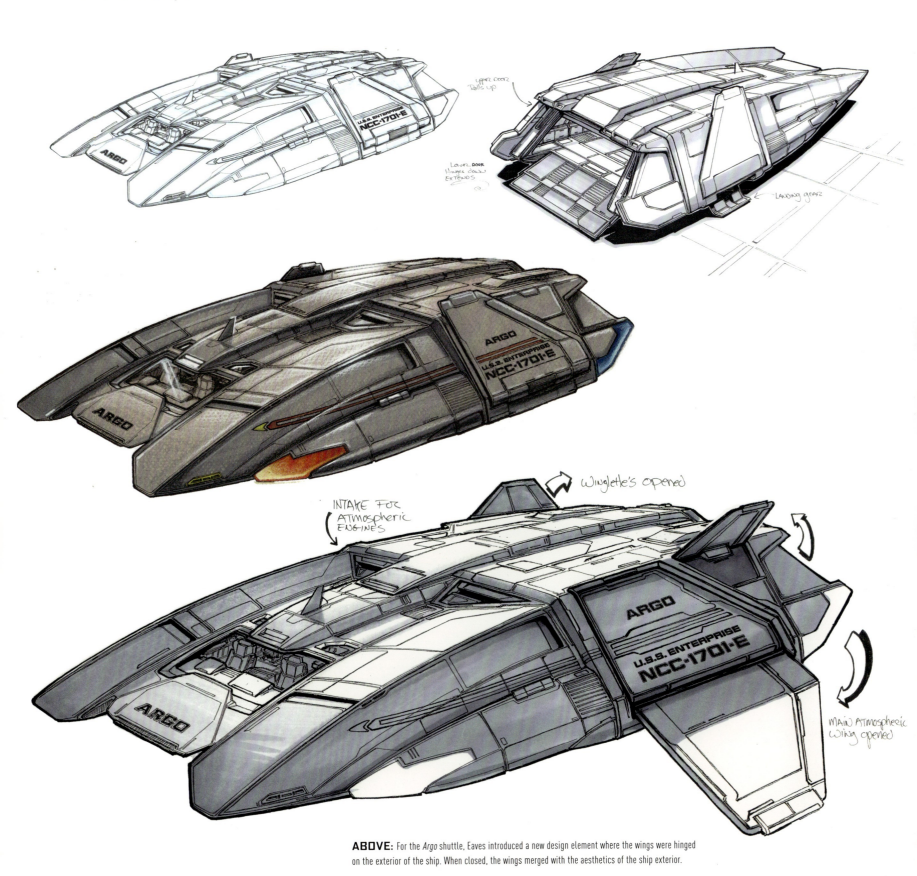

**ABOVE:** For the *Argo* shuttle, Eaves introduced a new design element where the wings were hinged on the exterior of the ship. When closed, the wings merged with the aesthetics of the ship exterior.

# U.S.S. ENTERPRISE-E

The original *Enterprise* drawing was designed for forward attack and defense, but when we got to *Nemesis* there was a scene where the *Scimitar* attacks from different vantage points, which meant there were a lot of blind spots on the ship that didn't have weapons coverage, so we added a bunch of rear-facing weaponry that didn't exist in previous films, including phaser strips added to the struts, and rear-facing torpedo launchers. We also did a beautiful sweep on the top of the ship where the upper shuttlebay is, which was right below the saucer and where the hull begins.

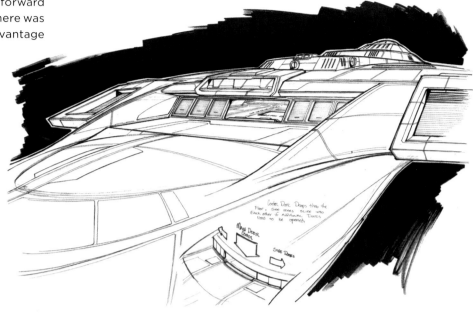

**BELOW:** Blueprints of the *Enterprise*.

**ABOVE:** Details of the shuttlebay and the main door opening system.

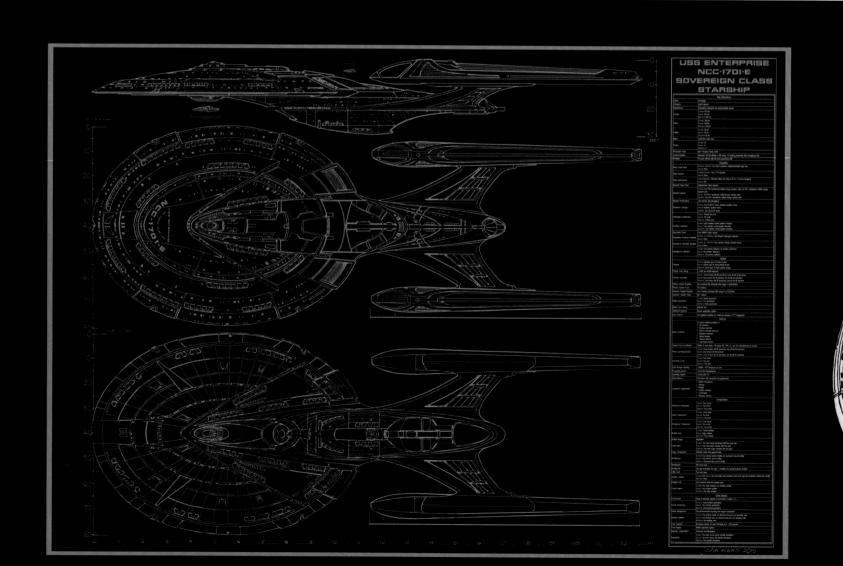

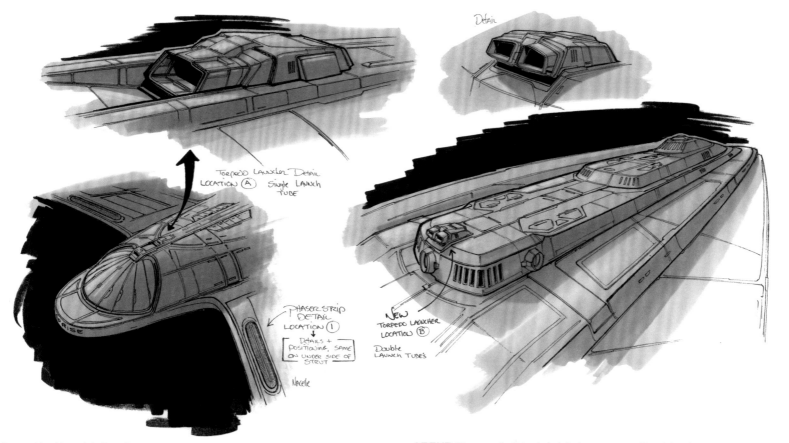

**BELOW:** Framework breakdown of the *Enterprise*.

**ABOVE:** Weapons on the *Enterprise* include phaser cannons and torpedo launchers.

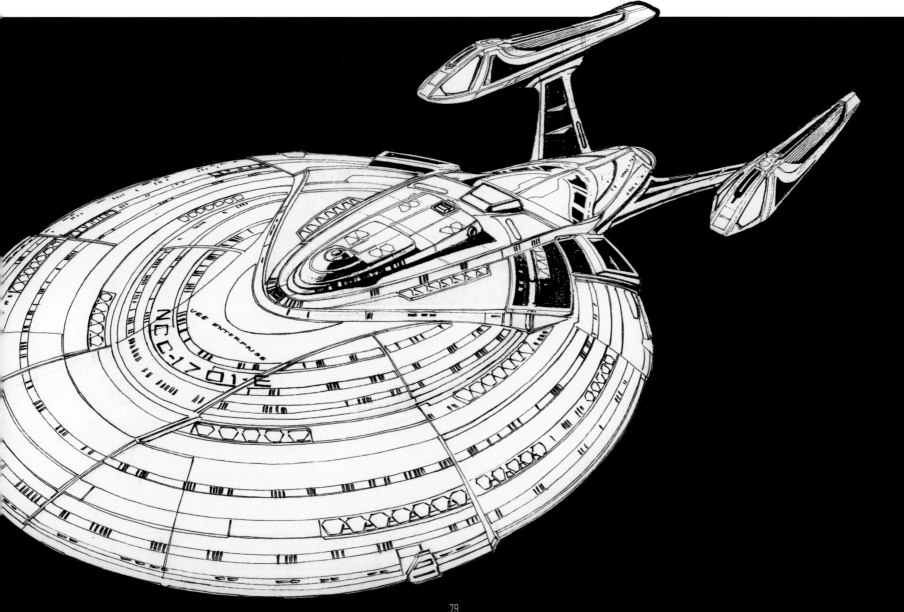

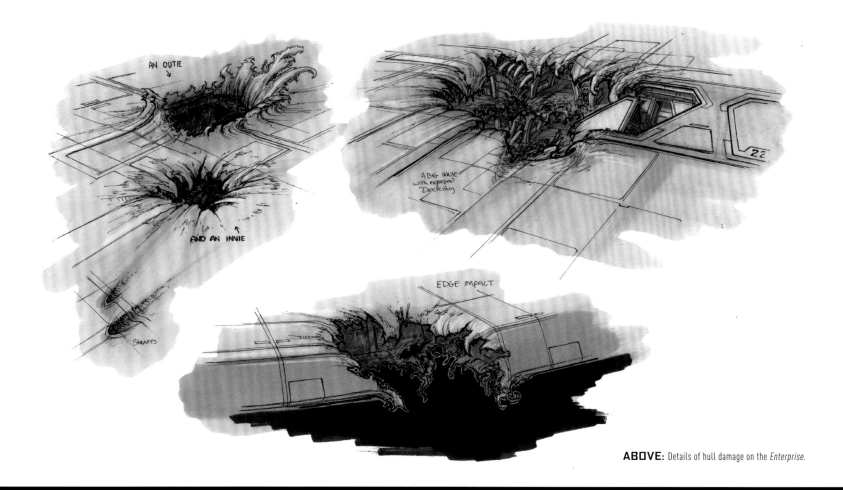

**ABOVE:** Details of hull damage on the *Enterprise*.

**BELOW:** Concept art showing battle damage to the front of the *Enterprise*.

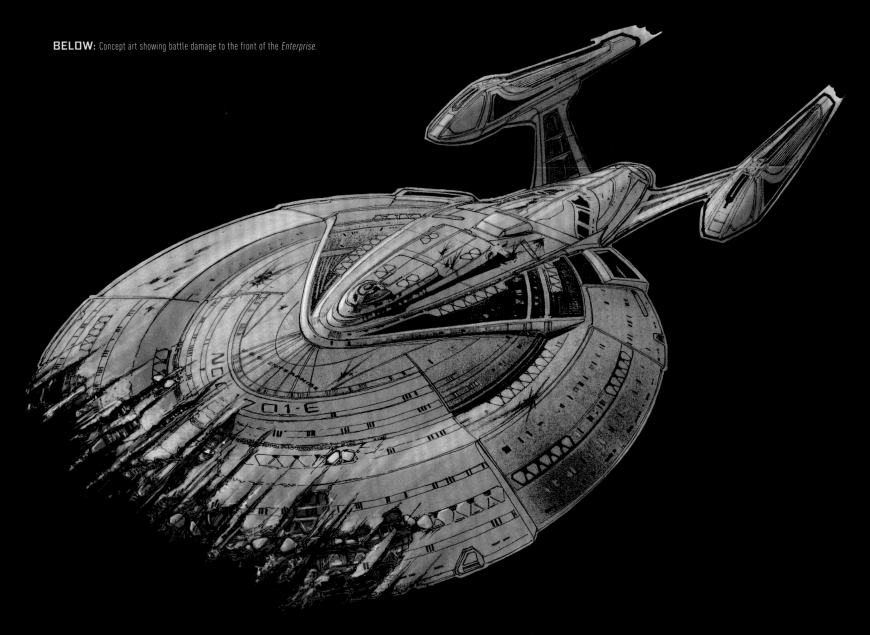

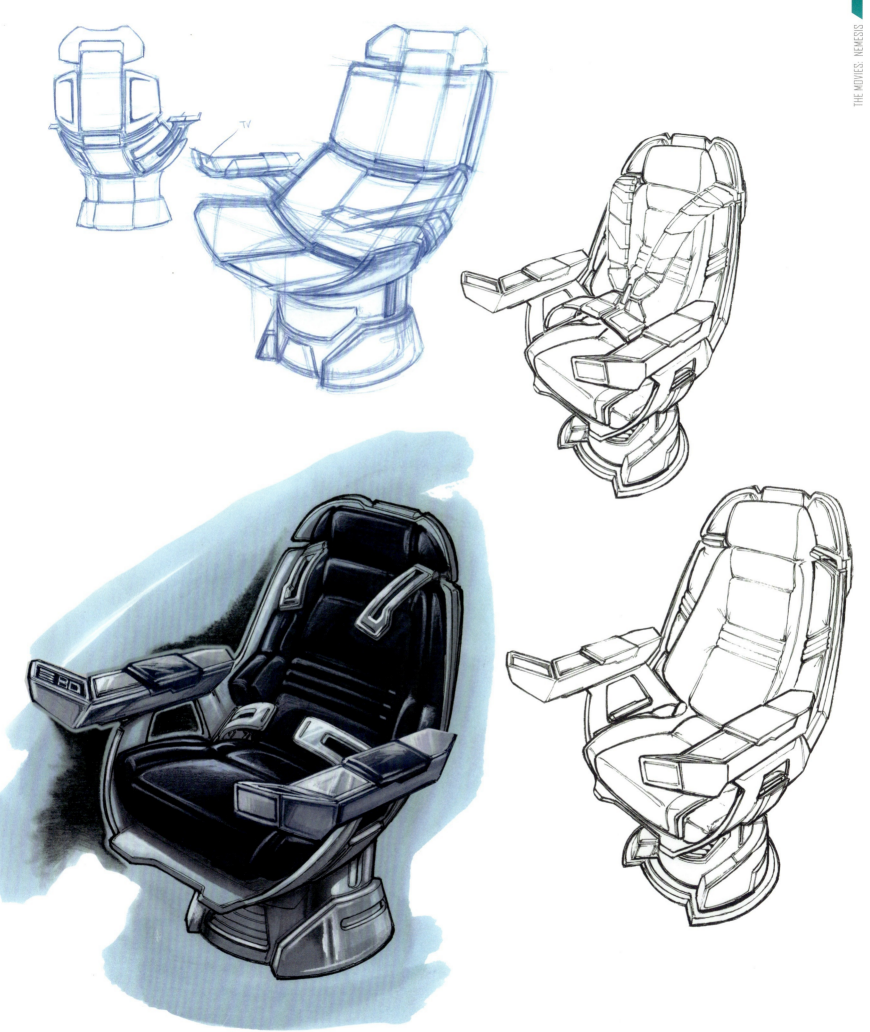

**ABOVE:** Eaves' designs for the captain's chair with seat belt straps.

**THIS PAGE:** Concept art of the *Enterprise* in flight.

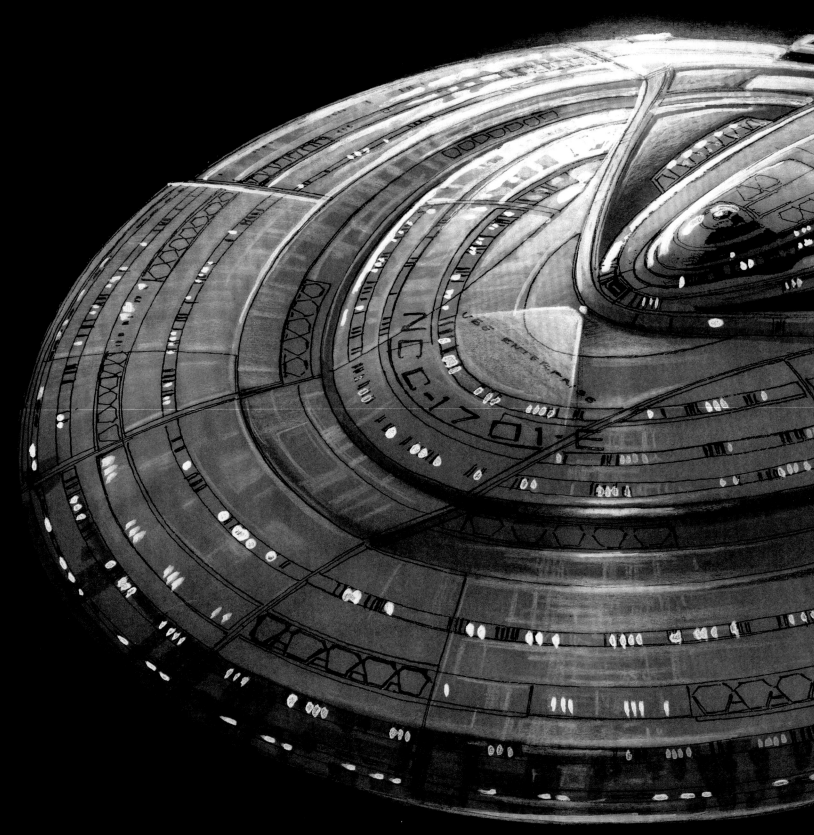

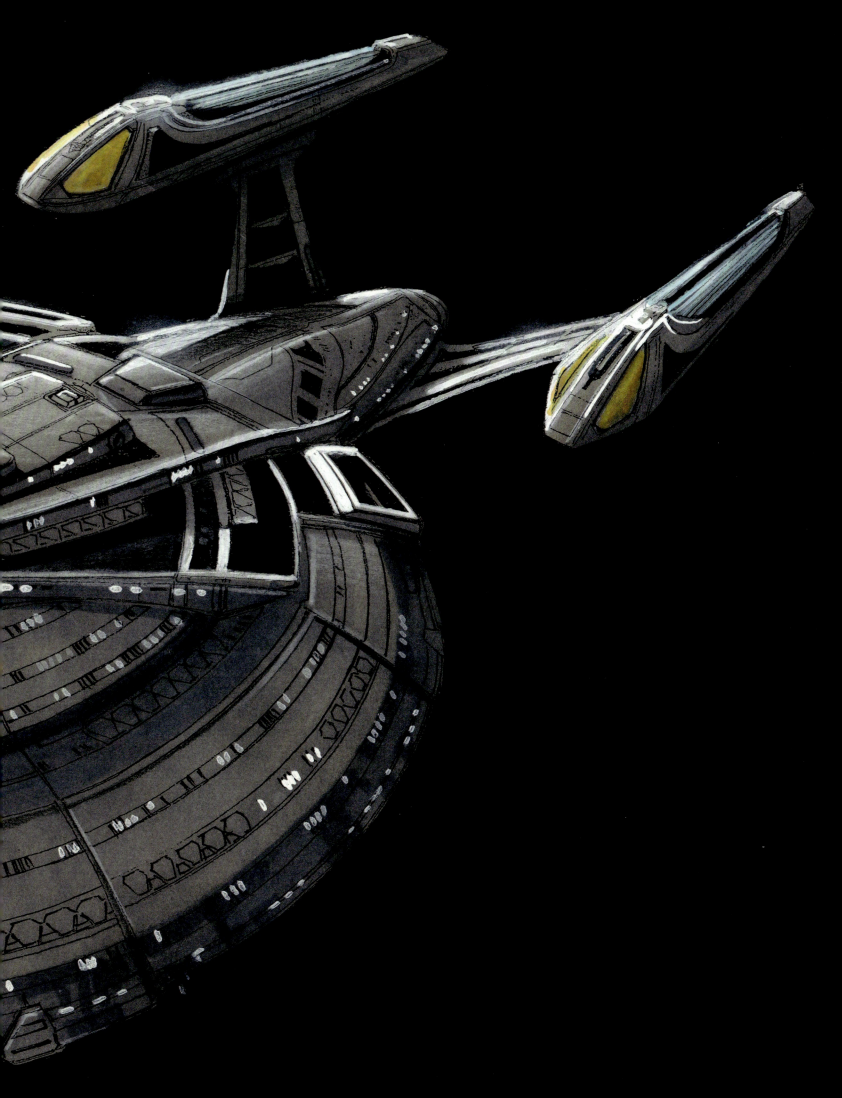

# SCIMITAR

Screenwriter John Logan provided the inspiration for the *Scimitar*. He can describe a visual in just five or six words, and his description was a gigantic black predator that had the look of a spider ready to strike. When we started doing the sketches, Herman said, "Let's do something we haven't seen before!" so we started with ships that looked like capsules with the wings folded up, but when we presented those sketches to Berman and Braga they said, "Let's see a little more wing structure to it."

*Nemesis* was the movie where I figured out that Rick Berman's favorite ship was a bird-of-prey. He thought it was the angry, aggressive-looking ship that was perfect for a serious major bad guy. We tried some new designs for the *Scimitar*, but we eventually came back to the bird-of-prey look.

In this case it also made sense to add some Romulan and Klingon architecture, because they shared that bird-of-prey in *Star Trek III*. The bird-of-prey was originally supposed to be Romulan, as it was in the original TV series, which is where you always had the bird-of-prey, but in *Star Trek III* they changed the Romulans to Klingons and turned the bird-of-prey into a Klingon ship. They created a whole backstory where the Klingons either stole the ship from the Romulans or did some kind of stolen technology trade, so all of that was created to explain how the Romulan bird-of-prey became a Klingon ship.

The big feature in this film was the wings opening up. I come from a miniatures background, but we were now in the CG world, which really opened things up as far as how the wings would work. I worked with Rory McLeish at Digital Domain, so we would go back and forth as he told me what I could achieve. Herman would drop his notes in too, so we had this giant three-way conversation going on about how we could make the ship do what it needed to do.

**BELOW:** As the design developed, Eaves experimented with the wings "spidering out" around the ship.

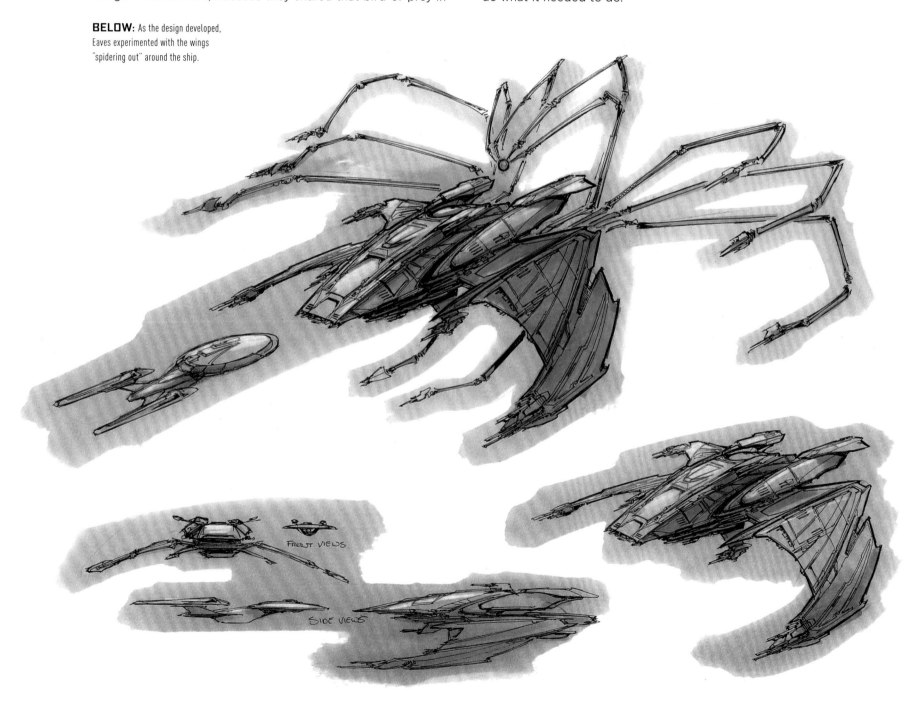

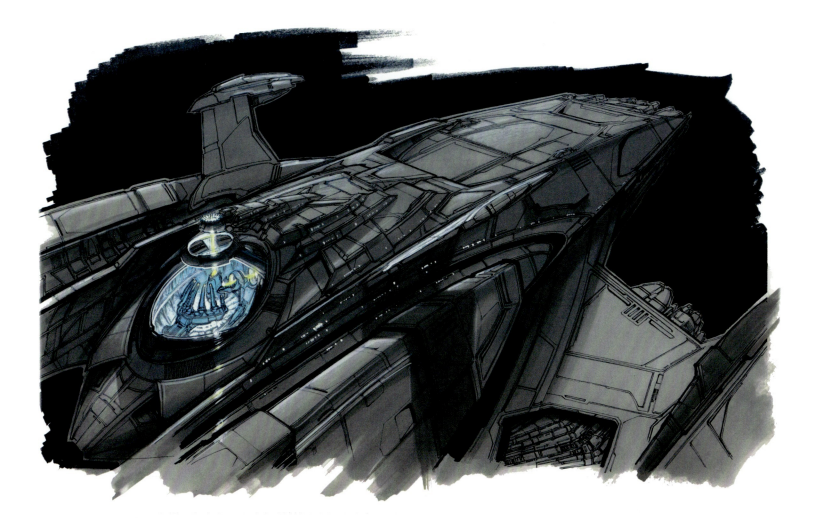

**ABOVE:** Close-up details of the bomb activation device.

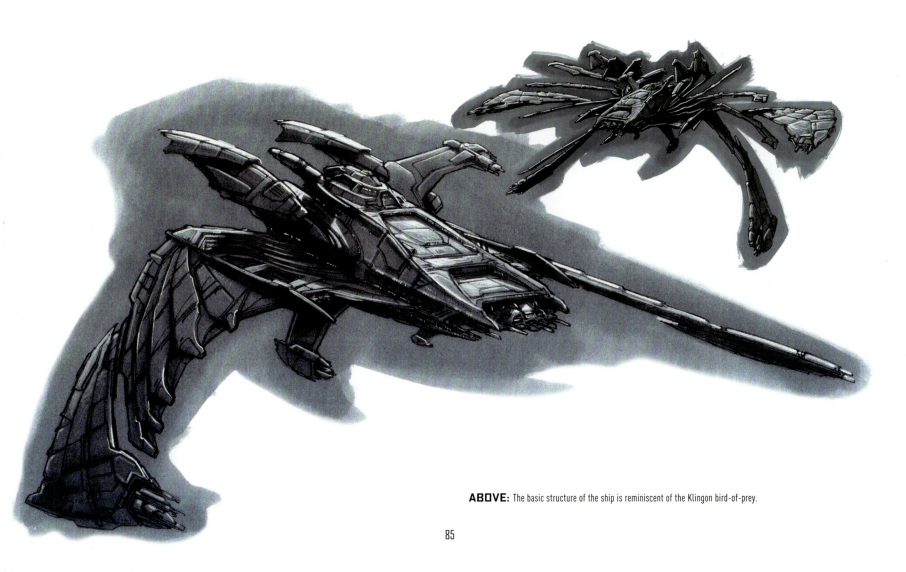

**ABOVE:** The basic structure of the ship is reminiscent of the Klingon bird-of-prey.

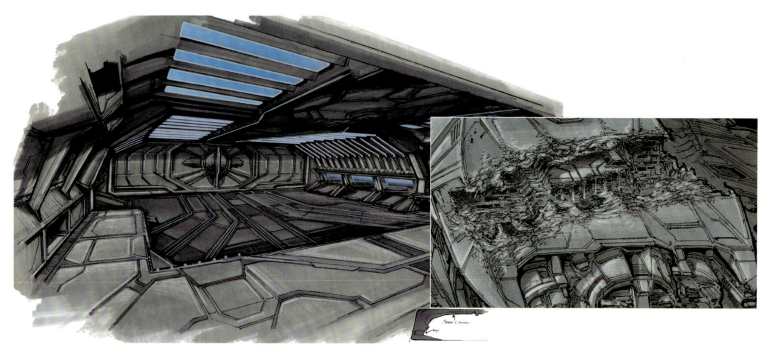

**ABOVE:** Interior of the shuttlebay, from the back looking forward.

**ABOVE:** Overview of damage sustained from the *Enterprise*.

We also went with a darker tone for the *Scimitar*. Herman and the set designers came up with a color palette for the interiors, and I took those colors and applied them to the exterior as well. The ship had a dark bluish metal chrome look, which added a really nice texture to the exterior. Rory added a gigantic nose section for the weaponry up front, so it was a neat collaboration.

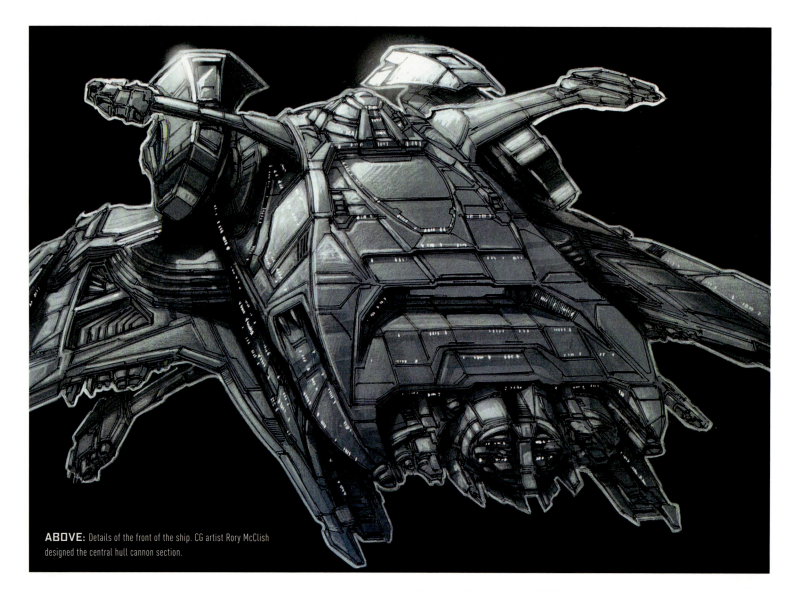

**ABOVE:** Details of the front of the ship. CG artist Rory McClish designed the central hull cannon section.

# SCIMITAR THALARON DEVICE

There were two design phases for the thalaron radiation release. In my initial drawings a little door opens up, exposing the thalaron device, but as the story progressed it was all focused in the wing tips, as opposed to a hatch. Once we got to that point, one of the effects supervisors came in and said, "We need one more little 'Oomph' to really sell this idea!" I suggested when the wing tips open up, some little focusing devices or charging weapons come out. Digital Domain animated the device as a blade coming out and opening up like a spider. They also added a neat little extra element where this little sideways focusing ring rotates into position just before it gets ready to fire. Even though you never see it fire, it looks like it's ready to annihilate everything.

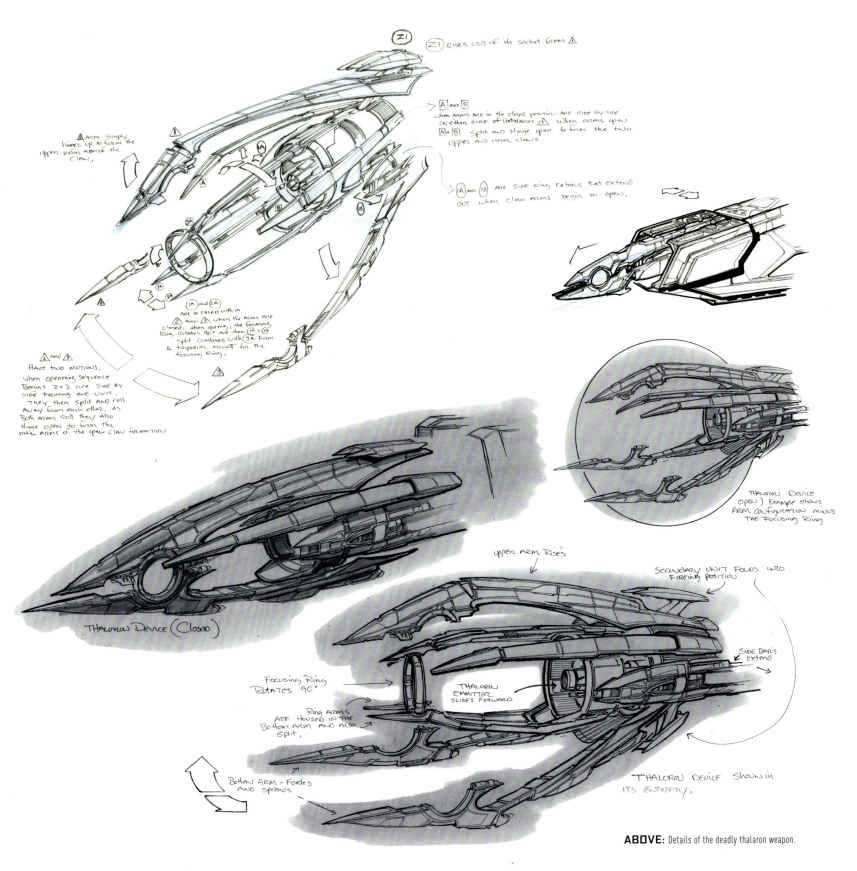

**ABOVE:** Details of the deadly thalaron weapon.

# VALDORE

**W**ith the *Valdore*, I was wondering how I could make the ship look like a bird-of-prey but *not* a bird-of-prey, so I bought a big book on predatory birds for ideas. I also looked at Andy Probert's Romulan ship from *The Next Generation*, which had a bird 'beak' on the front, and thought I would try to incorporate that idea as well.

When I leafed through the book, I could see where Nilo Rodis-Jamero got his feather reference for the original bird-of-prey, and I ended up changing my design so it didn't look as though I had ripped him off. I was also fascinated by biplanes, so I thought I would add an underwing beneath the main wing, which would create a bit of separation. I wanted something that would break up the design a bit, and that underwing detail did the trick.

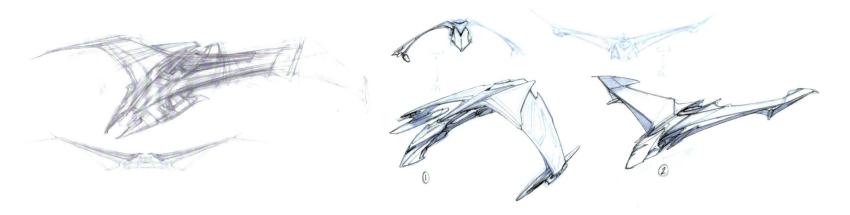

**ABOVE:** Early concepts for the *Valdore* experimented with the wing structure.

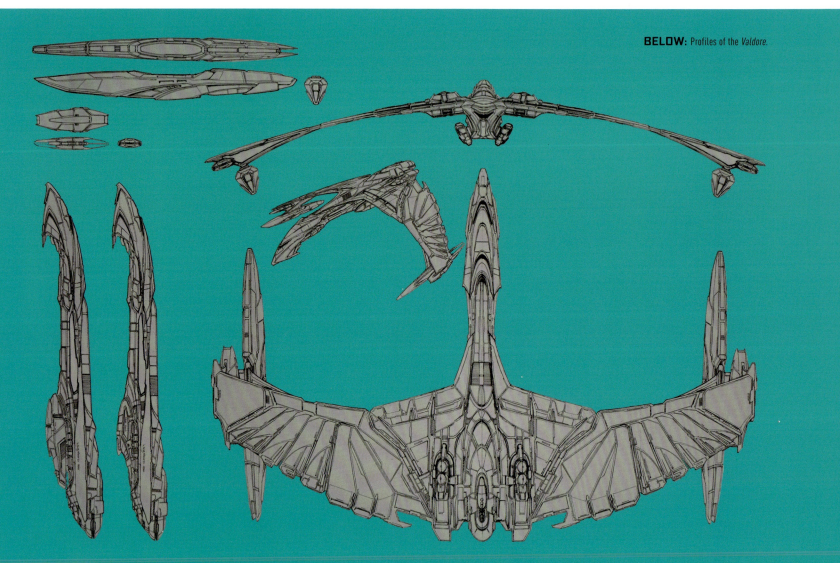

**BELOW:** Profiles of the *Valdore*.

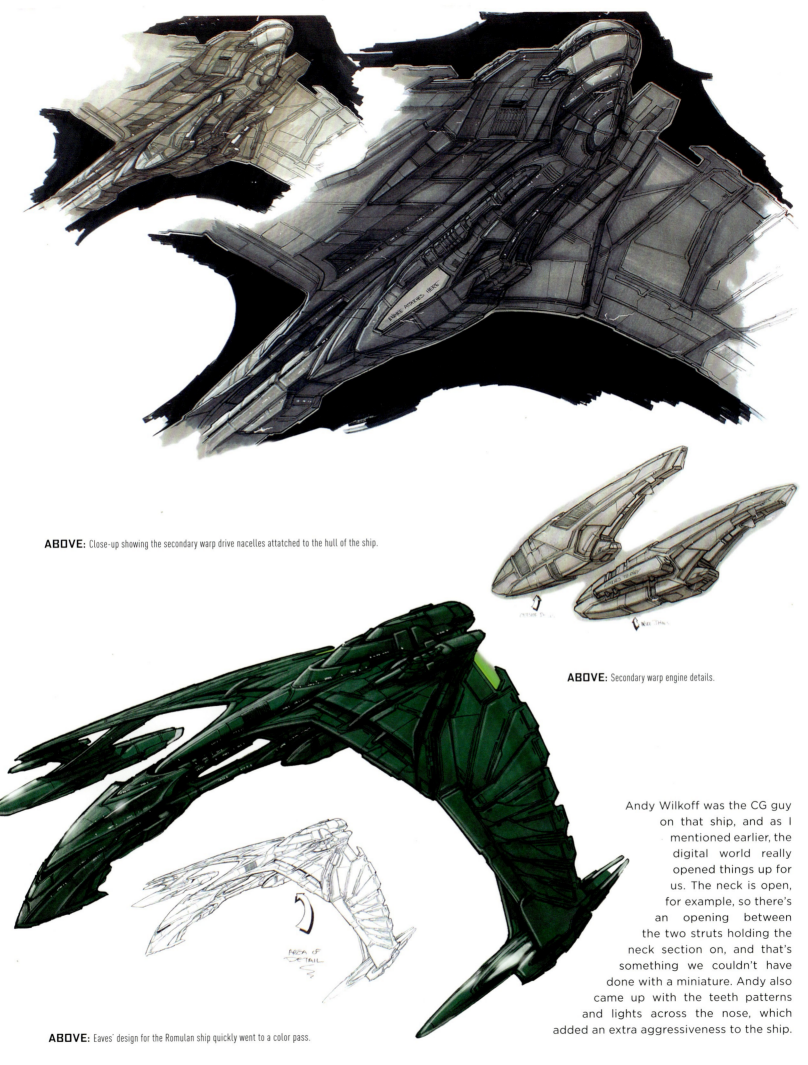

**ABOVE:** Close-up showing the secondary warp drive nacelles attatched to the hull of the ship.

**ABOVE:** Secondary warp engine details.

**ABOVE:** Eaves' design for the Romulan ship quickly went to a color pass.

Andy Wilkoff was the CG guy on that ship, and as I mentioned earlier, the digital world really opened things up for us. The neck is open, for example, so there's an opening between the two struts holding the neck section on, and that's something we couldn't have done with a miniature. Andy also came up with the teeth patterns and lights across the nose, which added an extra aggressiveness to the ship.

# SCORPION ATTACK FIGHTERS

For the *Scorpion* attack fighters, I was walking across the lot one day and they were filming an episode of *JAG* on the back lot. Next to the dumpsters were these F-18 canopies sitting on the ground, so I found one of the *JAG* guys and asked if they were getting rid of them. I showed the canopies to Herman and said, "How about if we use them for the *Scorpion* fighters?" If you've ever seen an F-18, we flipped the back canopy and used it for the *Scorpion*'s front window.

Bill Skinner was in charge of building the full-size *Argo* and the *Scorpion*, and he knew you could buy pre-curved wood (which I didn't even know existed) and I did a redesign so the wings would match this curved wood and everything was correlated together with the canopy on the top. The fighter originally had a different color—it was a weird blue-purple on the Friday night. When we came back to work Monday morning (they spent the entire weekend repainting it), it was black. I think it looked a bit too Batman-like at that point, but it all worked out.

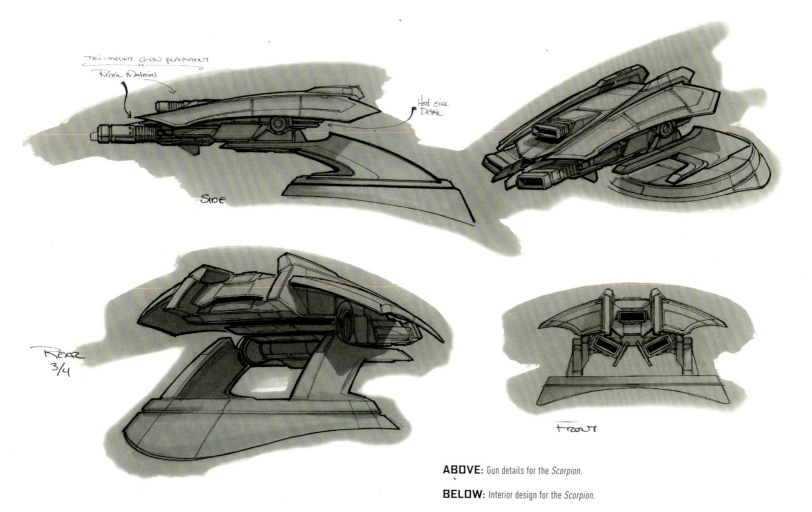

**ABOVE:** Gun details for the *Scorpion*.

**BELOW:** Interior design for the *Scorpion*.

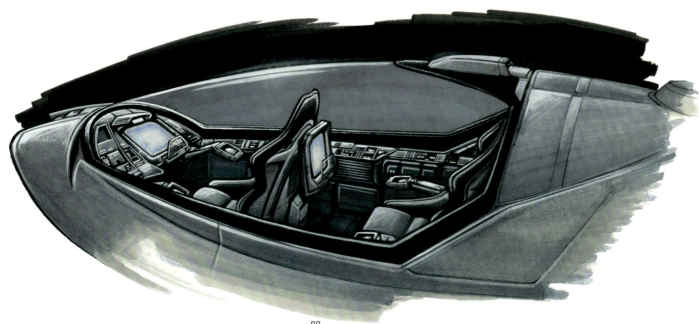

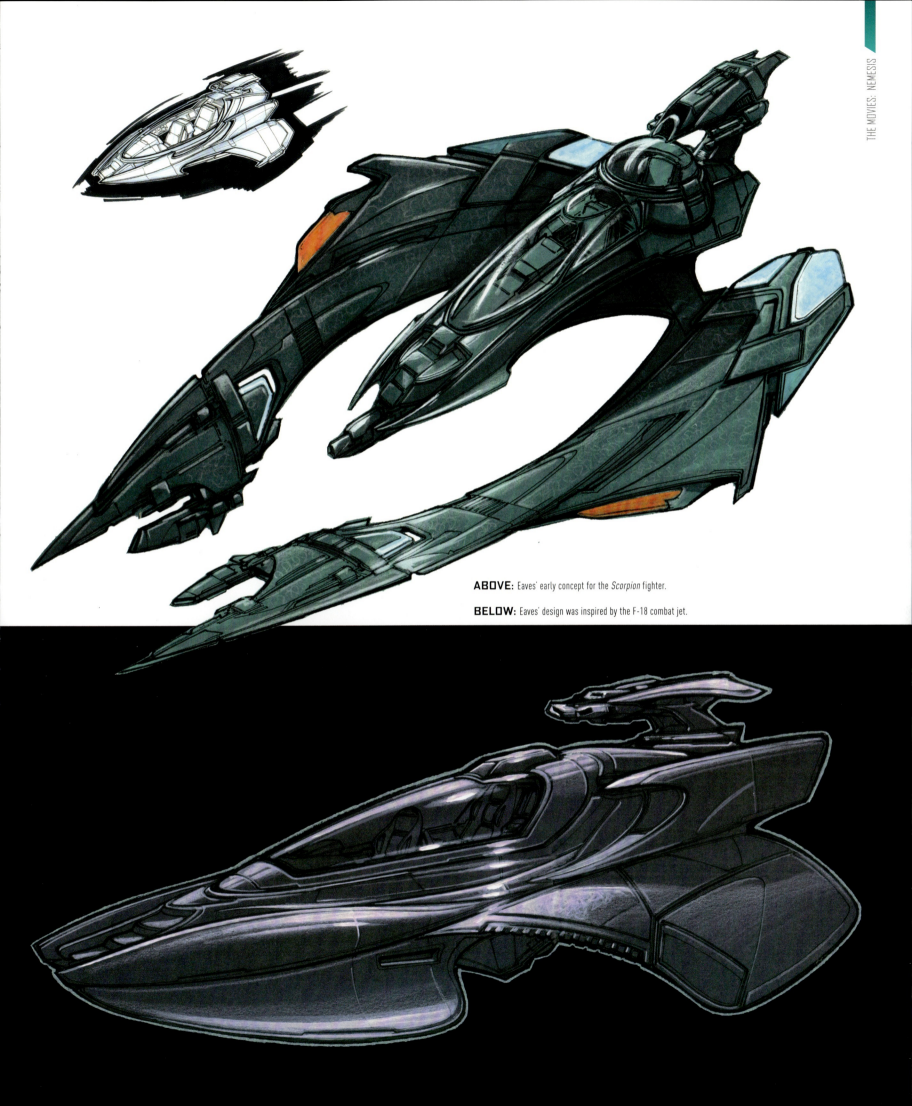

**ABOVE:** Eaves' early concept for the *Scorpion* fighter.

**BELOW:** Eaves' design was inspired by the F-18 combat jet.

# SPACE DOCK

The space dock that ends the film had been seen many times between the films and TV shows, and I always thought it looked a bit boxy. When I drew the *Enterprise-E* in that scenario, it had so much space above and below it, I suggested to Herman that we could design a new space dock that conformed more to the ships they were working on, so I did a more streamlined version that everybody liked.

There was originally a spine-like structure across the top that was very dense and heavy, but I thought it would be more interesting from a visual effects standpoint if they panned across the top and we were able to see what was inside as opposed to that structure on top, so we thinned that out. I added an umbilical that hooks to the ship for supplies, so you have this constant connection between the two instead of everything having to be carried back and forth. You could show the inside as well, so we did this umbilical that locked into the back of the shuttlebay.

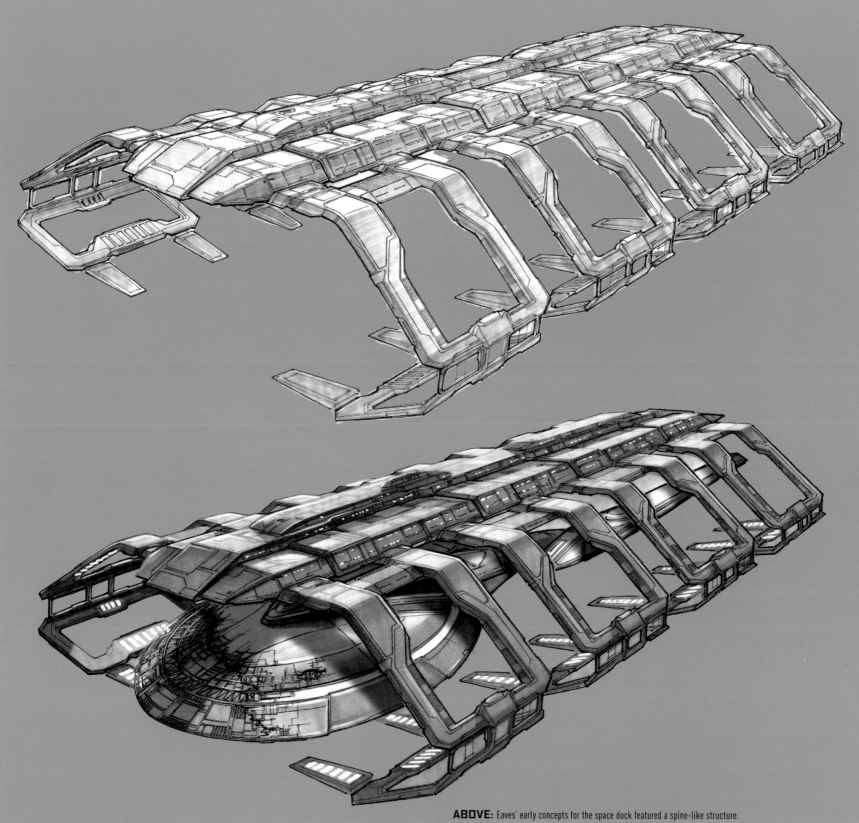

**ABOVE:** Eaves' early concepts for the space dock featured a spine-like structure.

**BELOW:** Details of the the dock coupling system.

Connects to "E" Saucer Shuttle Bay

Connects to Dry Dock

**LEFT:** A variety of "worker bees" in homage to Andy Probert's designs from *The Motion Picture*.

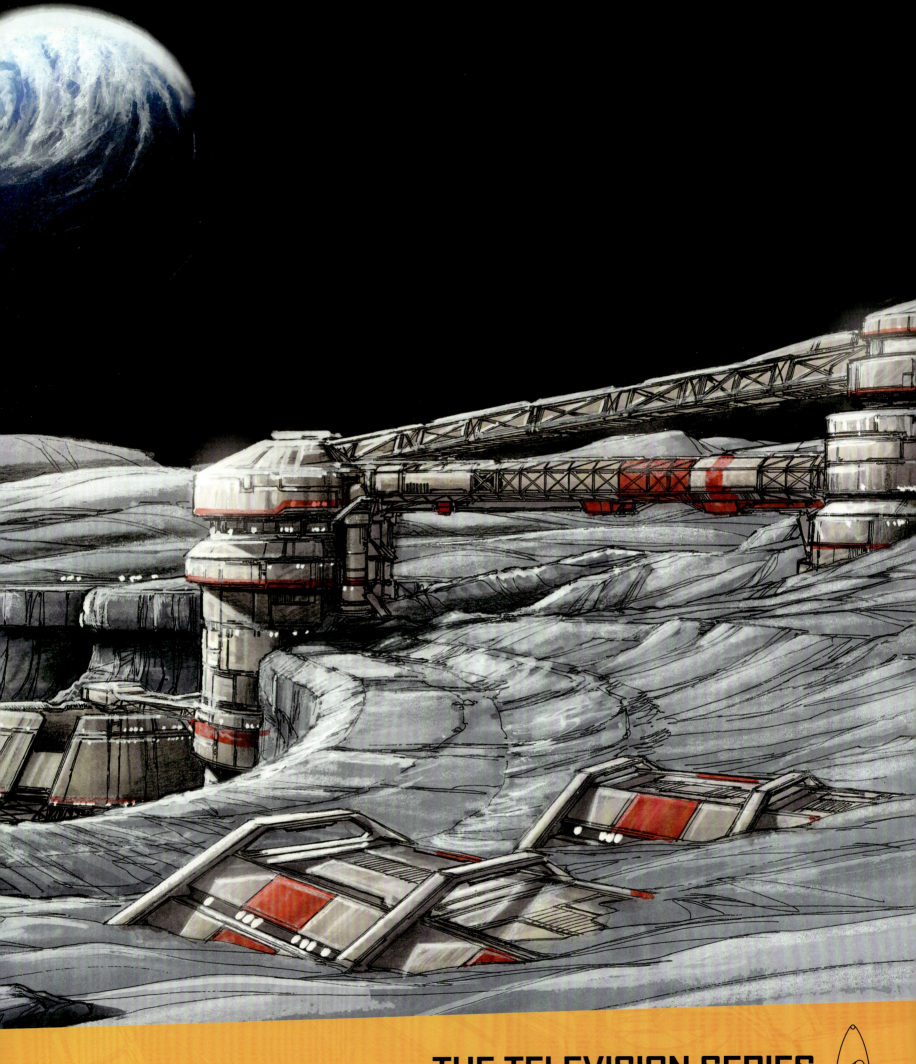

**THE TELEVISION SERIES**

# THE TELEVISION SERIES:
## DEEP SPACE NINE

### "OVER THE NEXT DECADE, WE WOULD BECOME A FAMILY."

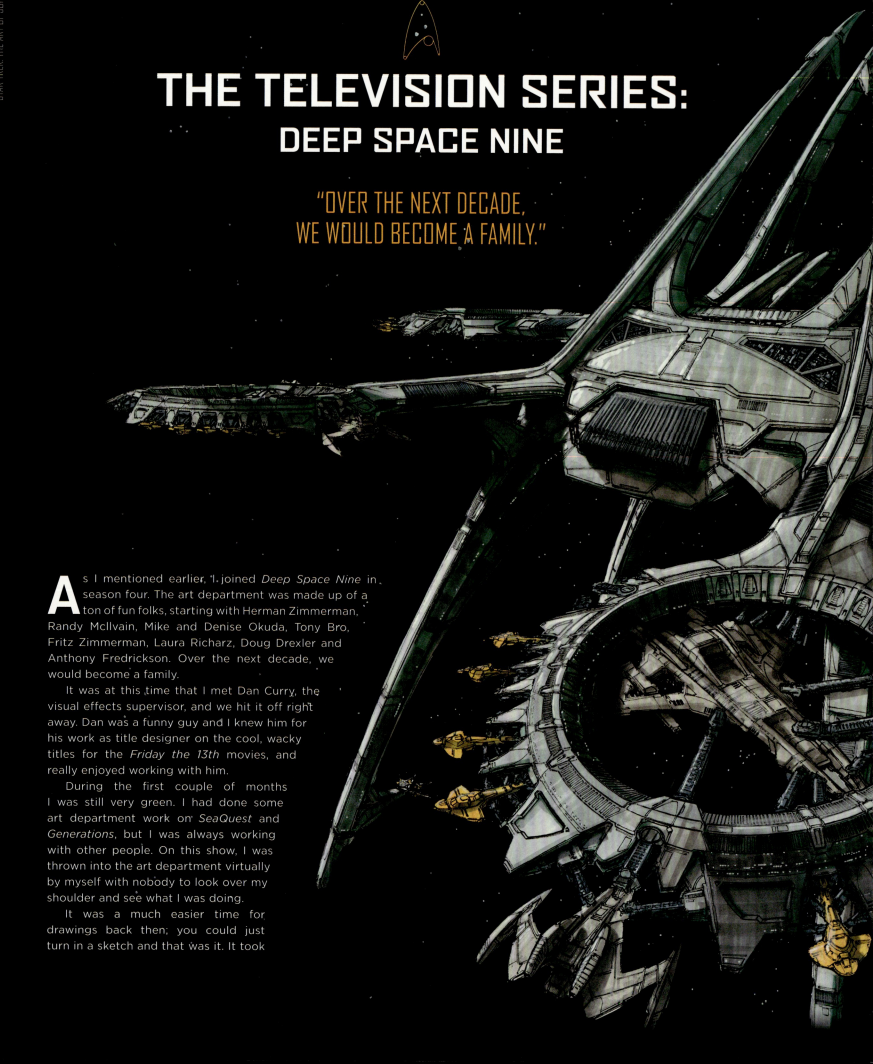

As I mentioned earlier, I joined *Deep Space Nine* in season four. The art department was made up of a ton of fun folks, starting with Herman Zimmerman, Randy McIlvain, Mike and Denise Okuda, Tony Bro, Fritz Zimmerman, Laura Richarz, Doug Drexler and Anthony Fredrickson. Over the next decade, we would become a family.

It was at this time that I met Dan Curry, the visual effects supervisor, and we hit it off right away. Dan was a funny guy and I knew him for his work as title designer on the cool, wacky titles for the *Friday the 13th* movies, and really enjoyed working with him.

During the first couple of months I was still very green. I had done some art department work on *SeaQuest* and *Generations*, but I was always working with other people. On this show, I was thrown into the art department virtually by myself with nobody to look over my shoulder and see what I was doing.

It was a much easier time for drawings back then; you could just turn in a sketch and that was it. It took

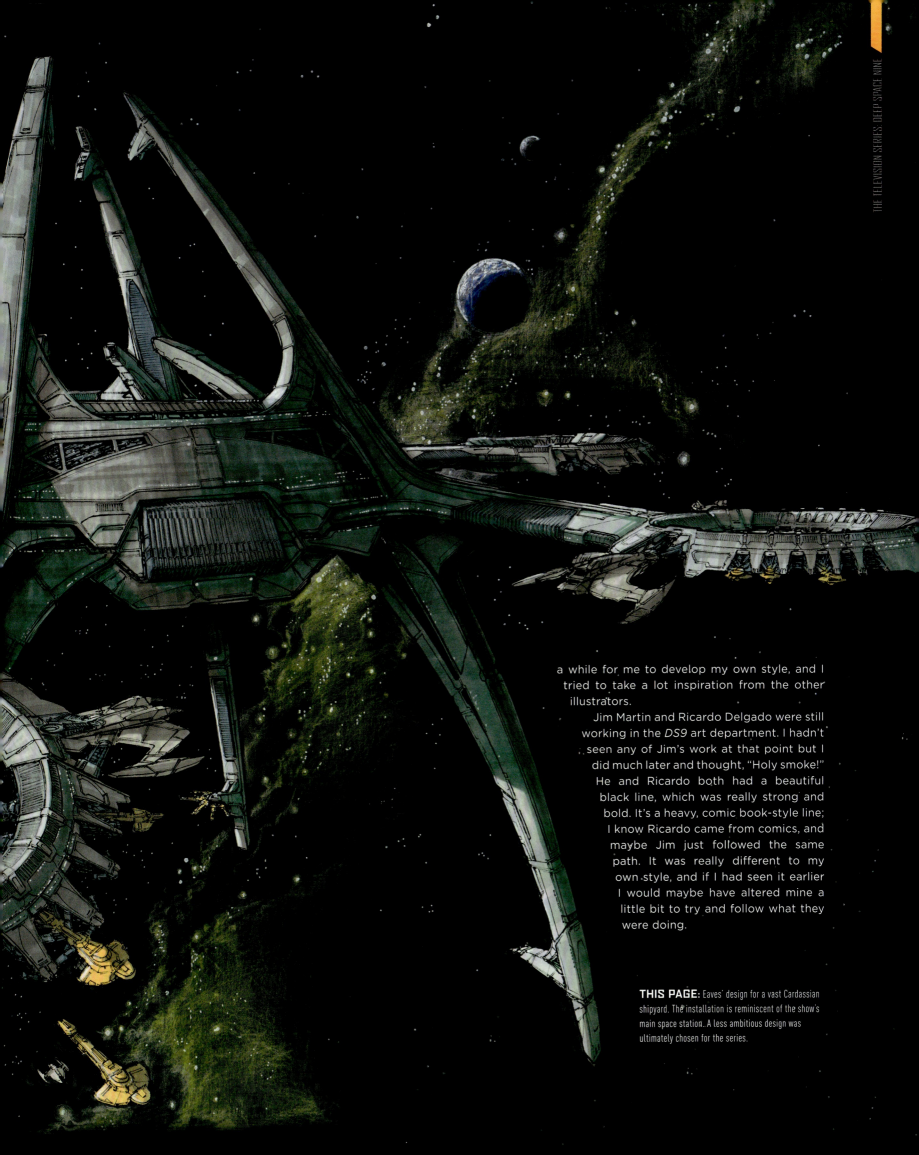

a while for me to develop my own style, and I tried to take a lot inspiration from the other illustrators.

Jim Martin and Ricardo Delgado were still working in the *DS9* art department. I hadn't seen any of Jim's work at that point but I did much later and thought, "Holy smoke!" He and Ricardo both had a beautiful black line, which was really strong and bold. It's a heavy, comic book-style line; I know Ricardo came from comics, and maybe Jim just followed the same path. It was really different to my own style, and if I had seen it earlier I would maybe have altered mine a little bit to try and follow what they were doing.

**THIS PAGE:** Eaves' design for a vast Cardassian shipyard. The installation is reminiscent of the show's main space station. A less ambitious design was ultimately chosen for the series.

# DEEP SPACE 9 SPACE STATION

We had a very big first season-opener episode called 'The Way of the Warrior,' in which we had to beef up the space station. It wasn't defenseless, but there wasn't a lot of exterior weaponry, and they were expecting a Dominion invasion, so my first job was to help re-armor the station with new Starfleet weaponry.

As the model of *DS9* had already been built and several effects sequences had been shot already, there was no question of altering the station. Thankfully Mike Okuda knew all the technical layout of the station, so I'd look at his drawings and go, "What about putting a weapon there and there." This meant that I could find ways of revealing more weapons that were normally concealed in the structure. I decided that most of the weapons would either pop out of the structure or emerge from behind hatches.

The VFX team also gave me a lot of guidance. They didn't want me to add too many elements as it would take a lot of work to have all those weapons firing at the same time.

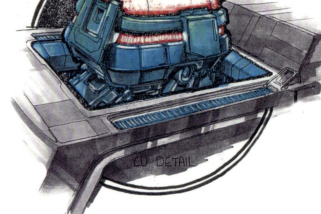

**ABOVE:** For the top of the docking pylons, Eaves added a pop-out section with a phaser.

**LEFT:** Eaves upgraded the defence sails, adding a cylindrical unit that popped out of the side. The VFX team completed the finished version, which rotated and shot bursts of phaser fire in different directions.

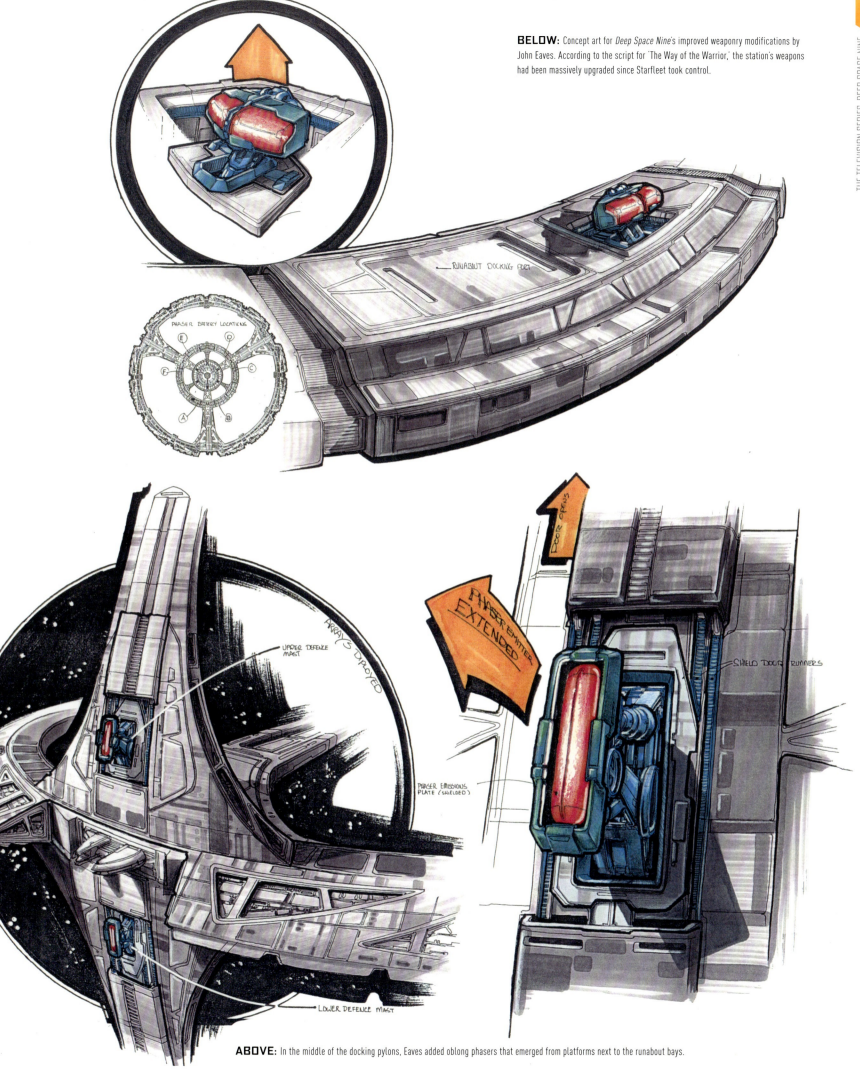

**BELOW:** Concept art for *Deep Space Nine*'s improved weaponry modifications by John Eaves. According to the script for 'The Way of the Warrior,' the station's weapons had been massively upgraded since Starfleet took control.

**ABOVE:** In the middle of the docking pylons, Eaves added oblong phasers that emerged from platforms next to the runabout bays.

# BAJORAN AND CARDASSIAN

When Herman brought me in, he said, "This is a very prop-heavy show, so you'll be working a lot with Joe Longo the prop master and Laura Richarz the set decorator. As we get other scripts in, we'll probably have other things to do like set interiors, but only rarely will we have spaceships because they're so expensive to do."

*Deep Space Nine* was completely new to me and I didn't know anything about Cardassians or Bajorans, so Mike Okuda had to give me a quick rundown of the station and the main species. He gave me a copy of the *Star Trek Encyclopedia* and I would look at that encyclopedia by the hour for the first several months I was in the art department. If I had to design a Cardassian tricorder, I would look up that species and think, "They've got those great sweeping half-curves, so I'll incorporate those lines into my drawings."

A lot of props could be drawn generically and easily adapted for different races and species. If it was a ceremonial staff with an incense burner on top you could just draw what you thought it would look like and then add the Cardassian details to it.

Looking back, everybody was beyond gracious. Not knowing an awful lot at the time, they put a lot of faith in me. Even though I didn't know what I was doing, they were patient and never criticized anything. My game got better as time went by, but in retrospect, Herman, Mike and those guys really gave me a huge opportunity. I probably didn't think too seriously about it at the time.

In one of the first conversations I had with Mike, we went

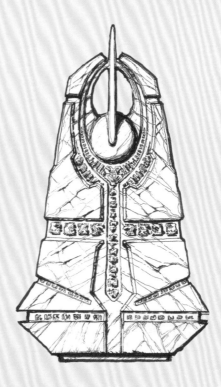
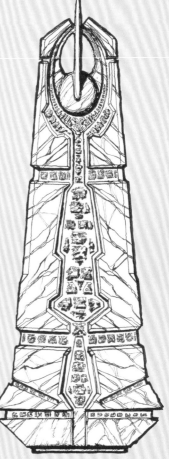

**BELOW:** Concepts for Bajoran obelisks from the episode 'The Rapture.' All ancient Bajoran cities were built with a *Bantaca* spire at its center. The spire marked the city's position in the cosmos, and there were symbols on its sides which represented the city's coordinates.

**BELOW:** Early concept art for the paitning of the lost city of B'hala. The painting shows the ancient city's *Bantaca* spire.

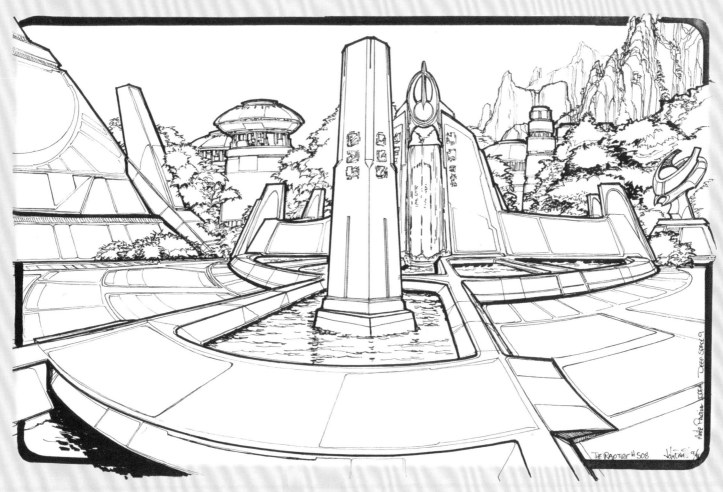

**ABOVE:** Concept art for an archaeological dig on Bajor.

back to what *Deep Space Nine* was supposed to be, which was a haunted space station originally run by the Cardassians that Starfleet eventually took over. Mike told me the Cardassians and Bajorans were very religious groups who followed spiritual leaders, so everything has a church-like feel to it.

What I did was harken back to a lot of Catholic designs for things, because they were really big with ornamentation and the way they sculpted the outside of their churches. When you look at furniture in a Catholic church, it's very ornate, with a lot of thought going into it, and you'll see little biblical/Christian storytelling going on in the filigree. I thought that was pretty cool, so I tried to do the same thing with the Bajoran and Cardassian props, where I tried to put in little swirly and curvy filigree into the background. It was supposed to be more ornate than functional, so everything had a really artistic look to it.

Mike Okuda was also the guy who helped establish each alien race with a symbol of some kind that captured their aesthetic. He was very quick about getting those little symbols

**ABOVE:** Concept for an excavated door in the city of B'hala.

**ABOVE:** The discovery of an ancient Bajoran tablet buried under the holy city of B'hala announces the Reckoning, the time when the future of Bajor will be decided.

101

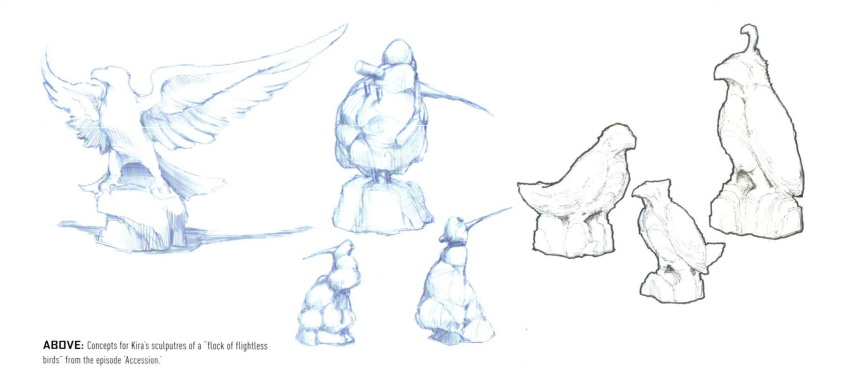

**ABOVE:** Concepts for Kira's sculputres of a "flock of flightless birds" from the episode 'Accession.'

out, and sometimes he would even have one ready before the first meeting so you could throw sketches together based on what he had come up with. We would wait to see what he came up with, and it was nice to be able to use him to fall back on. I don't think Mike realized I used him as much as I did because he knew it all and was a very gracious guy.

The *DS9* art department was a family that had been established for a long time, and many of them had started

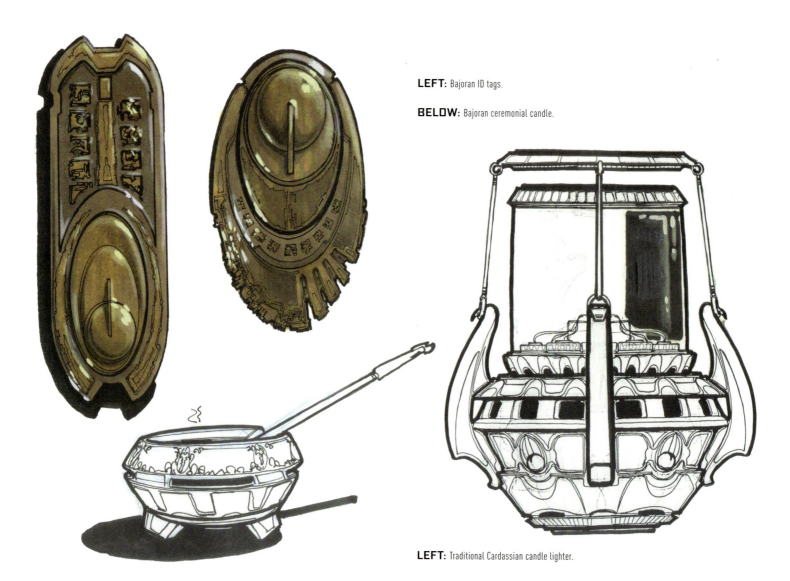

**LEFT:** Bajoran ID tags.

**BELOW:** Bajoran ceremonial candle.

**LEFT:** Traditional Cardassian candle lighter.

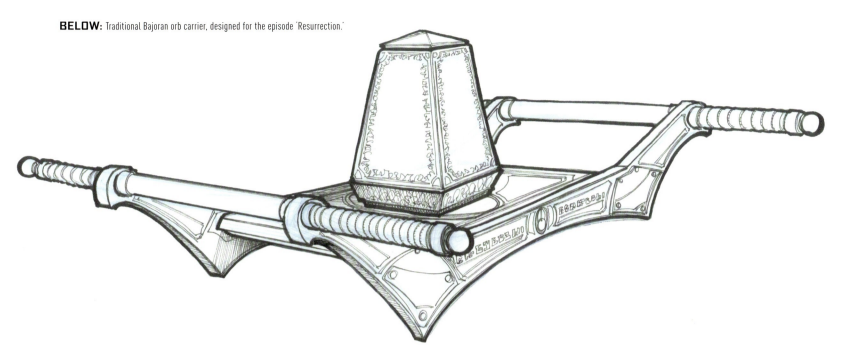

**BELOW:** Traditional Bajoran orb carrier, designed for the episode 'Resurrection.'

on *TNG*, run through *Deep Space Nine* with the features in between, so there was a great working environment. Once Mike started things, Doug Drexler and Jim Van Over would take it from there and turn Mike's ideas into practical set dressing. We all worked very closely together and incorporated each other's designs into our own.

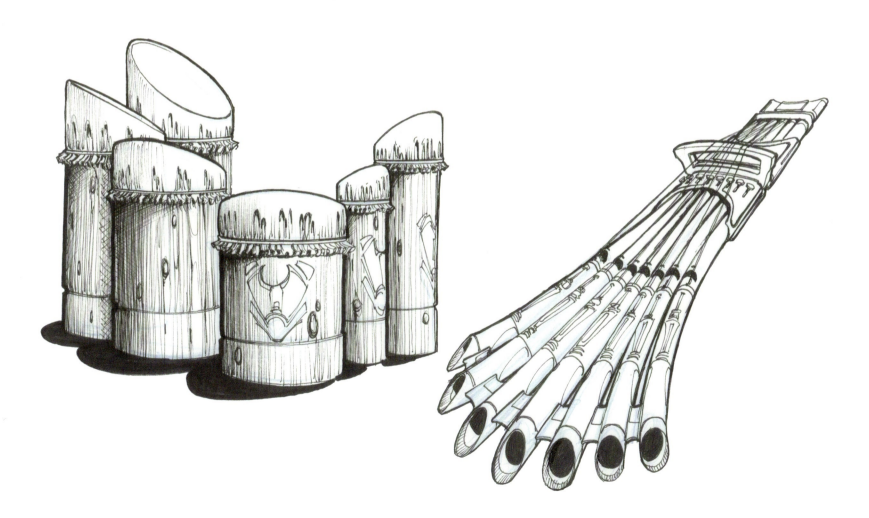

**ABOVE:** Concepts for alien instruments, including drums and a Bajoran woodwind and string insturment.

# KLINGONS

The Klingons were always great fun to work on because they had such a detailed history in the *Star Trek* Universe. As a proud warrior race, Klingon designs were always very strong and bold. We would work on a lot of military props, including weapons, medals, and banners.

In the episode 'Apocalypse Rising', the Order of the Bat'leth ceremony takes place to honor the greatest warriors. I drew a few designs for Klingon inspired by the shape of the infamous *bat'leth*.

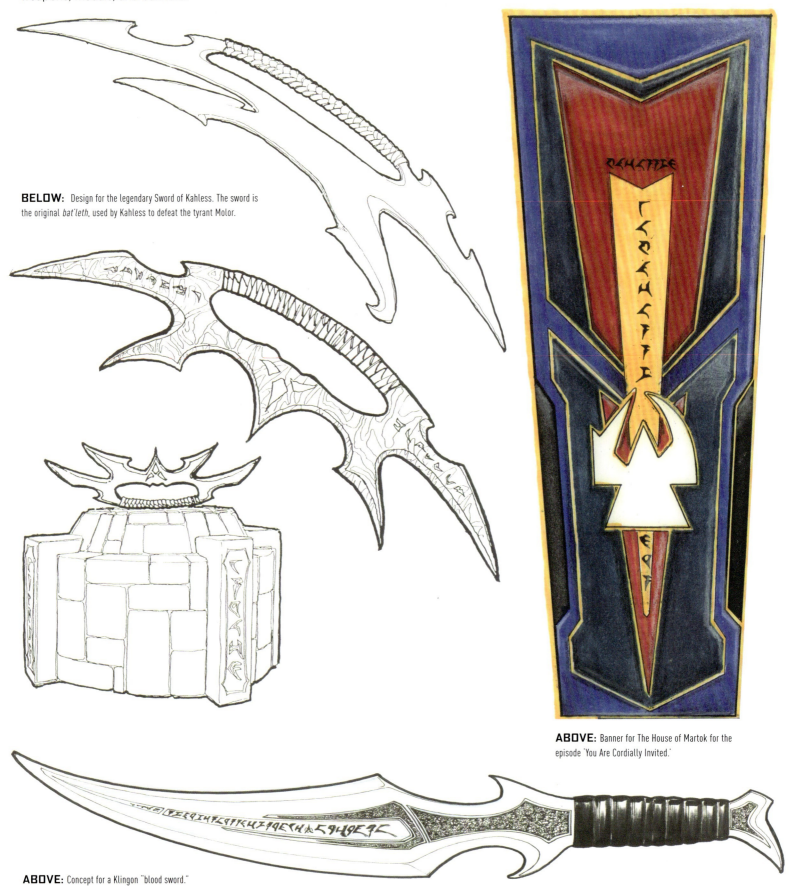

**BELOW:** Design for the legendary Sword of Kahless. The sword is the original *bat'leth*, used by Kahless to defeat the tyrant Molor.

**ABOVE:** Banner for The House of Martok for the episode 'You Are Cordially Invited.'

**ABOVE:** Concept for a Klingon "blood sword."

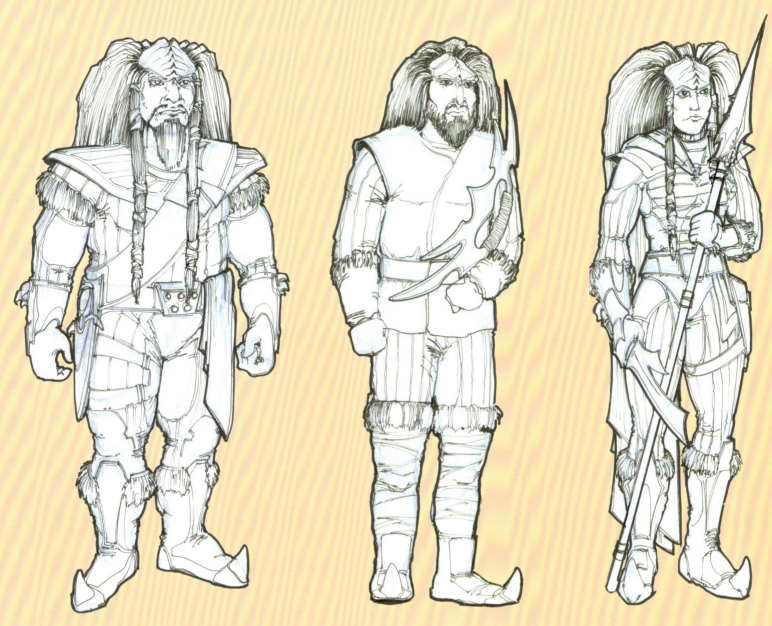

**ABOVE:** For the episode 'Apocalypse Rising', Eaves designed ancient Klingon statues.

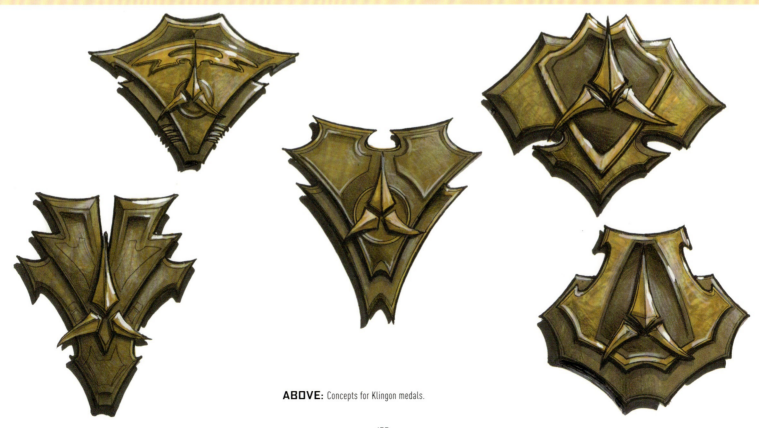

**ABOVE:** Concepts for Klingon medals.

# FAR BEYOND THE STARS COVERS

One of my favorite episodes was 'Far Beyond the Stars,' in which Sisko goes back to the 1950s, where he's a black writer in an all-white society, working for a pulp science fiction novel publishing company. We had to do a bunch of drawings for the old way of creating stories, where an artist would throw a bunch of drawings on the table and the writers would pick one and write a story around it.

Mike Okuda and Doug Drexler were enormous pulp fiction fans, and Mike took a lot of old matte paintings from the original series and put them on the magazine covers. I was more of a movie fan, so I went back to things like *Forbidden Planet* and *War of the Worlds* that I grew up with.

Jim Van Over did a rough CG version of the *Deep Space Nine* station, making it look like an old 1950s Air Force space station, and I had to translate it into a key drawing and that's the one where Sisko says, "I've got to do this one!" That was a unique episode, where we got to do things you just wouldn't expect to do on a science fiction show.

**LEFT:** 'Bad Day at Red Rock.' Eaves created a number of cover designs based on his favorite movies, including *Forbidden Planet* and *War of the Worlds*.

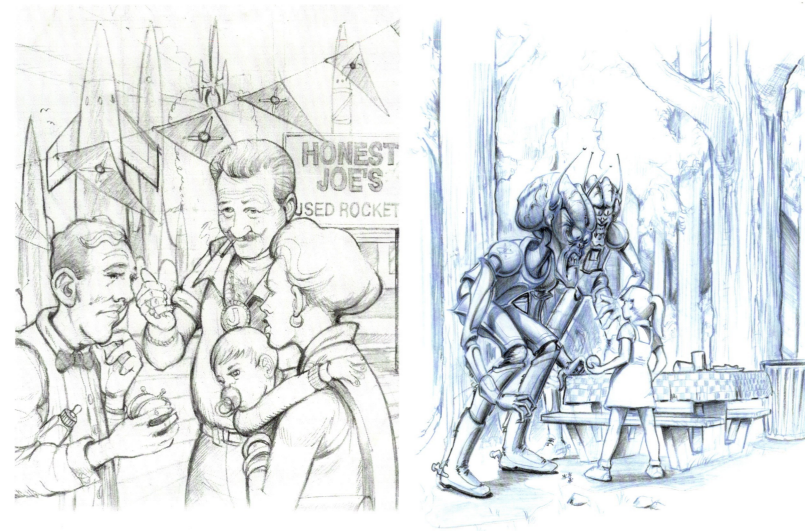

**ABOVE:** 'Honest Joe's Used Rockets.'

**ABOVE:** 'Borrowed Jacks for Rocket Parts.'

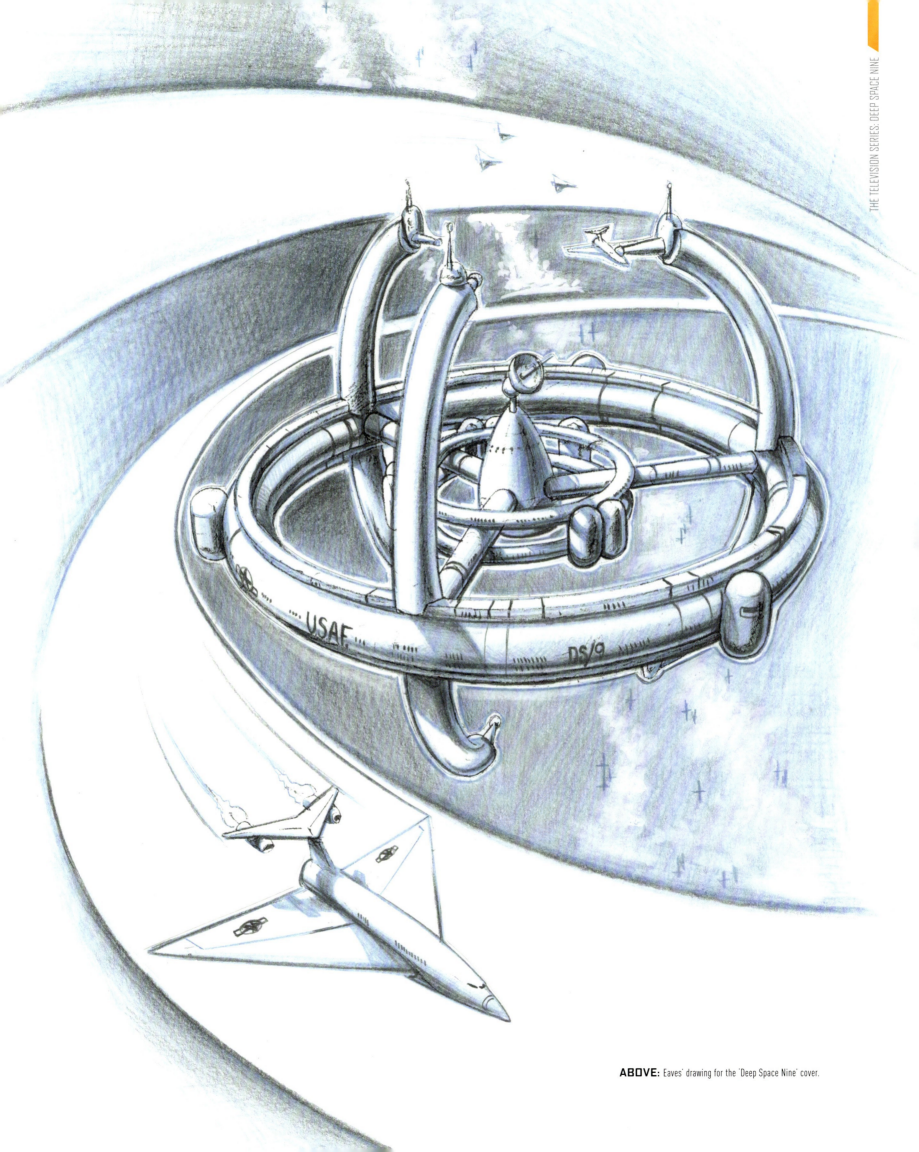

**ABOVE:** Eaves' drawing for the 'Deep Space Nine' cover.

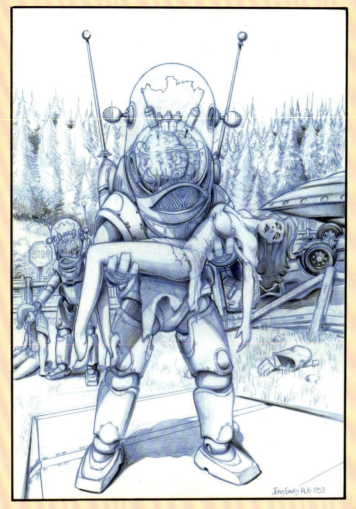

**ABOVE:** 'A Most Unfortunate Accident.'

**ABOVE:** 'Bathe Under a Different Sun.' The front surface of the mantis's claws are the top view of the *Enterprise*-E nacelles.

BELOW: "A Hillbilly Love Affair Turned into an Alien Nightmare."

The *Groumall* was one of the few new ships to be designed and built for the *DS9* series. The script called for a Cardassian freighter that was fitted with a secret disruptor weapon. The main design changes took place on the front of the ship and the rear piloting station. The final model was built over at Michael Lantieri's shop. Michael and his crew were responsible for most of the model construction on both *DS9* and *Voyager*, and their work was always brilliant.

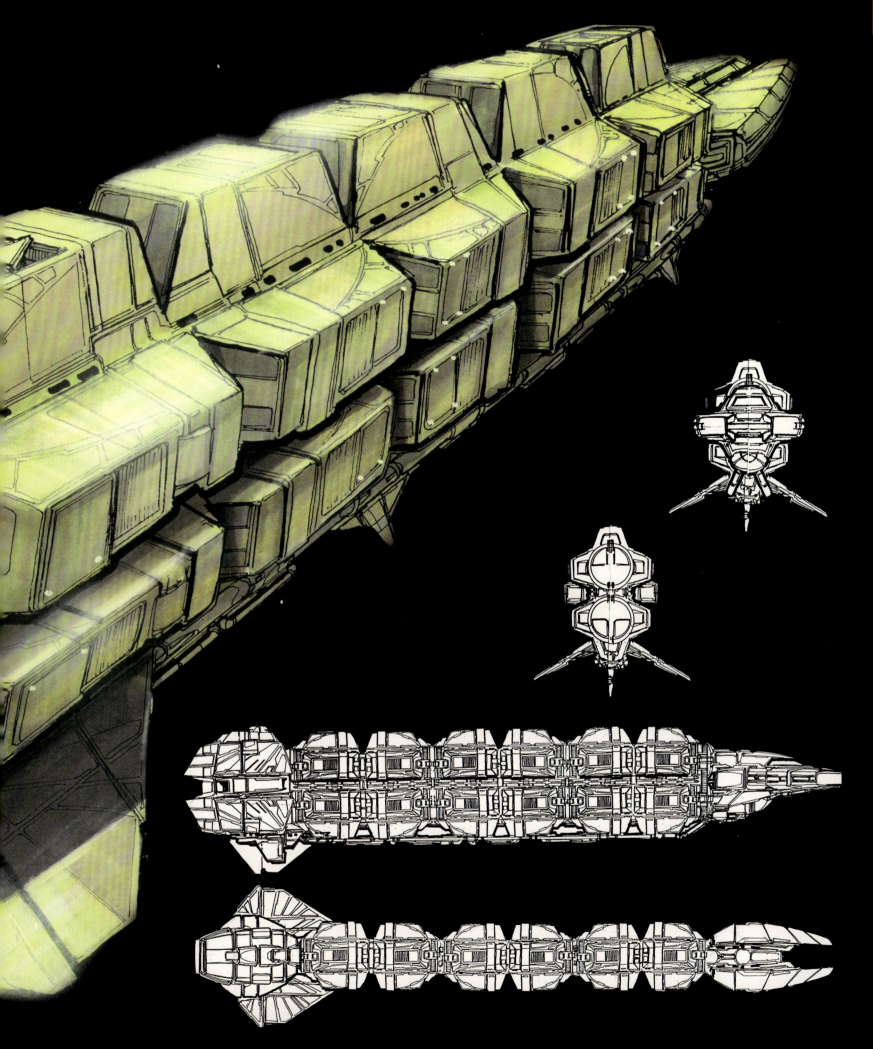

**ABOVE:** Concept designs for the Cardassian freighter featured in the episode 'Return to Grace.'

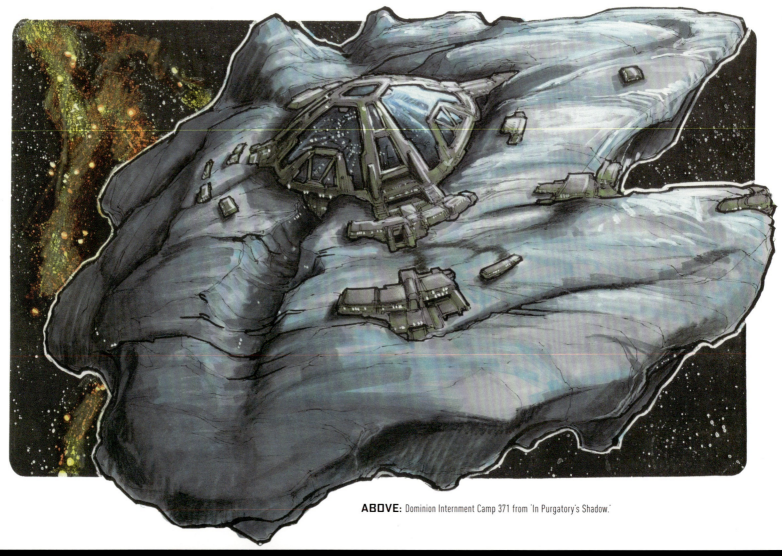

**ABOVE:** Dominion Internment Camp 371 from 'In Purgatory's Shadow.'

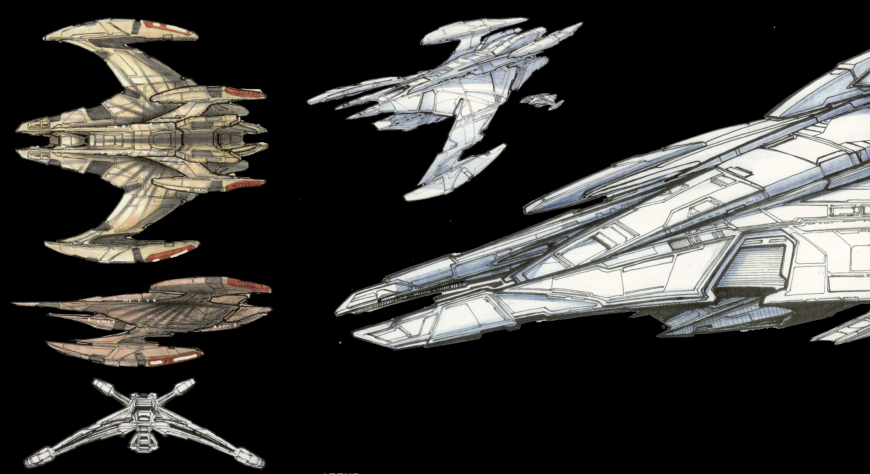

**ABOVE:** Concept designs for the Jem'Hadar battle cruisers introduced in the episode 'In Purgatory's Shadow.'

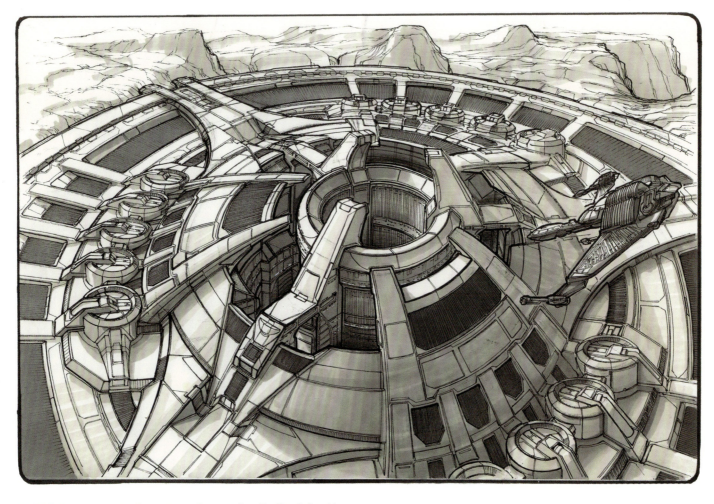

**ABOVE:** Klingon attack on the Dominion base in the episode 'Once More Unto the Breach.'

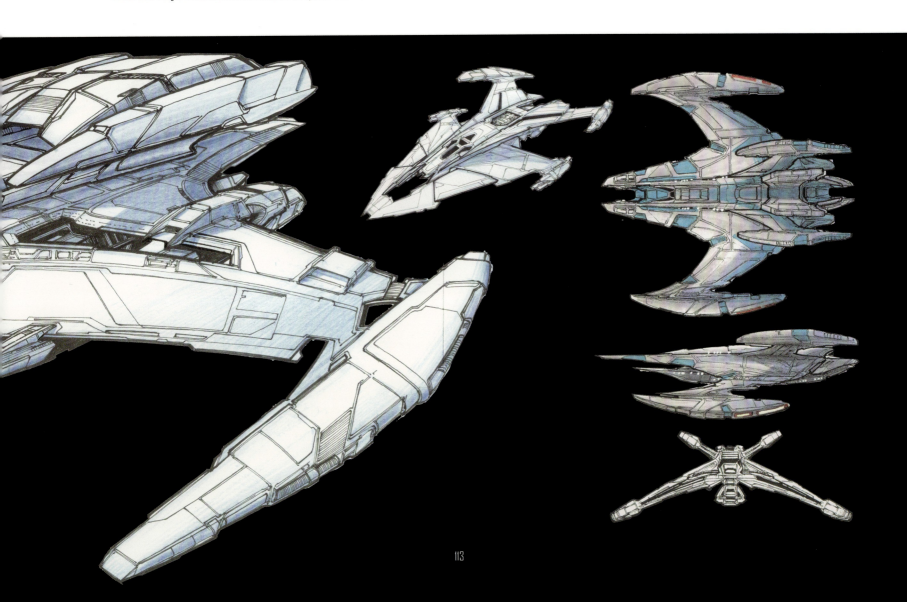

# DS9 ART DEPARTMENT CHRISTMAS CARDS

Another unusual challenge I had on *Deep Space Nine* had nothing to do with the show itself. Jim Martin had started the tradition of drawing art department Christmas cards while he was there during seasons one through three. One of the first things I was asked when I got there was, "Are you going to carry on with the tradition?" When I saw the cards Jim had done, I thought it would be great fun. Jim did the one with everybody hanging on the station, and that's the one Mike handed me and said, "Okay, it's almost Christmas, you've got to do the Christmas card!"

Anatomy is not my thing; I do mechanical stuff all day long, but drawing people is agony. I was so bad at drawing people, I took a picture of everybody and traced over the faces to make

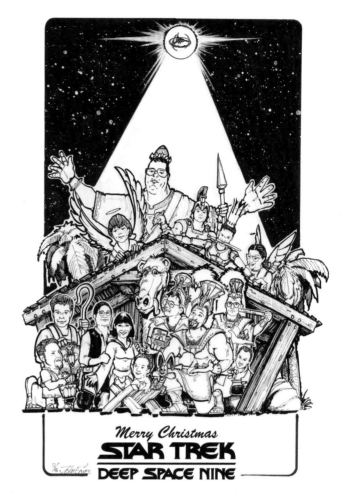

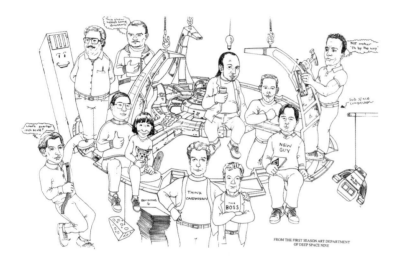

FROM THE FIRST SEASON ART DEPARTMENT OF DEEP SPACE NINE

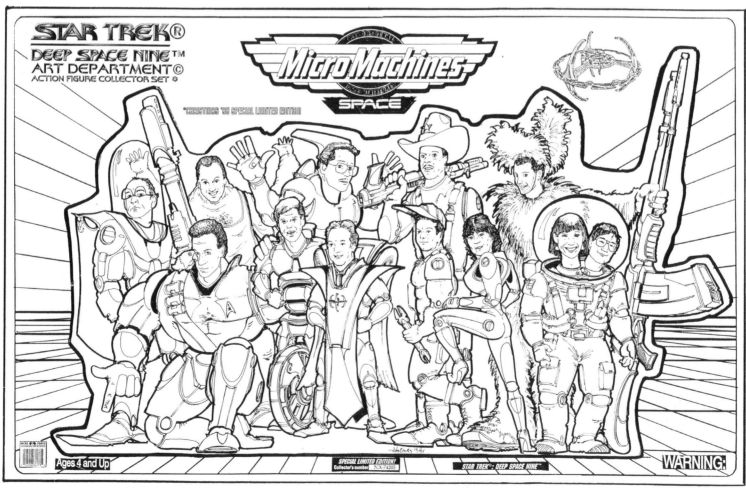

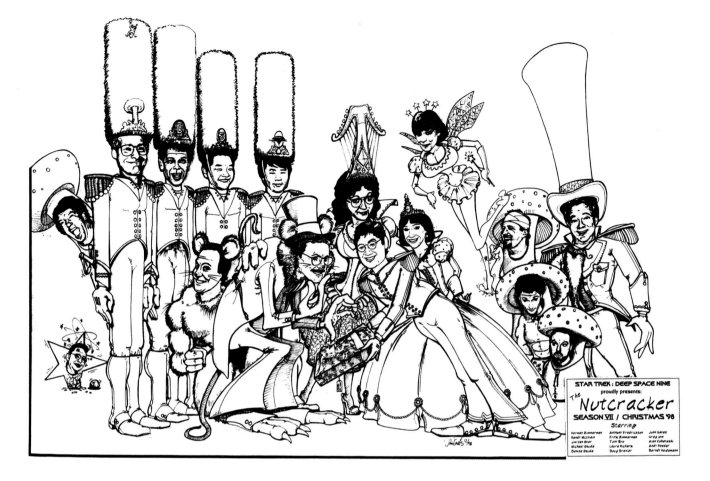

them match. I originally tried to do it by hand and it was just a blobby mess, so I had to find a way of cheating it.

The first card I drew was based on the Micro Machines world. A few days before, Herman had come over to see what I was working on. When he was standing behind me he said, "Looks like you're losing your hair too!" From that day on, Herman set his fate to always be the shortest guy on the Christmas card.

The star of my next card was Laura's assistant, Dennis. He was a giant! He must have been nearly six-foot eight and 400 pounds. It's no joke; that's how big he was compared to everybody else.

The next year was the Nativity card. I made Herman Zimmerman the baby and put 'Baby Herman', which was a reference to Who Framed Roger Rabbit?. Herman hadn't seen the movie so he didn't get it and said, "Why am I Baby Herman?" I said, "Baby Herman, Roger Rabbit...?" And he said, "I still don't get it! And why am I always short in these drawings?" To that I replied, "Do you remember that day you came behind me and said I'm bald? That's why you're short in all the Christmas cards!"

The Nutcracker card was one of my favorites, because Greg Jein was back in the art department at that time, so he got to be in that card. It was also the last Christmas card I would draw for our Deep Space Nine family.

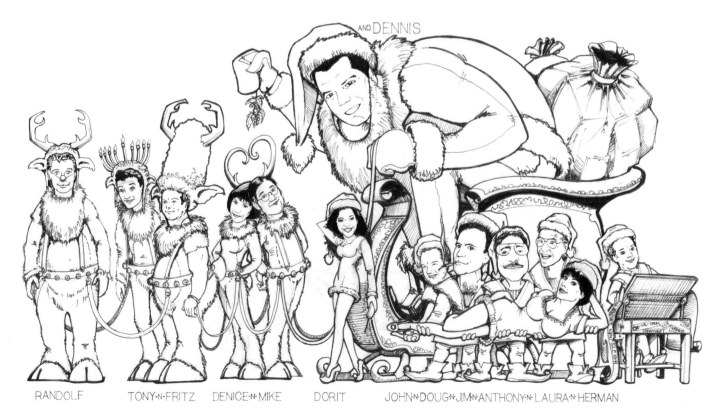

# STAR TREK:
## THE NEXT GENERATION AND VOYAGER

### "I LIKED WORKING IN TV AND I ENJOYED GOING BACK AND FORTH."

Most of the TV work I did was on *Deep Space Nine* and *Enterprise*, but every once in a while I would get asked to do something for *The Next Generation* or *Voyager*. A lot of illustrators didn't really want to do TV, which was considered a stepping-stone to movies, but I liked working in TV and I enjoyed going back and forth.

At one point they needed a new Klingon ship for *TNG*, but they didn't really have the budget for it, so Greg Jein would go back to his shop, pull out every piece that might work, throw them on the table and say, "Okay, draw the Klingon ship based on these pieces!" He would do a quick sketch and I would flesh it out a little bit, so that's the way it usually worked.

I was out of the *Star Trek* scene for a while working on other projects. During that time, I did a lot of commissions for licensed products from Franklin Mint and Hamilton. There was also a writer's strike going on, but I was lucky to pick up a John Carpenter movie, *Ghosts of Mars*, and literally finished that the day we started back on *Enterprise*.

**THIS PAGE:** Concept designs created alongside Greg Jein for a Klingon bird-of-prey.

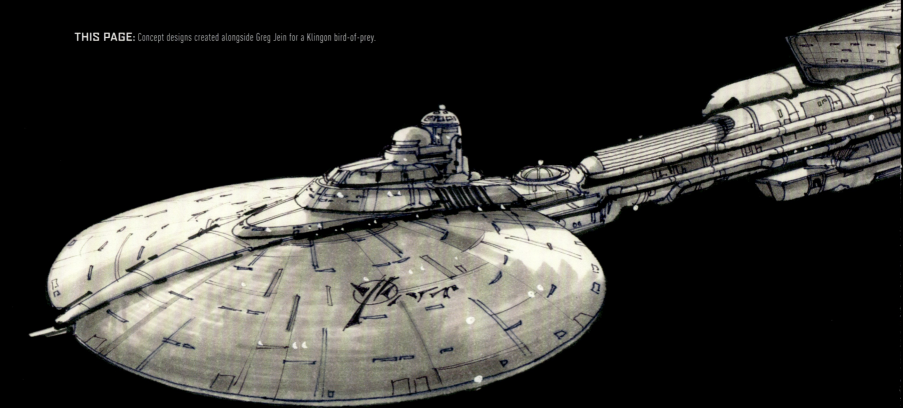

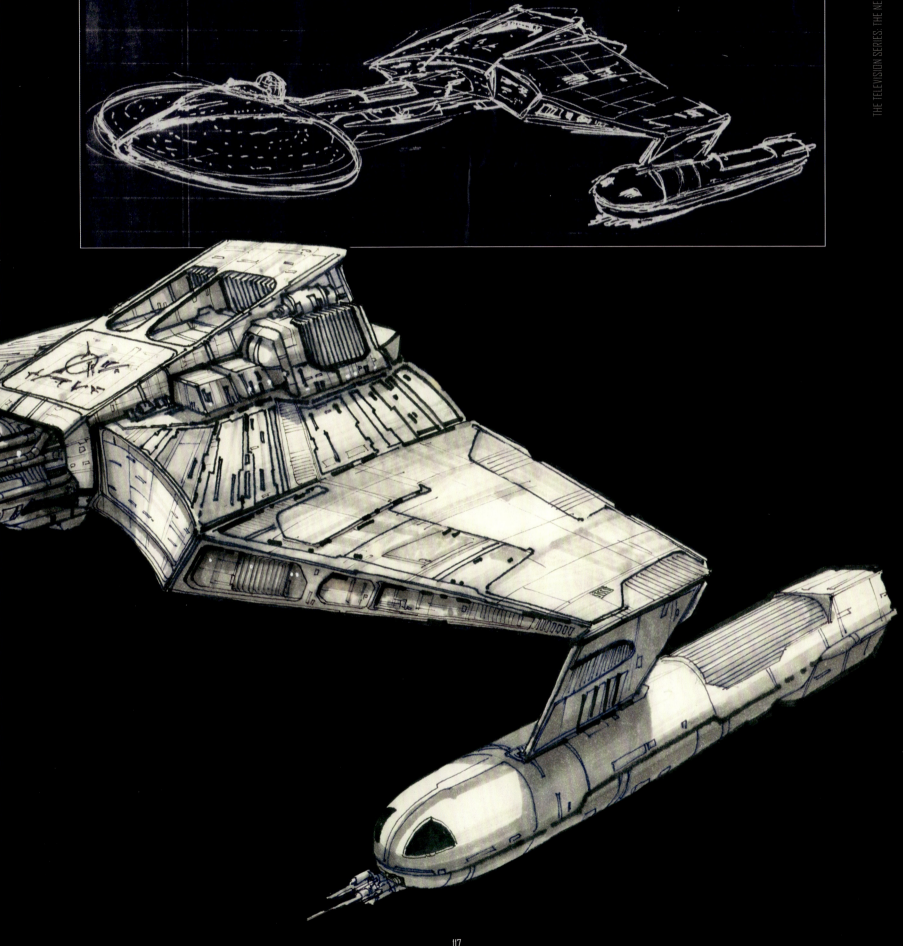

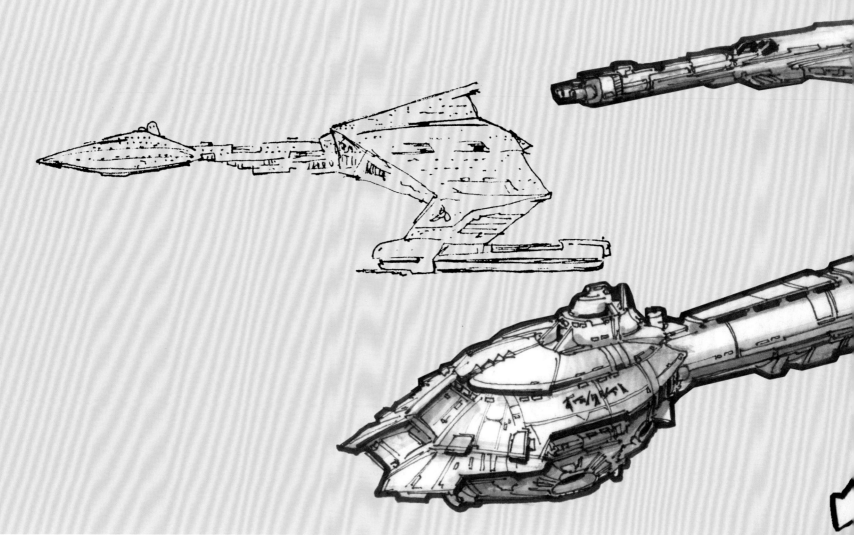

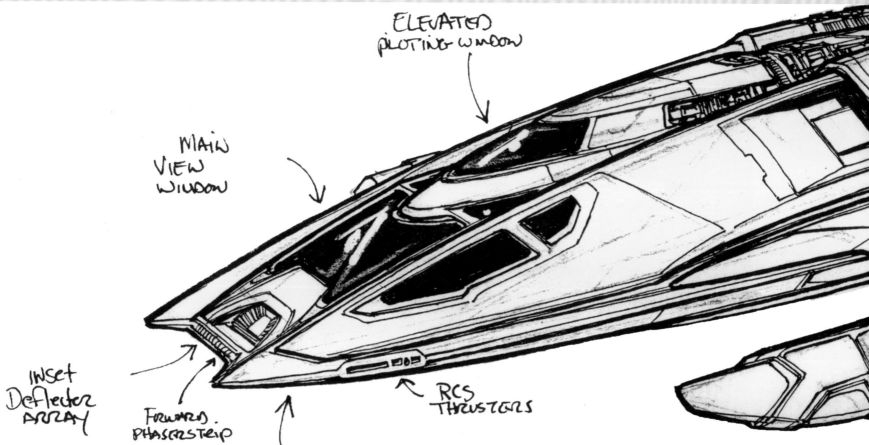

FEDERATION TECHNOLOGIES

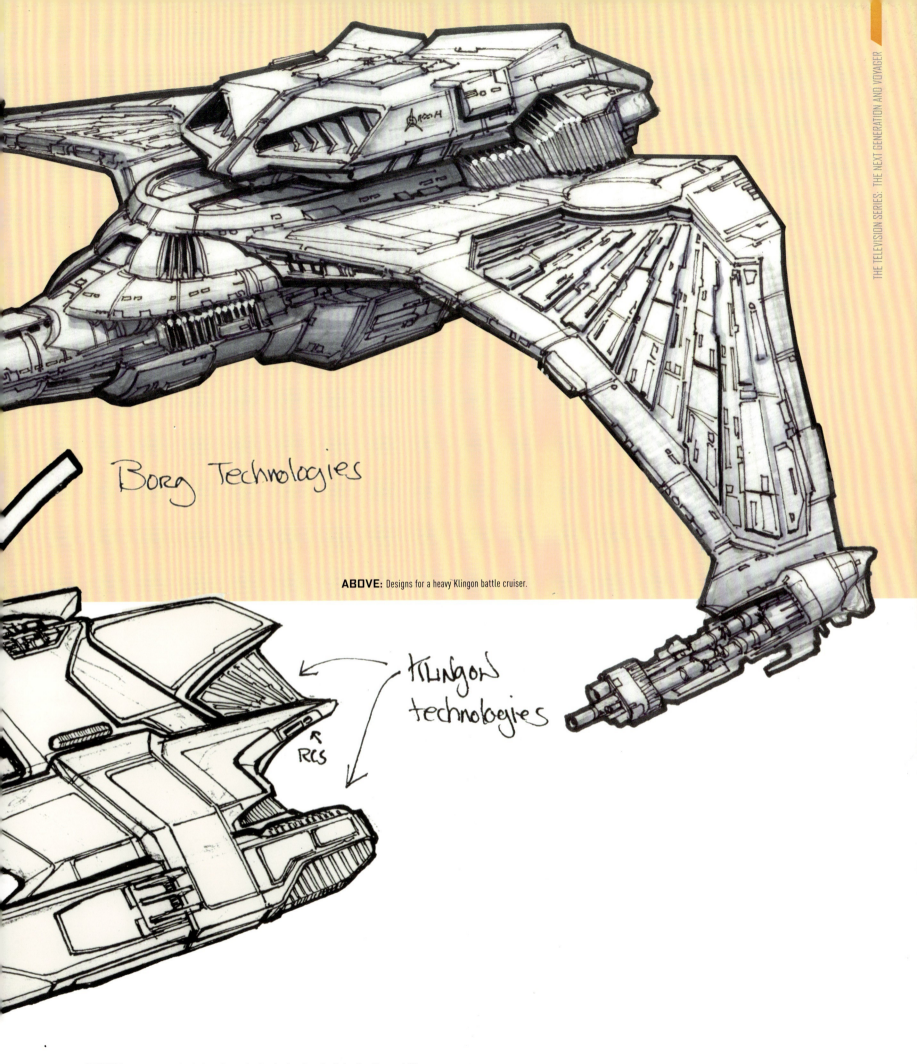

**ABOVE:** Designs for a heavy Klingon battle cruiser.

**ABOVE:** Concept for a shuttle featuring a mix of technology from the Federation, Borg, and Klingons.

# STAR TREK: ENTERPRISE
## U.S.S. ENTERPRISE CONCEPTS

### "IT WAS A UNIQUE WORKING ENVIRONMENT THAT I'VE NOT EXPERIENCED SINCE."

**D**eep Space Nine ended by June, 1999. It was almost a year and a half before Herman called and said, "We've got Enterprise starting up!" We knew there was another series coming, but we thought it was only going to be a couple of months before it started.

We basically had the same crew on the new series, minus Laura Richarz, who had moved onto another show, so we had a new set decorator, but the construction guys were all the same. Bob Blackman carried on from TNG, DS9, and Voyager as costume designer and Dan Curry was still around with the same effects guys. Brannon Braga and Rick Berman were heading up the show and I really enjoyed working with them again. There was a new group of writers, but they were all great too—you could call them and say, "I have a question about this…" and they would give you answers. It was a unique working environment that I've not experienced since, nor have most of the people I've talked to. I've never seen a show where everyone was there doing their best and feeding off each other like that.

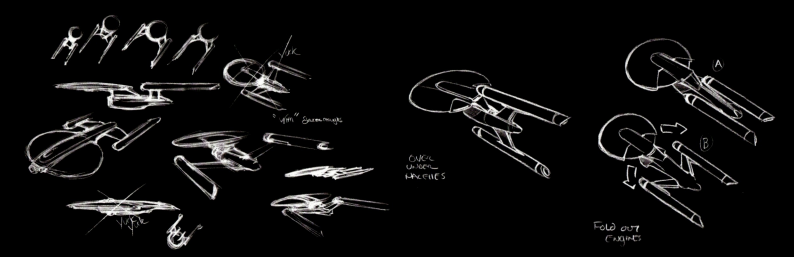

**ABOVE:** Eaves produced countless sketches for the new Enterprise.

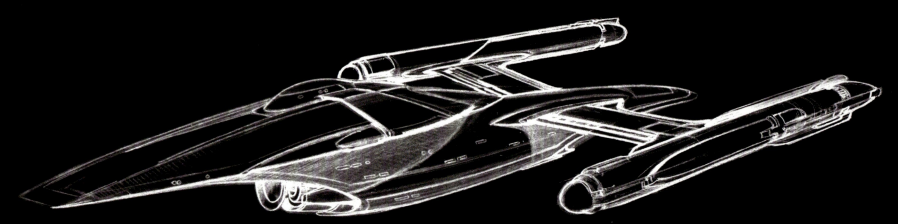

**ABOVE:** Originally, Herman Zimmerman wanted the Enterprise to go in a very different direction. The final design reverted to the traditional shape with the saucer as the main focus.

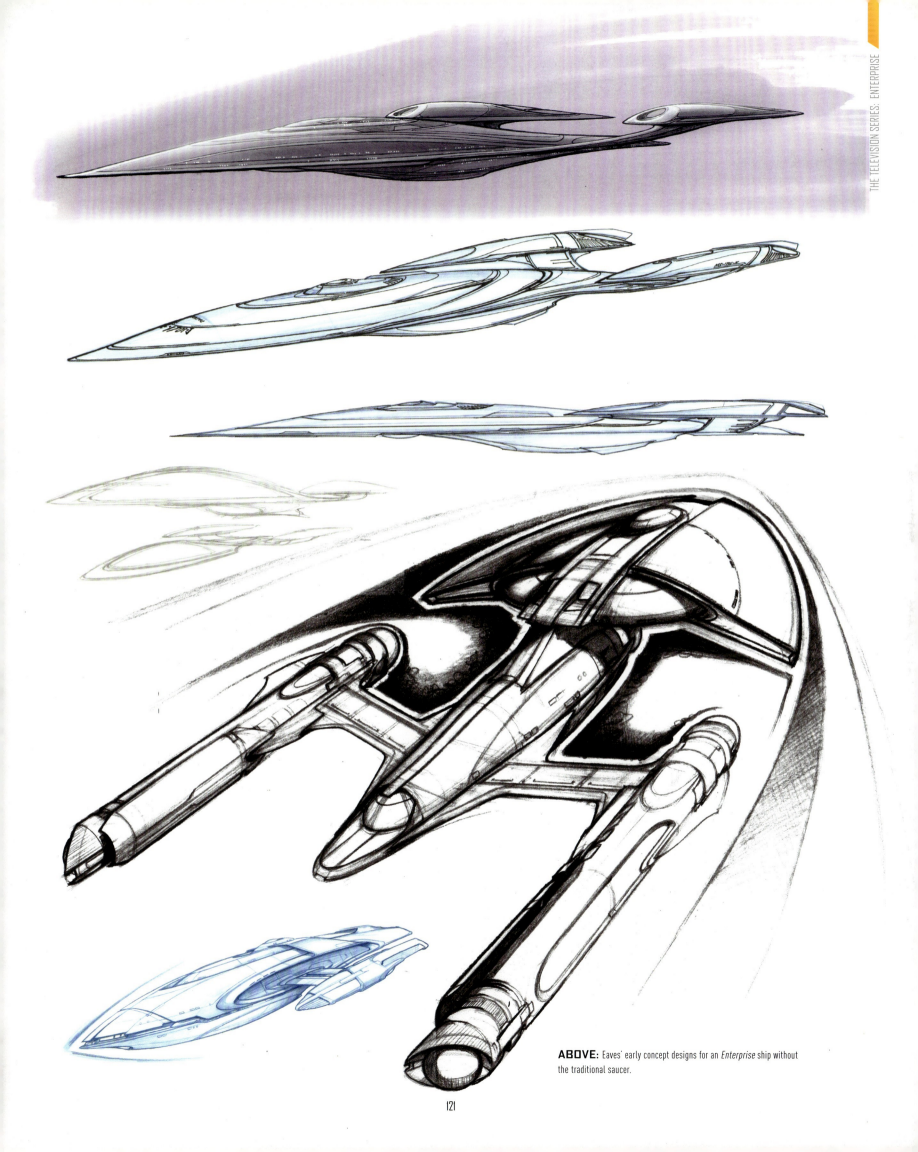

**ABOVE:** Eaves' early concept designs for an *Enterprise* ship without the traditional saucer.

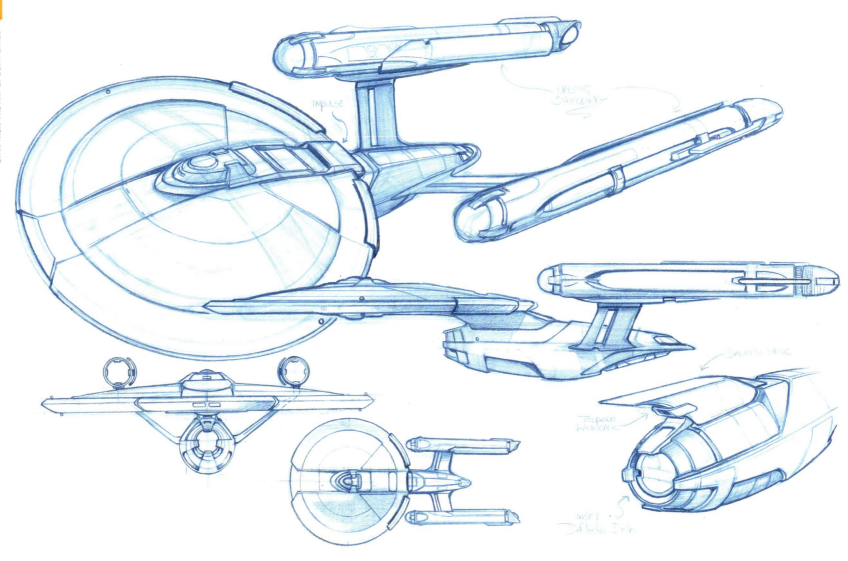

**ABOVE:** Eaves' final concepts for the new *Enterprise*.

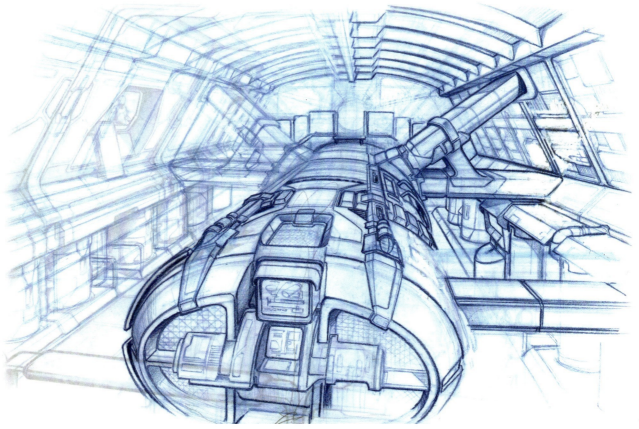

**ABOVE:** Concepts for the *Enterprise* engine room.

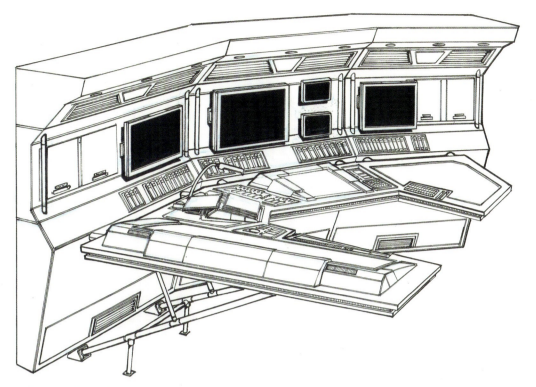

My first assignment was the *Enterprise*. Herman said, "I want you to get on with the *Enterprise*, because we need it right away!" It was an odd start, because he wanted me to try doing a starship without a saucer just to do something different, so I did these bizarre sketches of ships going in that odd direction.

As time went on, Herman said, "Okay, let's try a more traditional ship with a saucer, but don't make it too *Enterprise*-y!" so I started doing saucer stuff, sketch after sketch after sketch, but the producers just weren't agreeing with anything I was doing. We were getting late on time, and we still needed to work out the Suliban designs. Doug Drexler was on another show at that point, and he was really skilled in the CG work to where he could render really quick and crude CG models, so Herman said he was going to get Doug involved too.

Unfortunately, things got kind of labor-heavy for Doug on this other show, and he needed at least a week to work on our ship but he couldn't get out of the other job, so being a makeup artist, on the Sunday night, he made himself look as sick as he possibly could. On Monday morning, he went into work with this makeup on and said, "Guys, I feel really bad!" so they sent him home and he spent the entire week pretending to be sick so he could work on the *Enterprise*.

Since we were getting so busy, Herman finally told Doug to work on the *Enterprise*, while I worked on the Suliban. My last design was a blue pencil sketch of a bunch of different Enterprises and that's where I left it. Doug continued on, probably for months in no particular direction, but with everything he did, the producers would say, "No, we don't like it!"

During that time Rick Berman came in with a sketch of an *Akira*-class ship in his hand. Rick was looking at that sketch, and he finally flipped it over and said to Herman, "Let's make this the *Enterprise*!" so *that's* where the direction came from.

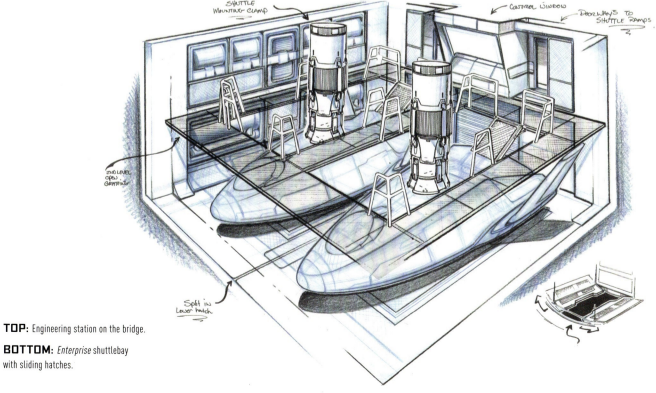

**TOP:** Engineering station on the bridge.

**BOTTOM:** *Enterprise* shuttlebay with sliding hatches.

# SULIBAN HELIX

Meanwhile, I was going through the same trouble with the Suliban helix ship. We couldn't get anywhere with it, because the producers described it as a helix and I was drawing it as a helix, but somewhere in the middle of the process they said, "When we say 'helix,' we don't mean a helix; that's just a term!" So their ideas were changing as quickly as my drawings.

I knew the helix was going to be an under-structured ship, and it had to have some kind of power source that connected everything together, but the sections had to be independent, because in the big climactic scene the *Enterprise* figures out a way to shut down their connection to the power source and everything flows freely at that point.

Finally, Rick Berman said, "Make a long pole down the center, and everything will helix off of that." I said, "Okay, a *real* helix or a helix that's not a helix?" Rick said he wanted a real helix and that helped me reach my final drawing.

**BELOW:** Eaves tried a variety of designs for the helix.

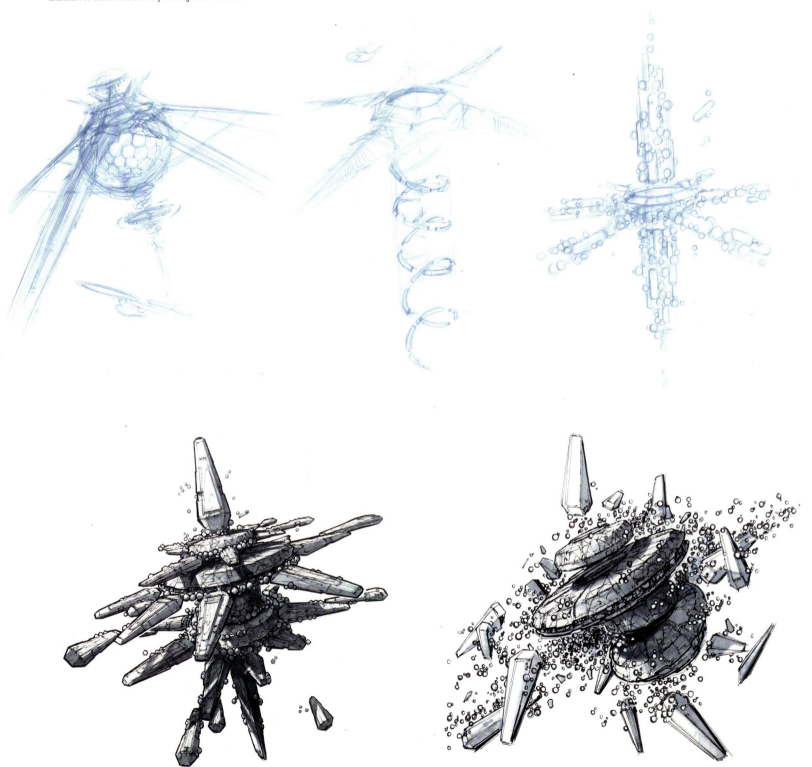

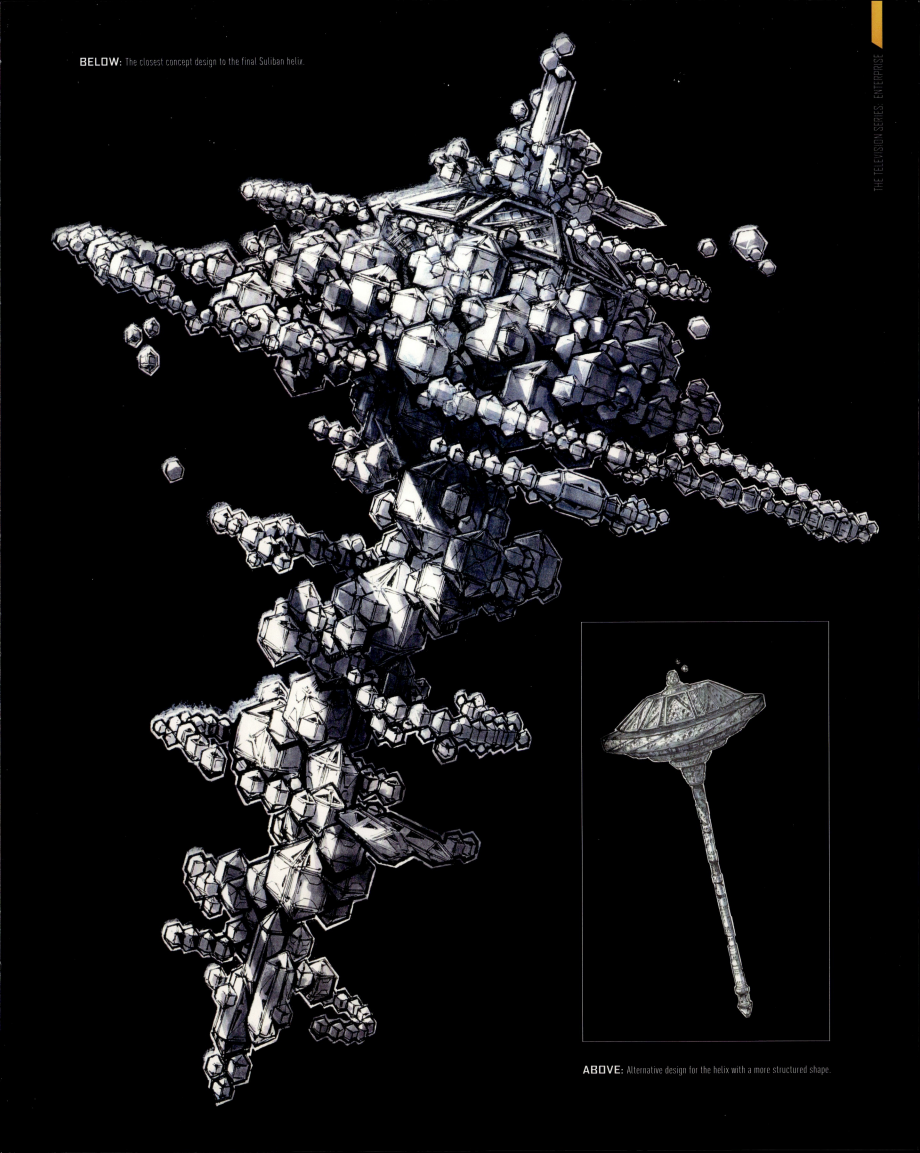

BELOW: The closest concept design to the final Suliban helix.

ABOVE: Alternative design for the helix with a more structured shape.

# XINDI

We started an arc with the Xindi, which was an interesting race because there were four or five different species to that race. We had the aquatic Xindi, the insectoid Xindi and humanoid Xindi, and we had to design ships around these different characters. With the aquatic Xindi, their ship was completely full of water, so there was a scene where one of the ships gets ruptured and all the liquid inside comes out, and these little floating Xindi are all over the place. We had to tie them all together, which ended up being a color issue as opposed to a design issue.

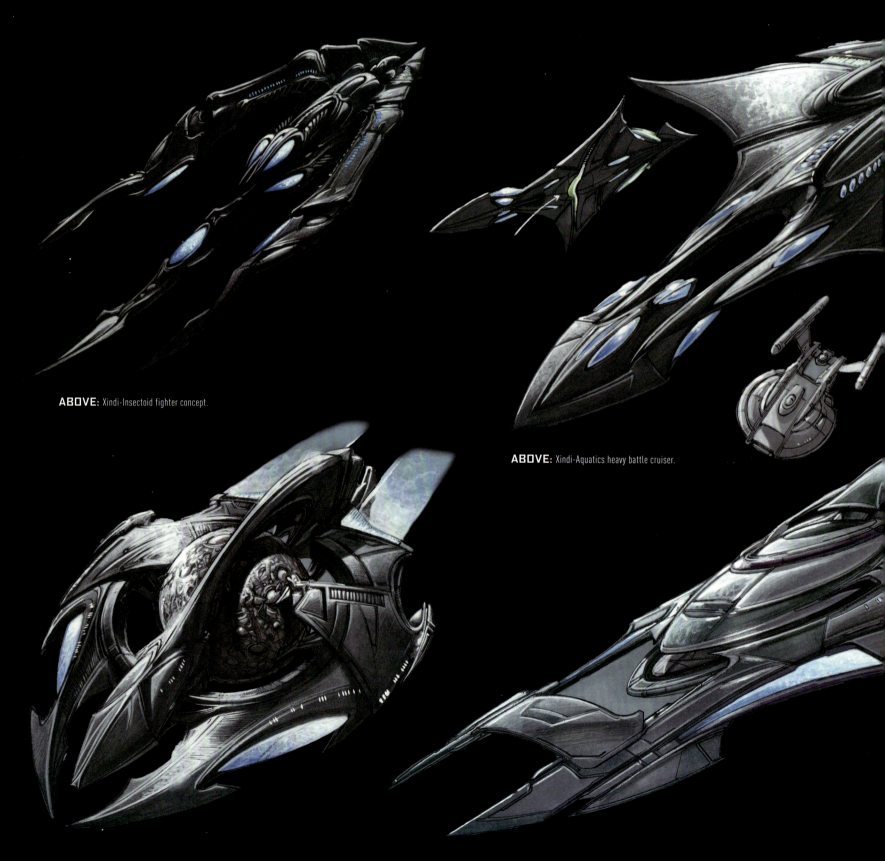

**ABOVE:** Xindi-Insectoid fighter concept.

**ABOVE:** Xindi-Aquatics heavy battle cruiser.

**ABOVE:** Early Xindi bomber concept.

**ABOVE:** Xindi-Primates ship concept from 'The Council.'

**BELOW:** Early design for the Xindi's ultimate planet-destroying weapon in its underwater cradle from the episode 'Azati prime.'

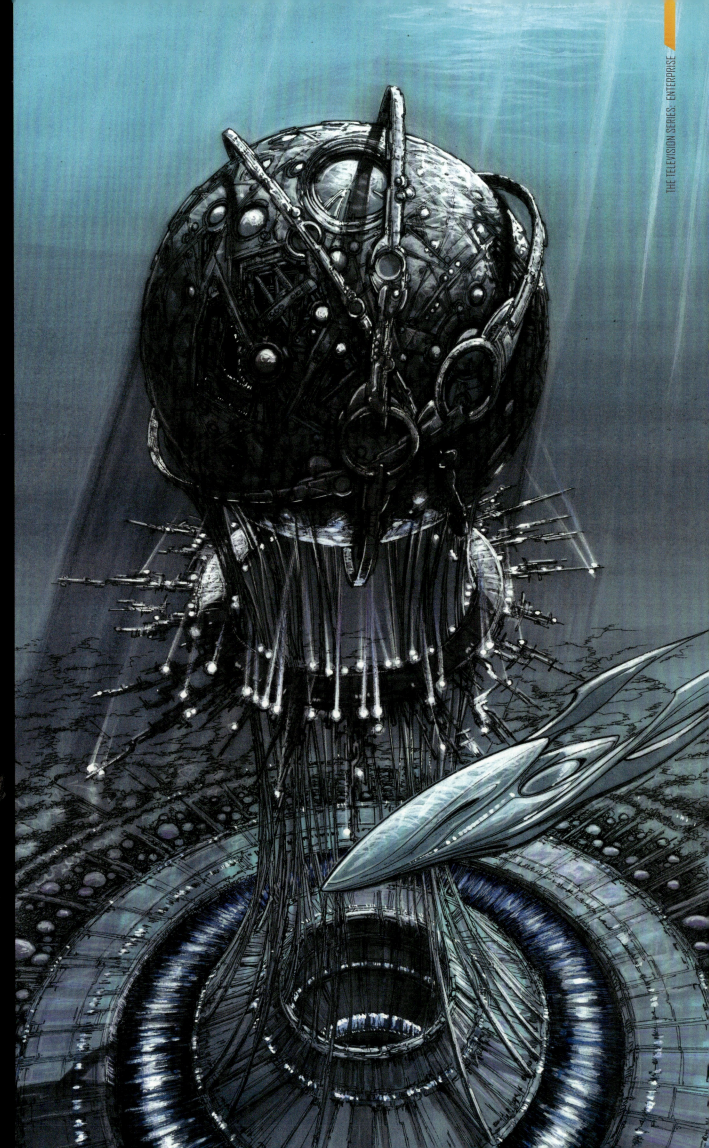

**BELOW:** Xindi bomber from the episode 'Proving Ground.' The bomber revolves 90° on its axis and releases the bomb. Once the weapon is uncoupled, firing rings unfurl and the weapon proceeds to its target.

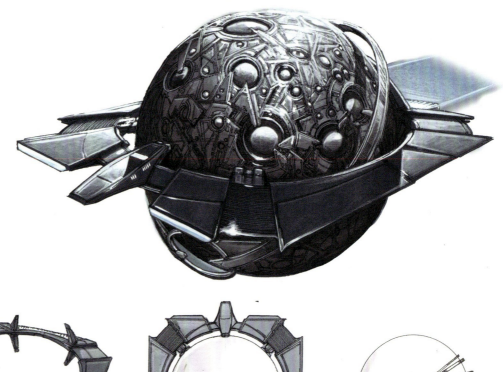

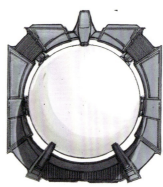
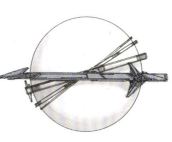

**BELOW:** Design for Xindi mining complex.

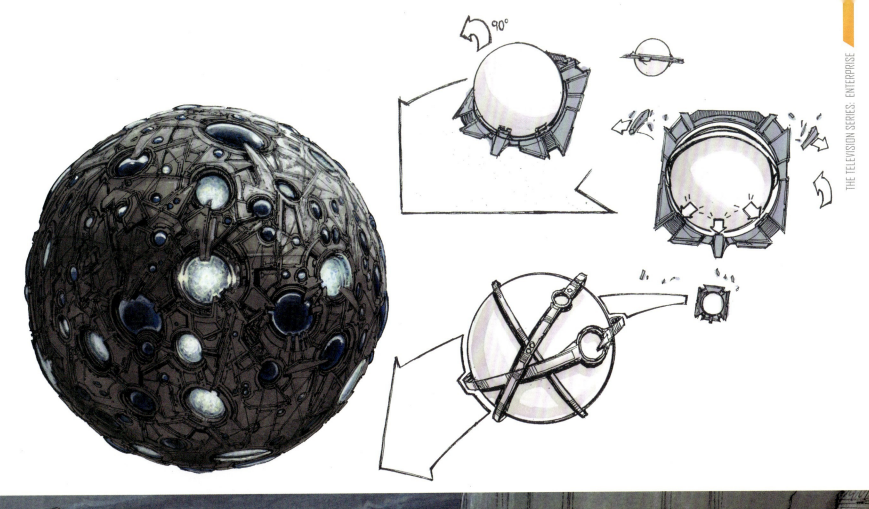

# ALIEN SHIPS

Unlike *Deep Space Nine*, we had an overwhelming number of ships on *Enterprise*, sometimes four or five different ships in a single episode. That meant *a lot* of different designs and sketches. By the middle of the first season I was running out of different shapes for the ships. I would go to the grocery store or Target and look at everything. I would look in the kitchen aisle, so a couple of ships were based on blenders or juice mixers. Across the board, everything was about, "What can I use as a new ship?"

Rick Berman's love for the bird-of-prey wasn't as prominent in *Enterprise* as it was in the feature films. But if you wanted to guarantee something got through, you would give it a little bit of a bird-of-prey look and you would be all right. Or if a design didn't get approved for an earlier episode, you could flip it backwards and Herman would say, "I like that ship they didn't like before; let's flip it and present it again!" so there are some designs that kept coming back.

What was interesting about *Enterprise* is we were working on a millennial TV show, but it was set in the 'past,' so we were always in this weird time flux. I would often think to myself, "What would a hundred years before Kirk's era look like?" You couldn't go back to the 1960s look as the basis for it, so we had to create a more updated, modern look and work backwards from that.

**BELOW:** Eaves designed countless alien vessels for the series. This particular ship was drawn for the episode 'Fight or Flight' and features its wings raised in an exaggerated attack position.

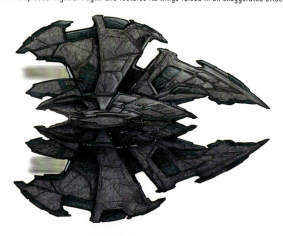
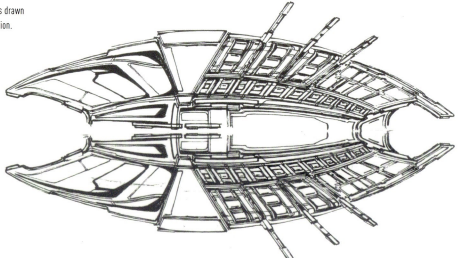
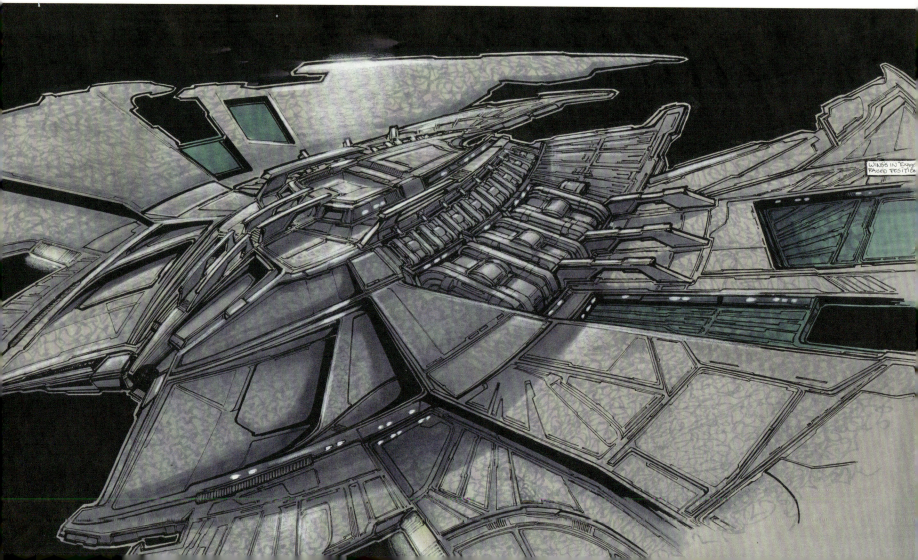

# THOLIANS

Every once in a while you had an episode where you got to see the original *Enterprise*, and we were always excited when we could use the original sets or exteriors as reference. We also enjoyed it when an original series alien came back. The Tholians were always one of my favorites, so we would say, "Okay, we've got to redo the Tholian ships about 70 years in the past, so what would they look like?" The same with the Klingons or Romulans: I would just take the original designs and pull them back, making them super-smooth, not unlike the 1960s style.

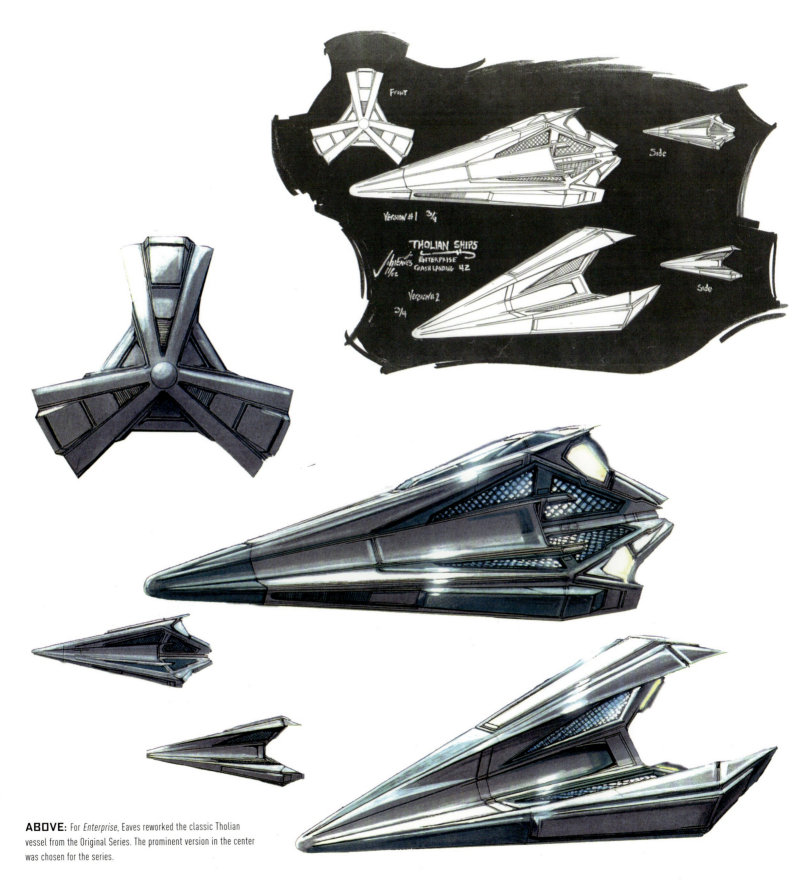

**ABOVE:** For *Enterprise*, Eaves reworked the classic Tholian vessel from the Original Series. The prominent version in the center was chosen for the series.

# KLINGONS

With the Klingons, I looked at old Soviet space race designs for inspiration. I also incorporated a lot of Soviet space race elements into their style. I remember the Apollo/Soyuz link-up in the seventies, where they had that little module where the two nations could meet in the middle. If you looked at the Apollo capsule, it was smooth and clean and sterile, but if you looked at the Soviet capsule, I don't know how it even moved around. It had hundreds of cables and hoses on it, so it was like a bowl of gravity spaghetti. I took that cabling and applied it to the Klingon designs, so each Klingon ship had cabling going from one end of the wing to the weaponry at the end.

**BELOW:** Klingon ship design from the episode 'Marauders.'

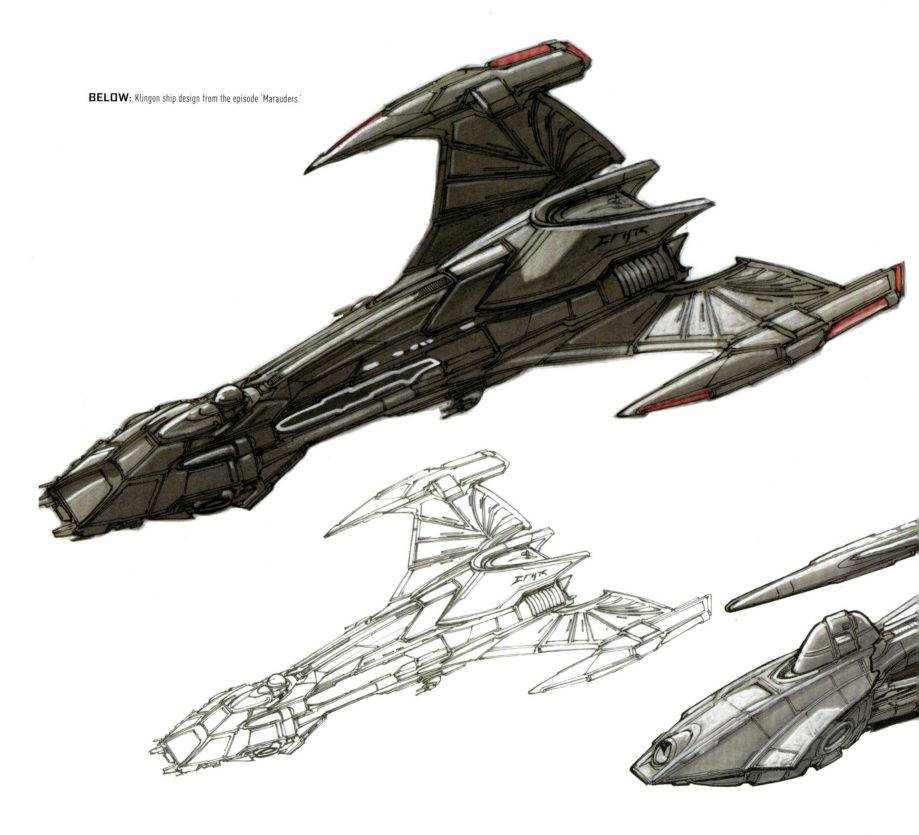

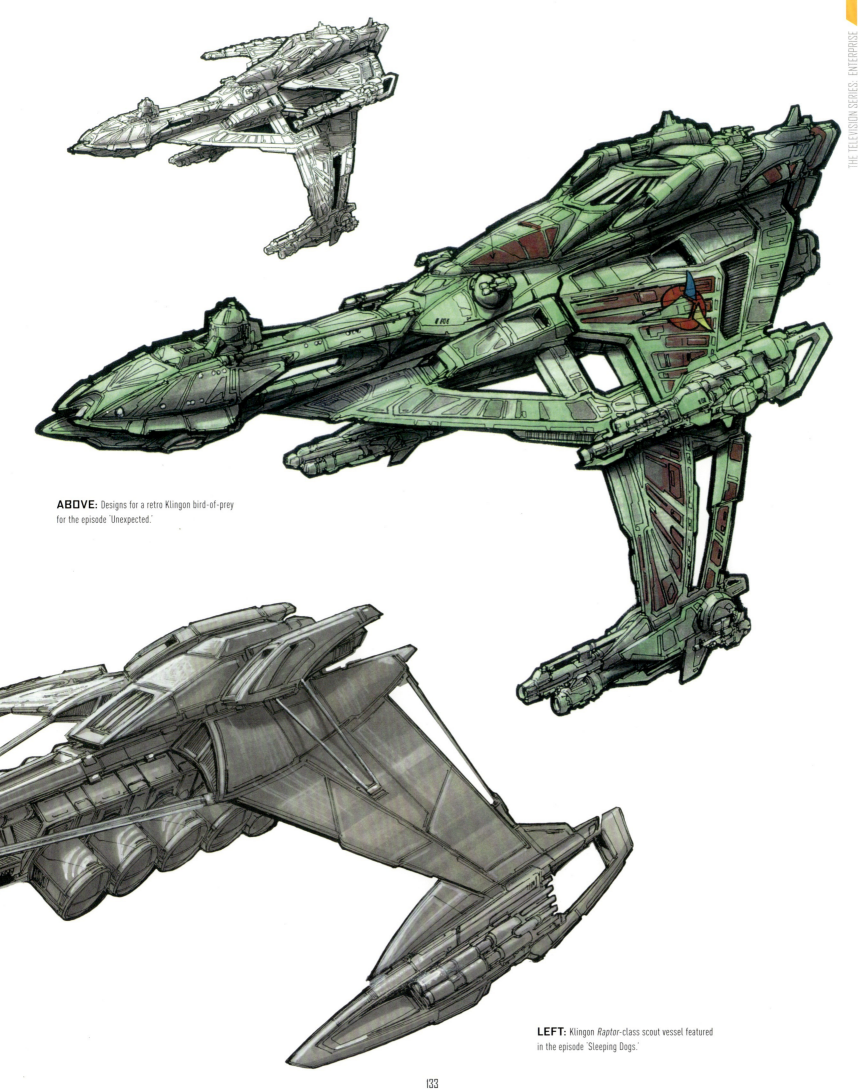

**ABOVE:** Designs for a retro Klingon bird-of-prey for the episode 'Unexpected.'

**LEFT:** Klingon *Raptor*-class scout vessel featured in the episode 'Sleeping Dogs.'

# ROMULANS

We saw the Romulans in the 'Minefield' episode, and I just went back to the original series Wah Chang design. I even drew the ship with the bird on the bottom but was told, "No, we don't like it; get rid of the bird!" but apart from that, I tried to copy what had already been established as closely as I could and take it into the *Enterprise* world.

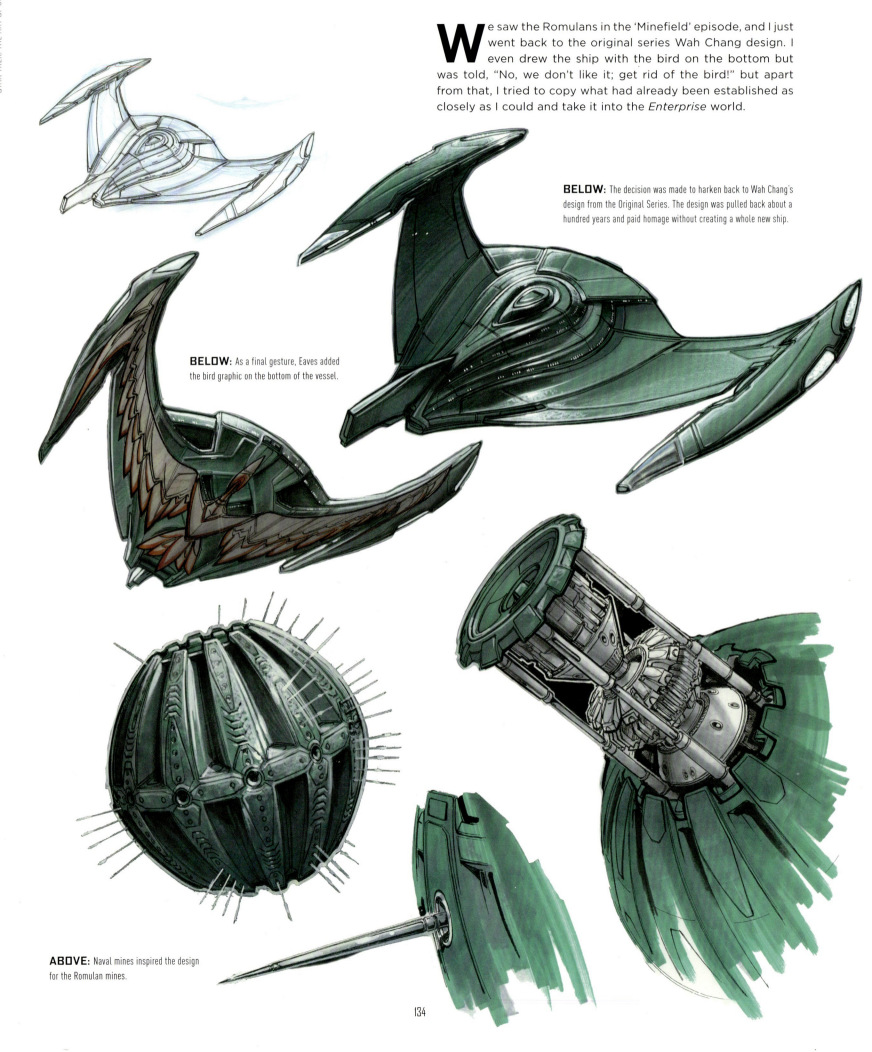

**BELOW:** The decision was made to harken back to Wah Chang's design from the Original Series. The design was pulled back about a hundred years and paid homage without creating a whole new ship.

**BELOW:** As a final gesture, Eaves added the bird graphic on the bottom of the vessel.

**ABOVE:** Naval mines inspired the design for the Romulan mines.

# VULCANS

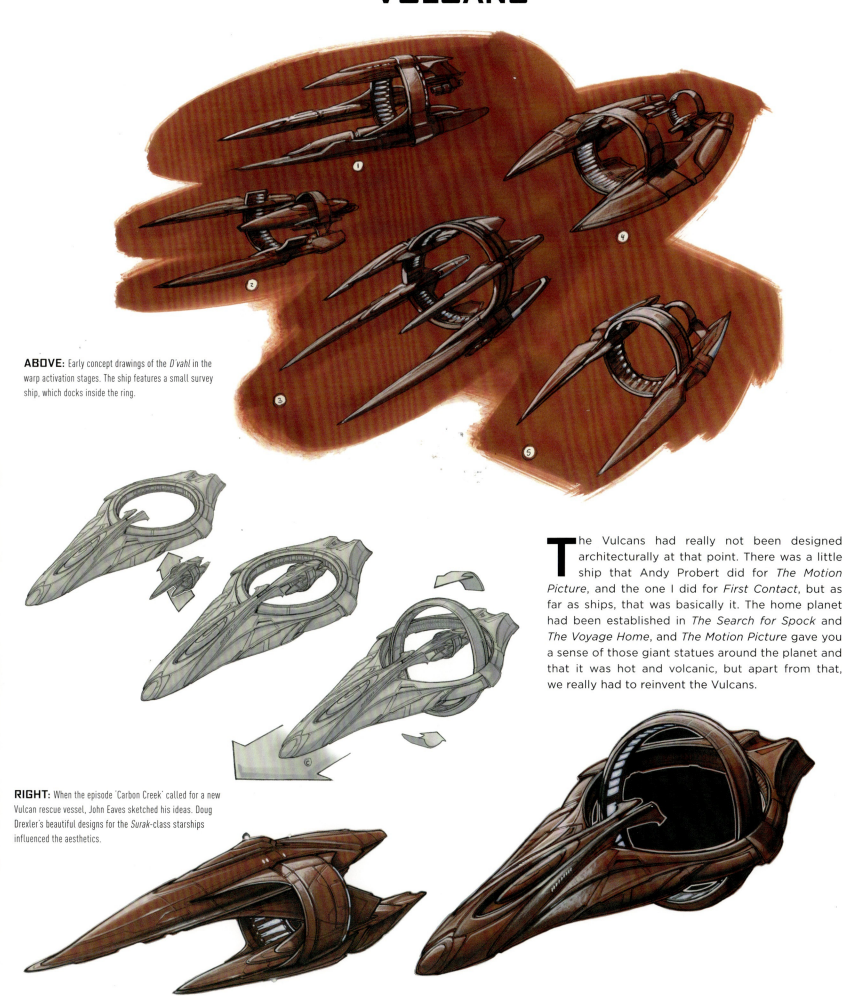

**ABOVE:** Early concept drawings of the *D'vahl* in the warp activation stages. The ship features a small survey ship, which docks inside the ring.

**RIGHT:** When the episode 'Carbon Creek' called for a new Vulcan rescue vessel, John Eaves sketched his ideas. Doug Drexler's beautiful designs for the *Surak*-class starships influenced the aesthetics.

The Vulcans had really not been designed architecturally at that point. There was a little ship that Andy Probert did for *The Motion Picture*, and the one I did for *First Contact*, but as far as ships, that was basically it. The home planet had been established in *The Search for Spock* and *The Voyage Home*, and *The Motion Picture* gave you a sense of those giant statues around the planet and that it was hot and volcanic, but apart from that, we really had to reinvent the Vulcans.

For the civilized areas of Vulcan, I actually took some inspiration from the 1982 movie Conan the Barbarian. Ron Cobb, the production designer, actually has a cameo in it, selling lizards on a stick. He's sitting there in this little booth with a bucket of swords, and I thought, "Wouldn't it be cool to base the architecture of the Vulcan city on upright swords?"

Although Enterprise only ran four seasons, we always thought it would go for seven. Manny Coto came on as showrunner in season four, and he had a very specific direction he was going for with the show and where it would go in the future, but somewhere towards the end of season four we got the feeling that something was wrong and the show wasn't going to continue. When we got to the end of the series we

**ABOVE:** Sketches for Vulcan ambassadors.

**RIGHT:** The United Earth Embassy on Vulcan. The faceted and angular lines contrast with the curved shapes of the architecture in the capital city.

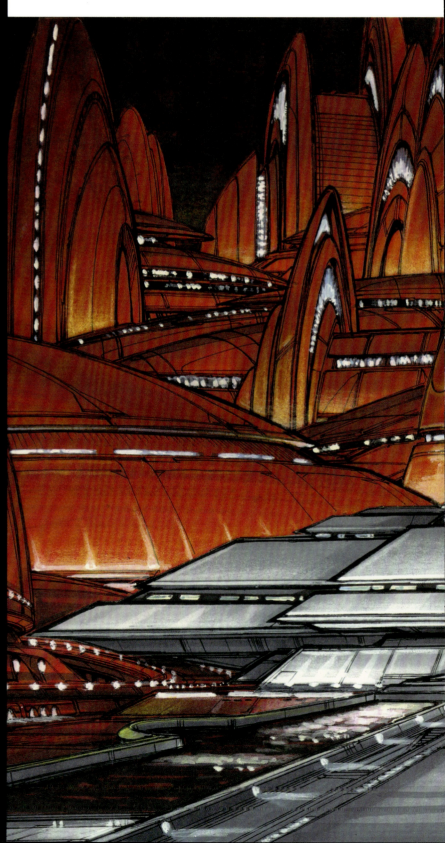

started to realize what was going on. People were protesting outside the gate, saying, "Keep *Enterprise* going, keep *Star Trek* going!"

After *Enterprise* finished, Herman semi-retired and everyone went in different directions. Mike started doing some work for NASA as well as assisting in the remastering of *The Original Series*. Jim and Doug had become full-blown CG graphic guys, while a lot of the other people moved on to TV work. It was a very sad parting; we had been together on and off, at least for my end, for almost ten years. I thought, "Well, *Star Trek* is gone forever and we'll never see it again!" but then J.J. Abrams came in to reinvent *Star Trek*, which was a monumental task...

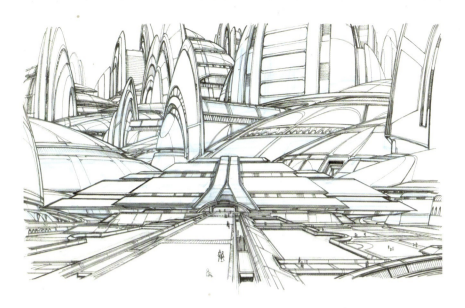

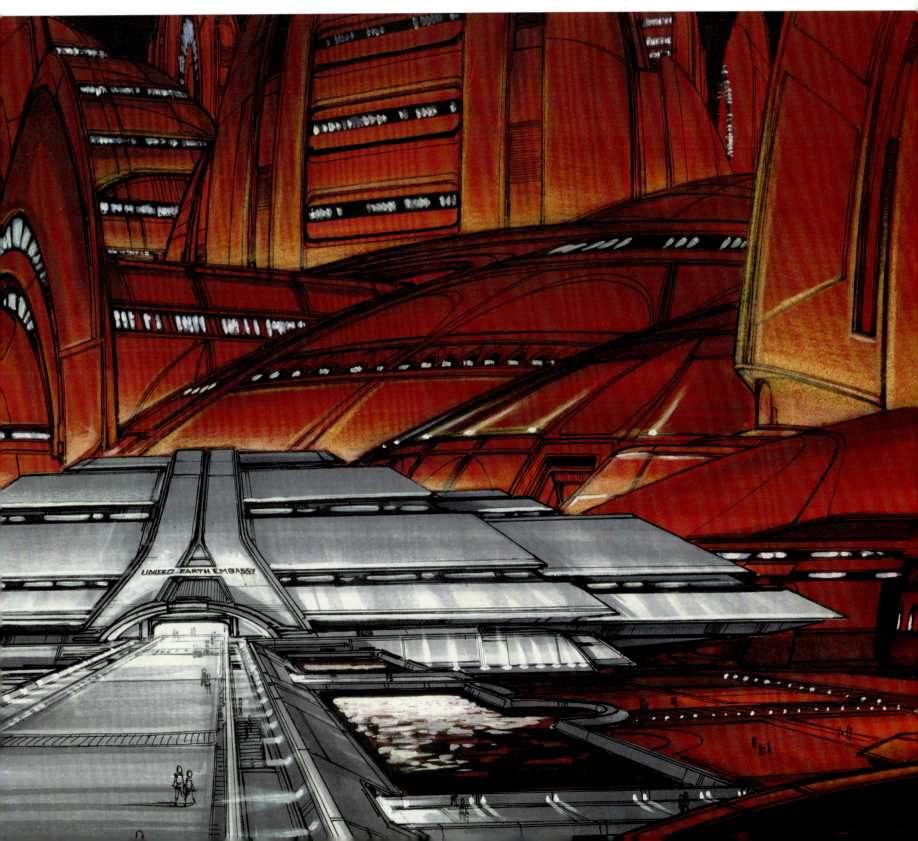

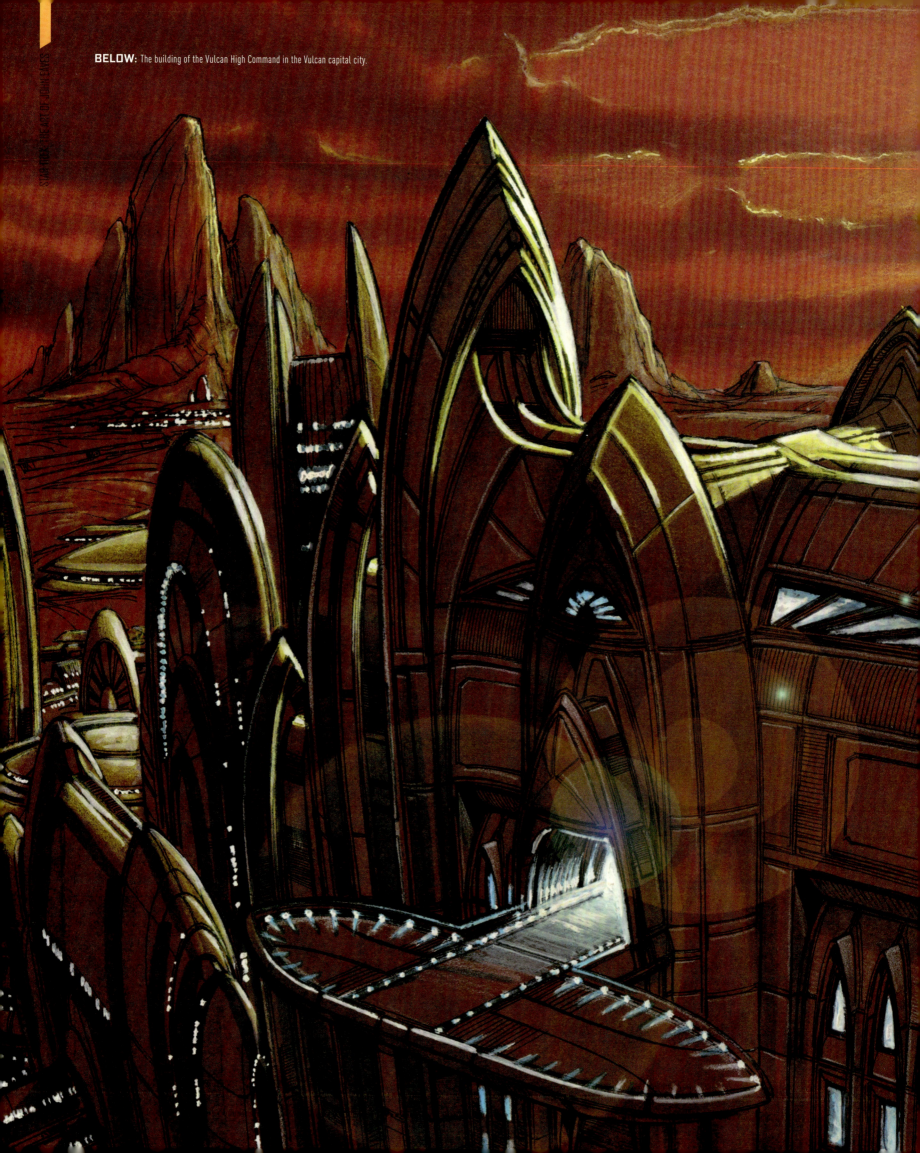

**BELOW:** The building of the Vulcan High Command in the Vulcan capital city.

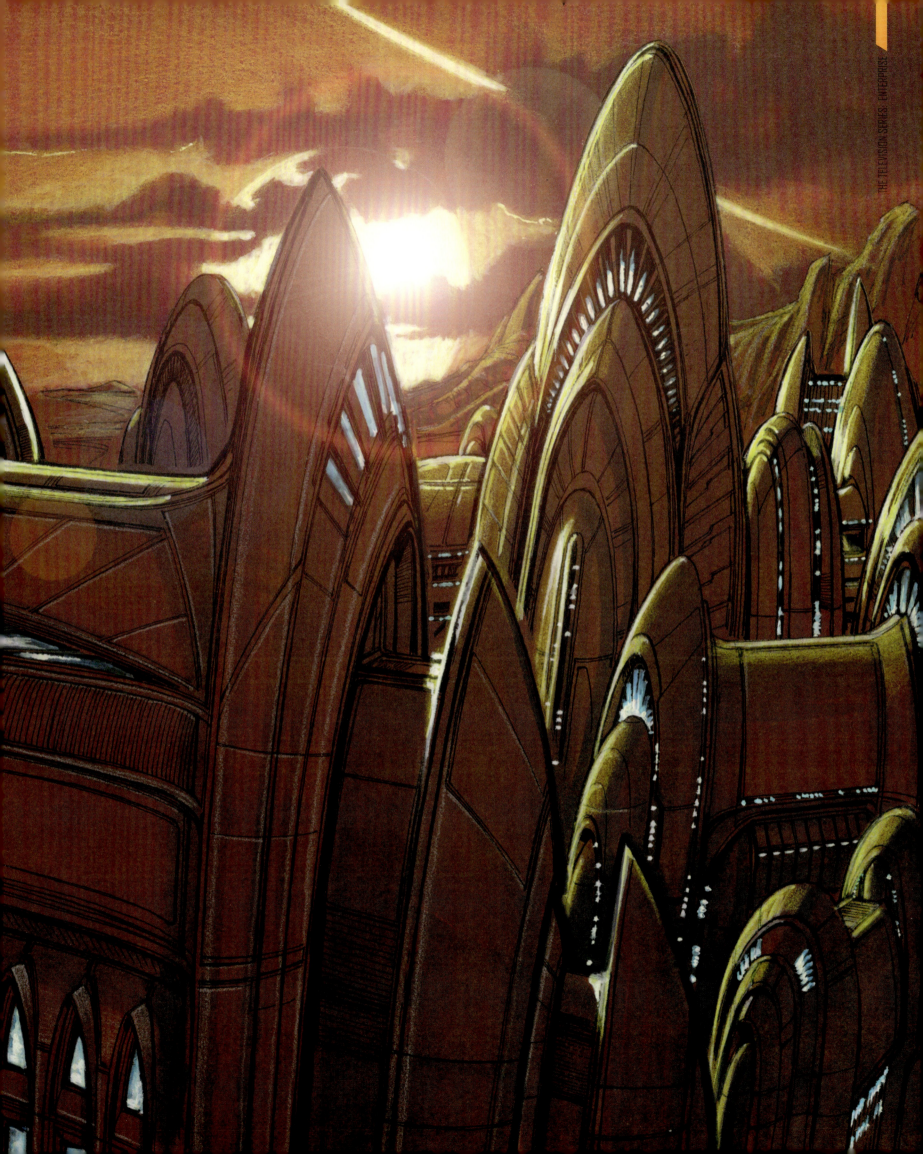

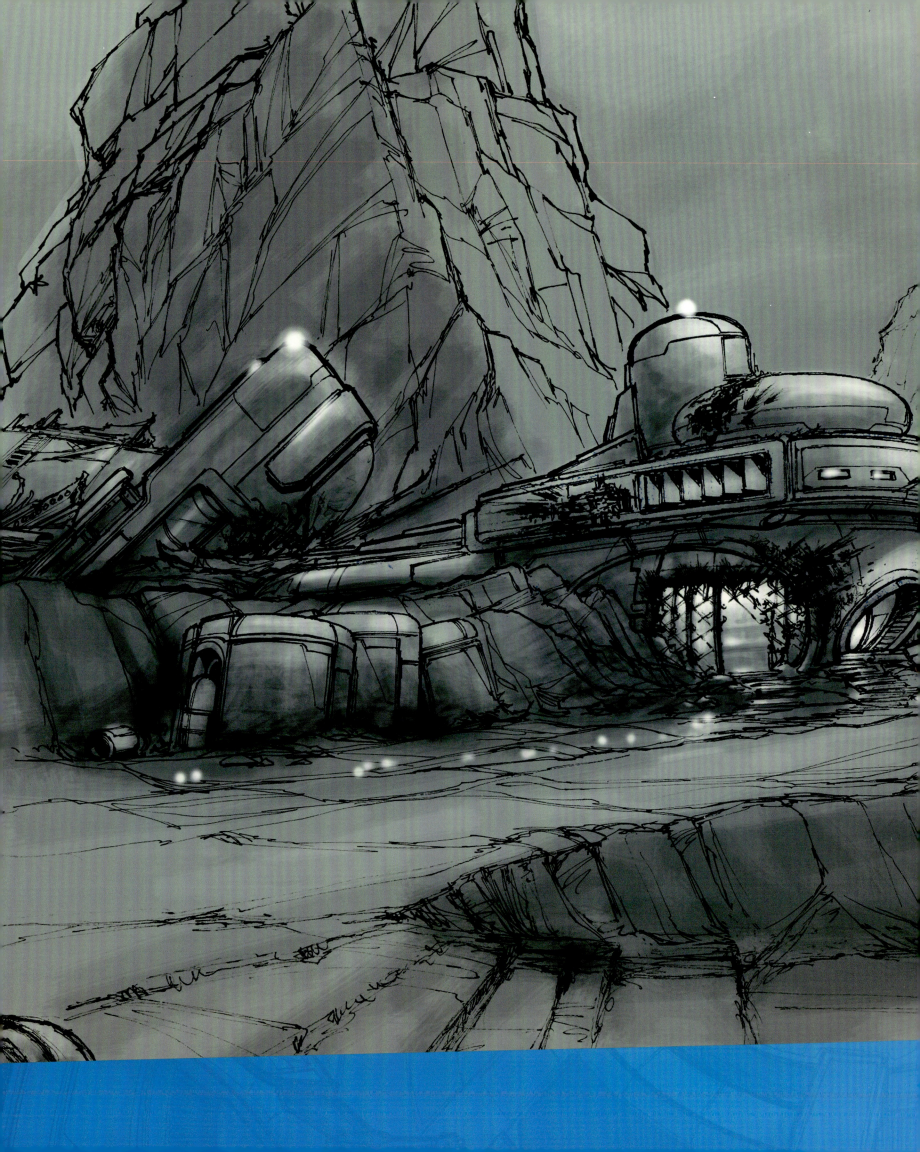

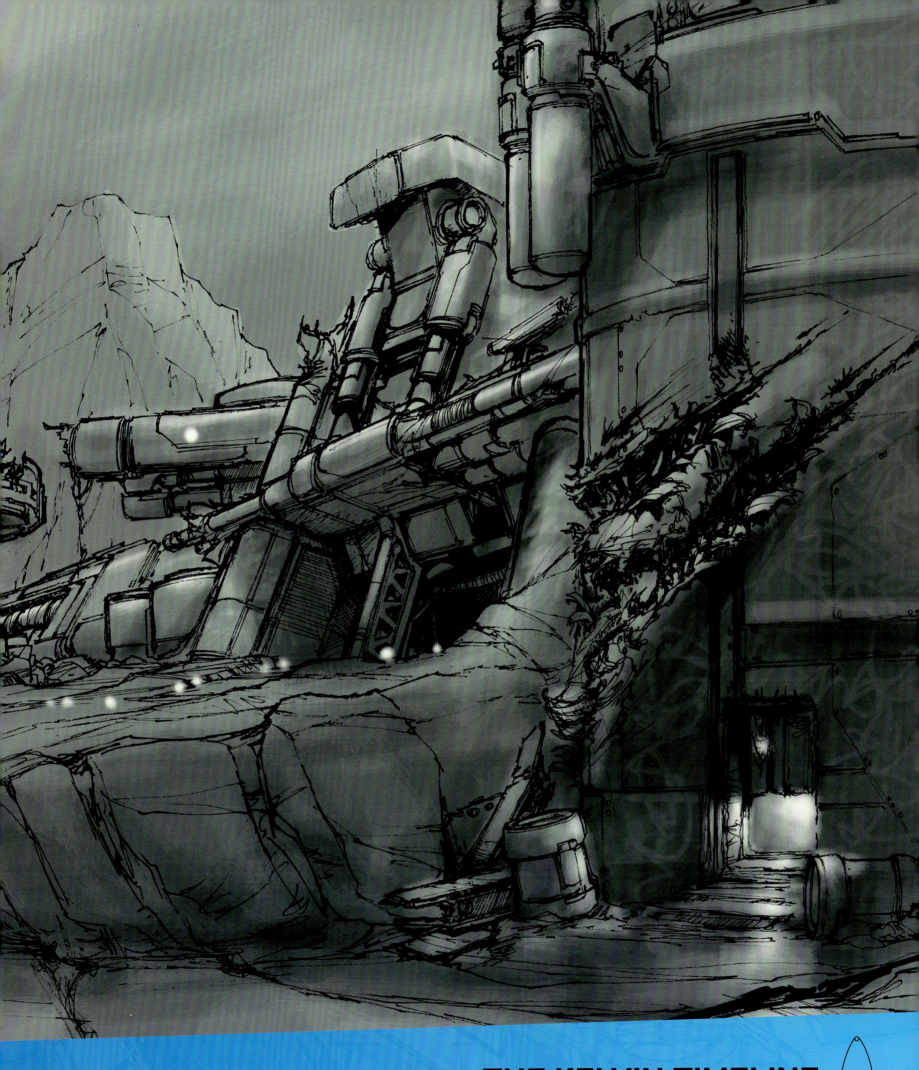

THE KELVIN TIMELINE

# THE KELVIN TIMELINE: STAR TREK

## "I COULDN'T BELIEVE THEY WERE BRINGING *STAR TREK* BACK."

A couple of years after *Enterprise*, I got a call from production designer Scott Chambliss. I first met Scott in 2005 when I was finishing *Enterprise* and he was working on the third *Mission: Impossible* film a couple of trailers away at Paramount. In early 2007, Scott called and said, "We're starting the next *Star Trek*, and I was wondering if you would like to join the crew." At first I couldn't believe they were bringing *Star Trek* back, but I said I'd love to be involved. About a week later, Scott called and told me that the production team didn't want too much design influence from the old TV shows or films, especially on the creative side, such as the art department.

But sometime in the summer of 2007, Scott called again and said, "I've had to let a couple of illustrators go, and you're on my availability list, but I have to ask you: if I bring you on as a test, could you try and not be influenced by what you did before?" I wasn't in the main art department, but Scott started giving me things like shuttlecraft to work on. Fortunately, that initial month worked out well, and I ended up working on the film for four or five months.

For the new film, J.J. Abrams was working to create a movie based on an alternate timeline, so that's where the rule came from: "We don't want any influence from the older series or movies," but they eventually discovered there was a lot of crossover with the previous work we had done. For example,

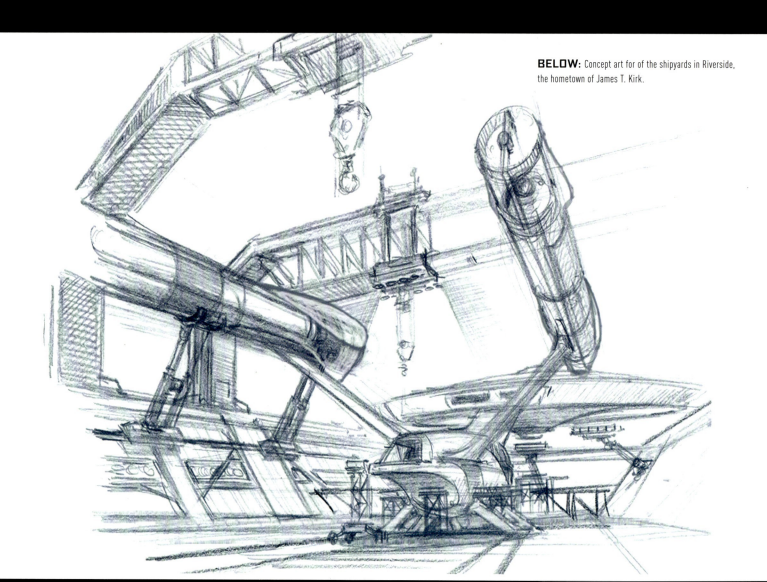

**BELOW:** Concept art for of the shipyards in Riverside, the hometown of James T. Kirk.

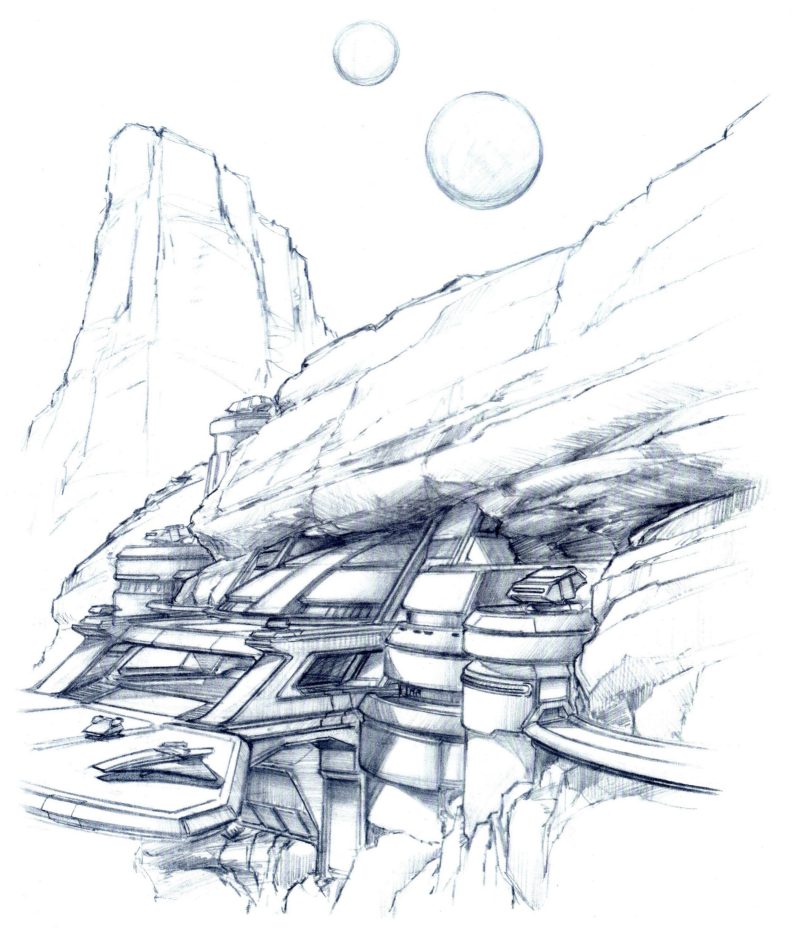

**ABOVE:** Concept design for a shuttlebay entrance on Vulcan.

we once used septic tank covers on the Klingon ships, and on this film, a guy came in one day carrying the very same covers and saying, "Look what I found; these would be great for the Klingon ships!" so they were rediscovering things we had done before.

# KELVIN SHUTTLE

On the other hand, Scott's point of view was that we needed a little bit of a tie-in. As I knew the old shows he wanted me to try and create some projects in a more traditional style. The first assignment he gave me was the shuttles for the *Kelvin*.

We needed a shuttle for an evacuation sequence in which George Kirk's wife escapes the doomed *Kelvin* with their newborn son James. The *Kelvin* was supposed to be a bit further back in time, so the aesthetic could be more retro in style. I tried to find a way to tie in the old Matt Jefferies shuttle to what Ryan Church and concept artist James Clyne were doing—I basically used what they had going on as a new sounding board, while trying to tie the two worlds together.

To keep in line with the design aesthetics of the original show, we started out with very blocky forms, but we worked with rounded corners to create a point of difference from the 60s style. The first pass of the craft had inset nacelles and was very rectangular in shape. Scott imagined that these shuttles were to be very utilitarian, with function over comfort, so we carried modern military design elements into our sketches. We also tried a version with a single nacelle on top of the ship to tie in with Ryan's designs for the *Kelvin*.

After trying a variety of different designs for the shuttle, we eventually moved more towards the style of Matt Jefferies' *Galileo* from the original *Star Trek* TV series. We made a few changes to Jefferies' original design with a few new details. Scott wanted stretched nacelles as opposed to flat wings, and the windows are sleeker; we also added exterior impulse engines to bulk up the back. But overall, our design really harkened back to the original *Galileo*.

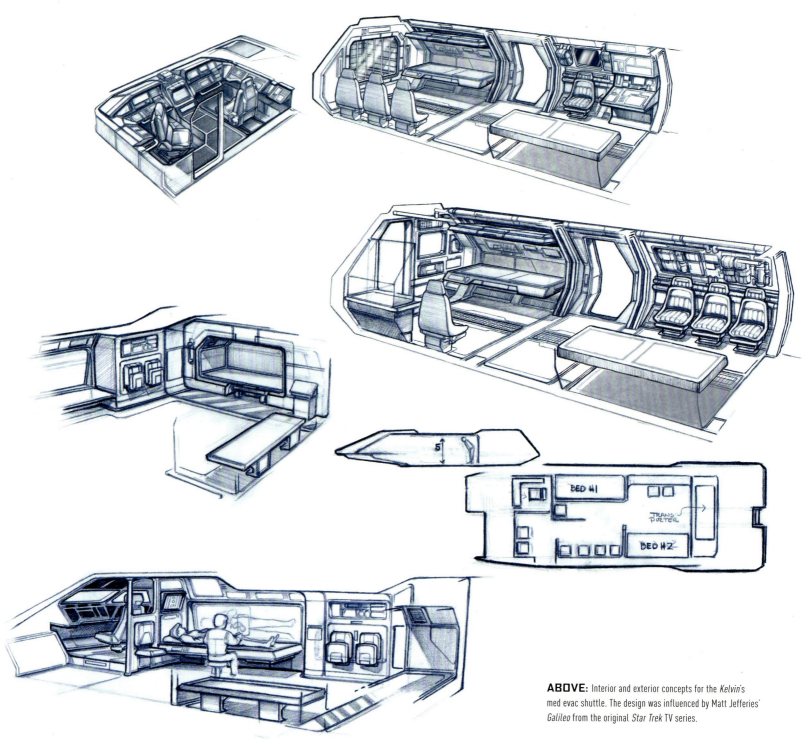

**ABOVE:** Interior and exterior concepts for the *Kelvin*'s med evac shuttle. The design was influenced by Matt Jefferies' *Galileo* from the original *Star Trek* TV series.

# ENTERPRISE SHUTTLE

**W**hen we got to the *Enterprise* shuttle, Scott suggested we make it a little sleeker and more like Ryan's *Enterprise*, so I would talk to Ryan about what he was doing, which was beautiful and streamlined. My drawings are actually based on his earlier designs for the *Enterprise*, which is different from the one you see in the film, so the shuttle nacelles were more in line with that original design.

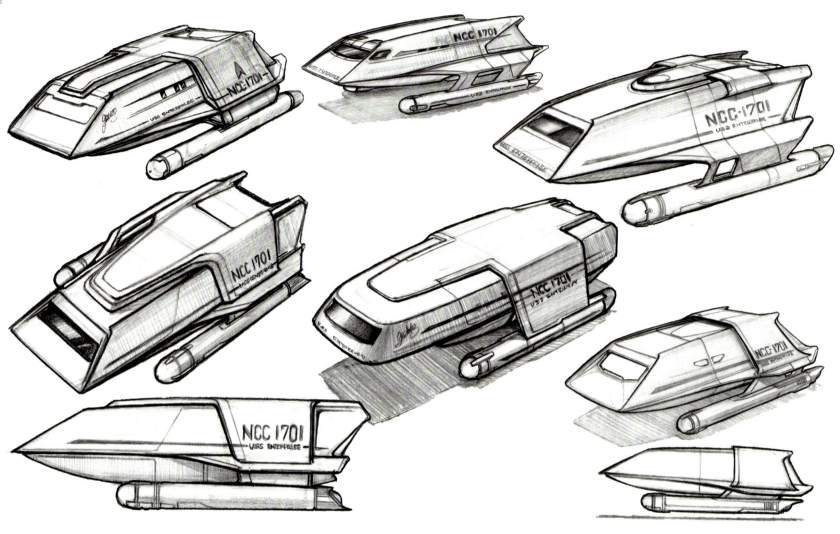

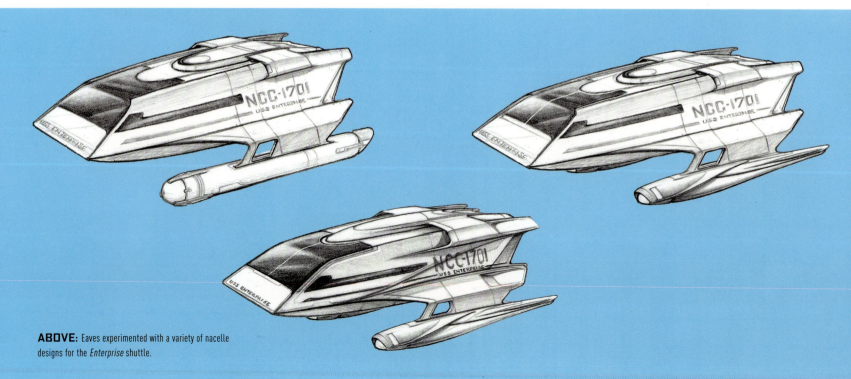

**ABOVE:** Eaves experimented with a variety of nacelle designs for the *Enterprise* shuttle.

**RIGHT:** Interior designs for the passenger shuttle.

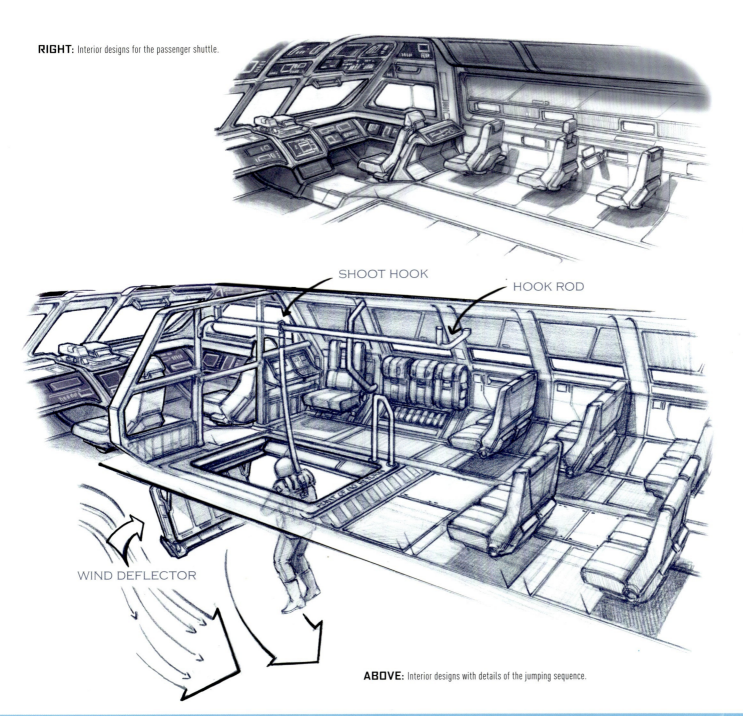

**ABOVE:** Interior designs with details of the jumping sequence.

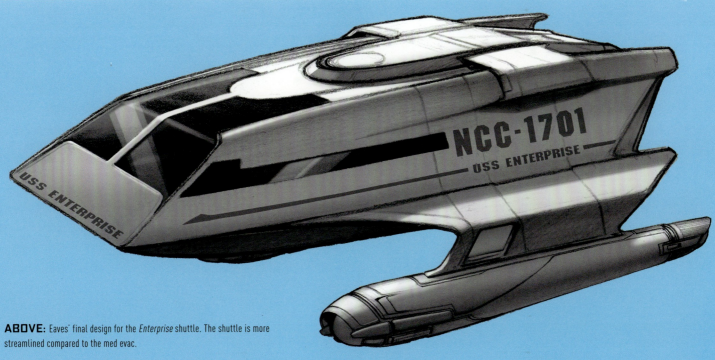

**ABOVE:** Eaves' final design for the *Enterprise* shuttle. The shuttle is more streamlined compared to the med evac.

# KOBAYASHI MARU AND KLINGON BATTLE CRUISER

Another early assignment was for the notorious *Kobayashi Maru* simulation that Kirk undergoes in the film. Mike Okuda referred me to a paperback novel by Julia Ecklar, which featured an illustration of the *Kobayashi Maru* cargo ship on the cover. I used the cover illustration as inspiration for my two designs, using similar elements like the underslung nacelles and faceted cargo modules. As this was one of my last projects, Alex Jaeger took over the design from here and you see his final version on film (although I wish it had got a bit more screen time!)

The Klingon warship in that sequence was actually a design I created for the very first episode of *Enterprise*. To help take the look back in time, I was inspired by the architecture of the Golden Gate Bridge. The long neck and engines are attached with heavy cables giving the ship an industrial framework. Even though it eventually got the boot, I thought the drawing had a really nice retro style to it and so did Scott.

Young Kirk cheating the no-win scenario is the stuff of legend. You never see the vessel in *Star Trek II: The Wrath of Khan*, so it was fun coming up with a new concept. Even though my designs didn't make it through, it was an awesome assignment working on this classic moment from *Star Trek* lore for JJ's new film.

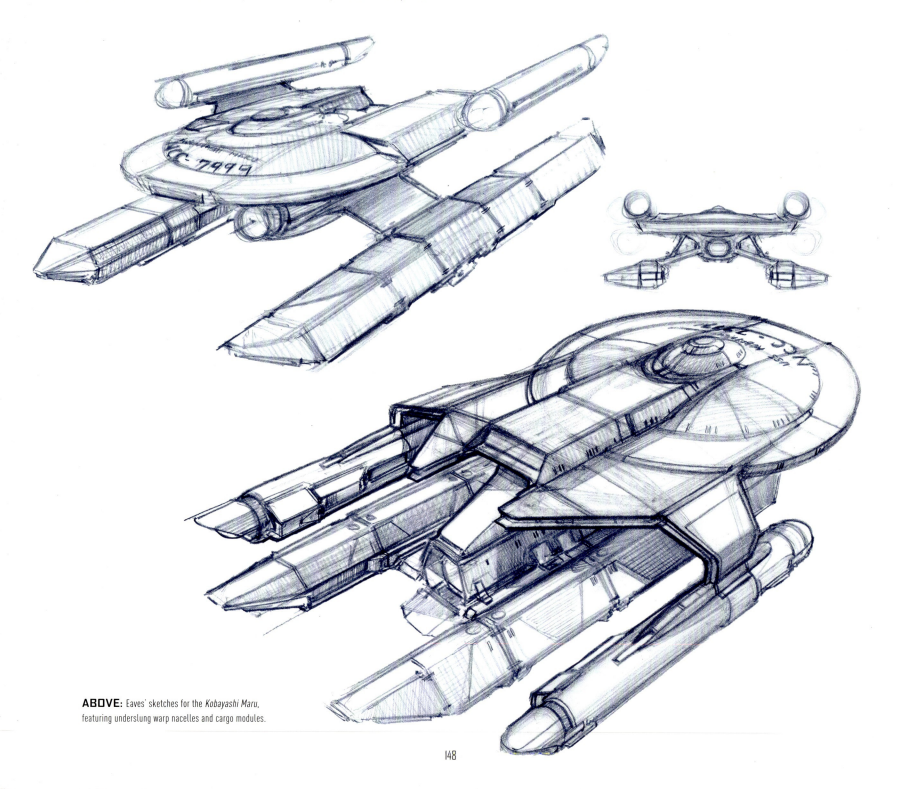

**ABOVE:** Eaves' sketches for the *Kobayashi Maru*, featuring underslung warp nacelles and cargo modules.

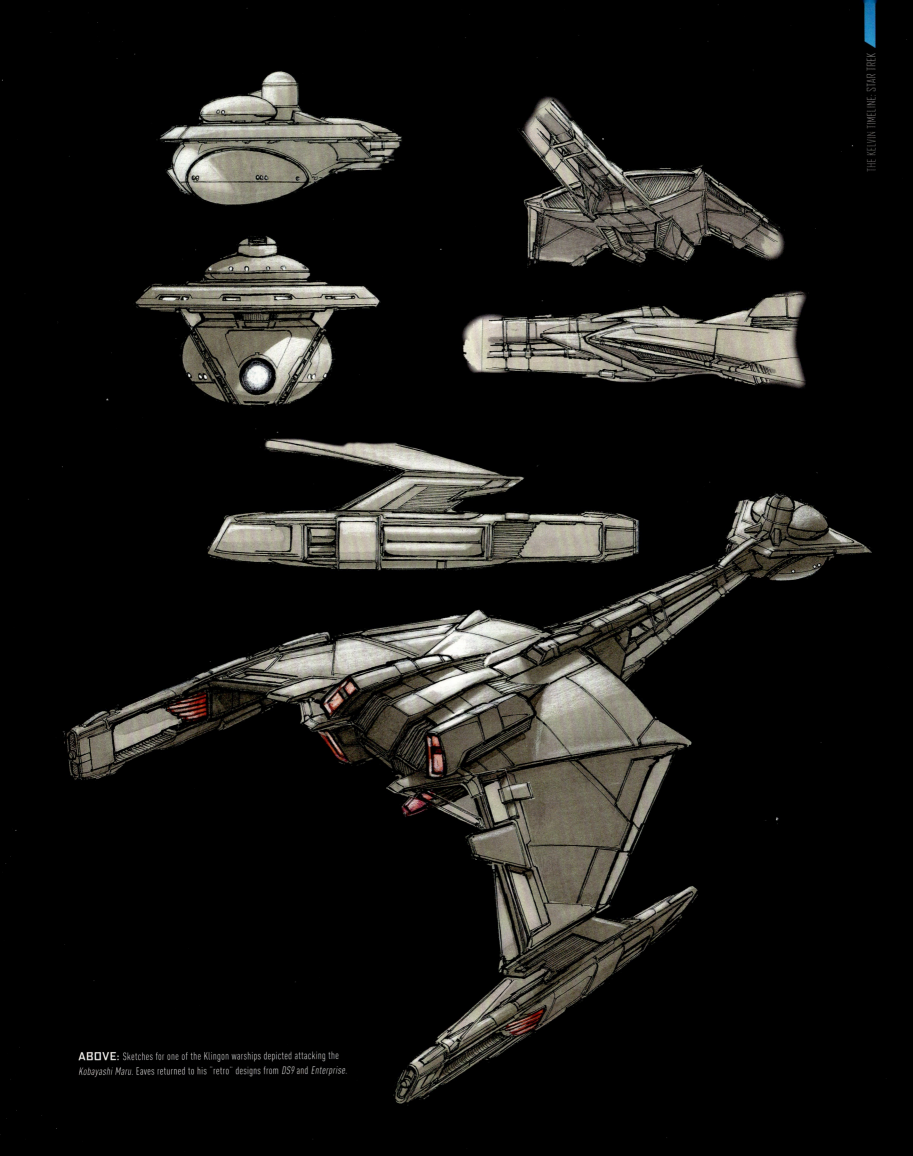

**ABOVE:** Sketches for one of the Klingon warships depicted attacking the *Kobayashi Maru*. Eaves returned to his "retro" designs from *DS9* and *Enterprise*.

# TECHNOLOGY

After working with Scott for a couple of months, I ended up moving over to props. Russell Bobbitt was prop master, and the only guy I knew who came in as early as I did in the morning. A lot of work had already been done—Paul Ozzimo had designed the phasers, tricorders, and major hand props—but there were still a few things they needed.

One of the first props I worked on was called a 'Bento Box.' It contained a Starfleet officer's equipment, including their uniform, tricorder, and Starfleet insignia. I also made up a fake phaser and threw it in there with some other props that were changed afterwards.

There was a scene in an odd-looking bar, where they needed some kind of credit device. I designed a few options for a hi-tech card and card reader, which would display all of your credit information.

In the scene with Kirk being born on the med evac shuttle, we needed a bunch of experimental medical equipment. I worked up a few options for Russell, including optimizers, transmitters and X-ray readers.

**BELOW:** Design for a Starfleet officer's Bento Box, containing their uniform, tricorder, and Starfleet insignia.

**ABOVE:** Designs for the *Kelvin*'s medical equipment used to treat George Kirk's pregnant wife Winona when she escapes on the med evac with their son James.

I loved working in the *Star Trek* art department. Ryan Church and James Clyne especially are extremely talented guys who will share anything with you, so it was a great working environment. We had wonderful art direction from Scott, as well as Curt Beech and Keith Cunningham, and everything flowed really well. Each department communicated with each other. I had a great relationship with Russell, and I worked on a few movies with him after that. Paul and I had worked together in the Apogee and Boss Film model shops 10-15 years earlier, so it was fun to hook up with old faces and to meet some great new people.

**BELOW:** Sketches of Starfleet credit card reader panel and credit cards.

**ABOVE:** Interior concept of a wrecked Klingon battle cruiser turned into a bar, with a gas-powered beverage dispenser.
**BELOW:** Starfleet personnel data card reader and data cards.

# STAR TREK
## INTO DARKNESS

### "WE HAD A LOT MORE DESIGN FREEDOM."

Working on the second film was a very different experience, because it was extremely high-security. Everything was nicknamed to keep it secret, so there was a cargo ship called 'the dump truck,' and something else called 'the spanker' (most of the names had nothing to do with what you were doing). They would come in and say, "Okay, we want the spanker to coordinate with this and this..." and you'd wonder, "What are you saying? Is this for the good guys or bad guys?" They were restricted in terms of what they could tell you, and that really influenced what we were doing. I was doing props for a character named April, for example, and it wasn't until the very end that I found out it was actually Khan. If I had known from the beginning it was Khan, I might have drawn things differently, so that inhibited you in a way, because if you knew a bit more, you might have put a different spin on things.

On the other hand, some rules we had on the first film about not acknowledging the original series pretty much went away, so we had a lot more design freedom.

Scott Chambliss was still leading the production design on the second film. Scott sees things in a very interesting way. Everything is based on what he sees in his home or out shopping. While everyone else has a more traditional approach, his take is more unusual. Andy Siegel was working as the prop master in the art department—we had worked with in the model shop at Boss Film—and it was great that we got to work together again on the new look for *Star Trek*. I had a very fun collaborative creative process with both Scott and Andy during this film.

**BELOW:** John Eaves' designs for "retro" Starfleet communicators.

**RIGHT:** Designs for the *Enterprise* warp core were inspired by European particle colliders and elements of the National Ignition Facility at Lawrence Livermore National Laboratory, where other elements of the engineering areas were filmed.

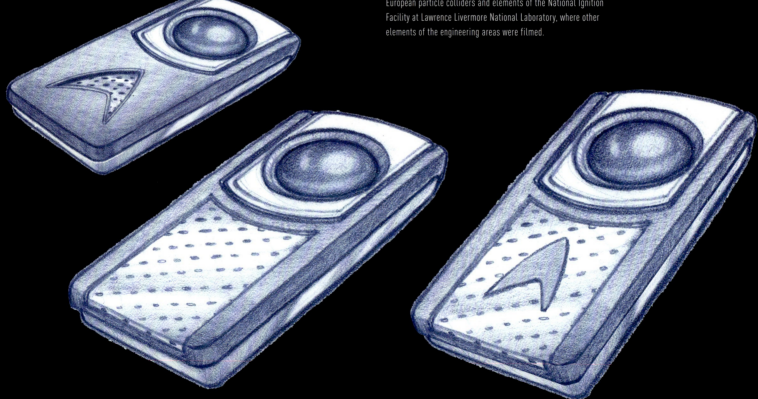

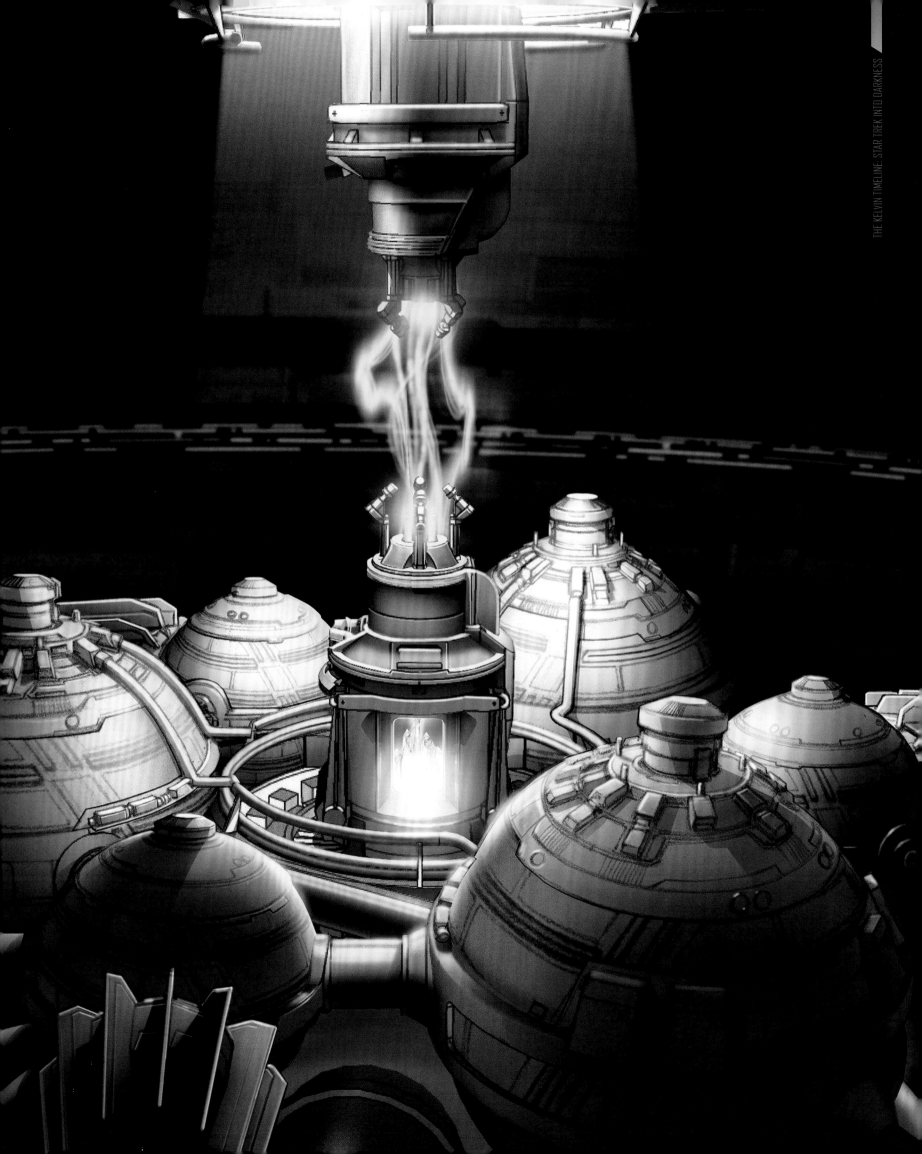

# NIBIRU

The original story for *Into Darkness* featured an elaborate opening, which was very short but extravagant, with different civilizations and cultures. Neville Page created some amazing early designs for the aliens, and from there it was a very collaborative process. As the film developed the opening scene went through significant revisions due to budget constraints, so a lot of the early concepts I created didn't make it in the film. But it was still really fun working together, and a lot of the elements contributed to the final look of the Nibirans.

The Nibiran weapons were the first props I was assigned to work on. I wasn't given much detail on the species, so I researched primitive weapons for inspiration, as well as designing symbols and patterns to represent that culture. I knew the designs centered around a primitive alien civilization that used blowguns, clubs, and spears, so I gave these weapons a *Star Trek* aesthetic.

We started out designing props based on Neville's original concepts for enormously tall, gangly characters that used sticks you could scoop up a rock with and throw it like a slingshot. I also drew a selection of long spears and stones tied with fabric to make them easier for throwing. I used a lot of weaves and braids to tie together the designs of the alien weaponry to give it an authentic, handmade look.

Neville Page was also coming up with all kinds of fantastic alien creatures on horseback, so I designed a few concepts for riding saddles for Nibiran mounts. I drew a saddle for one of the creatures to use, featuring three or four strands of fabric that are cut in a bevel on a shell, and that was something that tied everything together visually.

The Nibiru planet was under threat from a gigantic volcano, so the *Enterprise* crew were there to save them from extinction. The mission called for a 'volcano bomb', which Spock would use to prevent a catastrophic eruption. In the script, Spock falls, breaking the device, and there's a tense scene where he has to manually activate the bomb. In the original concept sketches, Spock connected his tricorder to the device, but this was too complicated for the timeframe of the scene. The final bomb was a lot simpler and could be triggered by a manual override on the device.

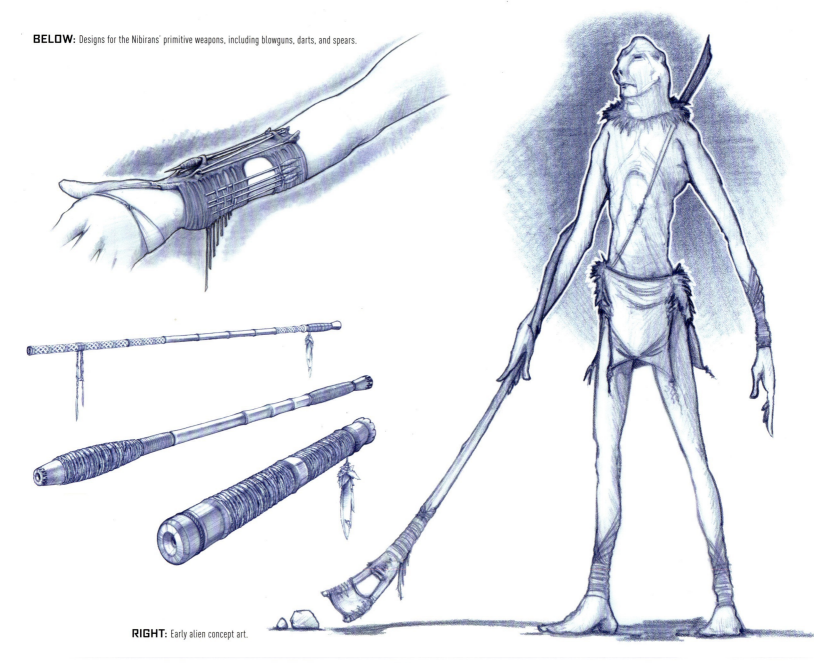

**BELOW:** Designs for the Nibirans' primitive weapons, including blowguns, darts, and spears.

**RIGHT:** Early alien concept art.

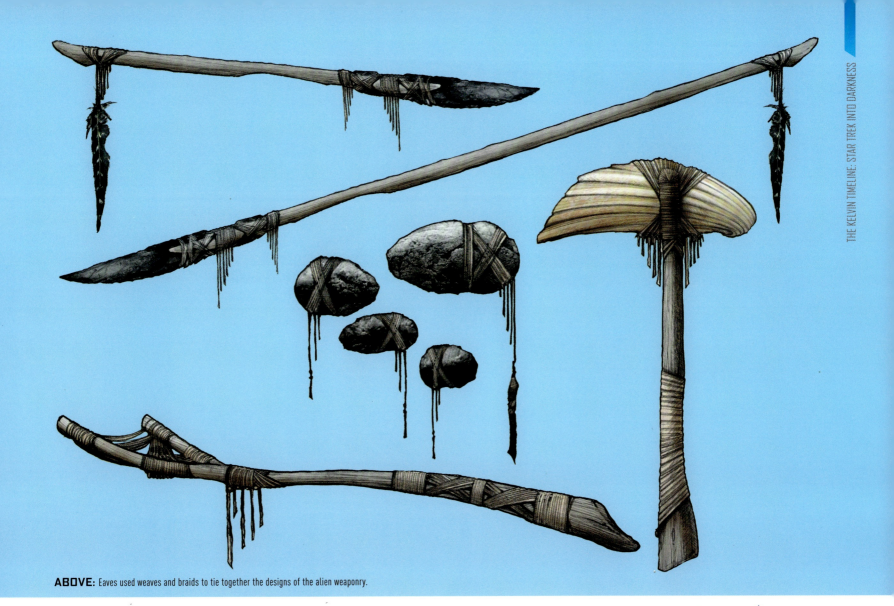

**ABOVE:** Eaves used weaves and braids to tie together the designs of the alien weaponry.

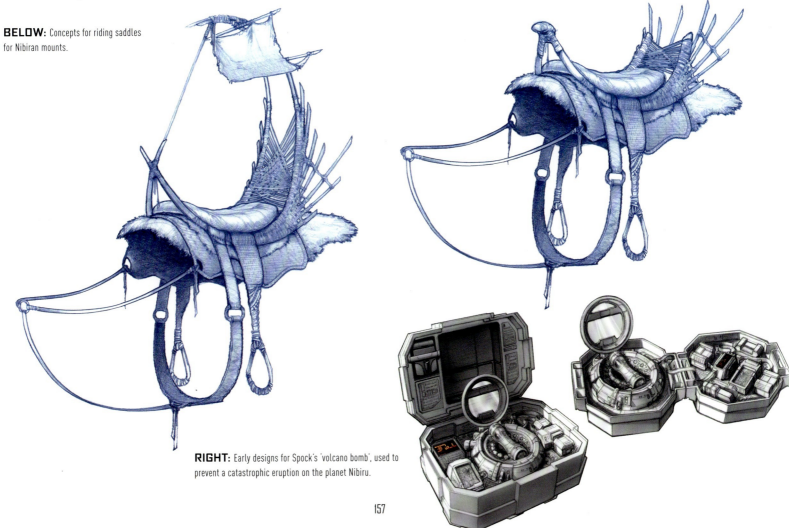

**BELOW:** Concepts for riding saddles for Nibiran mounts.

**RIGHT:** Early designs for Spock's 'volcano bomb', used to prevent a catastrophic eruption on the planet Nibiru.

# STARFLEET WEAPONS

Kirk, Spock, and Uhura end up in a shootout with Klingon troops—and Khan—on the Klingon homeworld, Kronos. For this scene I was asked to design a range of heavy-duty weapons for Starfleet and the Klingons.

We went with a much darker tone on the Starfleet weapons for this film, and everything looked more battle-ready. We used a combination of silver with black chrome so it looked like metal underneath, and we did everything in that double-colored pattern. We also experimented a lot more with the shape of the barrels so you could really differentiate between each gun in the scene.

J.J. also wanted to see some different features in the phaser rifles, including a visible pistol chamber where you could see this mechanism flipping the rounds on the inside. We came up with the idea of power cells, so they fire and rotate around, recharging themselves as they rotate out, so it was a fun idea. It ended up not being used, but the cut-out is still on the rifle where the mechanism would be.

**BELOW:** Eaves designed a range of heavy-duty Starfleet weapons for the battle on Kronos.

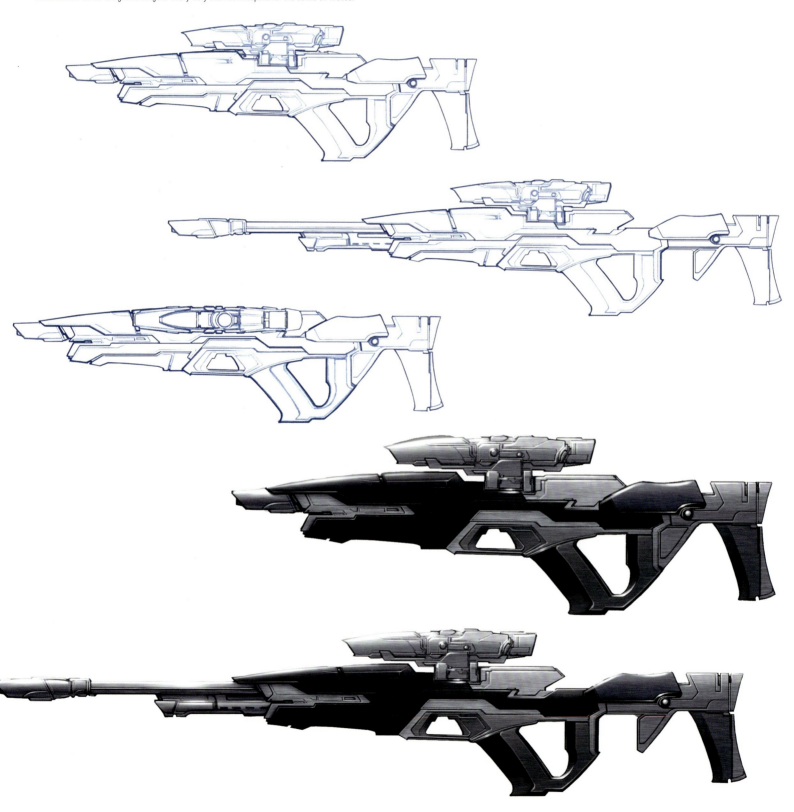

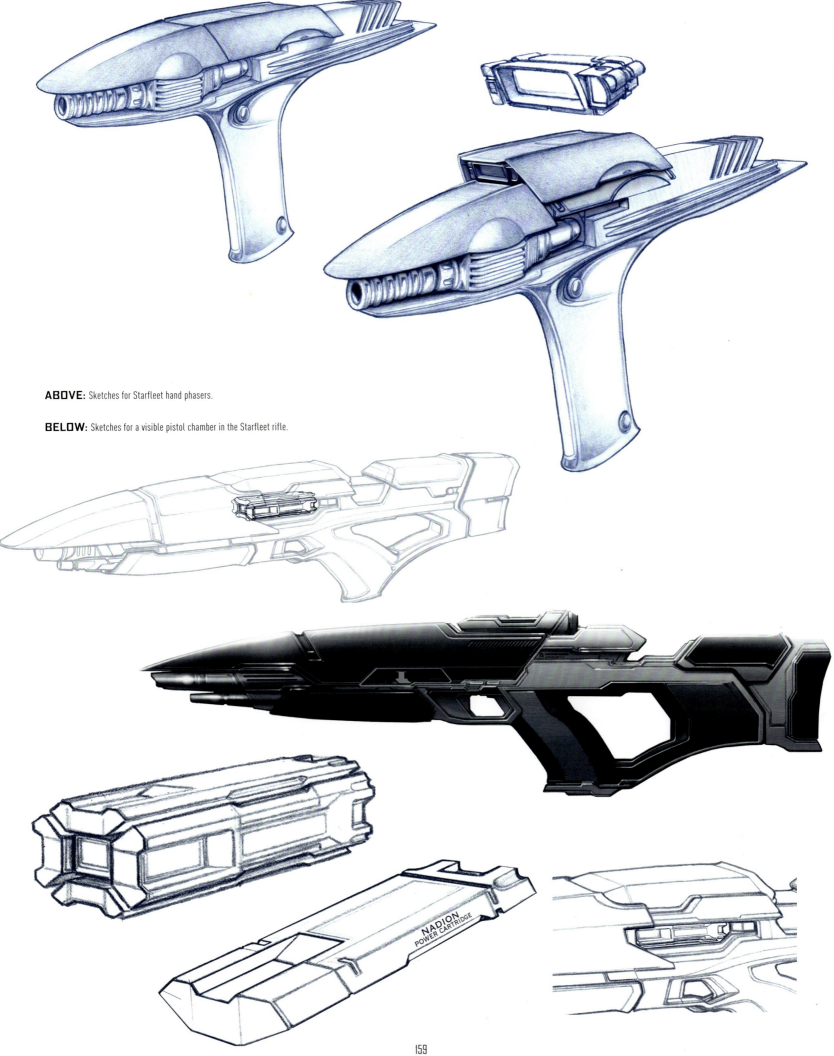

**ABOVE:** Sketches for Starfleet hand phasers.

**BELOW:** Sketches for a visible pistol chamber in the Starfleet rifle.

# VENGEANCE WEAPONS

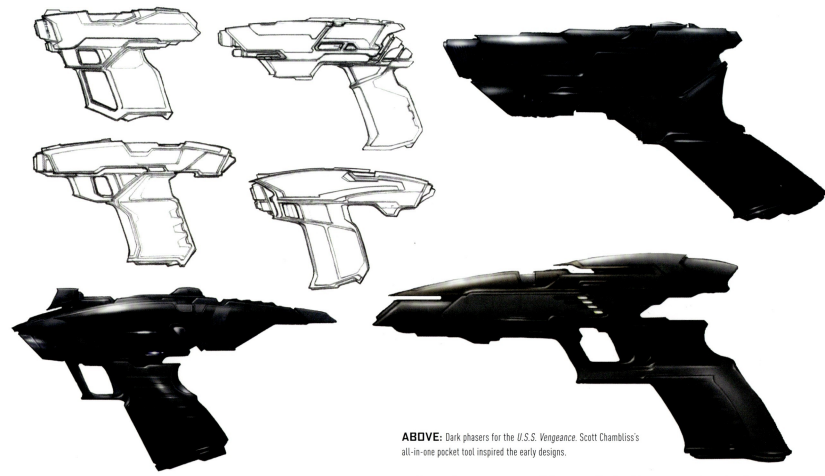

**ABOVE:** Dark phasers for the *U.S.S. Vengeance*. Scott Chambliss's all-in-one pocket tool inspired the early designs.

The *U.S.S. Vengeance* was originally referred to as the 'Black *Enterprise*,' which I thought sounded really badass! I started to think, "What would the weapons look like if Starfleet were bad guys?" The phasers and phaser rifles I designed for *Vengeance* all have a really deep, dark color pattern, because everything on that ship was going to be black. One of the props Scott had me design was a phaser for the dark *Enterprise*. He brought in this handyman tool, one of those things that folds out with pliers and everything else, and said, "Take this, make a phaser out of it, and make it dark!" You can see those plier grips on one of the older phaser designs.

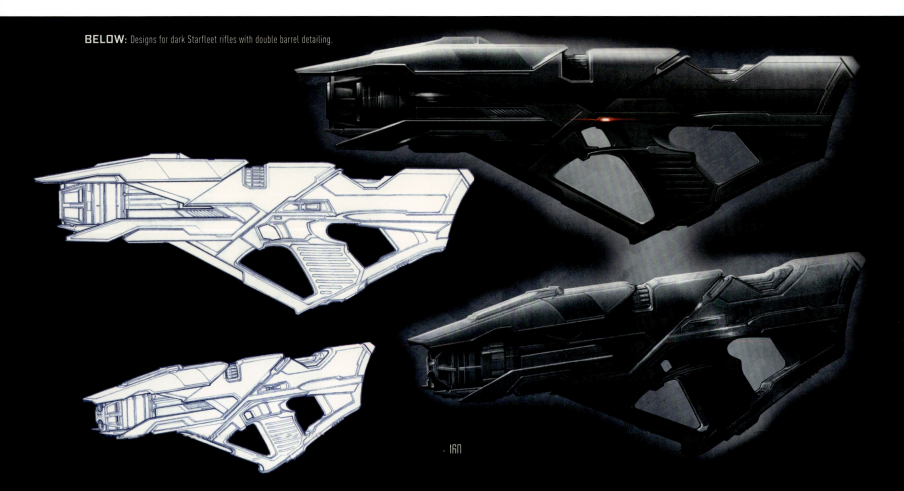

**BELOW:** Designs for dark Starfleet rifles with double barrel detailing.

# KLINGON WEAPONS

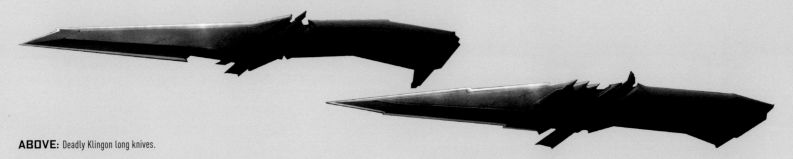

**ABOVE:** Deadly Klingon long knives.

I used the costumes Neville designed for the Klingons as the basis for their weapons. The early sketches looked a bit pirate-like, so I designed the first set of Klingon phasers to look like flintlock guns. I drew the handle and firing area as all one gentle curve, and I used the hard details to sell it as a Klingon weapon. I did three versions before thinking, "Maybe I should put a short bayonet on the front, and so instead of shooting you, they'll gouge you with the bayonet!" That idea struck a chord with Scott and Andy, so that blade ended up there through the entire design process.

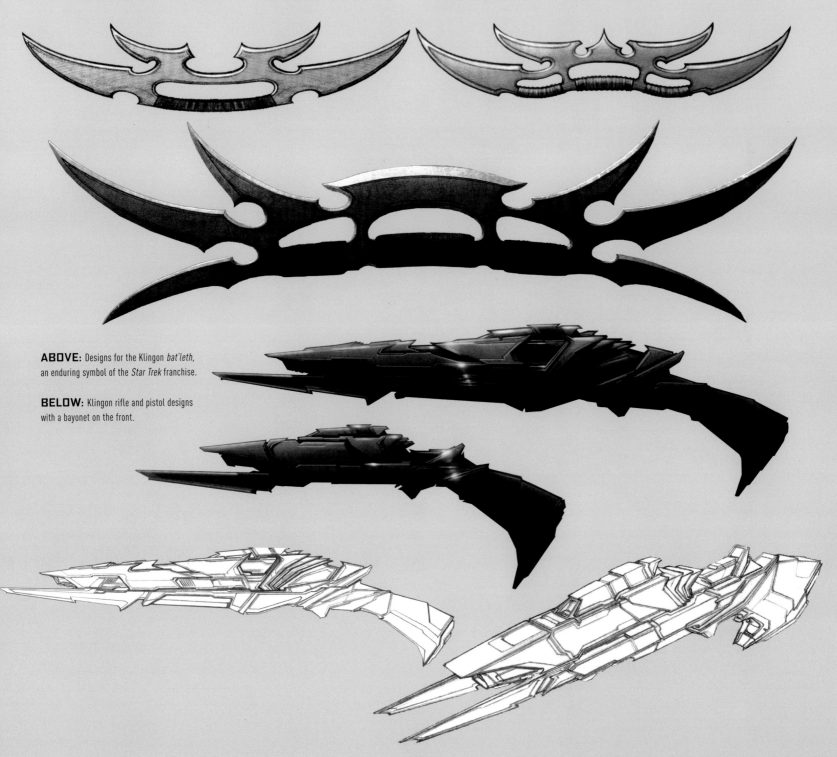

**ABOVE:** Designs for the Klingon *bat'leth*, an enduring symbol of the *Star Trek* franchise.

**BELOW:** Klingon rifle and pistol designs with a bayonet on the front.

# STARFLEET TECHNOLOGY

We designed lot more medical equipment for this movie to tie in with the storyline behind Khan's enhanced abilities and the healing powers found in his blood plasma. We worked on numerous props, including medical tricorders and diagnostic equipment for analyzing blood.

Some of the medical props had key moments in the film, like the goofy eye scanner Bones runs around with. Scott and J.J. both liked it, so it was built a bit bigger to be even more of an obnoxious prop; more funny than serious, as we see this thing in Bones' hands while he's trying to take Kirk's vitals.

**ABOVE:** Modified Starfleet tricorders.

**BELOW:** Starfleet medical scanner used by Bones.

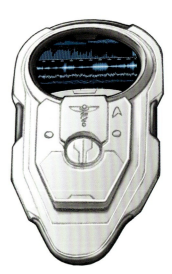

**RIGHT:** Starfleet medical tricorders.

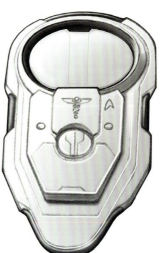

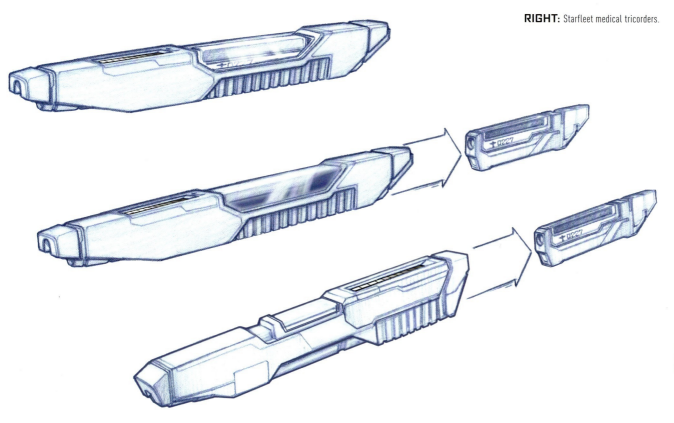

**ABOVE:** Variations on the blood draw device.

# KHAN'S TRANSPORTER DEVICE

One of our most unusual props was a mini-transporter device that Khan has to fit in his shuttle. We came up with these little things that he could put on either side of the seat, but they just didn't work because they looked too small. We were working on it really late one night at the studio when the inspiration suddenly appeared. What's funny about the studio is after everyone goes home at 7 p.m., the whole lot turns into Little Mexico—the cleaning people come in and they're playing Mexican music and eating tacos, and it's a lot of fun.

This guy came in with a vacuum strapped to his back and started vacuuming the halls, and I saw that vacuum and said, "Oh my God, that's the coolest thing I've ever seen!" I grabbed Andy and he agreed that it was perfect. We asked this guy if we could borrow his vacuum but he didn't speak English, so we had to find his supervisor and ask him if we could borrow this vacuum. We literally took the vacuum off this guy's back and took pictures of it, and I started drawing this transporter device based on this vacuum and that ended up being the prop. That poor guy had no idea what was happening, so he was very glad when he got his vacuum back!

**BELOW:** Designs for Khan's mini-transporter device.

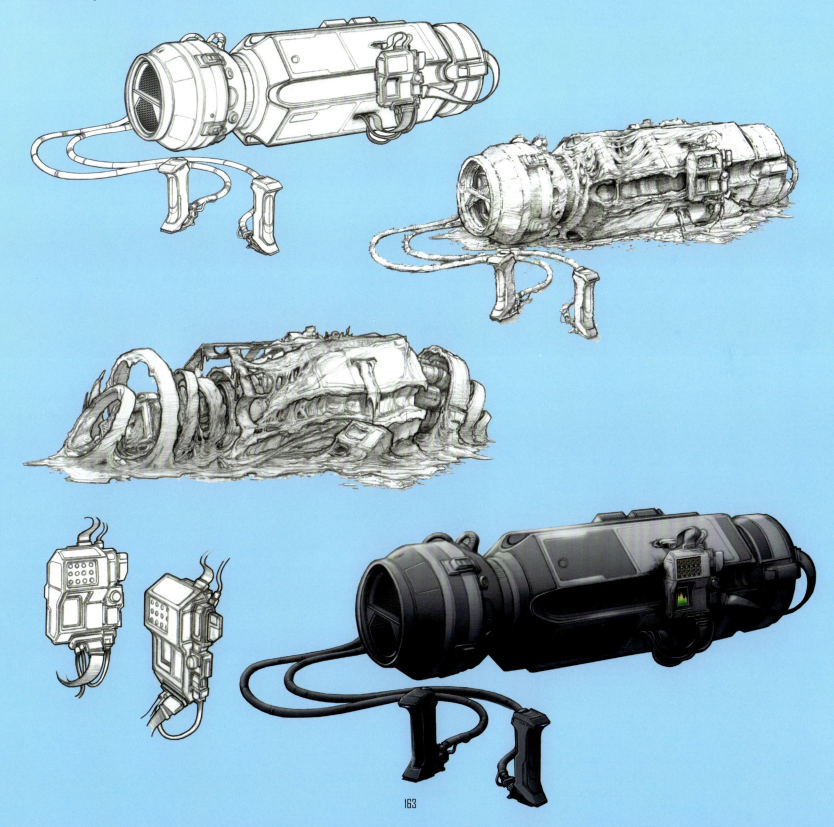

# KHAN'S GATLING GUN

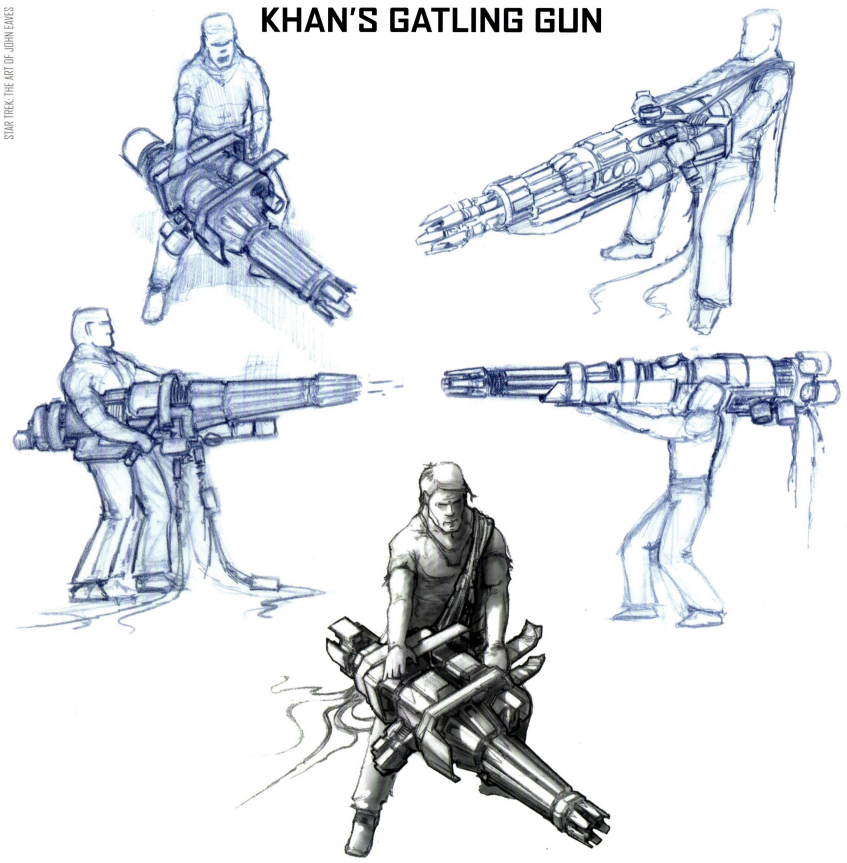

**K**han's Gatling gun was an interesting idea. The original beat sheet said, "Khan wields a Gatling gun to take out the Klingons," so it was originally drawn as a traditional weapon, but as the script developed, we increased the size considerably. We received a note that this big gun he's holding was originally on the exterior of a crashed Klingon ship. Khan rips off this huge gun and wraps the cable around him like a strap to hold up this inhumanly heavy weapon. That's why you see ripped-up metal on the sides in some of the early sketches. I also did several sketches showing a small character holding this enormous gun in front of him or on his shoulder like a bazooka, because they wanted it to be enormously over-scaled to show how strong Khan was. We kept changing the size to the gun you finally see in the film, and part of the barrel is computer-animated.

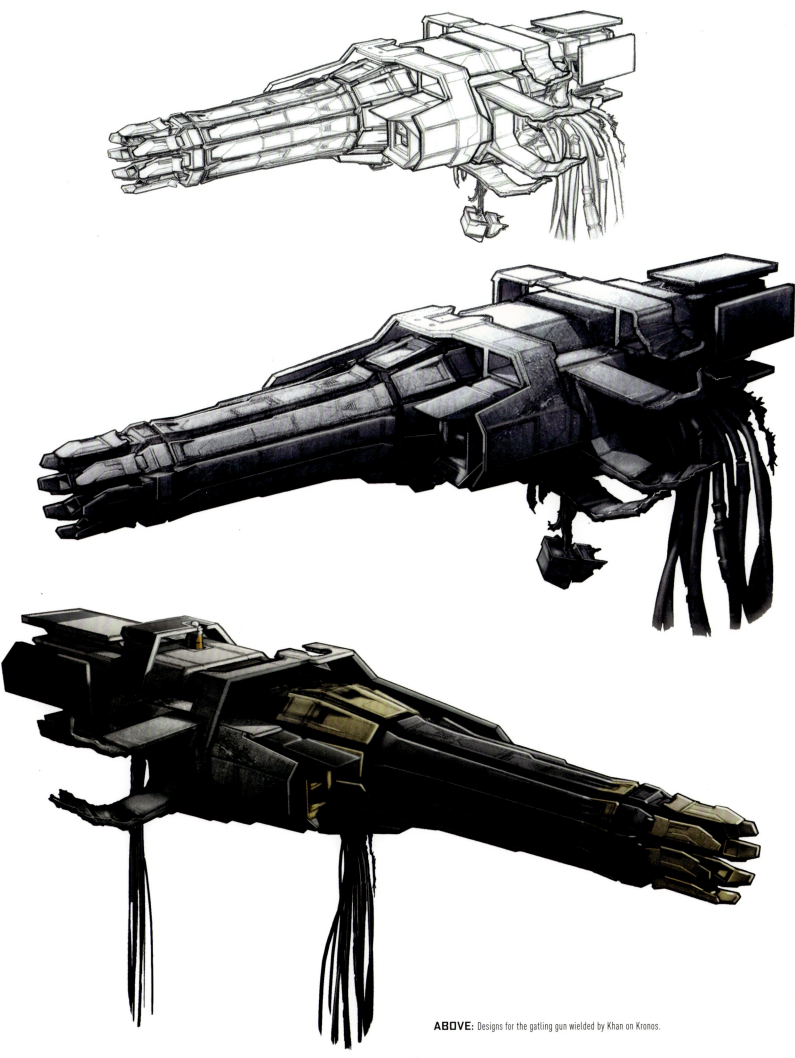

**ABOVE:** Designs for the gatling gun wielded by Khan on Kronos.

# STAR TREK
## BEYOND

### "I WOULD BE TYING TOGETHER A TRILOGY BASED ON THE ADVENTURES OF CAPTAIN JAMES T. KIRK."

Over three decades before, I made my first venture into the *Star Trek* Universe working alongside Greg Jein on *Star Trek V*. On *Beyond*, I would be tying together a trilogy based on the adventures of Captain James T. Kirk.

When Justin Lin came in as the new director, he wanted to bring in his own crew, so Scott Chambliss ended up not coming back but Andy Siegel did. I had just finished another project, so it was just by accident that I got back in.

Tom Sanders was brought in as the new production designer, and it was his last movie as it turned out. Tom had done all of Mel Gibson's movies like *Apocalypto* and *Braveheart*, so he was a brilliant designer and I was a big fan of his work. When I heard he was designer, I thought, "*Star Trek* is going to have a whole new look!" just based on his style, which was heavily practical as opposed to CG.

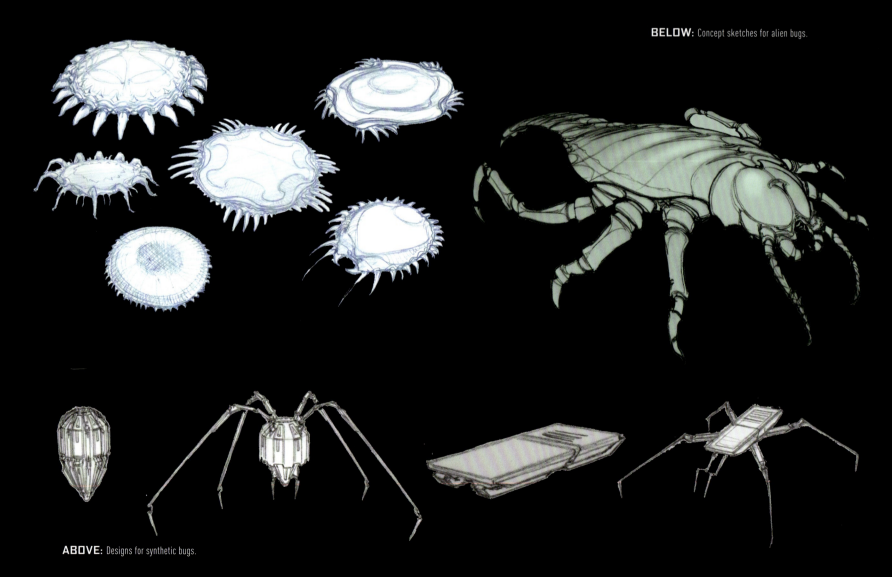

**BELOW:** Concept sketches for alien bugs.

**ABOVE:** Designs for synthetic bugs.

# ALIEN WEAPONS

We started out drawing primitive weapons again, because there was this story point where we had some kind of electronic rock on the planet that was naturally charged, so if you hit it with this club-like object, it ignites a natural charge.

Andy wanted to go a bit further, so he said, "What if the stick is charged by kinetic motion? You have a guy spinning three balls in one hand, which is connected to the club by a cable, so the more he spins, the higher the charge." We had all these interesting ideas, but it ended up changing a bit when they got to the planet, which was no longer as primitive.

**RIGHT:** Sketches for alien electric shock staff.

**BELOW:** Primitive alien electrical battle club.

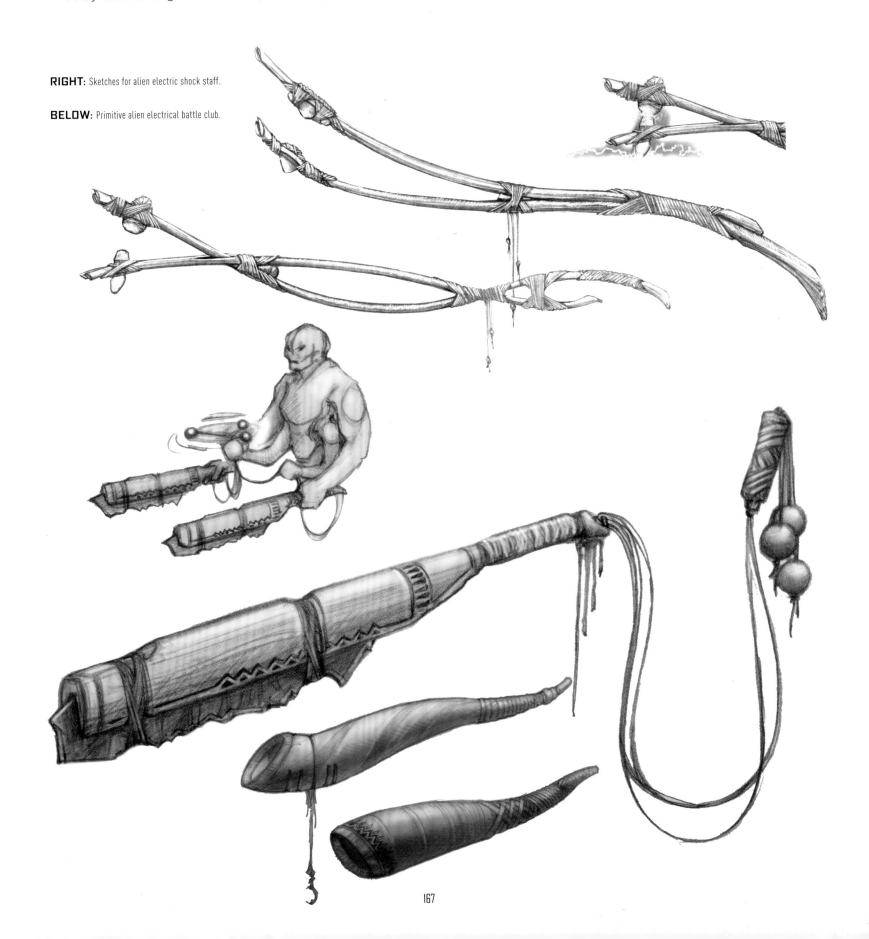

# VULCANS

Another prop we created early concepts for was a Vulcan harp. It was a nod to Scott, who had previously used multi-layered triangular forms for the Vulcan architecture, so we always tried to tie in Scott's sensibilities into any new Vulcan design. The harp didn't feature in the film, but we ended up using part of the design for the Vulcan jewelry. The design for Spock's photo box was also taken from the harps.

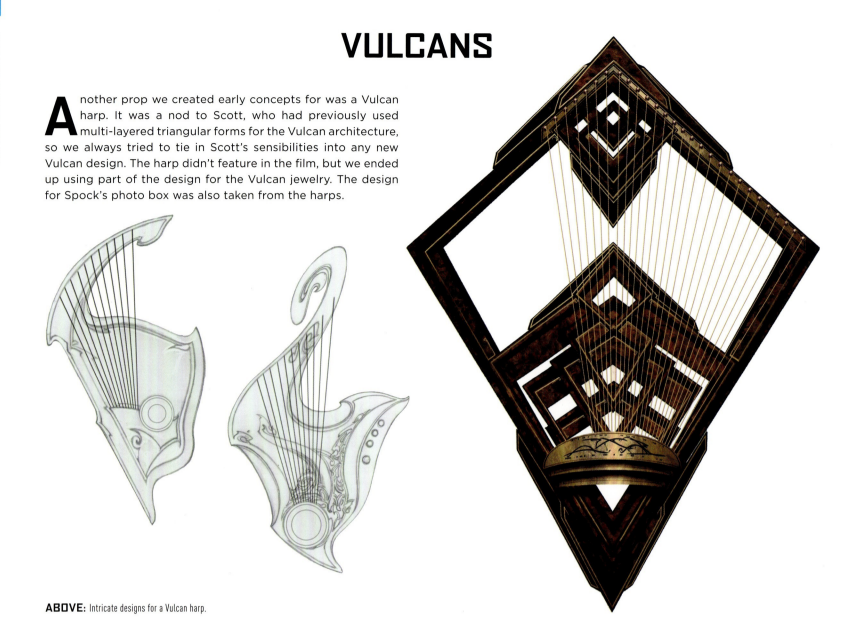

**ABOVE:** Intricate designs for a Vulcan harp.

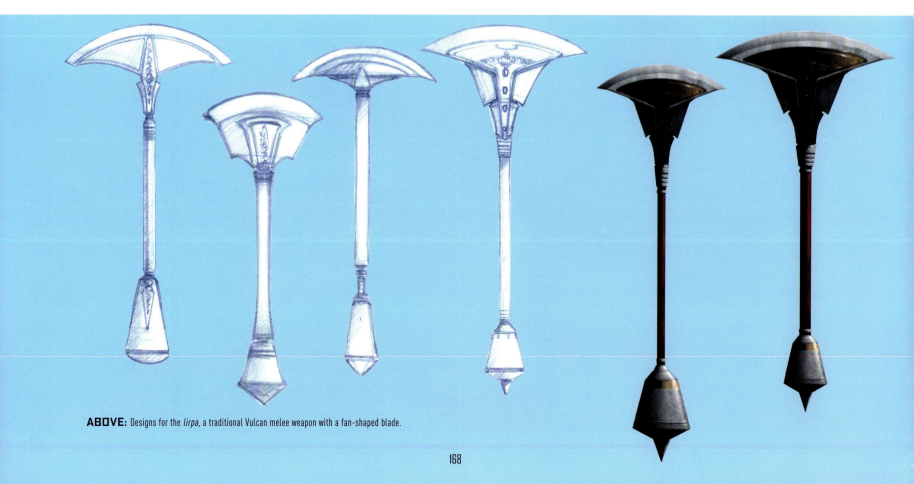

**ABOVE:** Designs for the *lirpa*, a traditional Vulcan melee weapon with a fan-shaped blade.

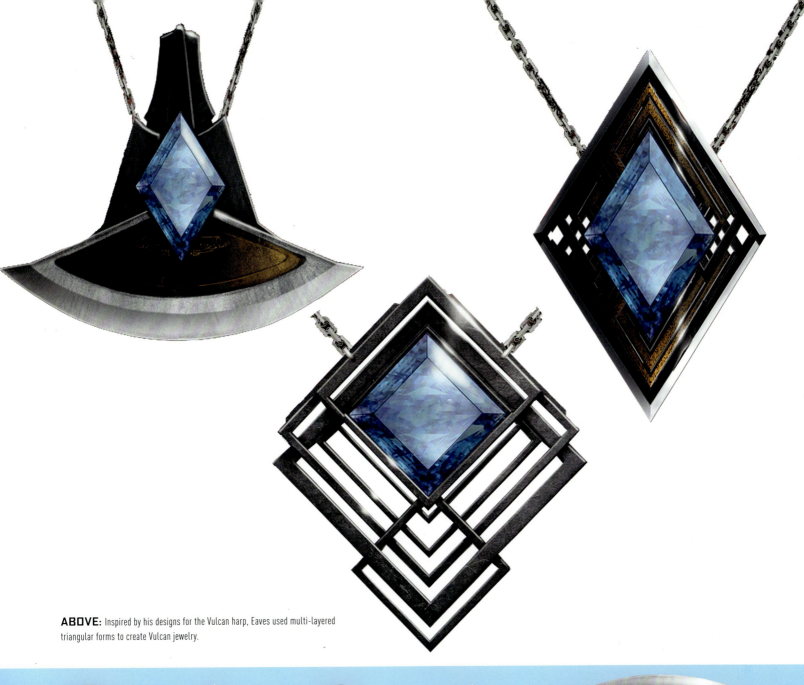

**ABOVE:** Inspired by his designs for the Vulcan harp, Eaves used multi-layered triangular forms to create Vulcan jewelry.

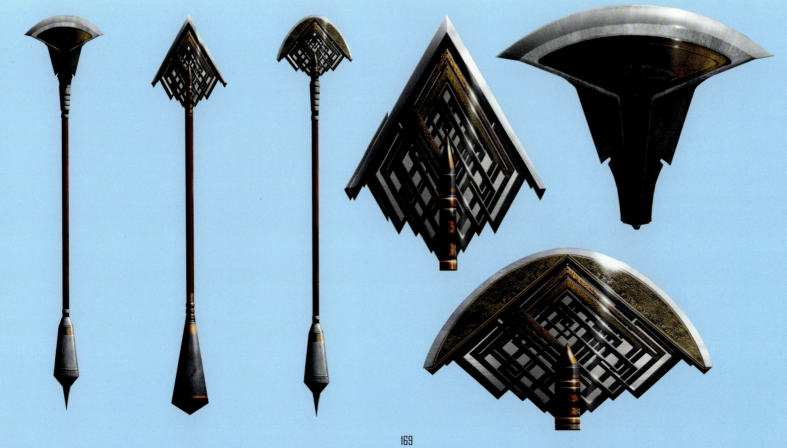

# STARFLEET WEAPONS

Production wanted to up the ante with some of the Starfleet props, including a series of heavy-duty weapons. Andy had been fighting to change the original phasers for a long time, because he thought the originals looked a bit toy-like, so he said, "What if we create a two-part system, where you have a rifle casing the phaser slips into, so the phaser pistol also converts to a rifle!" Paul Ozzimo, who originally designed the phasers, became available for a couple of days, and I suggested to Andy that he should ask Paul to revamp it since it was his gun.

Paul scrunched the phaser down, so instead of a circular barrel, it became an oval and a much sleeker piece. That took care of what Andy wanted to change without doing too much, and it was cool that we got to work with Paul. There's also a set of code numbers on the side of the pistol, which are Paul's initials and birthdate.

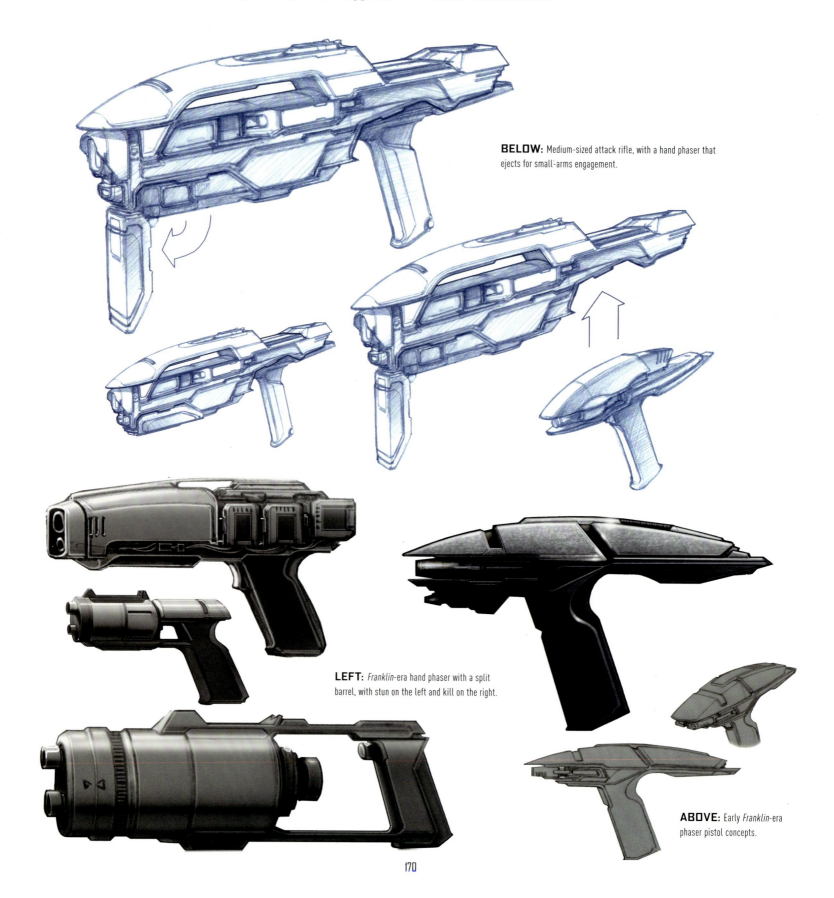

**BELOW:** Medium-sized attack rifle, with a hand phaser that ejects for small-arms engagement.

**LEFT:** *Franklin*-era hand phaser with a split barrel, with stun on the left and kill on the right.

**ABOVE:** Early *Franklin*-era phaser pistol concepts.

# STARFLEET TECHNOLOGY

We also got to make some interesting new Starfleet props, including devices that could strap on the wrist or forearm. Andy loves that wristband stuff, so we always draw it in every show we work on with him. Most of the time it gets the boot, but it's always fun to do them, because it harkens back to *The Motion Picture* where every piece of scientific or medical equipment involved those bands, so we thought it would be a cool transition to carry it through.

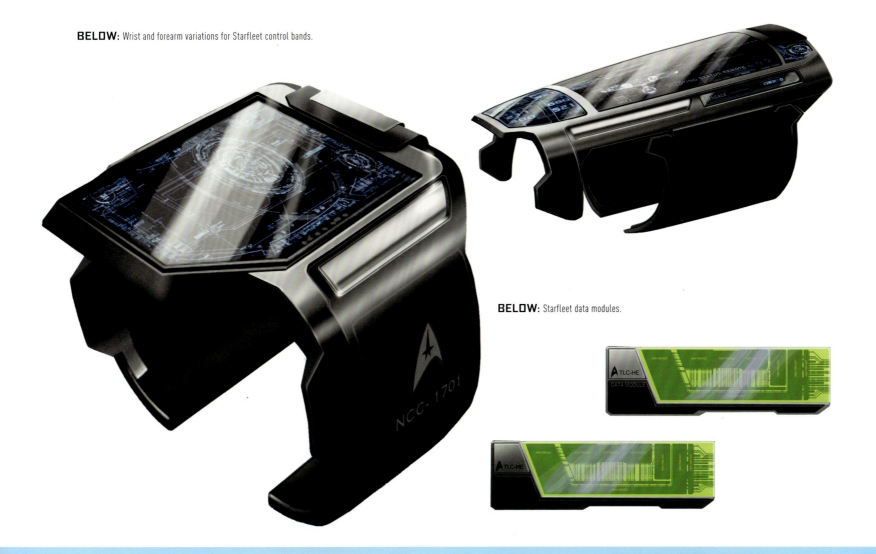

**BELOW:** Wrist and forearm variations for Starfleet control bands.

**BELOW:** Starfleet data modules.

**BELOW:** Starfleet binocular concept designs.

# FRANKLIN TECHNOLOGY

We had to create a number of props that would appear in the interior sets of the *U.S.S. Franklin*. The ship wasn't called the *Franklin* at that point—Justin Lin wanted the change to remember his father, whose name was Frank Lin, so if you see the commissioning plaque when they pan across the ship, there's a tiny gap between 'Frank' and 'Lin' just for him.

We knew this ship was supposed to be much older than the *Enterprise*, so we thought we could reference back to certain military communication devices and use existing present-day objects. We held off creating the props for some scenes until we saw what our set designers were doing with the ship itself. We knew, for example, there would be a radio that Jaylah pulls out and manipulates, and Andy managed to get some of the approved drawings for what those components would look like, so I was able to use them as inspiration to draw around.

By the time we were done with our sketches, construction had already begun, so we had a color palette, which was dark and rusty colors that tied in with the sets. We had to think about what circuitry would look like. Wires always say 'old' no matter what world you're in, so if wires are involved, you're looking at old technology, and allowing us to do that helped make things look older. It was great to have that information in advance, so I'm glad they were later props rather than earlier ones.

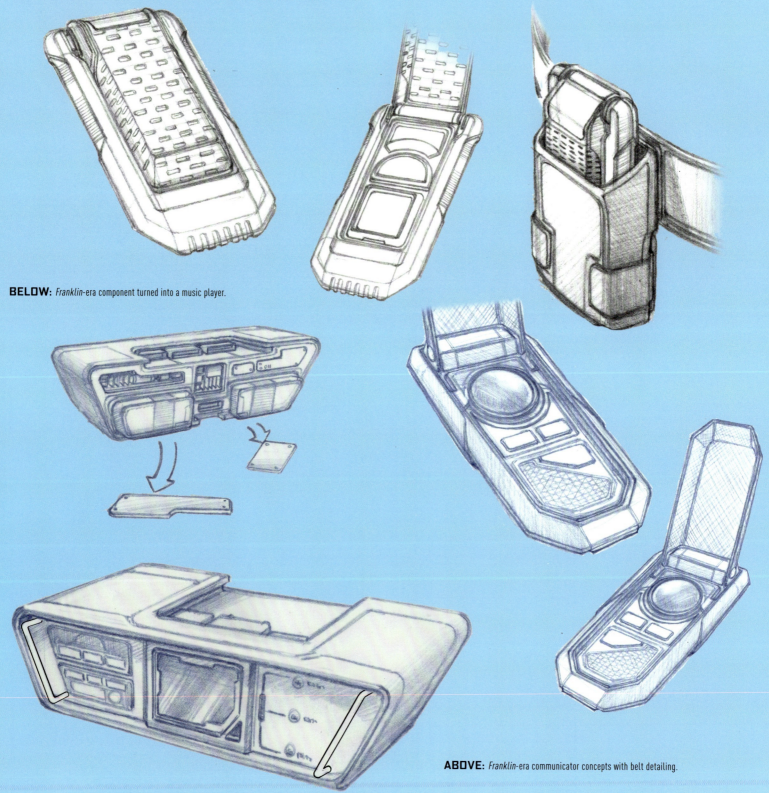

**BELOW:** *Franklin*-era component turned into a music player.

**ABOVE:** *Franklin*-era communicator concepts with belt detailing.

# FRANKLIN MEDICAL EQUIPMENT

With the *Franklin* medical equipment, there's a line of dialogue where Bones says, "I can't believe they actually worked with these devices!" so we had to come up with a whole new style to make these items more hands-on, where you actually had to practically do something before it works. We made a medical reader in two pieces, so it splits open and one piece is the reader while you run the other one across the patient and it gives you the feedback.

All these devices had some kind of physical interaction, as opposed to holding a reader up in the air and getting the information that way. With the blood readers we made a little device with a capsule you could eject out. We went back in time a little bit further than what we did in *Into Darkness*, where we had those little blood-draw machines for drawing Khan's blood. It was nice to go in that direction and create those devices that were a little more 'old school.'

**ABOVE:** Variations for hypospray medical device with interchangeable medication reservoir.

**ABOVE:** Starfleet emergency med kit for the *U.S.S. Franklin*.

# JAYLAH'S STAFF

Jaylah's staff was one of the most important props that I worked on. Andy's concept was, "What if it's something she made from the crashed ship?" We started thinking, what if Jaylah can manipulate technology just like Scotty does, so maybe she takes pieces of this and that and makes a staff out of it? The staff can be a rifle or a fighting stick, and maybe it carries an electrical charge, so we put all those features into it. For a while, it had an air gun with a trigger in the handle, but that got changed to a little keypad where you could type in different commands and it would disassemble into different things, so there was a central hub, and you could add different attachments to the butt of it. We went back and forth between, "Should it be thin or thick? Should it be one piece that separates into two?" We did a lot of variations, all of which got really good reviews, but in the end it was Andy's call as to which one would make it.

**BELOW:** Early sketches for Jaylah's staff, featuring a variety of elements to illustrate that it was created from parts of salvaged ships.

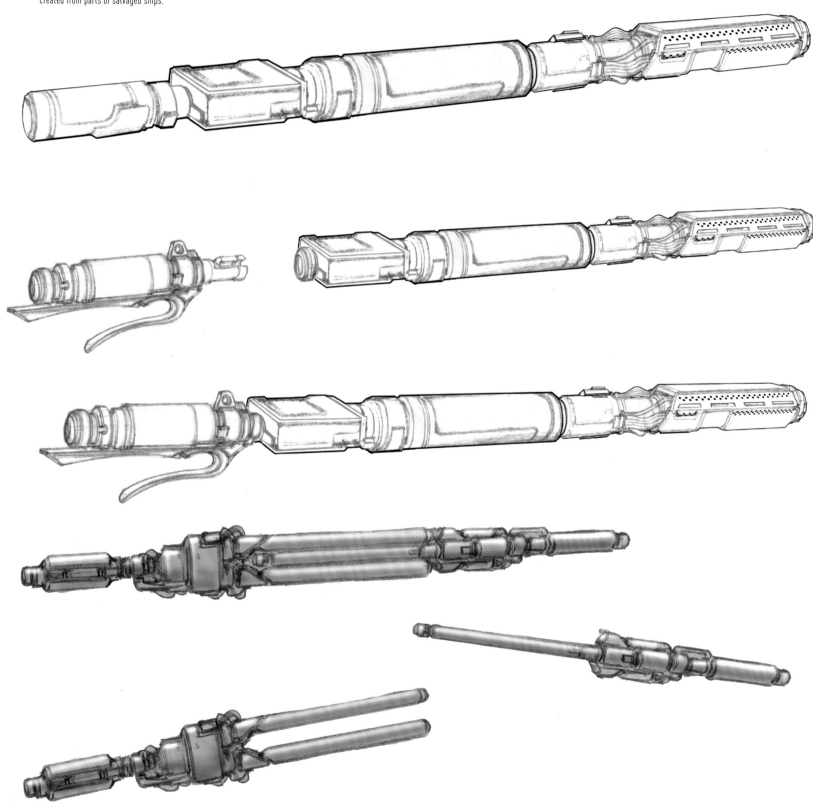

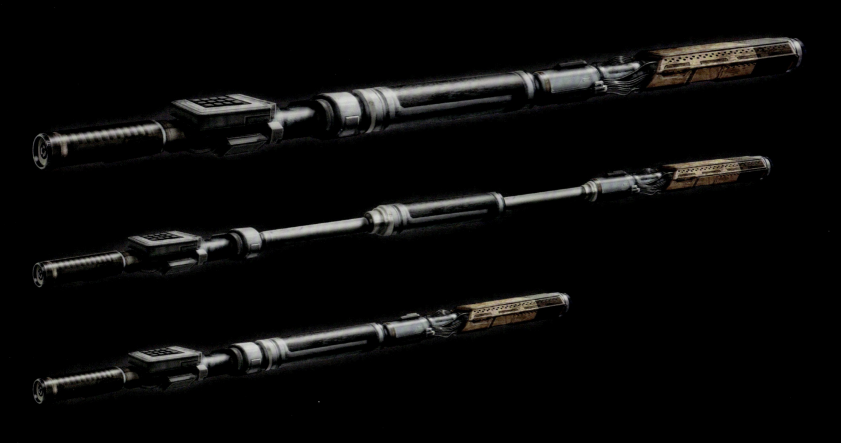

**ABOVE:** Concept for an extendable staff that would be five feet when fully extended.

**ABOVE:** Sketches for Jaylah's concussion bombs.

# SPOCK'S PHOTO BOX

## "WE DIDN'T KNOW IT WAS GOING TO CREATE SUCH AN EMOTIONAL RESPONSE."

One of my favorite props in the film is Spock's photo box. The box is based on a metal cigarette case and a business card case I found during my research, so we mixed the two together. It was supposed to open, but we didn't want a traditional hinge, because you've seen that many times before, so I wanted to add something different. We devised a little slider, so the box would slide, as opposed to hinge open.

The photo box started as a prop, so we didn't know it was going to create such an emotional response at the end of the film, because it certainly didn't read that way in the script. It was basically just a box that Spock had, but we didn't know if it was going to be old Spock or younger Spock. I initially drew the box with some Vulcan characters in it, so we just grabbed a picture of some Vulcans from one of the other shows and stuck it in there. It was like a family album with a couple of different uncles in it.

Then one day Andy called and said, "No, they want to have the *Enterprise* crew in it!" We chose an Original Series crew photo, because as far as we knew, the movies didn't exist in this timeline. A couple of days before they shot that scene, Andy called again and said, "We've got to change the photo!" so we ended up using one from *Star Trek VI*. Leonard Nimoy had passed away shortly after we designed that prop, and I think the producers felt, "Let's make this a more sentimental piece." So that's why they decided to change the photo inside. We didn't think anything more about that prop until we saw it in the movie and thought, "Oh my gosh, what an incredible moment!"

**BELOW:** Eaves' designs for the Vulcan memento box.

**BELOW:** The final box featured a photo of the crew from the Original Series.

STAR TREK: DISCOVERY

# STAR TREK: DISCOVERY

## "WE WERE GOING TO EXPLORE A REALM OF STAR TREK THAT REALLY HADN'T BEEN SEEN BEFORE."

I was working on *Spider-Man Homecoming* in Atlanta when I got a call from a friend of mine, Michael Meyers (not the killer from *Halloween* but the illustrator). We had worked together on *Captain America: Civil War* and became good buddies on that film, so if I heard about a job I would call him and vice versa. Mike told me about a new *Star Trek* series he'd interviewed for and that I should contact the production designer, Mark Worthington.

I called Mark, who said, "That's so funny, I wanted to get in touch, but we couldn't figure out how to contact you!" He told me they had an opening and so he suggested I come in for a meeting. Mark and I were about the same age, and we talked about things like *I Dream of Jeannie* and all the fun stuff we grew up with, so we hit it off right away.

I finished my work on *Spider-Man*, and we met in downtown LA a few weeks later, at a place called LA Center Studios, which I'd never heard of before. Somebody had bought this complex and turned it into a full-fledged studio. The way things work nowadays, the production designer normally sends you home to work, but in this case there was a group of us there who did maybe six weeks together before we split up, and I really enjoyed it.

This was in April of 2016. Bryan Fuller was showrunner at the time. As far as the look of the series at that point, Fuller's idea was that we were going back ten years before Kirk and Spock, and explore a realm of *Star Trek* that really hadn't been seen before. When I came aboard, Mark had drawings and photographs of the original TV series and early films all over the walls. I guess he was thinking we could use some of that existing material but maybe retro-ize it a bit and pull it all back in time. But what Bryan wanted was a whole new look, so it was all experimentation.

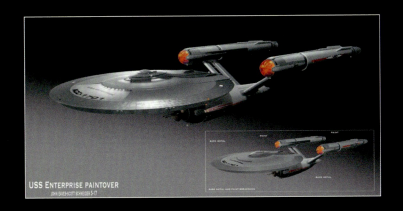
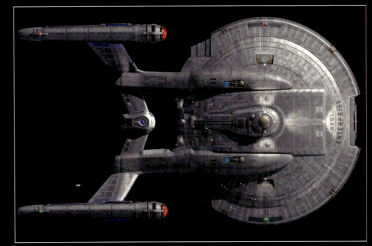

**ABOVE:** Early renders of the *Enterprise* show the classic red markings, light-gray paint scheme and orange bussard collectors seen in the original *Star Trek* TV series.

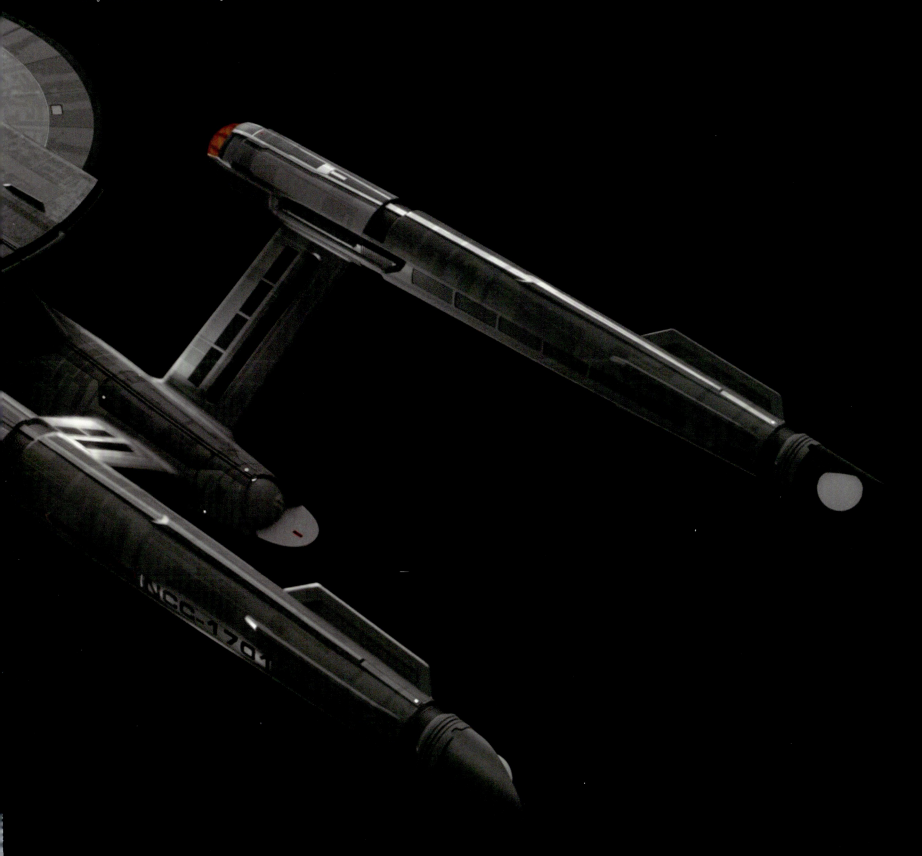

# U.S.S. DISCOVERY

One day, Bryan brought in some artwork done by Ken Adams and Ralph McQuarrie for *Star Trek: Phase II*, which was the never-produced TV series that was originally going to be done in the 1970s. Ken Adam was a world-famous illustrator, best known for his work on the early James Bond movies, and he had drawn some rough *Enterprise* designs, which were really cool to see. Ralph McQuarrie did some variations as well, but you could still see a lot of *Star Wars* influence in that work.

Bryan showed everyone these designs and he wanted them to be the root of our ideas for the *U.S.S. Discovery*. I remember when I first saw the drawing, I thought, "Oh my God, that's the ugliest thing I've ever seen!" simply because we're so used to the Original Series and the *Motion Picture* ships. Everyone was

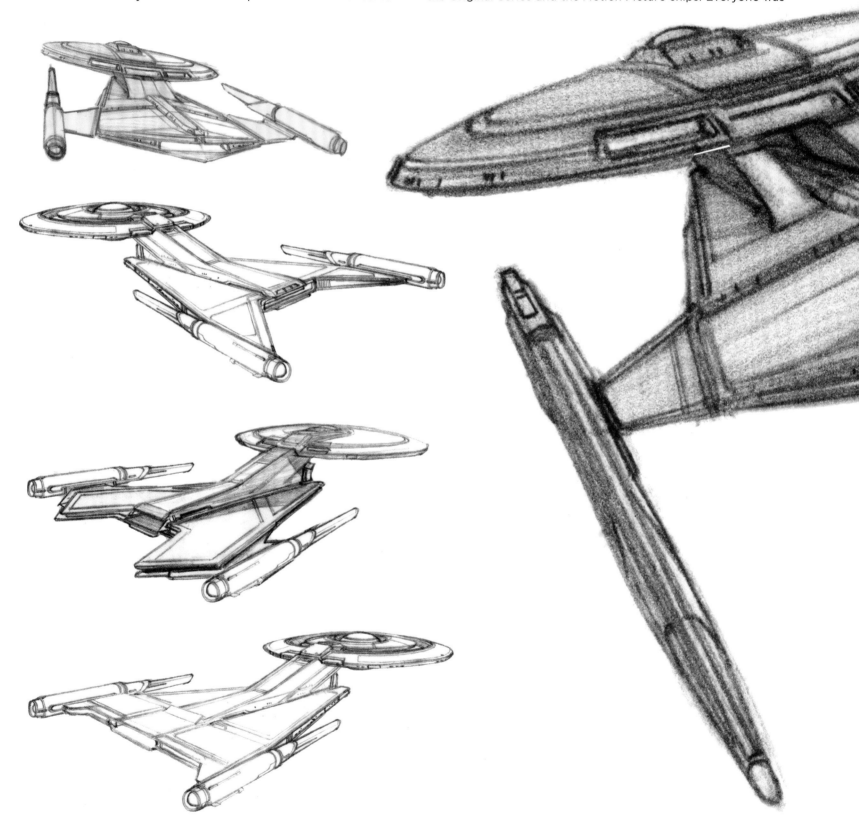

**ABOVE:** The XB-70 Valkyrie prototype bomber was the initial foundation for the design.

madly in love with that beautiful refit of the *Enterprise*, so to see this humongous departure, especially so early on, all you can think about is, "That doesn't fit at all!" But looking, it became a cool idea and a fun starting point.

I was set to work on the Starfleet ships, and in the beginning I was going back and forth between designs for the *Shenzhou* and *Discovery*. Meanwhile, Sam Michlap was given all the Klingon stuff immediately. Sam was fresh off the animation scene—he had worked on films like *The Lion King* (Disney) and *The Road to El Dorado* (DreamWorks). Paul Christopher was another illustrator working with us, and he would throw ideas out really fast. Paul had done a crude *Discovery* idea that Bryan really liked, so when I started on the *Discovery* Paul's design was one of my starting points. I was trying to create a nice mix between that design and the Adam/McQuarrie designs.

We started doing sketches based on those two ideas, but the first thing Bryan said when he saw them was that he didn't want to see any round nacelles on any Starfleet ships! That became a huge concern for all of us, because we were all thinking, "No round nacelles, what are we going to do now?"

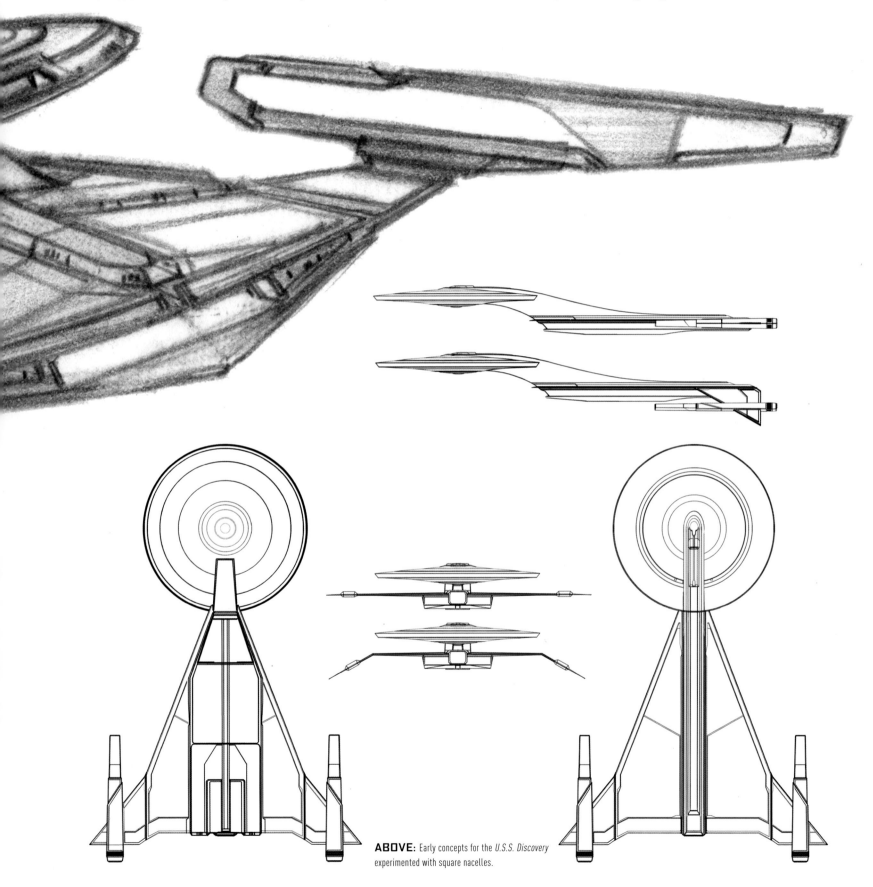

**ABOVE:** Early concepts for the *U.S.S. Discovery* experimented with square nacelles.

Since everyone knew our timeframe took place between *Enterprise* and the original TV series, round nacelles would really sell that timeframe without question, so having to alter them on all of our starships was strange.

We were probably 90% of the way there in the first month or so, but the nacelles became a big holdup. It ended up being a battle for easily five months, just trying to figure out what kind of nacelles we were going to do, and we tried every shape possible.

In the early days when we were still getting notes back about the nacelles, we were also talking about tying various aviation elements into it. There was a jet called the XB-70, which was this gigantic bomber that came out in the 60s and ended up not working, so they never went ahead with it. If you go to Edwards Air Force Base, they have this ship sitting there that looks like it was right out of *Planet of the Apes*, so we thought, "Why don't we use it for the transition between the McQuarrie/

**THIS PAGE:** Experimental aircraft from the 40s and 50s inspired Eaves to rework the *Discovery*, with the spore drive as a key reason behind the square nacelles.

Adams drawing to the *Discovery* world?"

Bryan liked that idea and Mark thought it was pretty cool, so we used that jet as the basis for what the *Discovery* was going to be. It had that beautiful streamlined element to it, and instead of putting the nacelles on these big struts, we gave it a very subtle, gradual 45° angle in the wings and the nacelles would sit on top of them, so it had a really beautiful flow to it. When the final CG model came back, it had a real sense of grace and majesty that took it out of the 1960s and gave it a really nice contemporary look.

While you always want your work to look good, you also try to put some meaning behind it. If a design is completely new and doesn't necessarily fit aesthetically into what you've done before, there has to be an explanation why things are different. In this case, because Mark Worthington and I thought the *Discovery* was going to be a spore drive ship, we got to thinking: what if we make this ship experimental, like the 1940s and 50s, where everyone was trying to go faster? That was the whole goal of the period, which was to make the fastest jet or the most successful airframe, so we applied that philosophy to the *Discovery* era. And because the spore drive hadn't been perfected yet we said, "What if the reason for the square nacelles is because they're part of a reworked traditional warp propulsion system?" That's how we explained why they were square, because sooner or later these ships were all going to transition over to the spore drive, which had the different-shaped nacelles.

**BELOW:** Eaves experimented with the design for the nacelles with direction from Mark Worthington.

**ABOVE:** The window panels were "retro-ized" on the bridge.

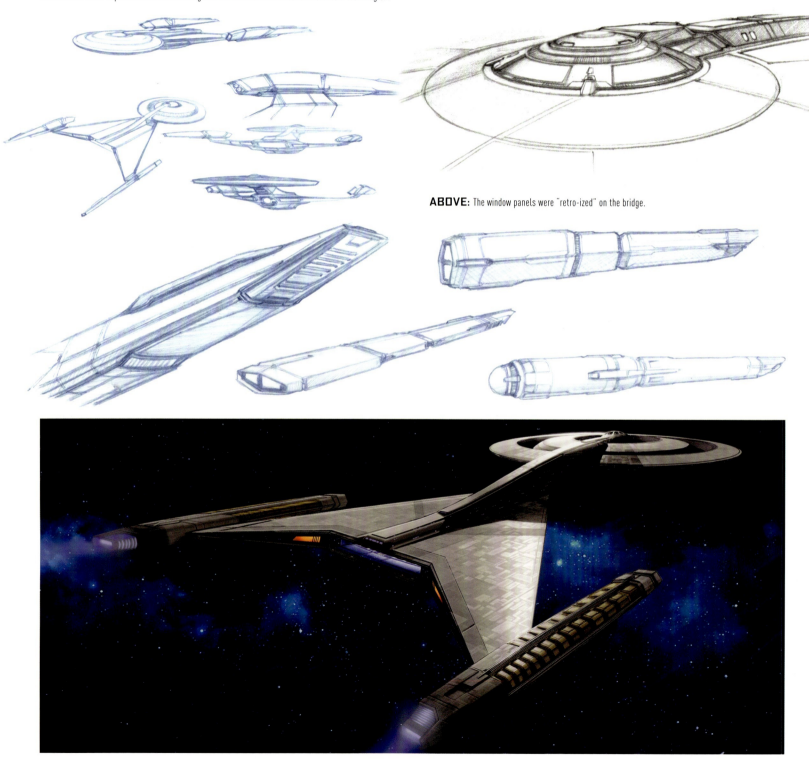

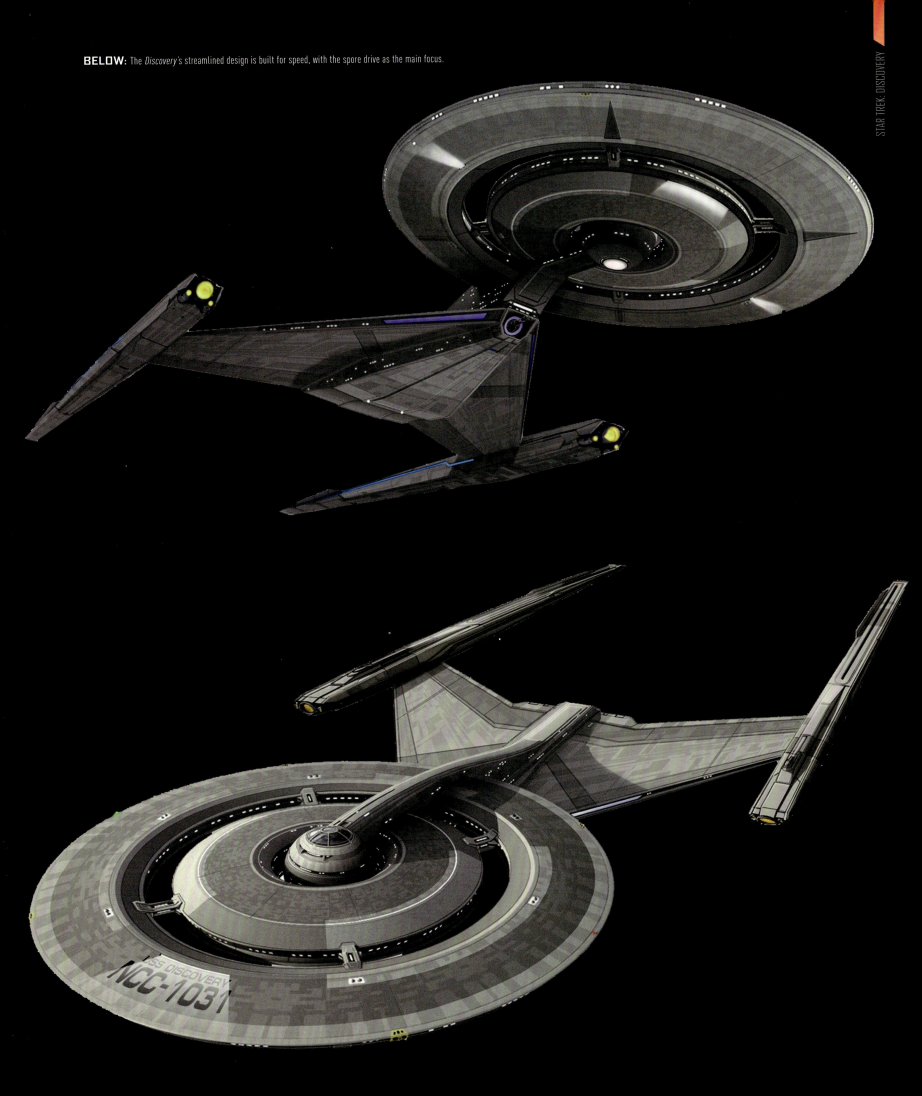

**BELOW:** The *Discovery*'s streamlined design is built for speed, with the spore drive as the main focus.

# U.S.S. SHENZHOU

While the *Discovery* was a year-long back-and-forth process, the *Shenzhou* was much quicker once we got the overall shape figured out. There was still a lot of work to be done at the beginning, as with the *Shenzhou* specifically, it was very new and hard to wrap your head around, especially with all the new requirements.

For the *Shenzhou*, the only real note I had was that the bridge was going to be on the bottom, plus we knew it was going to be an older ship. There was one sketch they liked so much that it went away for color rendering right away, but to be honest, I wasn't entirely happy with it. Todd Cherniawsky suggested I try something different, so I did two more sketches that had all the elements of that previous design but with things rearranged. I liked one of them a lot better, so I sent it to Todd who liked it too, and that final sketch was the one that got approved.

We knew the *Shenzhou* would have the nacelles, but I wanted something non-traditional to tie it all together. I thought about something that Tony Moore at Edwards Air Force Base told me about, which was a 'blended body' aircraft, where everything smoothly transitions into itself, so the hull blends into the wings and so forth. I thought I'd try the same thing, so my hull blended with the saucer, and that ended up being a nice idea that the producers really responded to. The *Shenzhou* had a body that arched across the top of the saucer with the bridge

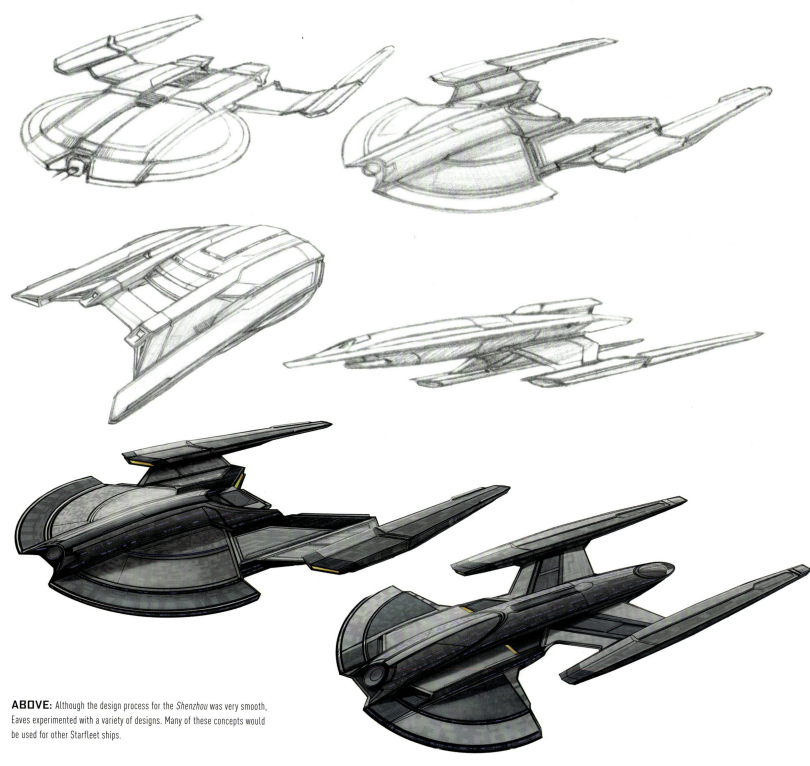

**ABOVE:** Although the design process for the *Shenzhou* was very smooth, Eaves experimented with a variety of designs. Many of these concepts would be used for other Starfleet ships.

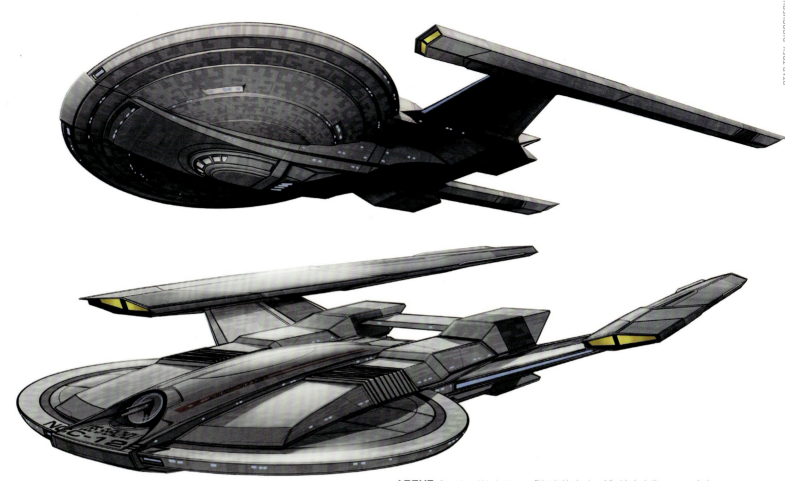

**ABOVE:** Eaves based his design on a "blended body aircraft" with the hull, saucer, and wings blended together.

**BELOW:** Early concepts show damage to the hull of the *Shenzhou* during battle with the Klingons.

on the bottom, so it had all the necessary elements, but in a new layout. It still said 'Star Trek,' but a new Star Trek. From there, everything flowed pretty well.

At one point, the Shenzhou was supposed to sustain some battle damage; the ship is hit pretty hard but not disabled. For a long time, we had a prison cell in the ship that gets ripped open and a force field goes around it so you could still see one of the characters inside it, but we couldn't figure out where to put that set so that we could rip off a piece of the ship without really destroying it in a major way. In the end, we came up with a little damaged section underneath the ship and the CG people did the work from there.

**BELOW:** The U.S.S. Shenzhou in flight.

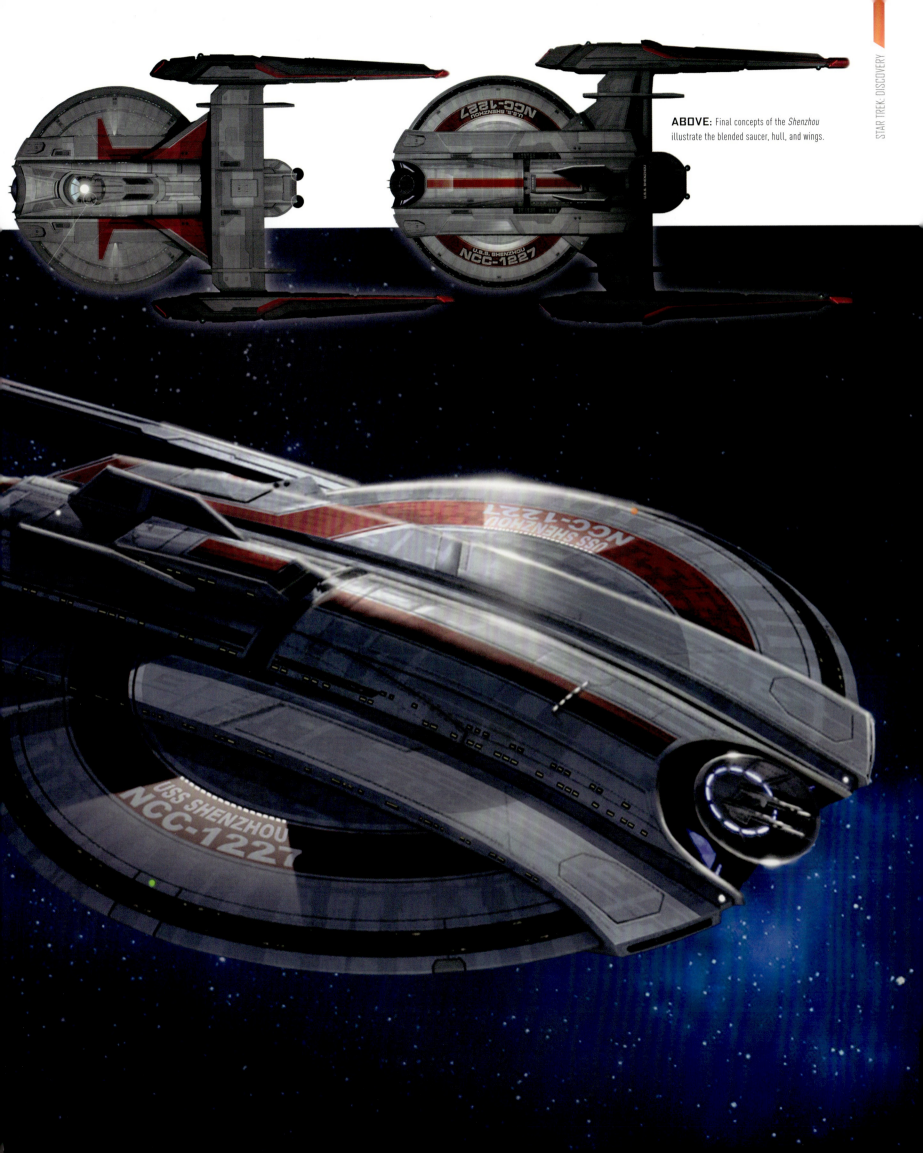

**ABOVE:** Final concepts of the *Shenzhou* illustrate the blended saucer, hull, and wings.

# STARFLEET SHIPS

In addition to our principal ships, we also had to come up with a Starfleet armada. We didn't necessarily know what it was going to be for, but we knew we were going to need at least a dozen background ships, so not only were they taken from rejected *Discovery* and *Shenzhou* designs, but I was also told from time to time, "Hey, why don't you draw a couple more starship ideas for the armada today?" We did something like 60 designs altogether, so we would start with rough sketches, and every once in a while, I would get a rough 3D model of one of them (which is when I knew they chosen that sketch) to do some finish work on top of it.

The class names are based on test pilots and astronauts. After a huge amount of discussion, we got all the ships picked.

The *Shenzhou* is *Walker* class, which was named after Joe Walker, an X-15 test pilot who had a horrible crash with an XB-70 plane, so it seemed appropriate to remember him that way. When his son heard about it, he wrote me to say, "That's so cool to have our dad's name remembered in a *Star Trek* show."

Our thought was, all these ships are experimental, and if you go back to the Original Series (and there's only a ten-year difference), all of those ships were based on United States aircraft carriers, so we thought it seemed appropriate if our experimental ships were named after test pilots. When you look at what Gene Roddenberry was doing, with the space race going on and all the pioneering done in aviation, that was the realm of thinking at the time, and naming our class names this

**BELOW:** Concept for a Federation ship without the traditional saucer.

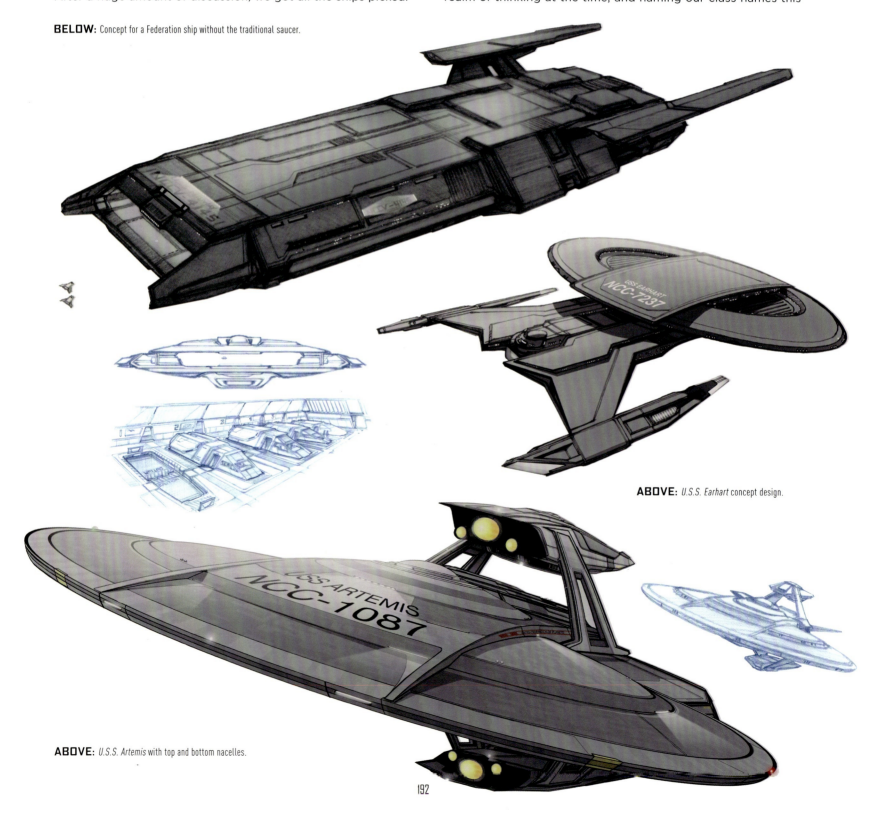

**ABOVE:** U.S.S. *Earhart* concept design.

**ABOVE:** U.S.S. *Artemis* with top and bottom nacelles.

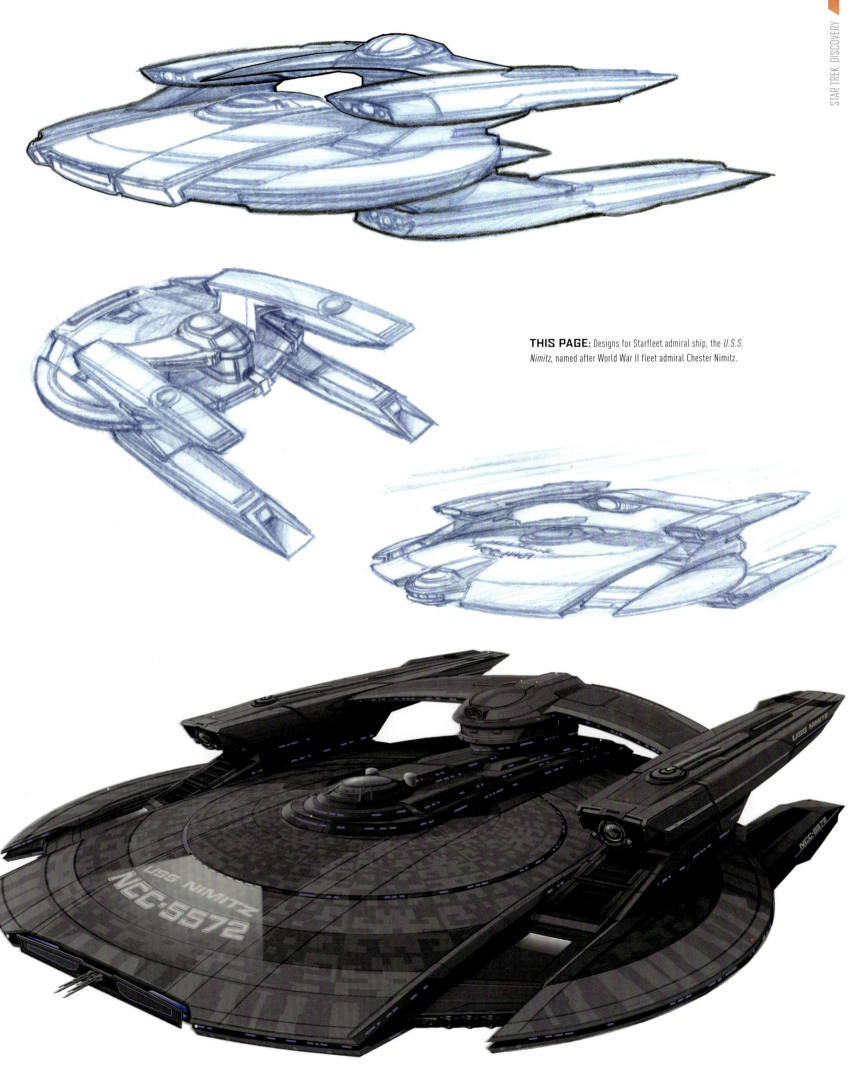

**THIS PAGE:** Designs for Starfleet admiral ship, the *U.S.S. Nimitz*, named after World War II fleet admiral Chester Nimitz.

way really fit into a Roddenberry way of thinking.

We also came up with seven or eight little features that you'll see on every ship, tying that whole era together, so with the deflector dish, for example, we did a double side-by-side antenna. We also added little runner fins to every ship. With the hull lighting, we came up with the idea of segmented spotlights. Instead of one major light, why don't we do it like an old-fashioned light bar, with a whole bunch of lights? That was another element we used to tie the ships together. We used the same style of RCS thrusters and markings for the ships, and all the titles are in white as opposed to black, so all of these things were done just to make our ships fit together in the same realm.

**BELOW:** Early concepts for the *U.S.S Jefferies*.

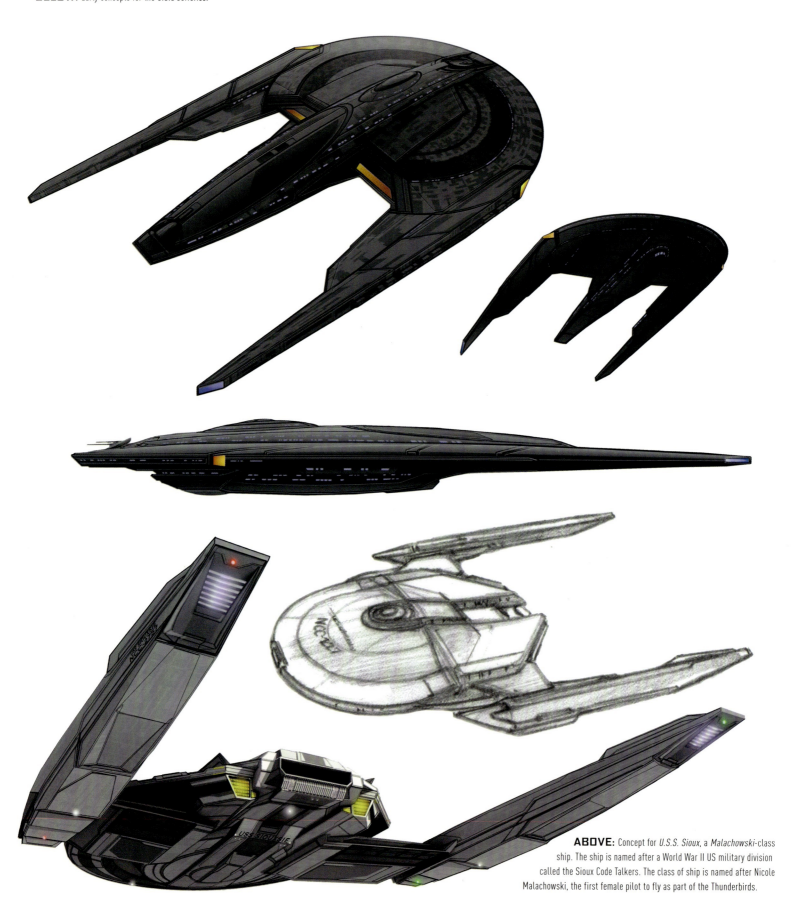

**ABOVE:** Concept for *U.S.S. Sioux*, a *Malachowski*-class ship. The ship is named after a World War II US military division called the Sioux Code Talkers. The class of ship is named after Nicole Malachowski, the first female pilot to fly as part of the Thunderbirds.

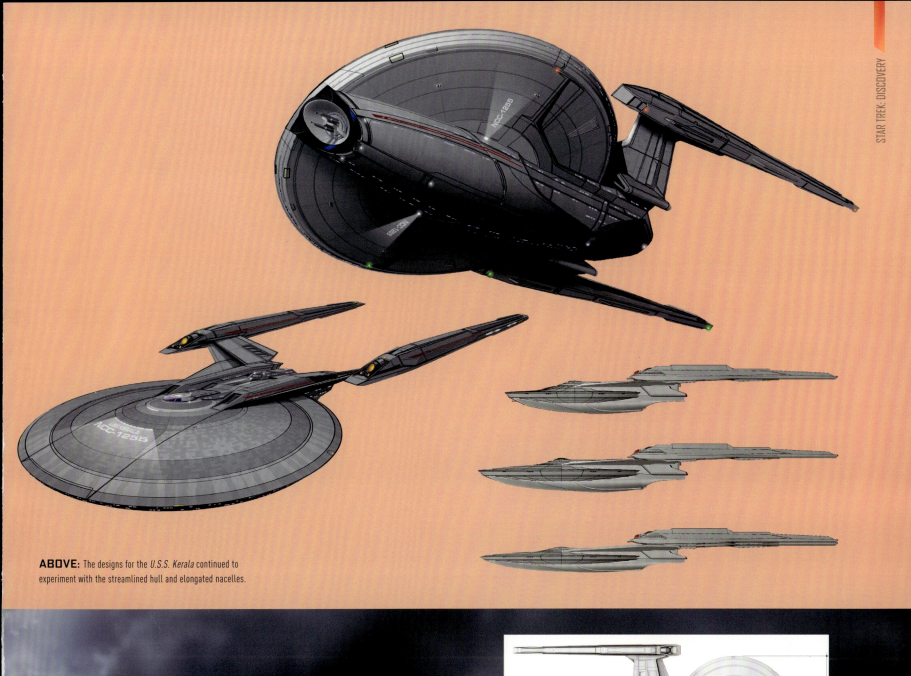

**ABOVE:** The designs for the U.S.S. Kerala continued to experiment with the streamlined hull and elongated nacelles.

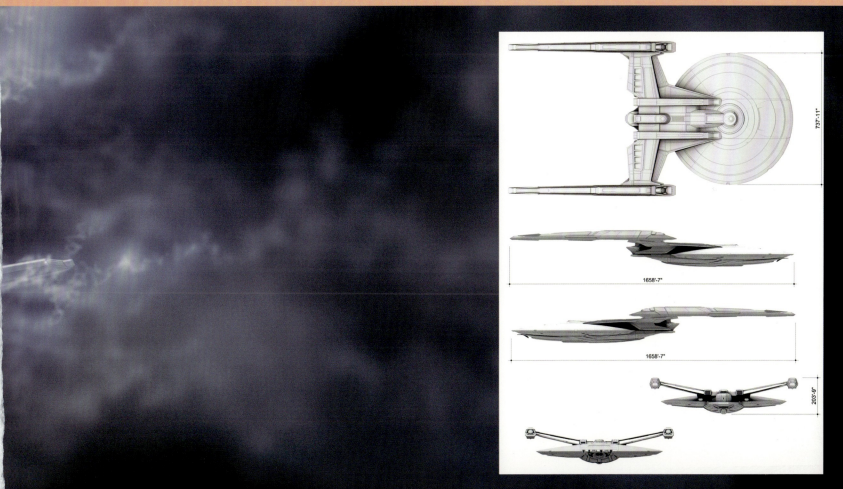

# I.S.S. CHARON

Aside from the Starfleet ships, one of the more interesting challenges for me was the *I.S.S. Charon*, a Terran Empire Imperial ship, which changed a number of times during the design process. It was originally going to be a doomsday machine with a palace-type look at the top, because of this imperial group in the alternate universe, but it was also a doomsday machine that destroyed planets. Just for nostalgia's sake, we said, "Let's take the old doomsday machine from that episode of the original TV series and maybe change it a little bit so it almost looked like it was made of whale bones." There's also supposed to be a floating star in it, so we thought, great, it could be what you saw in the cone of the original doomsday machine. Basically it's an inside-out version of that Original Series ship. As the script changed, it was still a doomsday machine, but you don't really get that information as far as its destructive capability. Instead, they focused more on the Imperial aspect of the ship rather than what it did. The shape didn't change, just the aesthetics of what it was supposed to be.

**BELOW:** Early designs of the *I.S.S. Charon* were originally palatial to illustrate the grandiose nature of the Terran Empire.

For the *Charon*, we started with a fairly smooth shape, but there were some little script changes that suggested it had to be a lot more aggressive-looking, so we added a snake texture to it and those dinosaur 'blades' across the top. Between the *Enterprise* and the *Charon*, Scott Schneider, and VFX art director William Budge and I became a trio working together with Tamara Deverell the production designer. I would do the sketches, Scott did the model and we would go back and forth with details as the script was being rewritten. I would take Scott's model into Photoshop and make changes there, and William would do the same thing, adding scales or suggesting where the shuttlebays would be, or where the weapons would be. He was the tech guy at the end of that process, so he would break down the drawing and add all these little headers with arrows pointing to details on the ship that would say, "Here's the deflector dish, here's the power source." That was something Scott really enjoyed doing, and it was a lot of fun, the three of us working together on the *Charon* and *Enterprise*.

Those two ships probably carried us from April to October, and it was a fun collaboration. Scott is a remarkable CG modeler, so I would give him a sketch and by the end of the day I would have a rough model of it to work with, so the turnaround was remarkably fast. I hardly had time to think about it before I had something to work on!

**ABOVE:** The *Charon*'s mycelial reactor is at the center of the ship and is later destroyed by the *U.S.S. Discovery*.

**BELOW:** The doomsday machine from the Original Series inspired the later designs of the *Charon*. Digital artist Scott Schneider created the 3D renders.

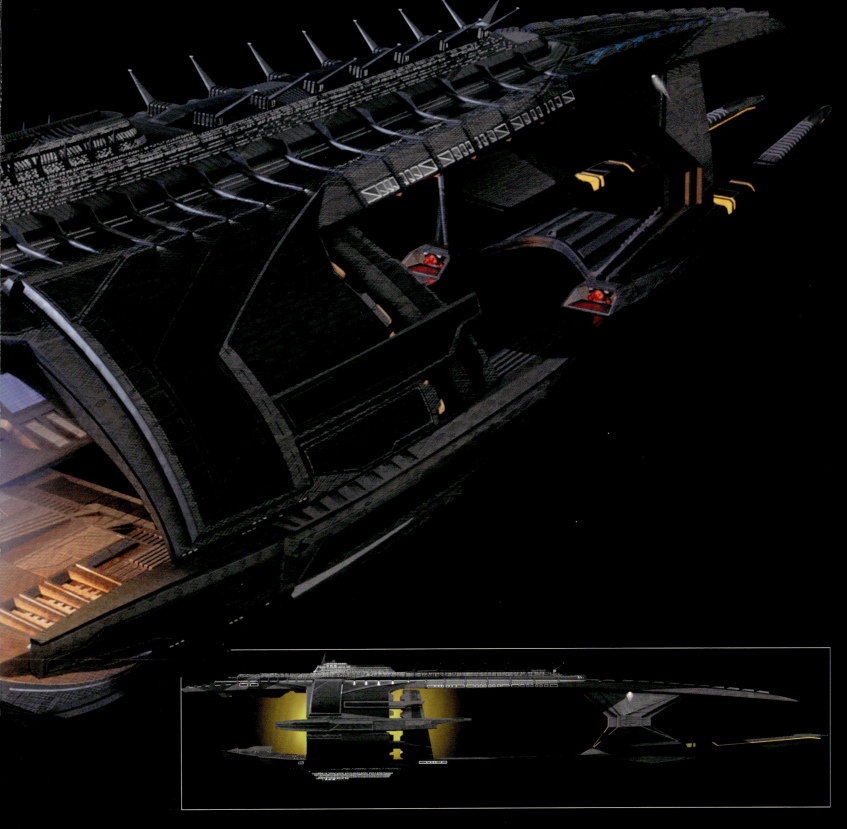

**ABOVE:** "Whale bones" formed the imposing external structure of the *Charon*.

# U.S.S. ENTERPRISE

It was much later in the season when the *Enterprise* came up. I had pretty much finished my work on the first season in January, and at that point it was mostly episodic so if they needed something they would call. Todd was about to move on, so he called and said, "I've got one last project for you: I need a new ship! I think we're going to have an *Enterprise* at the end of the season, so I want to see what you can do. It needs to be different, but I know you're going to want to harken back to the Original Series, so take those elements and go for it!"

At the same time, a friend of mine, Scott Schneider, had just started on the show. We had worked in the model shop together on films like *The Hunt for Red October*, as well as a little bit of work on the last two J.J. films, but this was the first time on the new series where I got to work directly with the CG model guy. We both had the same admiration for the original *Enterprise*, and now we were working together, me for the art department and Scott in the computer department, so that was really cool.

I did a bunch of sketches, knowing right off the bat that I wanted to pay as much homage to the original Matt Jefferies design as possible, but change some of the configuration and surface detail. This was the first time we were using a ship that tied into the Original Series, so we could still use the round nacelles on it. That was the first thing I worried about, that we were going to have to do square nacelles, but Todd said, "No, go as close to the original as you want," so that was good news.

I handed in my first sketches, and Todd had me do

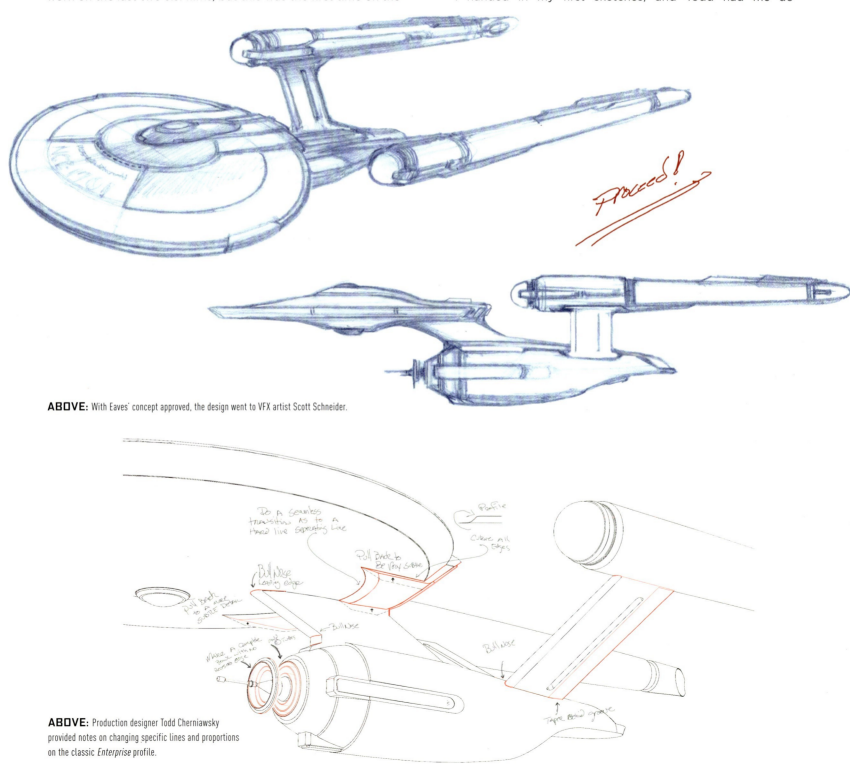

**ABOVE:** With Eaves' concept approved, the design went to VFX artist Scott Schneider.

**ABOVE:** Production designer Todd Cherniawsky provided notes on changing specific lines and proportions on the classic *Enterprise* profile.

**BELOW:** Eaves' final sketches. From here, Scott Schneider worked on the CG modeling.

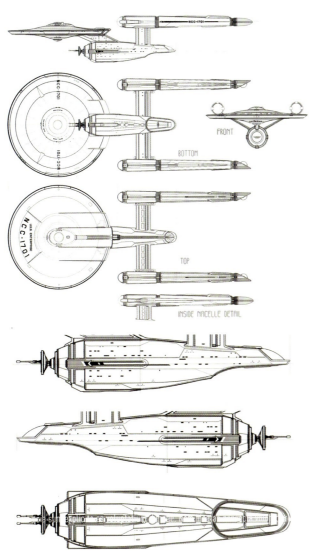

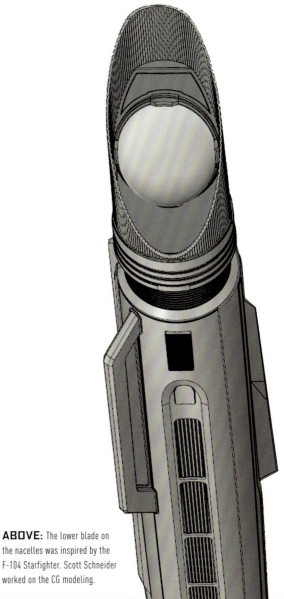

**ABOVE:** The lower blade on the nacelles was inspired by the F-104 Starfighter. Scott Schneider worked on the CG modeling.

**BELOW:** The domed bussards were based on the original *Enterprise* and feature the familiar orange hue. Scott Schneider worked on the CG modeling.

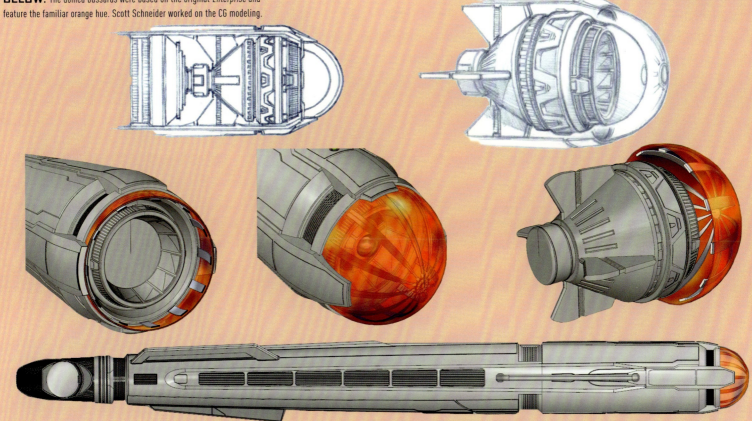

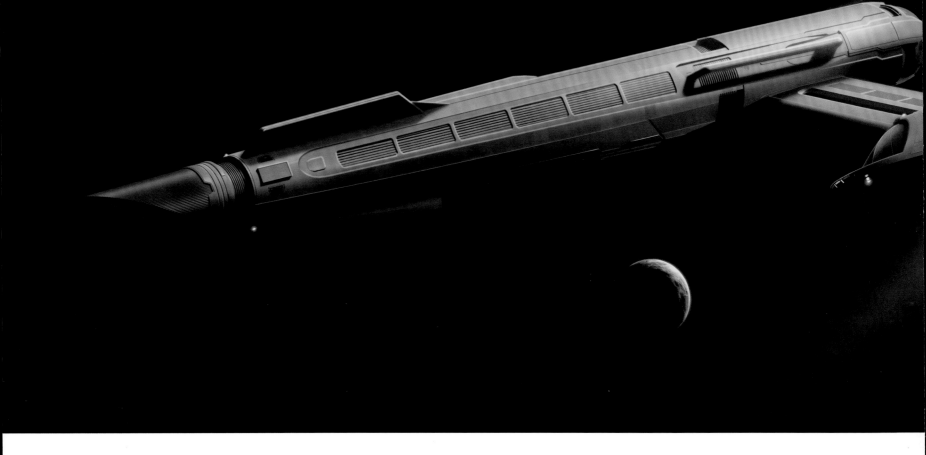

some small variations. By the time I got to version F, we'd really tied it all together and that's the one we went with. I did a line drawing of each view, and Scott did a rough model. At that point, we went back and forth, finessing the final design, talking maybe eighteen times a day about what we were doing. Scott would send me a grayscale CG model and I would Photoshop over the top of it and say, "Why don't we extend this or that?" and that process continued for several months. Scott and I had the

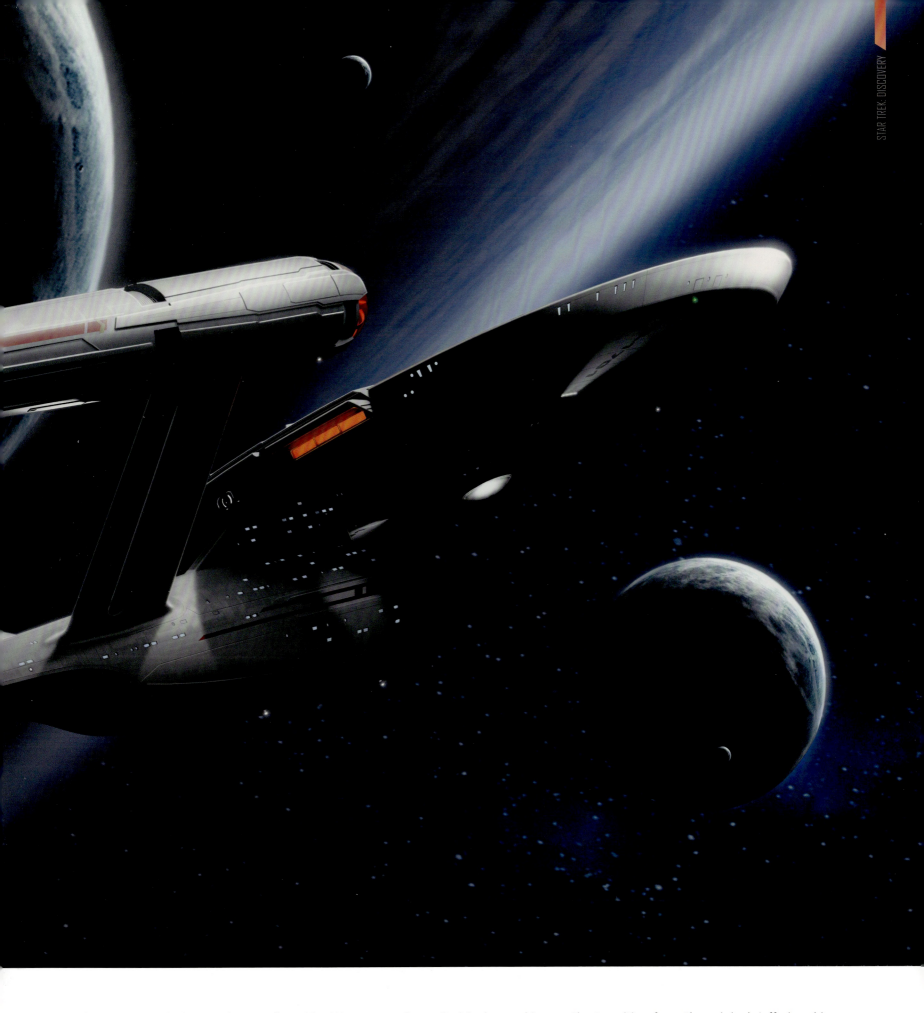

best time working together on that ship. We were really excited to be working on the transition from the original Jefferies ship to the *Discovery*, so that was a real highlight of the show.

**ABOVE:** The *Enterprise*, *Star Trek*'s most iconic ship, flies alongside the *Discovery*.

# AFTERWORD
## BY JOHN EAVES

### "I NEVER THOUGHT I WOULD BE LUCKY ENOUGH TO WORK ON STAR TREK."

August of 1985, the great summer I made the move to California from Phoenix, Arizona to begin a fantastic career working in Hollywood. The dream of working in movies started ten years earlier when I first saw *Jaws* in the movie theater. Once I found out that people were hired to draw and design the movies way before the cameras ever rolled, I knew what I wanted to do. I would spend the following years of my life learning everything I could about the artists behind my favorite movies.

From *Star Wars* to *Alien*, there was so much out there for a sci-fi-hungry kid such as myself. Then, in 1979, *Star Trek: The Motion Picture* came out. I loved *Trek* as a kid, and to see a big-screen epic of this beloved show was almost too much to take. As big as those dreams were back then, I never thought I would be lucky enough to work on *Star Trek*. Amazingly, this is my thirtieth year of being a part of this incredible adventure.

Looking back on those early days, I remember all the cinematic heroes of art, special effects, and model making, such as Ralph McQuarrie, Joe Johnston, Syd Mead, Richard Edlund, and John Dykstra. These artisans became household names, and their behind-the-scenes adventures were a common topic around our family dinner table. The works of Ron Cobb, Robert McCall, and Greg Jein really set my imagination on fire, and they were the ones that set the path for my future.

In any of life's great adventures, there are people that inspire and encourage your journey. This book is just over 200 pages long and in all honesty I think I could write at least that many pages with the names of these great people. Since that can't happen, I have to give thanks to those that were and are so influential to this day. Being a Christian man I always want to give God the credit, and with great thanks he has opened countless doors and blessed me with many great friends and a talent that I so love. My parents Jim and Fran Eaves and my sister Christi, who not only encouraged me along the way but also took me to the movies whenever something new came out. To Steven Spielberg, George Lucas, John Carpenter, George Miller, The Coen Brothers, Joe Dante, Jerry Goldsmith, John Williams, Siouxsie Sioux, Grant McCune, Glenn Campbell, Gene Warren Jr., Robert Short, William and John Shourt, Herman Zimmerman, Louise Dorton, Scott Chambliss, Andy Siegel, Russell Bobbitt, Graham (Grace) Walker, Danny Elfman, Dave Hodge, Marty Kline, Lee Stanton, Colin Gibson, Ed Verreaux, Daren Dochterman, Alfred Hitchcock, Todd Cherniawsky, Scott Schneider, Andy Probert, Miles Teves, Mark Stetson, Gary Gutierrez, Dave Sossalla, Melissa Harrison, Nelson Broskey, Mark Zainer, Pat McClung, Michael Possart, Mike and Denise Okuda, Tamara Deverell, Albert Whitlock, Henry Bumsted, William Budge, Martin Bower, Doug Drexler, Sean Hargreaves, Matt Jefferies, Fritz Zimmerman, Jim Van Over, Anthony Fredrickson, Penny Juday, Laura Richarz, Berndt Heidemann, Ron Nomura, Rick Sternbach, Jim Martin, Ricardo Delgado, John Goodson, Stuart Blair, Linda Gurney, Phil Edgerly, Leslie Mintz, Bill George, Timothy Earls, Chuck Bell, Richard Winn Taylor II, Darlene Goto, Richard Gross, John Bankson, Mark Worthington, Ramsey Avery, Kirk Corwin, James H. Spencer, Ryan Church, James Clyne, Dan Curry, Ron Moore, Brannon Braga, Rick Berman, Alex Kurtzman, Gillian Armstrong, Jo Kennedy, Ross O'Donovan, Peter Weir, Ridley Scott, Mel Gibson, Jim Henson, Terry Gilliam, Karl Martin, Tim Flattery, Dan Madsen, Bill "Retro Bill" Russ, Douglas Graves, Joe Johnston, Ralph McQuarrie, Alan M. Kobayashi, Mark "Crash" McCreery, Miles Teves, Danny Elfman, Jeff Bond, Gary Rhodaback, Jen Howard, James Cawley, Pete Gerard, Scott McGaugh, Syd Mead, Tony Landis, Sandy King, Bruce Hill, Wallace, Ladmo, Gerald, Bill Boes, David Harbster, Dickie Alexander, John Dykstra, David Stipes, Rod Andrewson, Phill Judd, Michael Westmore, Bob Blackman, David Duncan, Tony Moore, all the artists at Cowboy Cartoonist International, Gene Roddenberry, and to Joe Nazzaro, Charlotte Wilson, and John Van Citters for making this all happen. Thank you for sharing your visions, your talents, and friendships. God Bless.

John Eaves
June, 2018

# DEDICATION

This book is dedicated to my one and only, my lovely wife and my best friend, Tara. Thank you for being my heart and soul, and in many cases my eyes. To our daughters, Amanda, Olivia, Carlene, Alicia, and my little buddy Alyna. To the incredible Ron Cobb, the artist whose work inspired me the most. To Greg Jein, Grant McCune, Robert McCall, and Herman Zimmerman. J.E

**ABOVE:** John Eaves and Greg Jein working and having fun on *Star Trek V: The Final Frontier*.

# DEDICATION

To John Brew, the truest friend anyone could ask for. J.N

# ACKNOWLEDGEMENTS

In December of 2017, I got an email from the folks at Titan, asking if I was interested in a possible follow-up project to last year's *Star Trek Beyond: The Makeup Artistry of Joel Harlow* (and shame on you if you haven't bought a copy yet). Instead of makeup this time, we would be delving into the world of concept art and illustration, but with the same outstanding production values evidenced in the Harlow book.

I would like to thank my partner John Eaves for a wonderful and most rewarding collaboration. John had the tougher job by far; while I was responsible for stringing words together in some sort of coherent fashion, he had to track down, collate and scan three decades' worth of material, from finished artwork to sketches hastily drawn on a napkin outside an Arizona take-away barbecue. When you're measuring your workload by the number of piles that still have to be scanned, you know you've got a tough mountain to climb.

Thanks also to my editor Charlie Wilson and the team at Titan for their usual exemplary work. Once again they've taken a massive conglomeration of material and reshaped it into a visually stunning piece of work. I'm very grateful to all of them.

Joe Nazzaro
June, 2018

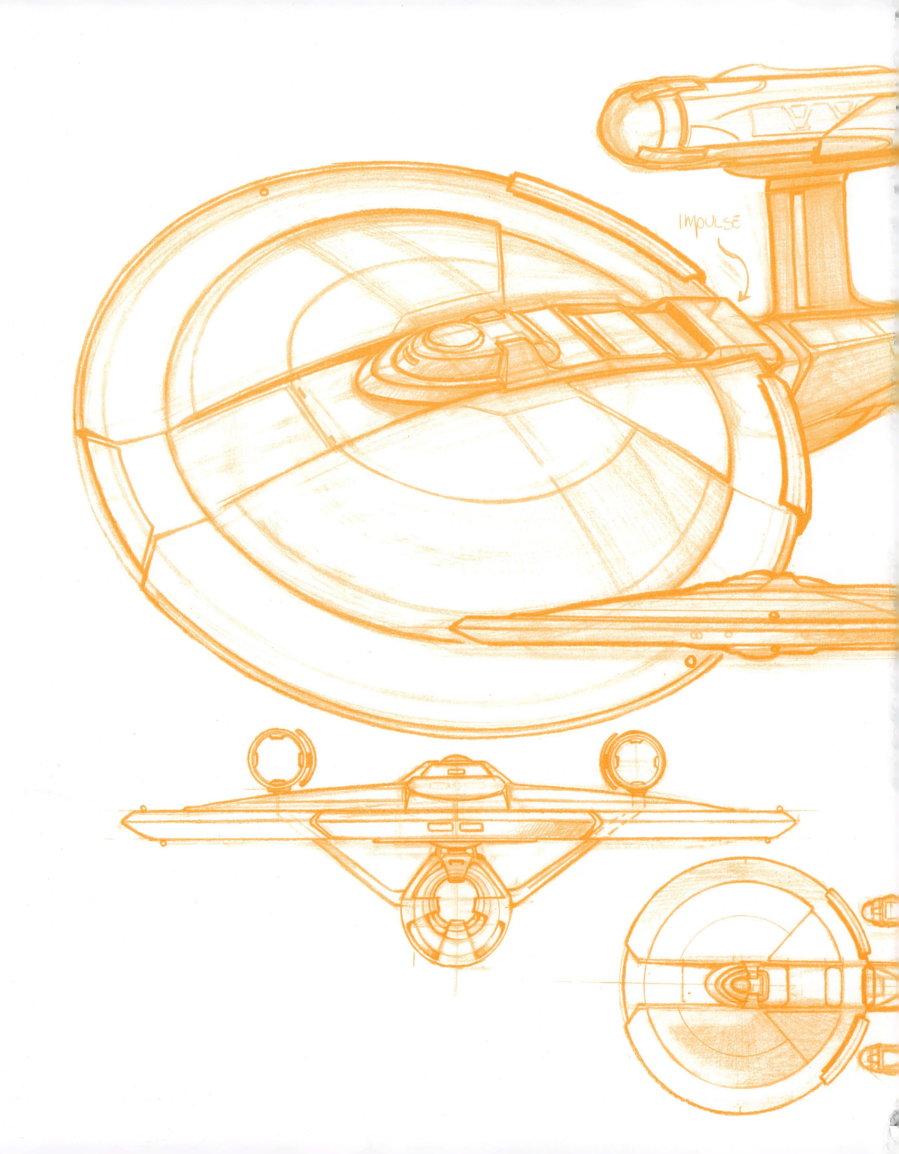